A Guide to the
Preventive Conservation
of Photograph Collections

A Guide to the Preventive Conservation of Photograph Collections

Bertrand Lavédrine

with the collaboration of
Jean-Paul Gandolfo and Sibylle Monod

Translated from the French by
Sharon Grevet

The Getty Conservation Institute, Los Angeles

The Getty Conservation Institute

Timothy P. Whalen, *Director*
Jeanne Marie Teutonico, *Associate Director, Field Projects and Science*

The Getty Conservation Institute works internationally to advance conservation and to enhance and encourage the preservation and understanding of the visual arts in all of their dimensions—objects, collections, architecture, and sites. The Institute serves the conservation community through scientific research; education and training; field projects; and the dissemination of the results of both its work and the work of others in the field. In all its endeavors, the Institute is committed to addressing unanswered questions and promoting the highest possible standards of conservation practice.

Getty Publications
1200 Getty Center Drive, Suite 500
Los Angeles, California 90049-1682
www.getty.edu/publications

© 2003 J. Paul Getty Trust

Second printing

Chris Hudson, *Publisher*
Mark Greenberg, *Editor in Chief*
Ann Lucke, *Managing Editor*

Tevvy Ball, *Project Editor*
Sheila Berg, *Copy Editor*
Atalier Baie and Hespenheide Design, *Designers*
Amita Molloy, *Production Coordinator*

Printed in Hong Kong by Great Wall Printing Company Limited

FRONT COVER: Julia Margaret Cameron (British, born India, 1815–1879), *Mrs. Herbert Duckworth*, 1872, carbon print, 33 × 24.9 cm (13 × 9¹³⁄₁₆ in.). Shown before treatment. The same print after treatment is shown on p. xvi. The J. Paul Getty Museum, Los Angeles, 86.XM.636.7.

Additional photo credits appear on p. 273.

Library of Congress Cataloging-in-Publication Data

Lavédrine, Bertrand, 1958–
 A guide to the preventive conservation of photograph collections /
Bertrand Lavédrine ; with the collaboration of Jean-Paul Gandolfo and
Sibylle Monod.
 p. cm.
Includes bibliographical references and index.
 ISBN 978-0-89236-701-6
 1. Photographs—Conservation and restoration. 2. Photograph
collections—Conservation and restoration. I. Gandolfo, Jean-Paul.
II. Monod, Sibylle. III. Getty Conservation Institute. IV. Title.
 TR465.L39 2003
 770'.74—dc21

 2003004070

Contents

PART FIVE Technical and Practical Information

Foreword to the
English-Language Edition

The twenty-first century appears to be a turning point in the history of photography. Traditional photography is gradually being replaced by digital photography and is in some respects becoming a thing of the past. Such technological developments have serious implications. As photographs become less tangible—often becoming images on a computer screen—their physical importance as objects has the potential to diminish. However, the opposite is proving true, and photograph collections are increasingly viewed as an integral part of our collective heritage and memory. The preservation of these objects has become a matter of concern for a society that appreciates and is fascinated by them.

In close collaboration with our partners at the Image Permanence Institute, in Rochester, New York, and the Centre de Recherches sur la Conservation des Documents Graphiques, in Paris, the Getty Conservation Institute has for the past several years been engaged in research to further the practice of photographic conservation. Over the past few decades, scientific research has advanced considerably in its efforts to understand the deterioration of photographs and to find more effective methods of preserving them. In addition, the profession has concurrently developed a more comprehensive vision of collections care which emphasizes preventive conservation.

Today there is both an increasing demand for conservation-related information from a worldwide constituency of photograph collectors, curators, conservators, and restorers and, happily, a significant store of new knowledge available to them. For this reason, the Getty is delighted to publish this English-language edition of *A Guide to the Preventive Conservation of Photograph Collections*, by Bertrand Lavédrine, director of the Centre de Recherches sur la Conservation des Documents Graphiques. Originally published in French in 2000, this very thoughtful book examines the state of photographic conservation today, presenting both the answers that have been found and the questions that demand further study. It also presents a systematic overview

of the concepts on which the preventive conservation of photograph collections is based. We hope that institutions, conservators, curators, and passionate amateurs alike will benefit from the discussions found in the following pages. And we hope that this translation helps to preserve and maintain the photographic heritage, which reflects and illustrates nearly two centuries of human expression and experience.

Timothy P. Whalen
DIRECTOR
The Getty Conservation Institute

Foreword

For various reasons—aesthetic enjoyment, interest in or nostalgia for the past, a desire to find visual sources to supplement written ones—there is increasing interest today in photograph collections. It is not surprising, then, that the demands on collections continue to mount. Over the past thirty years, exhibitions of photographs have become increasingly frequent and popular. A photograph, however, in the words of Jean-Marie Schaeffer, is a "precarious image," produced by chemical reactions as numerous as they are complex. It much more fragile than, say, a three-hundred-year-old painting or sculpture. And yet the photograph has become associated with the notion of the mechanical production of commonplace objects. Its very lightness seems to doom it to insignificance, and it rarely receives the consideration commonly accorded an antique statue or painting. Indeed, until recently, even among those responsible for managing photograph collections, such consideration was all too often the exception rather than the rule.

For this reason, we owe the authors a debt of gratitude for beginning this volume with a discussion of the essentially unstable and delicate nature of the photograph, a discussion that is accessible even to readers with limited scientific knowledge of photographic materials and the types of deterioration that endanger them. The chapters that follow develop the implications of this initial discussion, as the authors methodically present ways to ensure that these fragile images will not only survive but also maintain, along with their physical integrity, their emotional impact and their wealth of information.

The basic topics of conservation—physical preservation, communication, and dissemination—are handled sensibly and methodically in this volume. Preservation entails relatively few choices; communication and dissemination require many, for these activities may conflict with the need to preserve. The problem of commication is addressed lucidly. It is useless to pretend, for example, that there are no contradictions between conservation and

communication, or that such contradictions are easily resolved. They do exist, and they can sometimes prove insurmountable. In the following pages, the technical aspects of this issue are examined with great clarity. There are essentially two sorts of problems. One is based on the risks to photographs caused by handling; the other is based on their reactions to light and the environment. The pages devoted to dissemination, in particular to the various processes for reproducing photographs, deserve special attention. The authors have had the courage not to take the position—which superficially may appear the rigorous and honest one—that the public has the right to see original photographs, and that therefore originals must be shown. First, what public are we talking about, and what is it coming to see? In many—probably most—cases, people want information about the subject depicted in the photograph. What were the sights on the Rue de Rivoli when the tunnels were being excavated for the Metro? What did the man who assassinated Paul Doumer look like? The vast majority of the requests received by photographic collections, such as those of the Bibliothèque nationale de France and the Carnavalet Museum, are of this type. These are requests that a replica can satisfy, on condition, of course, that it is of good quality. And, of course, it must be disclosed that the image is a replica. The duplication of collections in wide demand is not a stopgap measure; it is an imperative.

The concepts that are commonly applied to photographs would appear absurd if applied to other types of art. No one would dream of suggesting that it is necessary to actually possess the original manuscript of Stendhal's novel *The Charterhouse of Parma* in order to read the book. To take a less radical example, it is possible to acquire suitable knowledge of Rodin's *The Thinker* and enjoy its qualities by looking at one of the many original prints in existence or even one of its innumerable castings. Consequently, it is necessary to make several distinctions.

The first, and undoubtedly the simplest, is the distinction between artistic value and documentary value, between works (*oeuvres*) and documents. We might agree to call a work anything that is of interest not only for the information it conveys but also for the material medium used to convey it. It is certain that paintings, sculptures, and drawings are works, and while they are of interest for what they depict—as a portrait, for example, tells us about the features of a individual who is no longer alive or a landscape tells us about the appearance of a place that has changed—they are also of interest as objects. The interest of a document, on the other hand, diminishes as the information it contains is conveyed. One might object that the physical form of a document, especially a very old document, is also of interest, as Riegl explains in *The Modern Cult of Monuments*. Consequently, a given object should not, by its intrinsic nature, be deemed only a document or only a work. Depending on how we regard it, it may be either. However, we cannot regard it in both ways at once. If we look at Coysevox's statue of the Duchess of Burgundy, the granddaughter of Louis XIV, to see what she looked like, we are distracted, even if only momentarily, from the formal qualities of the sculpture.

The second distinction is actually a restatement of the first. When considering an object, we distinguish between the text and the physical support, or medium. Text is everything that can be extracted from the object and reproduced without consideration for the object's distinctive material features. Text

may be embodied in any medium. For example, we can read the text of Balzac's novel *Père Goriot* without regard to the page format or the typeface.

The question becomes more difficult, however, when dealing with exhibitions. In that context, we show photographs not (or not only) for the information we can find in them, but for the prints themselves, in their status as objects, and for their formal qualities. That being the case, is it not then necessary to show the originals? The answer is not as simple as it seems. All things considered, many qualities of a purely formal nature may be conveyed by a reproduction. Art lovers of the past were well aware of this. They commissioned copies of antique statues and famous Renaissance paintings to adorn royal dwellings and for educational use by students of painting and sculpture. As late as the mid-nineteenth century, Charles Blanc planned to open—and even began work on—a museum of reproductions.

Furthermore, we learn in the present volume that the problem of photographic reproduction does not consist solely of whether to show originals or reproductions. There are a thousand kinds of reproductions, and the use of filters and digital image processing open up breathtaking possibilities, since, as we copy photographs, we can eliminate or correct certain defects in the original prints. We can produce copies that are, in a sense, better than the originals—a disturbing thought. This is a particularly slippery slope. As this book makes clear, photographic technology has reached an extraordinary degree of refinement. Recovering nuances that, due to the fading of the image, the eye can no longer perceive is, it would seem, perfectly legitimate. Nonetheless, the more photographic technology is perfected, the more important it becomes that we be rigorous about what we produce and how we present it to the public.

Conservation and restoration of collections, regardless of the nature of the works or objects they comprise, must be considered from several perspectives. It is important that we distinguish among them. The vocabulary we use in this domain is far from unambiguous, and decisions alone cannot remedy the situation, for in this regard, customs of usage reign supreme. At the very least, however, it is important to be aware of the traps that language sets for us. Let us focus on the word *restauration*, for example, which is precisely one of these equivocal terms, and which, in current French usage, roughly comprises the meanings of both "conservation" and "restoration" in American usage. Depending on the context, it can refer to the totality of measures that contribute to the physical conservation of a collection, or to a particular type of measure. In other words, we must distinguish between the broad sense and the specialized sense of the word.

For the public at large, *restauration* has a broad and rather vague connotation. It suggests everything that pertains to the physical maintenance of a collection, as well as to "repair" measures in particular. The distinction between *restauration* and repair is not self-evident, nor did it arise in all disciplines in the same manner or at the same time. The notion that *producing* objects or works of art and *repairing* the damage they sustain over time are two separate professions dates back barely two centuries and is not universally accepted. Often, this opinion is professed without any understanding of the implications involved. One need only consider such fields as those involving furniture or books to realize just how deeply rooted in our minds is the

confusion between restorer and artisan, between *restauration* and crafts-manship (*metiers d'art*). We see proof of this annually, with much hoopla and at great expense, at the so-called Salons du Patrimoine.

In its specialized sense, *restauration* refers to various activities whose goal is to improve the condition of deteriorated objects by making their appear-ance clearer and possibly more pleasant, or at least less unpleasant. Understood in this way, it is an activity of an aesthetic nature, not in the sense of aesthetic surgery, but in the sense of "relative to perception." It seeks to place objects in the most favorable condition possible, so that their cultural significance, as well as their formal qualities, may be perceived correctly. In practice, it also refers to cleaning (when this does not require removing harmful products) and to the closing or filling of lacunae.

We might say that such intervention, while never absolutely necessary, is highly desirable for the objects we exhibit, insofar as, in principal at least, it helps members of the public to understand what they are looking at and perhaps to derive enjoyment from it. However, if we wish to ensure that objects not be lost to us—or at least not lost too quickly—and that future genera-tions receive the collections that we have inherited or put together, we must also take essential measures of an entirely different nature. These measures, in turn, fall into two categories, depending on whether we are dealing with the works and objects themselves or with the environment in which they are conserved.

Rejoining component parts of objects when they have a tendency to separate, eliminating or mitigating the internal stresses that act on them, removing old repairs when they have incorporated harmful substances into the originals—these are conservation measures that may be termed active. They are comparable to a surgical procedure that frees an organ from the cancer eating away at it and returns it to a normally functioning state. Therefore, it is logical to speak of "curative conservation." I admit that the expression is rarely used, which is a shame, since it has the merit of clarity.

Working with the environment involves a different type of activity—that of prevention. The term "preventive conservation" has accordingly come into use, and it has a meaning quite similar to "preventive medicine." Here, we are no longer talking about actually intervening on objects. Preventive con-servation deals with something entirely different: the architecture of the build-ings that house museum collections, libraries, archives, and storage facilities; the heat and humidity that prevails in them; the way in which the light enters them; the materials with which the objects come in contact (shelves, boxes, etc.); the way in which objects are handled when they are transferred or exhib-ited, and so on. It is precisely this subject that the current volume examines.

Choosing such a focus and staying with it is admirable. If in usage the word *restauration* is ambiguous and problematic, whatever the discipline, this is particularly true of the field of photography. The trap consists not only of confusing the broad sense and the specialized sense of the word. In addi-tion, there is the larger problem of the position photographic objects occupy in what we call cultural heritage. Are they works or documents? Are they artis-tic objects that should be treated in light of their formal qualities and the sup-posed intentions of their creators? Or are they anonymous recordings of a volatile reality, valuable solely for their authenticity, whose evidentiary value

is the only thing that matters? These are not new questions, but they are still subjects of debate. There is great wisdom in not getting drawn into such debates, or rather in considering them primarily from the perspective of the problems and challenges they pose for conservation.

More than ever, with photography, it is apparent that questions of conservation and restoration cannot be approached correctly without constant critical analysis. We would do well to remember, in the wise words of Rabelais, that "science without conscience is but the ruin of the soul."

Georges Brunel
CONSERVATEUR GÉNERAL DU PATRIMOINE
City of Paris

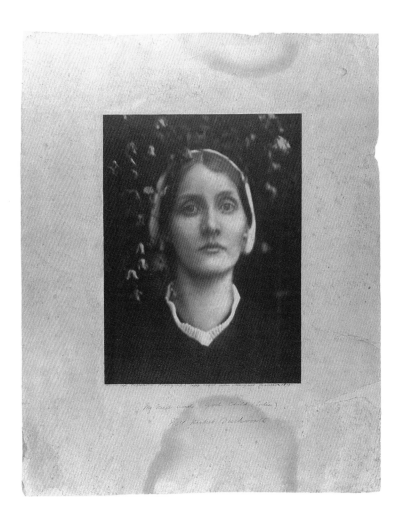

Julia Margaret Cameron (British, born
India, 1815–1879), *Mrs. Herbert
Duckworth*, 1872, carbon print,
33 × 24.9 cm (13 × 9¹³⁄₁₆ in.).
Shown with treatment nearly
complete; some work remains to be
done on the edges of the mount.
The J. Paul Getty Museum,
Los Angeles, 86.XM.636.7

Photo: Martin Salazar

Acknowledgments

A work such as the present volume involves the contributions of many people. The authors would like to thank Peter Adelstein, Jeanne Beausoleil, Claire Benoît, Ségolène Bergeon, Jean-Louis Bigourdan, Mary Brooks, Daniel Burge, Christine Capderou, Anne Cartier-Bresson, Gérard Cathaly, Martine Dancer, Floréal Daniel, Françoise Flieder, Lyzanne Gann-Ganet, Chantal Garnier, Martine Gillet, Claude Goulard, John Grace, Rudolf Gschwind, Gulia Cuccinella-Briant, Debbie Hess-Norris, Jean-François Joly, Nora Kennedy, Laurier Lacroix, Suzanne Laval, Constance McCabe, Luis Nadeau, Doug Nishimura, Monique Plon, Steve Puglia, Michel Quétin, Malalarina Rakotonirainy, James Reilly, Benoît Riandey, Jean Tétreault, Annie Thomasset, Léon-Bavi Vilmont, Sarah Wagner, and Jean-José Wanègue. A special debt of gratitude is owed to Grant Romer.

At the Getty, special thanks are owed to Deborah Gribbon, vice-president, J. Paul Getty Trust and director, J. Paul Getty Museum; and Tim Whalen, director, Getty Conservation Institute, as well as to Kristin Kelly, Mitchell Bishop, Cynthia Godlewski, Cecily Grzywacz, Shin Maekawa, Sheri Saperstein, and Dusan Stulik, at the Getty Conservation Institute; Marc Harnly, at the Getty Museum; and Jim Drobka, Amita Molloy, and Tevvy Ball, at Getty Publications. Finally, we would also like to thank Sheila Berg, Karen Stough, and Gary Hespenheide.

The Vulnerability of Photographs

FIGURE 1

Structure of a black-and-white print on baryta paper.

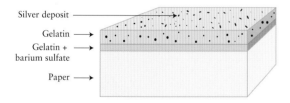

Silver deposit

Gelatin

Gelatin + barium sulfate

Paper

The structure of photographs can be represented in the form of superimposed layers. The base is the thickest layer. Its function is to provide the physical support for the photographic image, which is coated on one of its sides. It may be transparent or opaque, made on paper, glass, or a synthetic polymer. The base is usually covered with a layer of gelatin, which acts as a binder. The image-forming substance is made on a material that diffracts or diffuses light, usually silver (in black-and-white photographs) and dyes (in color photographs). There are also images composed of pigments (pigment processes such as carbon and carbro) and nonsilver compounds such as platinum and palladium.

It is the natural order of things that the objects we like to contemplate, touch, or display become damaged or even lost to us entirely. Although we are largely powerless in the face of the irreversible march of time, understanding the vulnerability of these objects enables us to have an impact on their future—if we follow a few basic rules of preservation.

Photographs are composite objects consisting of several layers, each of which has a different function (Fig. 1). The deterioration of a photograph may be chemical (Fig. 2), biological (Fig. 3), or physical (Figs. 4, 5) in nature. Physical and biological deterioration—for instance, a broken glass plate negative or the growth of mold—often occurs abruptly and therefore is generally immediately apparent. Chemical processes are slower, however, and their gradual, irreversible progression is not readily visible. By the time these changes can be seen (Fig. 6), the problem is usually too far along for remedy. This is the case, for example, with dye fading in color photographs and the decomposition of film supports. For this reason, it is important to monitor collections closely for problems that will cause deterioration in the future as

FIGURE 2

Gelatin silver print degraded by oxidizing agents (peroxides).

The yellowing is due to a change in the structure of the silver deposit, which was partially converted into colloidal silver.

© Photograph by Jean-François Joly

FIGURE 3

Motion picture film reel with corrosion and mold development.

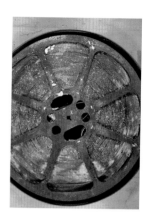

FIGURE 4

Delamination and loss of the image layer in a nineteenth-century print. Excessive temperature and humidity variations may be the source of this deterioration.

Pillet Collection, Collège de France

FIGURE 5

Cracks in baryta paper, caused by improper handling.

FIGURE 6

Gelatin silver glass plate negative.

The orange yellow coloring is probably due to intensification treatment by the photographer to correct an underexposed negative.

Photograph by E. Degas
Bibliothèque nationale de France

TABLE 1

Deterioration of photographs.

Symptom	Cause
spots, fading	processing/environment (Figs. 2, 6, 8, 10, 11, 12, 15, 17, 20, 41, 70, 108, 118)
microorganism growth	environment (Figs. 3, 91)
crazing, delamination, flaking	mounting/environment (Figs. 4, 65, 119)
deformation	environment (Figs. 20, 23, 58)
tearing, scratches	handling (Figs. 5, 26)

well as for deterioration that is already in progress (Table 1). The purpose of this chapter is to allow collection managers to easily identify the symptoms of deterioration.

IMAGE DEGRADATION

The Black-and-White Gelatin Silver Photograph

A modern black-and-white photograph is made by a process that includes chemical image development to amplify the action of light on silver salts (see p. 215). Such a print is called a developed-out print (D.O.P.). The image is generally composed of a relatively small quantity of silver—in dark areas of a print, about one gram of silver per square meter. During the nineteenth century, prints were made in a different way: the action of light alone formed the silver image on a silver salt. In these printed-out prints (P.O.P.), the quantity of silver is about one-tenth as high. Observing these two types of images under a transmission electron microscope reveals important morphological differences in the silver deposit. A modern D.O.P. is composed of silver filaments. The graininess observable under an optical microscope is only an agglomeration of these silver filaments. In printing-out processes, the silver is in the form of very fine, round particles much smaller than those in a D.O.P. These structures, which are characteristic of photographic images and give them their great precision of detail, also make them particularly vulnerable. Various chemical compounds are likely to react with the silver image, resulting in oxidation, which may in turn cause fading, staining, discoloration (Figs. 7, 8), and so on. The rate of deterioration potential increases when the silver deposit consists of small particles, as in P.O.P.

FIGURE 7

Degradation process of the silver deposit in a modern black-and-white photograph.

The developed silver consists of a filamentary deposit, visible under a transmission electron microscope. When it oxidizes, elemental silver (Ag°) loses an electron and is transformed into a colorless ion (Ag^{+}). These silver ions easily migrate to the top and react with atmospheric gases to form sulfide, silver oxide, or colloidal silver, generating the appearance of colored bloom.

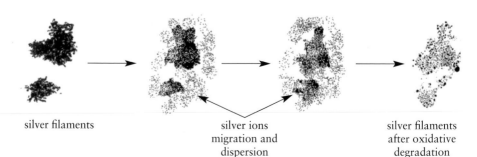

silver filaments silver ions migration and dispersion silver filaments after oxidative degradation

FIGURE 8

Faded nineteenth-century black-and-white print.

When prints are insufficiently washed and kept in a humid environment, the image fades and yellows.

Image fading

In modern photographs, the gelatin layer to some degree protects the silver deposit from the environment. Without it, images would quickly tarnish or fade, as occurred with daguerreotypes and salted paper prints exposed unprotected to air. Moreover, elevated levels of relative humidity (RH), acid pollution, and oxidizing agents can penetrate the gelatin and, over time, cause the silver image to fade. When the reactions spread, the contrast in the picture diminishes.

Sulfiding and staining

Sulfiding is often caused by inadequate washing. The fixer that is left behind decomposes in the presence of high relative humidity and combines with the silver to form colored silver sulfide stains. This degradation more markedly affects the middle tones of the image, which take on warm hues that may range from yellow to brown.

The use of an exhausted fixing bath has a more insidious effect. The residual insoluble silver compounds eventually decompose into silver and silver sulfide. The lighter areas of the photograph (e.g., skies and print margins) become stained. When the fixing time is too short, light-sensitive silver salts are left behind and soon begin to react with light to form colored stains (from yellow to red). Generally, these appear soon after processing, which alerts the photographer to improper fixing.[1]

During exhibition, the yellowing of
gelatin silver black-and-white prints may
have various causes. This flowchart is a
tool for identifying the possible cause of
the discoloration: nature of the paper,
presence of oxidizing agents, poor
washing, or excessive relative humidity
during storage.

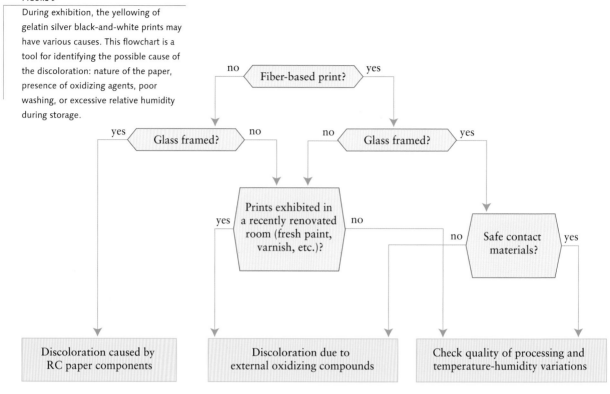

Gelatin silver print deteriorated by
oxidizing gas. Only certain density areas
have been degraded.

© *Roger Pic:* Cuba, the Coalman, and His Son

Yellowing

The symptoms of yellowing are similar to those of sulfiding (Fig. 9); that is,
the middle tones and sometimes the surface of the image become covered with
a brownish yellow veil, which may be quite vivid in color (Fig. 10). This dis-
coloration is due to the formation of a layer of colloidal silver. This phe-
nomenon occurs when fiber-based papers are exposed to oxidizing pollutants
such as peroxide released by plastics, paints, varnishes, poor-quality cardboard,
and so on. Some thoroughly washed prints are extremely sensitive to this type
of degradation (see p. 223). Only toning, for example, with polysulfide or gold,
can effectively protect them from this reaction. With resin-coated paper, yel-
lowing frequently appears on framed images mounted under glass and exposed
to light.[2] One explanation for this damage is that the titanium dioxide,
present in the paper support as a white pigment, promotes the formation of
oxidant agents (see p. 24) under the action of light. When the print is framed
under glass, these highly active oxidants are then trapped in the mounting and
react with the silver image.

Redox spots

Redox (*reduction-oxidation*) spots, or redox blemishes, are small reddish spots
that vary from one to several millimeters in diameter (Fig. 11). They have been
noticed in dark-stored microforms and resin-coated (RC) prints framed under
glass and displayed in galleries. Observed under a magnifying glass, these spots
appear as concentric rings, which in diffused light have a silvery sheen. They

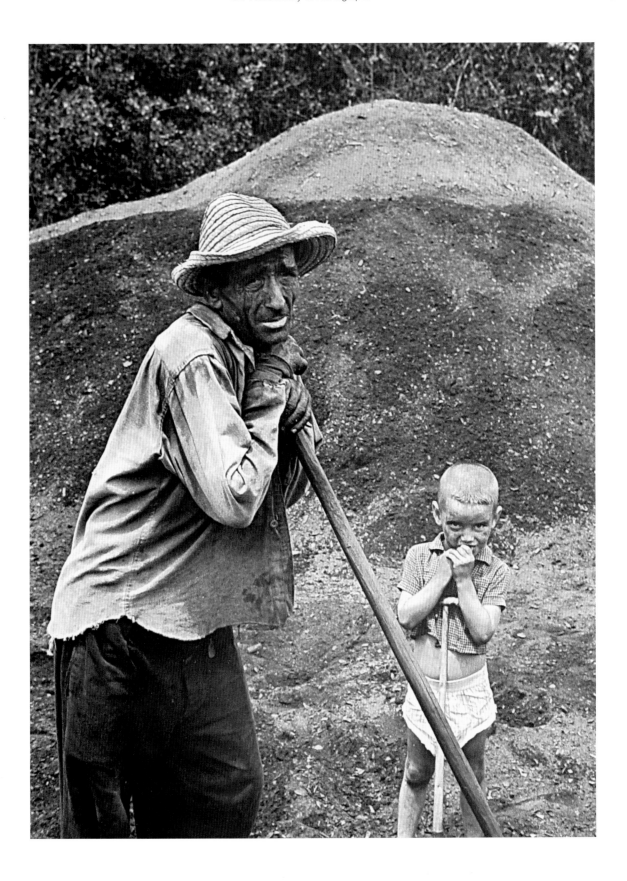

FIGURE 11

Redox blemishes, or reduction-oxidation
spots, on microfilm, seen under an
optical microscope.

have been attributed, in microforms, to the presence of peroxides that apparently emanate from poor-quality material stored in proximity to them and, in
resin-coated paper, to the nature of its components (see p. 26).

Silver mirroring

A "silver mirror," which gives to high-density areas an iridescent appearance
on the surface of the silver print (or negative), is visible in dark areas when the
photograph is examined in raking light (by lighting or observing the image from
the side) (Figs. 12, 13). This phenomenon occurs when silver becomes detached
from the filaments, migrates, and forms a layer on the surface. The process occurs
in two stages. First, air pollution and moisture oxidize some of the silver that
forms the image. The silver ions migrate to the surface of the gelatin. When the
ions come in contact with the atmosphere, they are transformed into metallic
silver (colloidal silver) and silver sulfide (see Fig. 7).

The Color Photograph

Chromogenic color photographs are composed of yellow, magenta, and cyan
organic dyes, in the form of spherical dye clouds measuring a few tenths of a
micron in diameter, distributed in (at least) three superimposed layers of gelatin
(Fig. 14). These color photographs appear to be less sensitive to pollutants
than black-and-white silver images. However, light does have deleterious
effects, such as the fading of dye over time. Prints may fade even when stored
in the dark. The early generations of color photographs have proven particularly unstable. Advances by film manufacturers in the 1980s have provided
more durable color products, but these are still sensitive to environmental conditions. The rate of fading varies, depending on the chemical structure of the
dyes. The azomethine dyes characteristic of chromogenic processes (e.g.,
Process E6, C41) deteriorate faster in the dark than those used in the Dye-
Transfer process or the azo dyes used in the silver dye bleach (SDB) process

FIGURE 12
Silver mirroring on a gelatin silver print.

FIGURE 13
At left, view, under a transmission
electron microscope, of a cross section
of a print with the silver mirroring at the
top (enlargement 45,000×); at right,
surface view of silver mirroring.

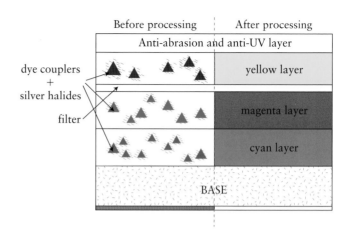

FIGURE 14

Structure of a chromogenic color
photograph.

known as Cibachrome or Ilfochrome Classic. The majority of manufacturers
(e.g., Agfa, Fuji, Ilford, Kodak, Polaroid) have conducted accelerated aging
tests in their laboratories using the Arrhenius relationship (see p. 32) to eval-
uate the life expectancy of films and color prints (ISO 10977). Although this
procedure is long and complex, several studies have confirmed that it is a use-
ful standardized artificial aging method.

Dye fading

The rate of dye deterioration is linked to processing quality and environmental
conditions (temperature, relative humidity, lighting). Dye fading is accom-
panied by a shift in the color balance (Fig. 15). The three colors—yellow,
magenta, and cyan—do not fade at the same rate, which creates an imbalance
in the color rendering to which the eye is particularly sensitive. For example,
when the cyan dye fades, the photograph appears too red. Perception of the
deterioration of a color image depends greatly on the subject. In a photograph
depicting fall foliage, the degradation is much less easy to detect than in a por-
trait, in which the color shift is readily perceptible (Fig. 16). Therefore, there
is no absolute threshold, and while some images satisfy observers despite a
40% loss in optical density, it is generally acknowledged that a 30% density
loss (measured relative to an initial density value of 1.0) and a 15% variation
in color balance are the limits beyond which a photograph appears obviously
degraded.[3] Under common dark-storage conditions in a temperate climate, it
is estimated that it takes some forty years before significant deterioration occurs
in chromogenic color photographs. The life span of a color photograph that
is exposed to light is directly linked to the intensity of the lighting and its ultra-
violet (UV) content. It should be noted that dyes that are very sensitive to light
are not necessarily those that degrade the fastest in the dark, and the effects
on the appearance of an image are therefore different after light aging or dark
aging (Table 2).

Highlight staining (chromogenic processes)

Over time, some prints acquire a yellow stain that is particularly visible in the
highlight areas. These stains are residual couplers (molecules that initiate dye
formation) that form colors as they decompose (Fig. 17). The coupler for the
magenta dye seems to be largely responsible for this phenomenon.[4]

FIGURE 15

Ansco slide after natural aging. The cyan
dye has faded.

FIGURE 16a–d

Original color photograph (a) and the
same photograph during dark aging after
fading corresponding, respectively, to
10% (b), 20% (c), and 30% (d) loss in
optical density of the cyan dye.

a

b

c

d

TABLE 2

Extrapolation of the stability of color
motion picture film (CRCDG study, 1983).

Negative Film	Least Stable Dye	$t_{10\%}$*	95% Confidence Interval
Eastman 5293	yellow	59 years	42–83 years
Fujicolor 8527	cyan	23 years	13–41 years
Gevacolor 682	cyan	8 years	3–24 years

* Predicted time at 21°C and 40% RH to reach a 10% loss of least stable dye.

BINDER DEGRADATION

The cohesion of a photographic image has been provided by an organic
binder such as gelatin, albumin, or collodion (cellulose nitrate). Since the
end of the nineteenth century, gelatin alone has continued in use, because
of its remarkable physical and chemical properties. To avoid dissolution of
the gelatin in a hot solution during processing, manufacturers render it insol-
uble by hardening. However, gelatin retains its hygroscopic property and

FIGURE 17

Fading and staining of a chromogenic
print (1954, Kodacolor print).

remains in equilibrium with the ambient relative humidity. The layer expands
or contracts as the relative humidity level increases or decreases. These
dimensional variations subject the base to lateral stress that often results in
curling of the print. To avoid this curling phenomenon in film, a layer of
gelatin is added to the back of the film. Its function is to counteract the stress
created by the layer on the image side.

FIGURE 18

Some insects may eat gelatin and
leave behind irregularly shaped
grooves on photographs.

Microorganisms and Insects

Gelatin's hygroscopic nature also makes it vulnerable to microorganisms. Gray spots, small individual deposits surrounded by filaments that are sometimes colored and accompanied by localized loss of the image, may be an indication of mold growth. Such contamination is cause for alarm, since it has the potential to cause additional irreversible and rapid image deterioration. The damage can spread to the entire surface until the photograph, binder, and base are totally destroyed. Infestation is not immediately visible to the eye, but it is often possible to detect under a microscope. Sampling and culturing can determine whether the fungi are active and to what species they belong. Degradation caused by insects (silverfish, cockroaches, etc.) or their larvae can be quickly identified. These feed on protein (gelatin, albumin), leaving grooves or tunnels (Fig. 18).

Physical Degradation

Dust and solid particles adhering electrostatically to the inside of enclosures is a frequent source of abrasion to photographs. This phenomenon is particularly harmful to negatives.

The change in an image's surface appearance may be aesthetically disturbing. For instance, a ferrotyped print loses its glossiness locally when it is humidified. This sometimes occurs during mounting, when an aqueous adhesive is used. Conversely, a matte print may acquire a glossy sheen in places if it is stored in a plastic envelope. Under pressure in the presence of moisture, the gelatin layer adheres to the plastic and becomes glossy when detached. Extensive fluctuations in temperature and relative humidity may result in the development of cracks in some prints.

BASE DEGRADATION

Transparent Bases

Three types of transparent bases have been commonly used in photography: glass, cellulose esters, and polyester. Glass, which was introduced around 1850 (Table 3), not only is a fragile base but can decompose, leaving a whitish film or deposit on the surface. Today, it is used only for certain scientific photographic applications.

Cellulose nitrate
The search to replace glass with a resilient, lightweight, transparent material gave rise to a great deal of research, benefiting to varying degrees from the dis-

TABLE 3

Evolution of primary photographic bases.

Year*	Base
1837	paper
1839	silver-plated copper
1847	glass
1885	baryta-coated paper
1889	cellulose nitrate
1923	cellulose diacetate
1930	cellulose acetate butyrate
1948	cellulose triacetate
1955	polyester (PET)
1970	resin-coated paper
1979	"voided" polyester
1996	polyester (PEN)

Approximate date of introduction for photography.

coveries in polymer chemistry that occurred in the first half of the twentieth century (Tables 3, 4). Cellulose derivatives were the first to be used successfully. In fact, cellulose need only be esterified by nitric, acetic, propionic, or butyric acid to produce cellulose nitrate, diacetate, acetate propionate, or acetate butyrate that can be produced in the form of a transparent and flexible support. Cellulose nitrate (CN), discovered in 1846 by C. Schönbein, was used in the 1860s by the Hyatt brothers as a substitute for ivory in manufacturing commonplace objects. It took some twenty more years for this discovery to be used industrially for photographic bases. In 1889 George Eastman, founder of Kodak, began using it to manufacture very long strips. It then became possible to replace heavy glass plates with light, flexible film. This base found application with the invention of the motion picture camera in 1895. Despite its excellent properties, cellulose nitrate has one major drawback: it is highly flammable. For safety reasons, the use of nitrate was prohibited in the 1950s.

Over time, another serious problem arose in collections, that is, cellulose nitrate's tendency to decompose, releasing nitric acid. While certain cellulose nitrate films are in excellent condition after more than one hundred years, others are nothing more than a shapeless mass of acid-emanating material. There are five steps in the decomposition of cellulose nitrate film base (Table 5).

Because of the chemical instability of cellulose nitrate, it is important to identify films and photographs on cellulose nitrate bases and to store them separately under appropriate conditions. It may be possible to determine the

TABLE 4

Contemporary photographic bases.

Type of Photograph	Type of Base
negative or reversal film	cellulose triacetate
	polyesters (PET, PEN)
microforms	polyester
	(cellulose triacetate)*
paper prints	baryta-coated paper
	resin-coated paper
	opaque polyester, voided polyester

* Used less and less.

TABLE 5

Stages of deterioration of cellulose ester bases.

Cellulose Nitrate	Stage	Cellulose Acetate
The base yellows (brownish yellow to dark brown). The silver image oxidizes and silver mirroring occurs.	1	The film is in good condition. There is a noticeable slight odor of acetic acid.
In a humid environment, the emulsion begins to get tacky and stick to the paper. In a dry environment, the base becomes very brittle. There is a pronounced odor of nitric acid.	2	The film is in good condition. There is a strong odor of acetic acid.
The base becomes very fragile. Gas bubbles form in the base. There is a strong odor of nitric acid. Nitric oxide is released. This gas attacks surrounding objects (envelopes, film) and catalyzes deterioration of the base itself. The entire collection is endangered by acid vapors and the risk of fire.	3	The edges curl. The film is slightly brittle.
The negatives stick to each other and their envelopes. Jackets and negatives are difficult to separate and handle. At this stage, the image is lost and the negatives should be destroyed to prevent continued deterioration of the rest of the collection.	4	The film deforms. A deposit of plasticizer appears on the surface. The film becomes fragile.
The only thing left of the negative is a brownish powder.	5	The gelatin layer wrinkles. The film is brittle.

type of base from the date of manufacture and original use, from certain information on the film itself, and from the deterioration (Table 6). If this is impossible, it may be necessary to test it, using nondestructive or microdestructive methods whenever possible. Such identification may be done by an analytic laboratory. The diphenylamine test provides an initial indication from a microsample (Fig. 19). The flotation test (based on density differences in polymers) and the flame test (based on the manner in which the film burns) have been abandoned, since the results they provide are less reliable and potentially hazardous.

TABLE 6

Identifying film bases.

Method of Identification	Indication	Type of Base*	Comments
date of manufacture	• manufactured before 1920 • manufactured before 1952 • manufactured after 1952	• CN • CN or CA • CA, PET, PEN	
type of deterioration	• base yellowed, image strongly oxidized • wrinkles, vinegar odor	• CN • CA	oxidation of the image may be caused by proximity to a deteriorating nitrate base
edge marking	• safety film • nitrate	• CA • CN	duplicate negative may transfer "nitrate" designation to "safety" film
notch code	• number and shape of notches on edges of film sheets	• depends on manufacturer[5]	some codes have been reused for different bases
burn test	• the film fragment burns rapidly • the film fragment stops burning when flame goes out	• CN • PET, PEN, CA	not recommended; unreliable and dangerous
chemical test	• turns deep blue in a diphenylamine/acid solution	• CN	recommended but microdestructive
mechanical test: tear resistance	• tears easily • very resistant	• CA, CN • PET, PEN	not recommended; too destructive
float test: fragment immersed in a tube filled with trichloroethylene	• sinks • remains suspended (middle) • floats	• CN • PET • CA	not recommended; toxic solvent, ambiguous results, difficult to evaluate
polarization test	• birefringence • fiber optic effect	• PET • PET	
infrared spectroscopy (FTIR)	• specific spectra	• all kinds	expensive equipment and expertise

* See Table 11.

FIGURE 19

FIGURE 19

Identifying nitrate bases.

 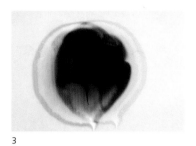

1 2 3

Diphenylamine test: (1) put one drop of 0.5% diphenylamine solution in sulfuric acid (Warning! Dangerous solution—handle with care) onto a glass slide; (2) using tweezers, place a minute fragment (under one square millimeter) of the base to be analyzed onto that drop; (3) in the presence of cellulose nitrate, intense blue coloration forms within minutes. This method requires microsampling, which may be done under a binocular magnifier. Certain acetate bases may induce blue coloration due to a cellulose nitrate substratum. To avoid any error of interpretation, scratch with a scalpel to eliminate the top layers.

Cellulose triacetate

The instability of cellulose nitrate (Fig. 20) led to the widespread use in the 1950s of cellulose acetates (CA)—cellulose diacetate and cellulose triacetate, inflammable bases known as "safety base film." Only cellulose triacetate continues to be used for film. In the late 1980s it was reported that, after some thirty years of storage,[6] much triacetate motion picture film emitted a characteristic vinegar odor, a phenomenon that has become known as the "vinegar syndrome" (our sense of smell, which is very sensitive to acetic acid, can detect concentrations of less than 1 ppm). This phenomenon was observed as early as 1954 in motion picture archives in India but aroused little attention at the time. CA hydrolyzes and slowly releases the acetate groups in the form of acetic acid. Hydrolysis may be accompanied or followed by peroxide-induced oxidation. The acid released into the atmosphere promotes the propagation of this phenomenon to film stored in proximity. This degradation is apparently unavoidable, and the higher the relative humidity, the more rapidly it occurs. Emanation of acetic acid is followed by embrittlement and deformation of the polymer. The base also shrinks, due to a loss of plasticizer, evaporation of residual solvents, and shortening of the polymer chains. This shrinkage may reach 0.7% in ten years[7] and up to 10% in extreme cases. As the plastic shrinks, the gelatin and the anticurl layer become delaminated, distorted, and wrinkled. The loss of plasticizer often results in the appearance of bubbles under the gelatin layer or a deposit in the form of small whitish crystals on the surface (see Table 5). The acidity may regenerate the antihalation dye, which the strongly alkaline pH of the developer renders colorless during film processing.[8] The formation of the antihalation blue or pink color in the anticurl layers is a direct consequence of the production of acetic acid.

It has been accurately demonstrated that there is an acidity threshold beyond which deterioration accelerates (Fig. 21). The life expectancy of modern and older bases has been extrapolated from accelerated aging tests, using the Arrhenius relationship. Charts have been established based on the various results, making it possible to arrive at an approximate determination, depending on the storage temperature and relative humidity, of the time before onset of the vinegar syndrome. For instance, at 21°C and 60% RH, it will take thirty years; at 21°C and 30% RH, seventy years; and at 13°C and 30% RH, two hundred years (Fig. 22).

Thus, in addition to the problems encountered in cellulose nitrate collections, there are those posed by triacetate bases, whose repercussions have

Deteriorated cellulose nitrate film from
the Harcourt Collection, Médiathèque du
Patrimoine, Saint-Quentin-en-Yvelines.
© Ministry of Culture and Communication, France

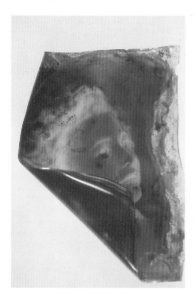
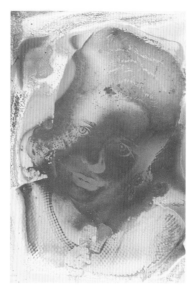
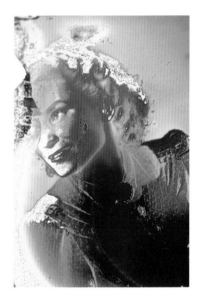

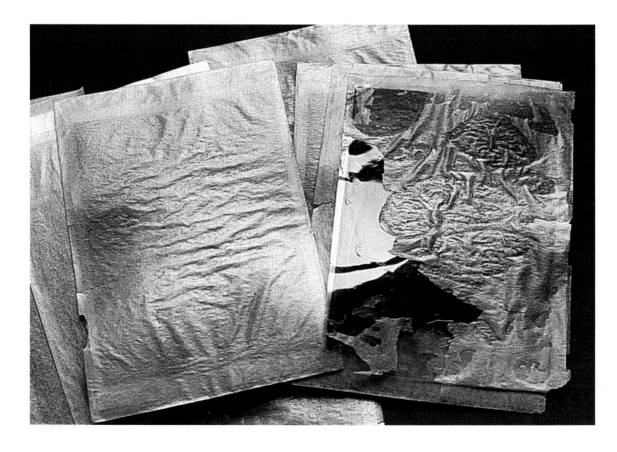

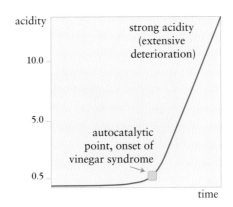

FIGURE 21

Curve representing the increase in acidity of a cellulose triacetate base over time. The autocatalytic deterioration phenomenon occurs at an acidity level of 0.5 (this figure corresponds to the number of milliliters of an alkaline solution necessary to neutralize the acid present; ANSI Standard IT9.1). Above this point, the deterioration of the base occurs very rapidly.

FIGURE 22

The IPI Storage Guide for Acetate Film.
This wheel can be used to predict the number of years before the onset of vinegar syndrome in cellulose triacetate film, based on temperature and relative humidity conditions in the storage vault.

the potential to be even more serious. Triacetate is still widely manufactured and used for film base, and awareness of the problem is still far from widespread (Fig. 23).

Polyester

"Polyester" is a generic term used for a family of polymers. In photography, the name "polyester" denotes either poly(ethylene terephthalate) or poly(ethylene naphthalate). Poly(ethylene terephthalate), or PET, was introduced in 1941 and has been used in the photography industry since 1955 (Figs. 24, 25). It is known under various brand names, depending on the manufacturer, for example, Estar (Eastman Kodak), Mylar (Du Pont de Nemours), and Terphane (Rhône-Poulenc). Contrary to cellulose triacetate, which is manufactured from a natural polymer, cellulose, polyester is entirely synthetic. Polyester's second difference from cellulose triacetate resides in its preparation. Since it is not easily soluble in any solvent, polyester is processed in sheets, by extruding it through a slot and then stretching it, which gives it great dimensional stability. It does not contain plasticizers.

Polyester is a polymer that is much more stable over time than is cellulose nitrate or acetate. Studies have demonstrated that polyester can have a life span of several hundred years. Since its hydrolysis reactions are relatively slow, shrinkage is limited to 0.03 % over a ten-year period.[9] Its weak point is the difficulty of achieving adherence of the image layer, which under poor storage conditions may eventually lead to delamination. Exposure to light is detrimental to PET, particularly when the light is rich in UV radiation. Polyester absorbs some UV wavelengths, and it gradually loses its mechanical properties. However, under standard use conditions, there is little reason for exposure to UV to occur. PET has relatively low permeability to water vapor and oxygen and is resistant to most organic solvents. On the other hand, it is sensitive to alkaline compounds, such as ammonia.[10] Although it has better mechanical properties than triacetate, some of its drawbacks have limited its use for sheet film. In fact, for a long time, no effective adhesive existed for splicing polyester-based motion picture film. Furthermore, PET is more difficult to wind on a reel and reflatten than is cellulose acetate.[11] Finally, because of

Figure 23

Examples of deteriorated cellulose triacetate bases (Stage 5).

To manufacture cellulose triacetate, cellulose from wood is treated with acetic anhydride in the presence of sulfuric acid, which acts as a catalyst. The hydroxyl groups in the molecule are replaced by acetate groups. A plasticizer— 10% to 15% triphenylphosphate or dimethoxyethylphthalate—is added to improve the dimensional stability and flexibility of the base. The triacetate is solubilized in dichloromethane, an organic solvent. The film is then produced by coating a smooth surface and evaporating the solvent. Several hypotheses have been advanced to explain the deterioration of

such bases. The residues from the sulfuric acid used during the manufacturing process were at first suspected. Then the substratum originally composed of cellulose nitrate was suspected. The instability of that polymer led to the conclusion that its breakdown might induce the breakdown of the triacetate. The treatment solutions (developer, fixer) were also suspected. Their acidic or alkaline character, combined with high temperature, is sufficiently pronounced to initiate hydrolysis of the triacetate, and their by-products may have a deleterious effect over the long term. Y. Shinagawa[12] believes that

triphenylphosphate, the plasticizer present in most cellulose triacetate bases, initiates this deterioration. The deterioration begins by hydrolysis of the plasticizer, forming diphenylphosphate, a strong and particularly corrosive acid, in turn causing hydrolysis of the triacetate. M. Edge,[13] on the other hand, has shown that the hydrolysis of the CTA is self-catalyzed by the release of acetic acid, and processing, by-products, and the environment also play an important role.

Figure 24

Some of the optical properties of polyester facilitate its identification. Polyester conducts light rays like an optical fiber. When a roll of microfilm on a polyester base is placed on a light table, light is propagated through the edge of the film (left), while a roll of microfilm on a triacetate base remains dark (right). (This may not be applicable for magnetic tape reel.)

Polyester has greater birefringence than acetate. When a piece of film on a polyester base is placed in front of a light source between two cross-polarizing filters, the light is transmitted. When the film is turned, interference colors (red, green, etc.) appear. Cellulose nitrate and acetate do not display this phenomenon.

its tensile strength, when there is extreme tension in a film processor or film projector, the parts of the machine are likely to give way before the film breaks.[14]

In 1996 the introduction of a new generation of format, the Advanced Photographic System (APS), made it possible for some manufacturers to introduce a new type of polyester, poly(ethylene naphthalate), or PEN (obtained by reacting ethylene glycol and 2,6-naphthalenedicarboxylic acid). This polymer has the property of being much easier to reflatten than PET, and it should have the same order of stability over time. Nevertheless, so far no data on long-term stability have been published.

Opaque Bases

Baryta paper

Paper has been the preferred photographic print base for one hundred fifty years. The criteria for selecting and preparing paper were a subject of great concern to early photographers, who sensitized it themselves. With the industrial expansion of the late nineteenth century, photographers became dependent on manufactured products.

The primary component of paper is cellulose, a polymer extracted from plants such as cotton, flax, wood, and straw. There are three types: alpha cellulose (cotton is naturally approximately 99% alpha cellulose) and beta cellulose and gamma cellulose (known as hemicelluloses), which are found in wood. Alpha cellulose must be present in a high proportion in photographic paper, whereas the beta and gamma cellulose content must be less than 4%.[15]

Until the early twentieth century, rag pulp (linen or cotton), which is rich in alpha cellulose, was used to manufacture photographic paper. However, this paper yellows over time, even when the raw material is of the best quality. In about 1920 a deleterious relationship was identified between this yellowing and the chemistry of the emulsion layer in storage prior to use.

It was also determined that this discoloration, due to hydrolysis of the cellulose, depends on the type of cotton used to make the rags and its degree of bleaching.[16] So it became imperative to find a type of stock whose quality was free of unknown factors in the composition of the rags. In 1929 research by Kodak resulted in the production of paper manufactured from highly purified, 100% wood cellulose (sulfite pulp), which ensures the properties of the emulsion while stored before use as well as permanence of the print.

Sizing, used to modify paper's physical properties, has evolved greatly. In the nineteenth century paper was sized with gelatin, starch, or rosin solutions. In 1926 rosin was replaced by sodium stearate. In 1945 the addition of a mixture of melamine and formaldehyde markedly improved certain mechanical properties of paper. Other polymers were subsequently used for sizing. Today, neutral alkylketene-based sizing is used to ensure better paper permanence.[17]

In about 1885 baryta-coated paper was widely adopted for photographic purposes. The process involves covering the paper base with one or more layers of gelatin containing a white pigment, barium sulfate. Baryta coating masks the paper fibers with a very smooth intercoat, considerably improving the reflective brightness of the base. Until the 1960s it was common practice to lightly tint the barium sulfate layer blue, pink, cream, or buff. This is now a rare practice. The formula used determines the surface appearance of the paper—matte, satin, or glossy; and by calendaring (feeding the baryta-coated paper through metal rollers), it is possible to create various surface textures, such as "pebble" and "silk." Since the 1950s paper whiteness often has been improved by adding optical brighteners.

While prints on baryta paper, called "fiber-based" paper, have excellent stability over time, they nevertheless remain sensitive to careless handling, which can crack the barium sulfate and the gelatin layer. Other types of damage—creasing, tearing, accretions (dirt, ink stains, traces of adhesive tape)—also bear witness to lack of care (Fig. 26).

Resin-coated paper

The origin of polyethylene-coated paper, more commonly called "resin-coated," or RC, paper, dates to World War II. At the time, an attempt was made to perfect a photographic paper for military use, capable of receiving a shorter processing sequence. Fiber-based paper, the only type then available, required relatively long washing (on the order of 30 to 60 minutes) to rid the paper fibers of the chemical substances they absorb during processing. By making the paper sheet impermeable, it became possible to reduce washing and drying time considerably. Various processes were tested, resulting, in the 1970s, in the commercialization of resin-coated paper, whereby the paper base is sandwiched between two layers of polyethylene. On the emulsion side, a white pigment, usually titanium dioxide, is added to the polyethylene.

The advantages of resin-coated paper are not limited to a shorter wash sequence. The good mechanical resistance of the resin-coated paper sheet when

wet allows processing to be totally mechanized. Accelerators—chemical com-
pounds that may be incorporated into the emulsion—further reduce devel-
opment time. After simple drying with warm air at the end of processing, a
regular, glossy surface is achieved, an aspect that is difficult to control with
fiber-based paper. To achieve a high gloss in fiber-based paper, the print must
be dried against a highly polished metal or glass plate. Prints on resin-coated
paper retain good flatness after processing, regardless of ambient relative
humidity conditions. Resin-coated paper was adopted by photographic lab-
oratories for automatic developer processing, which increases productivity for
amateurs and professionals alike. Several years after it was introduced, the
resin-coated paper craze was such that many photographers feared that baryta
paper—whose image quality was still clearly superior—would disappear
altogether. The alarm was sounded by the photographer Jean Dieuzaide at the
1977 Rencontres internationales de la photographie in Arles, France.[18] After
that peaceful but resolute protest, suppliers recognized the uniqueness of baryta
bases and the photographic community's interest in them and increased their
supplies of traditional baryta paper.

With today's color prints, the chemicals and machine processing preclude the use of fiber base. The last survivor, Agfacolor mcn 111, disappeared in the mid-1970s. Since that time, all supports used for color prints, except for those used in alternative printing processes (Dye-Transfer, Fresson, Ultrastable, etc.), have been made of resin-coated paper or synthetic polymer (Fig. 27).

The first generations of prints on resin-coated paper often displayed surface cracking when glass framed and exposed to light for long periods. In black-and-white prints, this was accompanied by redox spots, yellowing, and the silver mirror phenomenon.[19] Research has revealed the role played by the pigment titanium dioxide. During light exposure, it promotes the formation of active oxygen, which oxidizes the silver image and causes the polyethylene to deteriorate. This phenomenon occurs when the images are confined in a sealed frame where oxidants cannot dissipate. As it decomposes, polyethylene becomes less resilient. The dilatation of the paper and the gelatin in a humid atmosphere subjects the polyethylene to stresses that result in crazing. The addition of stabilizers and antioxidants to the base by the manufacturer limits such drawbacks, but the potential for yellowing is not completely eliminated.

On the perimeter of resin-coated paper prints, a yellowish area scarcely larger than a few millimeters can sometimes be observed on the back of the print. This is caused by processing solutions that penetrate the edge of the base between the two plastic layers, where there is little chance of eliminating them.

White pigmented polymers

Other attempts were made to produce resistant print bases suitable for industrial color processing, using pigmented polymers. In the 1940s Ansco introduced Printon and Kodak introduced Minicolor. In 1968 Agfa marketed cellulose triacetate filled with a white pigment, but the prints it produced did not hold up well in the acid bleaching solution (color reversal development), which embrittles the polymer. ICI introduced voided polyester and in 1979 began using it as a base for the glossy Cibachrome II (P3) process now known as Ilfochrome Classic. Despite its opacity, this polyester contains no additional fillers or pigments. The whiteness of the base is produced by light-diffusing microbubbles. Its optical properties are similar to those of a metal surface,

FIGURE 27

Cross sections of color photographs seen under an optical microscope: (1) Kodak color print on resin-coated paper, (2) Cibachrome print on voided polyester, (3) Dye-Transfer print.

Photographs by Fred Poole, Felix Schoeller Technical Papers, Pulaski, New York

1 2 3

that is, a high degree of reflectance in a narrow cone (approximately 28° with respect to a vertical axis).[20] The resultant prints are very glossy, with a near-metallic appearance. Flaking of the gelatin layer from its polyester base has occasionally been reported. This is a result of the lack of affinity between the two materials.

Mounting supports

To achieve perfectly flat print surfaces, photographic prints are sometimes laminated. However, problems may arise due to the poor quality of the adhesive and secondary support (Fig. 28). Some cardboard or wood supports release harmful agents, resulting in degradation (stains, embrittlement, silver mirror phenomenon). Prints on baryta paper laminated to a plywood support and subjected to excessive relative humidity and temperature variations have experienced spectacular degradation in the form of cracks and blisters (see Fig. 119).[21] Cardboard supports, even those of poor quality, sometimes have historical value (Fig. 29), and it may be necessary to retain them.

Poor-quality adhesives (glues, pastes, tapes) are sometimes carelessly used to mount photographs. These are very problematic to remove. The adhesive yellows and becomes tacky, and, once it penetrates the paper fibers, it can become visible on the image side. Therefore, it is necessary to carefully determine what type of adhesive to use, depending on the application. The range of available products is quite extensive. Some of them are appropriate for preservation purposes (see Table 12).

FIGURE 28

Back of a fiber-base photograph adhered using poor-quality two-sided tape. The glue has yellowed and migrated into the paper substrate. Note the number written in ballpoint pen that has diffused into the paper.

FIGURE 29a–g

Print terminology: vintage, period print, modern print, facsimile.

One negative may be used to make several generations of prints. There is no general agreement on the terminology used to describe the various stages of a print. A vintage print is a photograph printed around the time that the negative was taken. A period print is one made after shooting (an interval of up to 10 to 15 years is generally considered compatible with this term). If the time of printing is unknown or more than 15 years after shooting, the photograph is qualified as an old print, as opposed to a modern print. A modern or contemporary print is a recently printed photograph from the original negative. An original print is a definitive print made by the artist or under his direct supervision. A facsimile is a print made by rephotographing a print or by using the original negative, whose print base and processing are, to the extent possible, identical to those used for the reference print (generally, a vintage print).

a

Period print on albumin paper (the Sphinx and the Great Pyramid of Giza).

Copy negative made from period print on 4 x 5 in. (10 x 12 cm) film.

b

Modern reproduction print made from copy negative.

c

Glass plate negative (gelatin silver bromide process).

d

Period print (gelatin silver printing-out paper).

e

Modern print (developing-out paper), made using the original negative.

f

Facsimile (gelatin silver printing-out paper), made using the original negative.

g

Standards

Cover of an ISO and ANSI standard.

PROCESSING AND PRESERVING PHOTOGRAPHS

Contrary to other areas of cultural heritage, photography is in the fortunate position of having had standards relative to specifications and recommended preservation practices for many years. National and international standards are also useful tools for clarifying terminology and describing testing methods. Tables 7 and 8 present the American National Standards Institute (ANSI) and the International Standards Organization (ISO) standards relevant to this book (Fig. 30). Today, photography and photographic collections encompass digital information and computer hardcopy. For that reason, standard references pertaining to these materials have been added. While standards for "traditional" photography are well established, standardization committees have been discussing new issues arising from the spread of digital technology and computer output.

To keep up with advances in knowledge and techniques, new standards have been written and old standards are periodically updated. A standard that is more than five years old may be obsolete and significantly altered. Therefore, it is important to make sure that the version one is using is the most recent and that it is not currently being revised or eliminated. The contents of most of these standards are explained later in this book.

TABLE 7

ISO and ANSI standards for archiving and processing photographs and several types of audiovisual media.

Number	Title	New Number
ISO 417 ANSI/NAPM IT9.17	Photography—Determination of residual thiosulfate and other related chemicals in processed photographic materials—Methods using iodine-amylose, methylene blue and silver sulfide	ISO 18917
ISO 543	Photography—Photographic films—Specifications for safety film	ISO 18906
ISO 3897 ANSI/NAPM IT9.18	Photography—Processed photographic plates—Storage practices	ISO 18918
ISO 5466 ANSI/NAPM IT9.11	Photography—Processed safety photographic films—Storage practices	ISO 18911
ISO 6051 ANSI/NAPM IT9.20	Photography—Processed photographic reflection prints—Storage practices	ISO 18920
ISO 8225 ANSI/NAPM IT9.5	Photography—Ammonia-processed diazo photographic—Specifications for stability	ISO 18905
ISO 9718 ANSI/NAPM IT9.12	Photography—Processed vesicular photographic film—Specifications for stability	ISO 18912
ISO 10214 ANSI/NAPM IT9.2	Photography—Processed photographic films, plates and papers—Filing enclosures and storage containers	ISO 18902
ISO 10356	Cinematography—Storage and handling of nitrate base motion picture film	—
ISO 10602 ANSI/NAPM IT9.1	Photography—Processed silver-gelatin type black-and-white film—Specifications for stability	ISO 18901
ISO 12206 ANSI IT9.15	Photography—Methods for the evaluation of the effectiveness of chemical conversion of silver image against oxidation	ISO 18915
ISO 12606	Care and preservation of magnetic audio recordings for motion pictures and television	—
ISO 14523 ANSI/NAPM IT9.16	Photography—Processed photographic materials—Photographic activity test	ISO 18916
ISO 14806 ANSI/NAPM IT9.19	Imaging media (film)—Thermally processed silver microfilm—Specifications for stability	ISO 18919
ISO 15524 ANSI/NAPM IT9.23	Polyester base magnetic tape—Storage practice	ISO 18923
ISO 16111 ANSI/NAPM IT9.25	Optical disc media—Storage	ISO 18925
ANSI/NAPM IT9.13	Glossary of terms pertaining to stability	ISO 18913
ANSI/NFPA 40	Storage and handling of cellulose nitrate motion picture film	—
ANSI/AIIM MS45	Recommended practice for inspection of stored silver-gelatin microfilms for evidence of deterioration	—

ISO and ANSI standards for evaluating
the stability of several types of
audiovisual media.

Number	Title	New Number
ISO 10977 ANSI/NAPM IT9.9	Photography—Processed photographic color film and paper prints— Methods for measuring image stability	ISO 18909
ISO 12040	Graphic technology—Prints and printing inks— Assessment of light fastness using filtered xenon arc light	
ISO 15640	Photography—Imaging materials— Test method for Arrhenius-type predictions	ISO 18924
ISO 15525 ANSI/NAPM IT9.21	Life expectancy of compact discs (CD-ROM)— Method for estimating, based on effects of temperature and relative humidity	ISO 18921
ISO 16112 ANSI/NAPM IT9.26	For imaging materials—Life expectancy of magneto-optic (MO) discs— Method for estimating, based on effects of temperature and relative humidity	ISO 18926
ANSI/PIMA IT9.27	Life expectancy of information stored in recordable compact disc systems— Method for estimating, based on effects of temperature and relative humidity	ISO 18927
ASTM F 2035-00	Standard practice for measuring the dark stability of ink-jet prints	—

EVALUATING THE PERMANENCE OF MATERIALS

Artificial aging tests have become essential tools for evaluating the permanence of materials when they are exposed to light, stored in archives, handled, subjected to extreme conditions, and so on. These tests give us a better understanding of the changes that materials undergo over time. This then allows us to develop environments suitable for various materials and to guide users in selecting materials of proven stability. For a long time, manufacturers conducted various tests, whose results were published in specialized journals or data sheets. Unfortunately, the disparity in methodologies often made it impossible to compare the information provided by different laboratories. Standardization is now providing uniform operating conditions (Figs. 31, 32).

Life Expectancy

To replace the unspecific notion of medium- or long-term storage used in the past, standards have now defined the concept of "life expectancy,"[1] which represents the estimated time for which information remains accessible at 23°C and 50% RH when artifacts are stored in the dark. Thus, a film whose life expectancy, or LE, does not exceed ten years is classified "LE-10." Cellulosic base films, for example, are in the category of LE-100 and polyester bases are LE-500. This life expectancy is obtained using the Arrhenius relationship. The method is based on several assumptions. The first is that the chemical degradation mechanism follows a preferred reaction path that remains the same through a series of aging tests, that is, at different temperatures and humidities, and the reaction that governs deterioration obeys a simple kinetic law.

Controlled-environment chamber used
to investigate the behavior and life
expectancy of materials for conservation.
CRCDG, Paris

Experience has shown this to be the case with many degradation mechanisms (hydrolysis of dyes, certain polymers, paper, etc.). With a few exceptions, the Arrhenius law has demonstrated its utility.[2] Thus, it is used in stability studies on color and black-and-white photographs (ISO 10977 and ISO 15640) and on certain polymers as well.[3]

From the Arrhenius law, a simple correlation between temperature and time is established:

$$\mathbf{Log}\ (\tau) = \mathbf{a}/T + \mathbf{b}$$

where

a and b are constants for a given humidity
τ is the time to achieve a given rate of degradation
T is temperature in kelvins ($T = t°C + 273$)

The experiment consists of subjecting materials to temperatures ranging from 50°C to 90°C at constant humidity. They are kept at each of these temperatures for the time necessary to achieve a given level of degradation (e.g., 30% loss of optical density for a dye). These points are then plotted on a graph, with the time on a logarithm scale on the x axis and the inverse temperature in kelvins on the y axis. A straight line connecting these points is

FIGURE 32

Light aging test for ink-jet printouts.
CRCDG, Paris

extrapolated to obtain, on the *x* axis, the time required for similar degradation to occur at room temperature or any other temperature (Fig. 33).

In the past, most aging tests consisted of placing materials in a test chamber at a high temperature and, after some time, comparing them to others in order to rank them by order of stability (this was the case with ANSI Standard PH1.42-1969 for color photographs, which is now obsolete). However, it was found that the relative stability of materials at a high temperature did not always correspond to the relative behavior actually observed at ambient temperature. In fact, the Arrhenius lines need only cross between the test temperature and room temperature for the results to be reversed. Extrapolation by applying the Arrhenius equation avoids this trap. Furthermore, it gives us a much more accurate idea of the time scale for the durability of materials. We can also calculate the gain in stability provided by cold or cool storage. This experiment can be repeated at different relative humidities to evaluate the effects of moisture. But this methodology has its limitations. The degradation processes can prove more complex than the underlying assumption. The only purpose of raising the temperature is to increase the speed of a chemical reaction that occurs during natural aging. However, when a polymer (gelatin, cellulose esters, or polyester) is heated, its physical properties are modified and may cause different phenomena than those that occur at room temperature.[4] If this is not taken into consideration, the extrapolations based on such results will be erroneous.

To calculate the life expectancy of CDs (CD-ROMs, CD-Rs, and CD-RWs), the Eyring model, which factors in the effects of humidity, is used instead of the Arrhenius model. Degradation of a CD is monitored by measuring the block error rate (BLER) in the recorded data. For evaluating life expectancy, the time necessary for more than one error to occur in 10^{12} bits[5] is used for

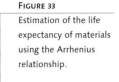

Estimation of the life
expectancy of materials
using the Arrhenius
relationship.

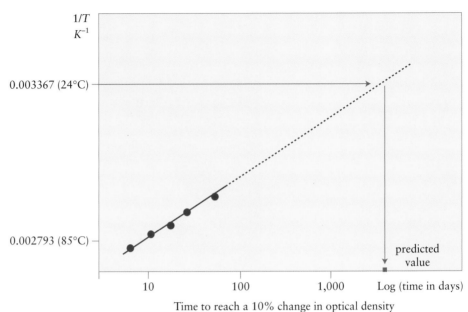

Time to reach a 10% change in optical density

the extrapolation (in the ANSI/NAPM IT9.21 standard, the end-of-life crite-
rion is expressed as a BLER limit of 220 per sec.). This methodology has been
standardized and is in use by research laboratories.[6] It has the same types of
limitations as those indicated above: The aging tests must be conducted at
temperatures below the glass transition temperature of the polymer; the reac-
tion mechanisms that come into play during these tests must reflect those that
occur during natural aging; and factors such as pollution and variations in
temperature and humidity are not taken into account. Finally, no correlation
has been established between such artificial aging and natural aging.

Light Stability

Evaluating light stability also requires specific procedures (ISO 10977 and ISO
12040). Moreover, the accuracy of these tests is linked to compliance with
certain constraints. The spectral distribution of the light source used in the
experiment must be identical to what occurs during natural aging. For expo-
sure to daylight, the accelerated aging test cannot rely on aging under fluores-
cent tubes. In addition, the relative humidity and temperature of the exposed
surface must be controlled. These few rules necessitate the use of climatic test
chambers.

 These tests also assume that light follows a law of reciprocity. In other
words, briefly exposing an artwork to very high luminance produces effects
equivalent to those that result from long exposure to lower luminance. This
law seems to apply below 100,000 lux. However, for higher intensities, other
factors, such as oxygen diffusion, come into play.[7] To evaluate the light sta-
bility of a material, it is subjected to strong lighting for a short time. Thus, a
color photograph in which a dye fades by 20% after 1,000 hours at 10,000
lux is believed to undergo the same degradation when exposed for 100,000

hours at 100 lux. This method can be applied to classify dyes by order of stability after one test under high luminous intensity.

Stability of Computer Printouts

With the development of printout technology (p. 232) and its use by artists and the public to print photographs, there is considerable concern about permanence. The lack of light-fastness of some ink-jet prints was mentioned very early on in a number of publications. The standards for testing traditional color photographs have been applied to evaluating light stability of computer printouts. However, these standards were created for chromogenic color photographs and do not address all the specific problems of these new generations of images, improperly called "digital images." For instance, some prints are very sensitive to humidity, wetting, handling, and ozone. The need for appropriate test methods has been clearly identified, and the ISO committee is working on various issues, such as humidity-fastness, water-fastness, fingerprints, indoor lighting, outdoor weathering, dark stability, and gas fading.

Quality of Paper and Board Enclosures

Over the past twenty years, several attempts have been made to establish standards for selecting preservation materials for photographs. In the 1980s T. J. Collings and F. J. Young[8] designed a test to identify materials capable of tarnishing silver, by incubating them for eight hours at 75°C in contact with a polished silver plate. If the plate showed traces of tarnishing, the test material was considered inappropriate for preserving photographs. However, this test was not very predictive of the suitability of an enclosure. Also during the 1980s, V. Daniels of the British Museum suggested two additional methods.[9] The first was a method for detecting substances that tarnish silver, specifically, sulfur derivatives. Fragments of the test material are sampled and placed under a microscope in contact with a small quantity of sodium nitride and iodine. In the presence of sulfur, sodium nitride breaks down and releases nitrogen microbubbles that can be seen clearly under a microscope. The greater the quantity of sulfur, the greater the amount released. This test is not very satisfactory either, since there are many compounds in addition to sulfur that are capable of degrading photographic images and that cannot be detected in this manner. The second method was based on a phenomenon described in the late nineteenth century by W. Russell, which bears his name: the Russell effect.[10] Peroxide is capable of making a latent image suitable for developing. Therefore, after an enclosure material is in contact with a photosensitive emulsion for several hours in the dark, once this emulsion is developed, a photographic reaction is produced whose intensity is proportional to the quantity of peroxide released. The more intense the reaction generated by the material, the more harmful its use for archiving photographs. Attempts have been made to apply the Russell effect to test paper enclosures for photographs,[11] but the test is neither sufficiently reliable nor sufficiently reproducible.[12]

The first so-called photographic activity test (PAT) was standardized in 1978 in the United States (ANSI Standard PH1.53) and then in Europe (ISO

Standard 6051:1979). It consists of incubating the test material for thirty days (at 50°C and 86% RH) in contact with a sample of the photographic document to be preserved. As a control, a sample of very pure filter paper is aged under the same conditions. If it is to be used, the material should not produce more degradation in the photograph than in the filter paper. This method quickly reveals its limitations. Admittedly, the test eliminates products of very poor quality, but it does not distinguish between mediocre and good materials. In other words, while this test reliably allows us to recommend not using certain products, it does not, conversely, allow us to recommend any for use. Ten years later, based on work at the Image Permanence Institute in Rochester, New York, a more sensitive PAT was adopted.[13] The material to be tested is no longer incubated with a sample photograph. The innovation consists of introducing two detectors that are aged in contact with the test material for fifteen days at 70°C and 86% RH. One is an image interaction detector and the other a stain detector.

The image interaction detector[14] was originally used to detect the presence of oxidizing pollutants in archive areas. It looks like a yellow filter and is composed of colloidal silver (also called Carey Lea silver) dispersed in gelatin and coated on a polyester base. The fineness of the particles—a characteristic of colloidal substances—makes them very sensitive to the oxidation and reduction phenomena that rapidly result in a change in optical density.

The stain detector is a piece of photographic baryta paper that has been fixed, without exposure to light, and washed. Degradation in this detector is indicated by varying degrees of yellowing.

The two detectors are measured, before and after aging in contact with the test material, using a densitometer (blue filter), and the results are compared to those obtained from contact with Whatman filter paper (Fig. 34). The materials that can be recommended on this basis are specifically appropriate for preserving gelatin silver prints. For other processes, it is advisable to prepare appropriate detectors. For example, for color photographs, three detectors need to be added (one yellow, one magenta, and one cyan photo-

FIGURE 34

Photographic activity test. At right, various tested materials. At left, the colloidal silver detector after 14 days in contact with these materials. Stains are characteristic of harmful emanations.
(1) filter paper
(2) glue-coated paper
(3) paper covered with red ink
(4) cardboard
(5) paper covered with black ink

graphic image and a color stain detector, all measured using status A red, green, and blue densitometer filters). The details of this photographic activity test are described in ISO Standard 14523.

Mounting Photographs

Later chapters of this book address issues such as framing, mounting, laminating, and coating of prints. Standards for mounting photographs have been published and are regularly updated. However, these do not focus on conservation practice and do not necessarily reflect conservation requirements. These standards are

ANSI/PIMA IT4.21: For Photography—Thermally Activated Adhesive Dry Mounting Systems for Mounting Photographs—Specifications

ANSI/PIMA IT4.20: For Photography (Processing)—Pressure-Sensitive Adhesive Systems for Use in Mounting Photographs—Specifications

PRESERVATION PRACTICE STANDARDS FOR COLLECTIONS

In recent years, standardization committees have been established for preservation in archives, libraries, and museums. New documents are being prepared for evaluating the permanence, durability, and stability of materials, condition surveys and levels of deterioration of collections, storage and exhibition conditions, enclosures, and so on. These should provide guidance to individuals responsible for setting up photographic archives (Table 9).

TABLE 9

Standards for storage of archive and library documents.

Number	Title
BS 5454	Recommendation for storage and exhibition of archival documents
ANSI/NFPA 90A-1993	Installation of conditioning and ventilating systems
ANSI/UL 72-1990	Tests for fire resistance of record protection equipment
NAPM TR-1-1995	Imaging media technical report—Imaging material—Humidity measurement
ANSI/NFPA 232-1995	Protection of records
BS 3484	Specifications for blue black records inks
CD 15659 (draft, not yet available)	Information and documentation—Archives boards—Migration test
DIS 11798 (final, not yet available)	Information and documentation—Permanence and durability of writing, printing and copying media on paper documents—Requirements and testing methods
DIS 11799 (final, not yet available)	Information and documentation—Document storage requirements for archive and library materials
ISO/WD 16245 (draft, not yet available)	Information and documentation—Archives boxes and file covers for paper and parchment documents

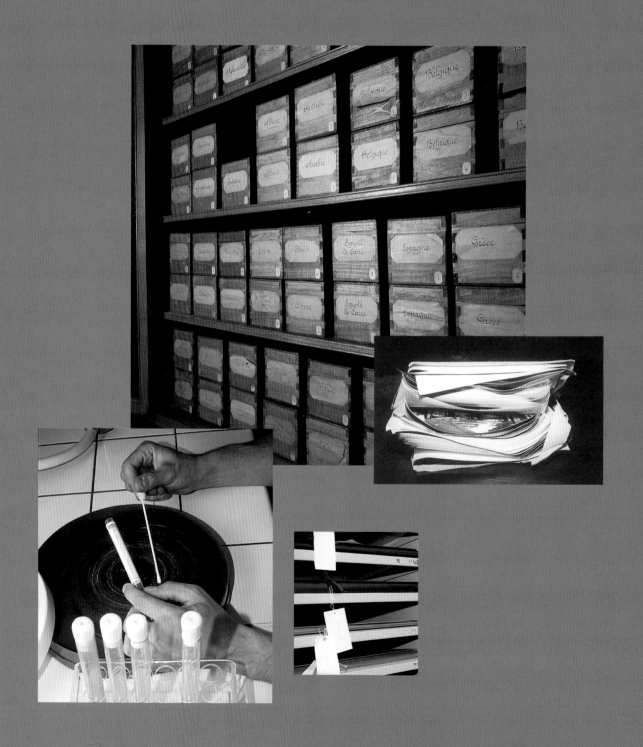

Protection

Enclosures

The protection of photographs is accomplished by means of a set of physical barriers that meet specific and complementary objectives. There are three levels of protection: filing envelopes and boxes (Level I), storage furniture (Level II), and storage areas (Level III). In preventive conservation, the enclosures (Levels I, II, and III) serve a function that goes well beyond passive protection or storing and organizing collections. They may be selected or designed to help establish a microenvironment, which requires good prior knowledge of the behavior of the materials—containers and contents—in order to avoid deleterious effects. If all of the variables are not controlled, undesirable microenvironments may develop, for example, due to accumulation of harmful compounds from materials or high relative humidity in a box, cabinet, or area, promoting mold growth.

CONTACT MATERIALS (LEVEL I)

Selecting Materials

Sleeves and boxes effectively protect photographs from particulates (Fig. 35), abrasion, and inappropriate handling. The closer the materials come in contact with the photograph, the more carefully they must be selected. Advertising slogans such as "Suitable for filing and storing photographs" often refer only

FIGURE 36

Permanent paper surface seen under a scanning electron microscope.

The calcium carbonate deposit that constitutes the alkaline reserve is visible between the fibers.

FIGURE 37

Traces of a poor-quality tape on the back of a photograph.

to the physical organization of the photographs and do not necessarily mean that the material is inert and harmless. Even if the chemical properties of the archival products have been well documented, their texture must be appropriate. A surface that is too smooth or too rough can also result in damage to the photograph.

Methods of evaluating conservation materials

Experience acquired over the past few decades has made it possible to better evaluate the diverse range of potential dangers to photographs and to better understand the active role enclosures play in the protection of prints or, conversely, in their deterioration. Of course, specialists have long been aware of the risks—emanations (acids, peroxides) that are harmful over the short or long term, such as ink migration, plasticizers, and corrosive compounds—but there were no reliable tests capable of detecting a possible interaction between storage materials and the photographic image. For photograph storage, they first turned to the materials that had proven effective for preserving and restoring graphic documents, that is, papers rich in alpha cellulose or starch paste, Japanese paper, and so on, whose composition, pH, and behavior over time were known (Fig. 36). But they also had to take into account the silver that constitutes the image in black-and-white photographs and its sensitivity to certain pollutants, such as peroxides and reduced sulfur compounds. Thanks to the photographic activity test, choosing photographic preservation materials has now become a simpler matter. Papers and boards that pass this test may be used for long-term archiving of photographs. However, in the case of synthetic polymers (sleeves, adhesives, and varnishes), it is also necessary to determine their composition and long-term physical behavior. Glue, for example, may yellow, become tacky, or lose its adhesive properties and still pass the PAT, which evaluates only chemical suitability (Fig. 37).

Cellulose materials and alkaline reserve

Paper is a highly recommended material for protecting artwork, on condition, of course, that it is of proper quality. We know that starting in the mid–nineteenth century, industrialization radically transformed paper manufacturing processes. Wood-derived cellulose replaced cellulose from linen, hemp, and cotton rags. The acid rosin-alum sizing used in those papers caused acidification over time. In addition, there were the effects of increasing levels of acid pollutants (nitrogen oxides, sulfur dioxide) in the atmosphere. In the 1970s, to limit this phenomenon, manufacturers began adding an alkaline buffer, generally calcium (or magnesium) carbonate, to certain paper pulps to neutralize developing acids and give paper more permanence. The pH of buffered paper is not neutral but alkaline (Fig. 38). Since that time, requirements have been refined and criteria for "permanent" paper for use in book printing were established[1] and then standardized.[2] To achieve the same permanence and quality in the protection of artworks, an alkaline reserve (measured according to ISO Standard 6588) of calcium or magnesium carbonate or zinc oxide was added to paper for use in preserving graphic arts. The recommendations for paper for use in archiving photographs are specified in ISO Standard 18902. It must be chemically stable, made from cotton fiber or bleached wood pulp, with an alpha cellulose content greater than 87%. It must contain no dyes, waxes, metal particles, or products capa-

FIGURE 38

FIGURE 38

pH scale.

There is some confusion about the use of the term "neutral," which is used by some to mean "noncorrosive," "inert," or "nonacidic," as in neutral glue and neutral plastic. For example, one manufacturer offers "neutral" cardboard boxes with a pH between 6 and 9(!). First and foremost, "neutral" is a basic chemistry concept meaning that the pH is equal to 7. Likewise, it is incorrect to speak of the pH of paper. By definition, pH is relative to an aqueous solution, and if usage allows us to speak of the pH of paper, this suggests that the pH is measured in an aqueous solution after extraction, or the pH is measured in a drop of water in contact with the material. This value can vary, depending on the method of measurement.

Hydrogen ion concentration (moles per liter)		pH scale	
1	10^0	0	very acidic
0.1	10^{-1}	1	
0.01	10^{-2}	2	
0.001	10^{-3}	3	
0.0001	10^{-4}	4	
0.00001	10^{-5}	5	
0.000001	10^{-6}	6	
0.0000001	10^{-7}	7	neutral
0.00000001	10^{-8}	8	
0.000000001	10^{-9}	9	
0.0000000001	10^{-10}	10	
0.00000000001	10^{-11}	11	
0.000000000001	10^{-12}	12	
0.0000000000001	10^{-13}	13	
0.00000000000001	10^{-14}	14	very alkaline

ble of damaging the photograph by migration or decomposition. It is imperative that it not contain chemical impurities, particularly reducible sulfur compounds, lignin, or peroxide. Its sizing must be neutral or alkalinized by an alkaline reserve (Table 10).

Since there are no conclusive experimental results, some professionals mistrust the addition of an alkaline reserve to papers that will come in contact with photographs, fearing that such alkaline products may damage the images over the long term.[3] Furthermore, the standards have long urged a degree of caution, recommending storing color photographs in paper with no alkaline reserve. However, many papers with an alkaline reserve have passed the PAT and not the slightest damage has yet been reported when they are used under normal storage conditions. An alkaline reserve improves the durability of the sleeve and may slightly increase the protection of photographs against pollutants. This ability to neutralize acid pollutants is limited, however.[4] In short, there is currently no decisive evidence suggesting that enclosures should not contain an alkaline reserve, providing that it is not excessive (approximately 2%). After selecting a material whose composition is consistent with its intended use and environment (Table 10), it is necessary to ascertain that it meets the standardized criteria and particularly that it passes the PAT.

Glassine paper

Many issues have been raised regarding the use of glassine paper. Although it has been in use for many decades by photographers for storing negatives, it was banned by ISO Standard 18902 for archiving purposes. Most such paper, formerly sized with rosin, becomes acidified, discolored, and brittle over time. It may also contain plasticizers. One frequent type of degradation is linked to the adhesives. Some sheet films or prints preserved in glassine paper enclosures

TABLE 10

Some properties of papers used for
housing photographs.

Black-and-White Photographs	Storing Color and Diazo Process Photographs	Test Method
bisulfite chemical pulp or bleached kraft pulp	same as black-and-white	fiber identification by microscope
alpha cellulose content greater than 87%	same	TAPPI T 429 om-78
less than 0.0008% reducible sulfur	same	TAPPI T 406 om-88
no metal particles	same	TAPPI T 266 om-88
no lignin	same	TAPPI T 222 om-88
no dyes or pigments capable of migrating after 48 hours of immersion in distilled water	same	
no waxes, plasticizers, or peroxides	same	
no rosin sizing	same	TAPPI T 416 wd-39
neutral or alkaline sizing, if necessary	same	TAPPI T 504 om-84 TAPPI T 466 cm-82 TAPPI T 505 wd-74
alkaline reserve equivalent to at least 2% calcium carbonate, uniformly distributed	alkaline reserve equivalent to no more than 2% calcium carbonate, uniformly distributed	TAPPI T 428 pm-85
no acid, pH between 7.2 and 9.5	pH between 7.2 and 8.0	TAPPI T 529 om-88 TAPPI T 509 om-88 TAPPI T 435 om-88

FIGURE 39

Glassine envelope that has stuck to the
photograph due to excessive humidity
or water damage.

with their image side in contact with the cemented seam are now showing visible signs of fading of the silver image. The frequency of this type of degradation has led to banning the use of this material in collections.

Some manufacturers are now offering higher-quality glassine paper. The appropriateness of its use is still subject to debate. A problem that we should be aware of is that in the event of a flood or accidental water splash, glassine paper adheres permanently to the emulsion if left to dry without first separating it from the emulsion (Fig. 39).

Synthetic polymers

Many polymers are inappropriate for preservation because they release harmful products—plasticizers, chlorinated or nitro compounds, and acids. That is the case with the poly(vinyl chloride), or PVC, that is found in the form of sleeves and transparent sheets intended for filing slides or negatives (Table 11; Fig. 40). PVC is a material that releases hydrochloric acid as it ages. It also contains plasticizers that can migrate and be deposited on photographs in fine droplets. Cellulose acetate is not recommended either, since in a humid atmosphere it hydrolyzes, generates acid, and deforms. Cellulose acetate has been used for making enclosures for many years in photograph archives and libraries. For example, the Dunhuang manuscripts (China, tenth century) at

TABLE 11

Abbreviations routinely used for several polymers.

Abbreviation	Name
ABS	acrylonitrile-butadiene-styrene
CA	cellulose acetate
CN	cellulose nitrate
CTA	cellulose triacetate
EVA or E/VAC	ethylene vinyl acetate (copolymer)
PCTFE	poly(chlorotrifluoroethylene)
PE	polyethylene
PEN or PENP	poly(ethylene naphthalate) (polymer)
PET or PETP	poly(ethylene terephthalate) (polymer)
PMMA	poly(methyl methacrylate)
PP	polypropylene
PS	polystyrene
PTFE	poly(tetrafluoroethylene)
PUR	polyurethane
PVAC	poly(vinyl acetate)
PVOH	polyvinyl alcohol
PVC	poly(vinyl chloride)
PVDC	poly(vinylidene chloride)
PVDF	poly(vinylidene fluoride)

the French National Library were stored in sheets of Rhodoid (a cellulose acetate–based material) from the 1950s through the 1970s. The Rhodoid sheets are now deteriorating and endangering the manuscripts, which have had to be extensively rehoused in better sleeves.

The polymers used must be inert, must not contain plasticizers, and must have good chemical stability. Freshly manufactured plastic materials may produce harmful compounds such as monomers, peroxides, etc. Although the photographic activity test was not originally designed for synthetic polymers, it is advisable that they be tested. If they fail the PAT, they should not be used for archiving photographs. However, passing the test does not necessarily mean that they are recommended. Identification and additional tests should be conducted. A good example is PVC, which, while banned by the preservation standards, may sometimes pass this test.

The few usable materials include polyester, polyethylene, polypropylene, and polystyrene, on condition that they have not undergone any chemical surface treatment (e.g., application of an antistatic agent) and do not contain additives harmful to the photographs. Polyester, or poly(ethylene terephthalate), is remarkably stable over time and widely used for protecting all sorts of artifacts. However, it is expensive and it is slightly electrostatic, which may cause abrasion and scratches on photographs.

Polyethylene, which is less expensive, can easily be used to make various sizes of sleeves by heat sealing. However, it is less transparent, less rigid, and less chemically stable than polyester. The problem with this

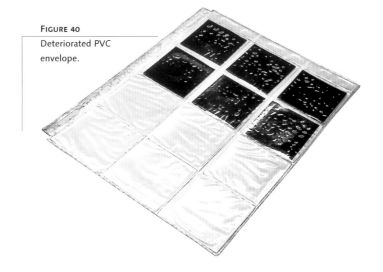

FIGURE 40

Deteriorated PVC envelope.

TABLE 12

Products tested for use in contact with
photographs (not a complete list).

Category	Not Recommended: do not meet ISO 10214	Recommended: meet ISO 10214
cellulose materials	kraft paper	acid-free paper
	glassine paper	permanent paper
polymers	PVC, CA	polyester
adhesives	tube and aerosol glues of unknown composition	methylcellulose (Tylose), Klucel G, Paraloid B72, starch, gelatin

common product is the wide variety of qualities and compositions it encompasses. The researcher Henry Wilhelm makes a distinction between high-density and low-density polyethylene; he does not recommend the latter.[5] In addition to the additives it may contain, whose effects on photographs are unknown, it has a tendency to stick to the emulsion, particularly with 35 mm films. Du Pont de Nemours markets Tyvek, which is similar in appearance to paper but is composed of heat- and pressure-bonded, high-density polyethylene fibers. Antistatic treatments and coatings to increase ink receptivity are used to produce a wide range of Tyvek products. These are distinguished by a letter: Tyvek D, R, K, and B. Tyvek B, which is an untreated product, would be the most appropriate, along with a similar product, Archivek (Curtis 1000). The only advantage of these materials over paper is their greater tear resistance.

Polypropylene and polystyrene are frequently used in more rigid structures, such as boxes and sheets for filing slides.

Inks

Pencil should be used to mark photograph accession numbers on envelopes and to mark information (reference, date, number, etc.) on the back of baryta prints. The lead should be soft enough not to damage the image layer with embossing pressure. An ink that has passed the photographic activity test can be used for indelible marking. Some inks may migrate through the paper base and appear on the image side (Fig. 41). To be certain this will not occur, one can test by placing a paper sheet marked with the ink in question in contact with a blank sheet, immersing it in distilled water for forty-eight hours, and then observing if there has been any transfer. For collection prints, an embossing stamp may be used in the nonimage margin area. However, slight flaking may appear on the embossments of the stamp. If it is necessary to write on resin-coated paper or negatives, markers that pass the PAT and whose inks do not have the potential to bleed through the base should be used. It is advisable to write on the back (base side) of negatives, not on the image-bearing, emulsion, side.

Adhesives

It is generally advisable to use four-flap envelopes or sleeves that are glued on the edge. Adhesives used to assemble paper envelopes should meet preserva-

Poor-quality paper envelope causes silver mirroring on the photographic image.

Deterioration of a chromogenic color print caused by an inappropriate glue.

© M. Matthieussent, Ministry of Culture and Communication, France

tion standards (e.g., the PAT) (Table 12). When using paper envelopes with adhesive flaps, care must be taken not to place the image side in contact with the glue seam. Most synthetic polymer sleeves are heat sealed. PET may also be ultrasound welded. For adhesives used in mounting photographs, refer to chapter 7 (Fig. 42).

Creating a Microenvironment

When it is not possible to create suitable preservation conditions in an entire vault, microenvironments are created around objects using the so-called active materials that have recently been developed by various manufacturers. These new approaches are appealing, but we still do not have enough perspective and experience to evaluate their effectiveness. Airtight packaging of photographs is an effective guarantee against relative humidity, dust, and pollution during storage or shipping. It also protects from the potential consequences of a flood. Placing objects in a "controlled atmosphere" or adding adsorbent materials (active charcoal, molecular sieves, silica gel, etc.) can offset certain deficiencies. But major drawbacks of these enclosure choices are already surfacing. These techniques are not simple to implement and require trained personnel to establish and maintain. Finally, the use of airtight packaging limits access to photographs, since the packaging must be opened each time they are viewed, disrupting the conditions that have been achieved and necessitating reestablishment of the original conditions.

Adsorption and gas-solid interactions

When an object is placed in an unfavorable environment, it deteriorates. This degradation is visible on the surface, but the actual object is not limited to what can be perceived with the naked eye, nor is its surface closed. Many materials are a veritable Swiss cheese at the molecular level. To define this porous structure, which differs depending on the material, physicists have come up with the concept "specific surface area," which represents the surface that is

accessible to the gases in the atmosphere. It is expressed in square meters per gram of matter. Interaction between vapors and a solid occurs only in areas where the gas comes in contact with matter. The greater the specific surface area, the greater the reaction. This phenomenon is well illustrated by the action of pollutants on a silver image. The printed-out prints of the nineteenth century are composed of silver particles that are much finer than those found in modern developed-out processes. For the same quantity of metal in gelatin, the specific surface area of silver is much greater in the historic processes and therefore more quickly deteriorated by pollutant gases. In general, gas-solid interactions have significant implications from a preservation perspective. They determine the exchanges between a material and its environment and also make it possible to develop specific techniques for controlling that environment.

In the mass of a material, the spatial distribution of the charges surrounding the atoms or molecules is in equilibrium. On the periphery of the material, that equilibrium disappears. The molecules or atoms at the surface compensate for the discontinuity of the force field by binding to the gas molecules (water, acid, etc.) in the air with which they have the greatest affinity. If the bonds between the solid and the gas are weak (van der Waals interactions), this phenomenon is called "physical adsorption" or "physisorption." If the bonds are stronger and identical to those created by chemical bonding, it is called "chemical adsorption" or "chemisorption," or simply adsorption. Chemisorption represents a transformation of the substrate. These phenomena are used in certain air treatment products, such as the activated alumina filters impregnated with permanganate used to neutralize sulfur dioxide, the zinc oxide granules (Catalyst 75-1, ICI) used to trap hydrogen sulfide,[6] and oxygen scavengers (Ageless®). Not only do they trap gases, but they break them down into harmless by-products. The same applies to hygroscopic salts, such as lithium chloride, which react with water and are transformed into hydrated salts.

Physical adsorption is not a static phenomenon. It results in a constant exchange between the gas molecules that are bound to the material and those in the atmosphere. In the equilibrium phase, the number of gas molecules at the surface is constant. When some are desorbed, they are replaced by others. Pressure and temperature variations affect this equilibrium. If the temperature increases, the thermal agitation of the molecules releases some of them and the adsorption rate decreases. Above 100°C, the molecules desorb. When the pressure or concentration of the gas increases, the reverse occurs; that is, a greater number of molecules are deposited at the surface of the solid.

Physisorption phenomena determine the quantity of water retained by organic materials, such as gelatin, paper, and polymers. They enable the creation of microenvironments through air purification with adsorption of pollutants on activated charcoal, stabilization of relative humidity with silica gel, and so on.

Using a sealed enclosure

Sealed enclosures have been used for cold storage of color movie film. A sealed enclosure (possibly with a vacuum) eliminates the risk of degradation from pollutants, dust, abrasive particulates, or water or moisture damage, but it is not suitable for large collections, since it would be both too time-consuming and very expensive to implement.

Packaging film at low humidity and then vacuum bagging it in a sealed envelope is a solution that has been proposed for cold storage of motion picture film (FICA process).

Since many polymers are permeable to water vapor, it is necessary to ascertain the properties of the materials used for packaging. In that regard, the most effective are those consisting of aluminum foil sandwiched between different types of material layers. For example, Kodak Storage Envelopes for Processed Film are composed of a sheet of aluminum foil sandwiched between a sheet of paper and a sheet of polyethylene. However, the opacity of the container makes it impossible to see the object without opening the jacket.

For archiving motion picture film, the Swedish Film Institute has developed the FICA (Film Conditioning Apparatus) System, which is in use in several countries. The FICA System includes a winding device, a conditioning enclosure, and a vacuum sealing system for the bags. The film is first rewound at low tension and then stored at 25% RH for one week. It is then vacuum sealed in a polymer/aluminum foil/polyethylene laminate enclosure that is airtight and water vapor–tight. For a small collection, the FICA System (Fig. 43) can be a beneficial solution. It makes it possible to place films and prints in a domestic freezer and thereby greatly prolong the life expectancy of color and triacetate film, on the condition that some of the film is inspected from time to time to verify that the base is not releasing acid emanations. It is not advisable to use the FICA System for storage at room temperature.[7]

Using a sealed controlled-atmosphere enclosure

To avoid accumulation of harmful gases, a compound capable of trapping or neutralizing them may be added to the preservation packaging. However, most of these compounds have a limited active life, which will mean extensive repackaging work sooner or later, but they will have ensured better preservation for some time.

Stabilizing relative humidity In small airtight enclosures (film boxes, crates, cabinets, display cases, etc.), relative humidity is controlled with preconditioned silica gel or other highly hygroscopic compounds. These are extensively used in museums, and a wide variety of specifically packaged products are commercially available. They are not effective for neutralizing pollutant gases, but their stabilization or reduction of relative humidity prevents mold growth and slows hydrolysis phenomena.

FIGURE 44

Use of molecular sieves for storing motion picture film.

Zeolites (natural or artificial) are aluminosilicates with a network structure of three-dimensional poly-hedra formed by assembling SiO_4 and AlO_4 tetrahedrons. These are porous compounds that act as molecular sieves by trapping molecules whose size is consistent with the size of their micropores. For acetic acid, type 4A molecular sieves (pore diameter 4 angstroms) are used. Each reel of film is surrounded by a string of small pouches, each containing 12.5 g of zeolites, corresponding to at least 2% of the film by weight (molecular sieves, Kodak Cat. No. 859 7684). The box or bag must be hermetically sealed to prevent the sieve from absorbing external humidity, to the detriment of other gases. Studies by T. Ram and D. Kopperl[10] seem to indicate a degree of improvement in the life expectancy of the base and yellow and magenta dyes when the film is stored with molecular sieves. Adsorption of organic compounds produces a slight negative effect; that is, films on a triacetate base retract somewhat more (approximately 0.6%). This phenomenon is attributed to the extraction of residual traces of the solvents used to manufacture triacetate bases. This type of packaging is not permanently effective and the molecular sieves must be regularly renewed. It is impossible to accurately provide the replacement frequency, which depends on temperature and humidity conditions, the condition of the film, and the quantity of zeolites used. With 75 g per 600 m of 35 mm film, renewal is necessary every two to three years at 21°C, and every ten to fifteen years at 2°C, at a humidity of 20% to 30%. As they neutralize acid, the molecular sieves are destroyed, so it is not possible to regenerate them. Fuji has introduced a similar product under the name Keepwell®.

Acid scavenging To capture the acid released when cellulose acetate bases deteriorate and to thereby limit auto-catalytic decomposition processes, Kodak recommends the addition of zeolites (Fig. 44). These adsorb acetic acid, water vapor, ammonia, sulfur dioxide, hydrogen peroxide, hydrogen sulfide, and various solvents. The use of molecular sieves has been tested by film archives in France, Belgium, Britain, the United States, Australia, and Japan. These molecular sieves markedly slow down film deterioration when added at a proportion of 5% of the film by weight. However, this beneficial effect is apparently linked more to their ability to dry the air than to neutralization of acid gases. Similar results have been achieved by packaging the film at 20% RH. Furthermore, molecular sieves are not effective for films that are in the process of deteriorating.[8] Reels of film form compact structures, and acetic acid diffuses through them very slowly. This promotes a dangerous accumulation of acid inside the film, even if an acid trap is placed outside the reels.[9]

The use of molecular sieves in large film archives poses problems of cost and handling. An analysis of cost-benefit ratios would seem to favor decreasing the temperature, which also slows down the deterioration of dyes in chromogenic color film. However, for sheet film or collections of negative strips stored in envelopes, it may be beneficial to add zeolite to the boxes.

Oxygen scavenging Oxygen plays a role in many deterioration processes of organic components, and reducing its concentration to a level low enough to stop oxidation reactions increases the life of those materials.[11] Recent innovations in the food industry for increasing the shelf life of foodstuffs are being put to use to preserve cultural property in an oxygen-deprived environment. Currently, the most successful application in museums, libraries, and archives is irradication of insects by oxygen deprivation (see p. 143). Other developments are being studied, particularly for the preservation of certain unstable polymers and dyes.[12] The success of such methods depends on the oxygen permeability of the enclosure, which must provide an effective barrier against infiltration over the long term (Table 13).

An oxygen scavenger is a mixture of a metal powder (iron or sometimes copper) and sodium chloride in little bags. When these bags are exposed to air, the metal very rapidly consumes the oxygen and in the process is converted into an oxide. There is a whole range of powdered iron products whose performance is linked to the volume and relative humidity of the enclosure to be treated.[13] For conserving artworks, Ageless Z® (Mitsubishi Gas Chemical Company) is widely used. Packets of Ageless® are sealed with the object in an airtight package. If a sufficient amount of the product is added, the oxygen level decreases from 20% to less than 0.1%. This reaction is accompanied by two phenomena that must be monitored. First, there is a drop of pressure in the container, which may be deformed as a result, caus-

TABLE 13

Diffusion of water vapor and gases in various materials (calculated using NF Standard H00-030).*

Material	Thickness (microns)	Diffusion of Water Vapor in Grams per m²/24h	Diffusion of Oxygen in cm³ per m²/24h (25°C, ΔP = 1 atm)	Diffusion of Carbon Dioxide in cm³ per m²/24h
polystyrene	800	120.0	10,000	25,000
polychlorofluoroethylene	100	1.0	200	520
polyester	35	15.0	60	180
cellulose acetate	25	>600.0	1,900	3,900
laminate foil: • polyethylene 20/1,000 • cellulose 64 g/m² • aluminum 9/10,000	40	0.2	<5	<5

* G. Ballot and M. Duminil, Isolation frigorifique, guide théorique et pratique (Paris: Pyc édition, 1981).

ing stress to the photographs it contains, and, second, the conversion of the iron into oxides (magnetite and akaganeite) is an exothermic reaction and the temperature of the reagent may reach 42°C.[14] Therefore, it is preferable to avoid placing packets of Ageless® in direct contact with the objects.

To provide decades of preservation in an oxygen-free atmosphere, it is necessary not only to eliminate oxygen during packaging but also to ensure that it does not slowly penetrate into the packaging by diffusion or through pinholes. Only enclosures made of polymer/aluminum foil/polyethylene laminate, such as Marvelseal®, are practically impermeable to oxygen. They are nevertheless fragile, since microcracks may form in the aluminum foil where they are folded. There are also several types of polymer film (e.g., PVDC, PCTFE, PET) that may be expected to be suitable for long-term use because of their very low permeability. It is possible to use indicator tablets (Ageless Eye®) whose color changes from pink to purple at oxygen levels greater than 0.5%. In that case, a transparent film must be used. It is also necessary to be aware that the light stability of these tablets is very limited over time. While the laboratory results are promising,[15] they are still too recent to determine whether such a tool will be effective for preserving photographs.

Using a filtering enclosure

The MicroChamber® In 1993 the American company Conservation Resources introduced MicroChamber®, a new generation of papers and boards. These products are marketed by other companies under the names Alphamat® and Artcare®. These materials are composed of an assembly of paper layers, each with a different chemical composition—paper with an alkaline reserve for the outer layer, activated charcoal and molecular sieves (zeolite) for the middle layer, and pure pH-neutral alpha cellulose for the inner

FIGURE 45

MicroChamber® cardboard seen under a scanning electron microscope. Zeolite deposits are visible between the cardboard fibers.

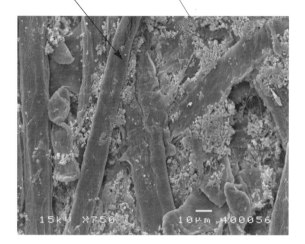

layer. Harmful gases released by the photographic base and external pollutants are trapped by the active charcoal and molecular sieves dispersed through the fibers. Thus they eliminate corrosive products and act as a filter for airborne pollutants (Fig. 45). Preliminary tests are very positive and show increased protection of photographs. The efficacy and durability of that protection remain to be determined under actual conditions of use.[16]

Static and corrosion control polyethylene These films—marketed under the names Static Intercept Films® and Corrosion Intercept® Polyethylene Films—originally intended for packaging and protecting electronic equipment, are made of polyethylene combined with copper atoms that intercept corrosive gases as they oxidize and thereby protect the artifacts contained in the envelope. However, no research has yet been done to evaluate the effectiveness and safety of this protection for photographs.

Note that the presence of copper gives the polymer certain conductive properties, so there is no accumulation of electrostatic charge. For magnetic media, such film may also serve as a Faraday cage and provide protection from an electromagnetic field (see p. 200).

Types of Enclosures

If the collection allows, it is desirable to avoid mixing different types of photographs, for example, by separating negatives from prints. The ideal situation would be to group together photographs that are of the same type and that require specific storage conditions, for example, black-and-white prints, color photographs, acetate-base negatives, nitrate-base negatives.

Collection prints and negatives should be handled with cotton gloves. The use of rubber bands to bundle photographs and rolls of film or to close boxes should be avoided, since, as they age, they generate harmful off-gassing.

TABLE 14

Advantages and disadvantages of paper and polyester for enclosure.

Type	Advantages	Disadvantages
paper	• buffering effect for humidity • permeable to internal gas emissions • neutralizes some pollutants (with or without buffer)	• opaque • tears • permeable to external pollutants
polyester (PET)	• transparent • resistant • inert and stable • protection from external pollutants	• electrostatic • low permeability, risk of ferrotyping • keeps photographs in contact with off-gasses in internal gas emissions

Choice of enclosure material.

 Choosing a container involves a variety of factors. This decision tree makes it possible to determine which material—polyester or paper—is more appropriate.

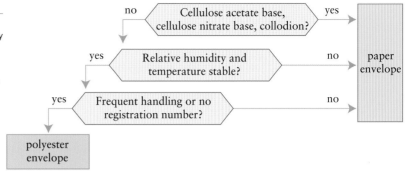

FIGURE 47

Four-flap paper envelope.

FIGURE 48

Types of collapsible boxes for photograph storage.

Choosing an enclosure

Sleeves The nature and shape of the enclosure should be determined by the conditions of use (e.g., frequent handling, temporary exhibitions, security archiving). For sleeves, paper or synthetic polymers (PET, PE), which have the advantage of being transparent, are widely used (Table 14). However, they have the drawback of retaining, inside the container, the off-gassing produced by the photograph, its mat, and certain poor-quality adhesives. Therefore, these should be avoided for unstable materials such as cellulose ester bases. Furthermore, in the event of internal condensation due to temperature fluctuation, the gelatin might adhere to the plastic envelope and microorganisms could proliferate. It is also necessary to know how the sleeves will behave in the event of an accidental increase in temperature (fire). In a heat test (four hours at 150°C), the material should not catch fire, deform, or melt to the extent that the photograph that it contains is damaged beyond repair.[17] Therefore, except in cases in which frequent handling for viewing may lead to degradation through abrasions and accretion, it is preferable to use paper sleeves, which are gas and water vapor permeable (Fig. 46). Depending on the format of the photographs and their fragility, there is a choice of various models (open on one or two sides, with or without flaps) (Fig. 47).

Albums Sheets for filing slides or negatives should be bound in looseleaf ring binders made of cardboard, PE, or PP and then placed in appropriate cases or stored in cabinets. Photo albums are stored in boxes.

Boxes The boxes in which photographic paper is sold should not be used for storage purposes, since they are made of poor-quality cardboard and are intended for use only in the short term. Appropriate storage boxes are those manufactured from materials that will not endanger the photographs (in conformity with ISO Standards 14523 and 10214), for example, cardboard with an alkaline reserve, anodized aluminum, painted metal, or synthetic polymers that have been proven safe. The polymers used to make boxes should contain antioxidants as well as nonhalogenated fire retardants such as antimony oxide. The properties and solidity of the boxes should be verified in accordance with current standards.[18]

Corrugated cardboard has several advantages. Boxes made from this material are less expensive, light, and easily assembled and therefore save a significant amount of space when transported and stored unassembled (Fig. 48).

But they are not always of good quality and do not hold up well under repeated use. In the event of a fire, they are quick to catch fire and be consumed, and they are more fragile when wet.

Boxes, particularly those that are intended to contain unstable bases (nitrate or acetate films), should not be sealed airtight, so that air can circulate (unless they contain an adsorbent compound).

Storing prints

Prints that will be exhibited frequently should be inserted in a window mat. If they are accessed and handled repeatedly, a PET sleeve may be used and rigidified, if necessary, by inserting a sheet of archival-quality cardboard. Encapsulation has the advantage of preventing all contact with the photograph during handling while leaving both sides fully visible (so any annotations or marks made on the back by the photographer may be read). The photograph is sandwiched between two sheets of polyester that are sealed on the edges. However, a photograph mounted in this way runs the risk of remaining confined for many years in an atmosphere laden with harmful emanations, especially if the photograph has been mounted on low-quality cardboard. For prints that are not consulted often, it is preferable to use paper sleeves.

Prints should be stored flat in boxes. Only a small number of prints should be stored in a single box in order to avoid placing too much pressure on the photographs at the bottom.

Storing negatives

Cellulose acetate films may be cut into strips and stored in paper sleeves to avoid an accumulation of acetic acid. Polyester-base sheet film may be placed in paper or polyester jackets.

Storing slides

Few studies have been devoted to the physical and chemical effects of slide mounts, whether they are made of cardboard, plastic, or glass. To date, no degradation specific to a type of mount or mask has been reported. Glass mounts are by no means unanimously approved. They do protect the emulsion from scratches, dust, and fingerprints, but, during projection, they are a source of overheating, deformation, and condensation that can lead to adhesion to the glass or to mold growth.

Slides mounted under glass may be placed in appropriate boxes or drawers or stored in polyethylene binder sheets or rigid polypropylene sheets. Open frame-mounted slides should be protected with a sleeve before storing in slide storage boxes or cabinets. If the slides are not mounted, they should be treated like flexible negatives.

Storing rolls of film

Storage method For rolls of 35 mm film (microfilm or motion picture film), the film should be wound to an appropriate tightness (the tension created by a force of 0.3 Newton), but excessive tension should be avoided. Motion picture film reels longer than 150 meters should be stored flat. Shorter lengths

Acetate motion picture film stored in polyethylene cans.

Cellulose triacetate film bases depolymerize less quickly in a metal can than in a plastic can, but they acidify more quickly. In fact, laboratory studies show that in a plastic can acetic acid is absorbed by the plastic and partially reacts with it, resulting in a decrease in the acid level but an increase in the peroxide level. These molecules formed during chemical reactions promote breakage of the triacetate polymer. In a metal can, since acetic acid is not absorbed, the metal corrodes. However, peroxides are neutralized by the metal ions.

Collection Services, Archives du Film, Centre National de la Cinématographie, Paris. Photo: Jim Purcell.

may be stored vertically, provided that they are wound around a flanged core or a center spindle so as to avoid crushing the film. The reel core should be made of an inert material such as those recommended for boxes.

Types of containers The most common method of packaging motion picture film is in metal (tin-plate) or plastic (PP) cans. It is advisable to use enamel-coated metal cans or containers made of a stabilized, fire-retardant polymer, such as polyethylene, polypropylene, or polystyrene (ISO Standard 5466). Comparative studies have been done on the long-term effects of these two types of containers for film storage (Fig. 49).[19] However, at present, it is difficult to determine whether one is preferable to the other.

Evacuating contaminants A roll of motion picture film represents a large quantity of cellulose triacetate, so there is the potential for acetic acid accumulation inside the can and for accelerated degradation. Therefore, it is advisable to use containers that allow some degree of ventilation. It is always possible to make a 1 cm diameter opening in the bottom of the can.[20] The air in the storage room must also be exchanged regularly. To avoid dissemination of acid in the storage area, Kodak recommends inserting molecular sieves capable of neutralizing the decomposition by-products. Of course, it is necessary to use cans with a diameter large enough so that the film can be surrounded with a string of Tyvek pouches containing zeolite (see Fig. 44).

Degradation indicators Degradation indicators are tablets or pieces of filter paper impregnated with a reagent whose color changes in the presence of a few parts per million (ppm) of acetic acid. They are used to provide

Acidity indicators (A-D Strips) before and after 24 hours of exposure in contact with film. The change from blue to yellow reflects advanced deterioration of the base.

immediate information on the condition of the film or for ongoing monitoring.[21] The Image Permanence Institute has developed instant indicators (A-D Strips; Fig. 50) made of filter paper impregnated with a pH-sensitive dye (bromocresol green). A strip is placed in the film can for twenty-four hours (or longer, if the relative humidity and temperature in the storage area are low). The deterioration level of the base can be rated by comparing the resultant color of the indicator against a reference chart. Some cans (Dancan Danchek) are designed with a small window to allow the color of an indicator tablet to be viewed without opening the container and thereby to allow quick detection of reels that are decomposing on the shelf.

PROXIMITY MATERIALS (LEVEL II)

Selecting Materials

Evaluation methods

While the photographic activity test may be used on certain materials that come in contact with photographs, the Oddy test[22] provides valuable information on the potential for harmful emanations from construction materials. It is easy to use. A strip of polished metal (copper, lead, silver, etc.) and a fragment of the material to be tested are sealed in a tube at high relative humidity (80% to 100% RH). After two to four weeks at a fixed temperature between 30°C and 60°C, the extent of the corrosion layer formed by the test material on the surface of the metal strip indicates the harmfulness of the material. The results may be compared, visually or quantitatively (by weighing), to those obtained with a blank sample such as filter paper (Fig. 51).

Wood

In addition to being flammable, wood (solid, plywood, melamine laminate, etc.) produces emanations of peroxide, organic acids (acetic acid),[23] and other compounds such as the formaldehyde released by pine, particle board,[24] and lacquers. It should therefore be avoided for photographic preservation. Although laminated panels release less gas, emanations can occur through the edges.

FIGURE 51

Oddy test: the corrosiveness of materials is determined using metal coupons.

Metal

Metal components (anodized aluminum, quality stainless steel, enameled or painted metal) are recommended provided they are protected against corrosion. Painted metal, which is used widely, can cause problems. Paint-coated metal components are dried in an oven. If they are not baked long enough, solvents are left behind. Several institutions have reported ongoing noxious emanations.[25] For example, when the National Archives in Washington, D.C., found that a metal cabinet used for storing glass plate negatives was giving off a marked and persistent odor, it was returned to the manufacturer for another baking. A simple test that consists of vigorously rubbing the lacquered surface with a rag saturated with methyl ethyl ketone (a toxic solvent) can be performed; a pronounced trace of paint on the rag can be a sign of insufficient baking.

To eliminate such drawbacks, it is advisable to avoid solvent-based paints and choose an electrostatically applied powder coating instead. These coatings present no risk of emanations. Consisting of a powder containing approximately two-thirds binders (resin and hardeners) and one-third pigments, fillers, and additives, they are electrostatically sprayed onto the support. A film approximately 0.1 mm in thickness is formed by heat setting in an oven for about twenty minutes at 140°C to 180°C. The diversity of such paints resides in the choice of a binder. There are five types of binders: epoxy, polyester/epoxy, polyester/TGIC (triglycidyl isocyanurate), polyurethane, and acrylic. The first three are most frequently used in decorative furniture paint and do not seem to present any risk for photographic preservation.

Choosing a light-colored paint enables earlier detection of microorganisms, insects, rust spots, and blistered paint.

Furniture

A well-organized preservation space provides fast and safe access to objects. When choosing between open (shelves) and closed (cabinet) storage, take into account factors such as safety, dust, light, and microclimates. Structures should be chosen that are suited to the weight of the photographs they are intended to hold, particularly in the case of glass plate collections. If possible, provide tables for setting down artworks when they are handled and carts for moving them, if necessary. Wood furniture is not recommended for the aforesaid reasons. If it must be used for financial, aesthetic, or historical reasons, interior surfaces should be painted (with acrylic paint) or varnished and then ventilated for several months before storing photographs in them. Polyester or polyurethane varnish can considerably reduce harmful emanations.[26] However, in the long run, these bleed through, all the more quickly if the coat is thin or uneven. Applying a heat-activated film (PE/aluminum foil/Nylon) such as Marvelseal 360®, Marvelguard®, or Moistop 622® is more effective. The inner sides of cabinets and drawers can also be covered with board or cloth containing activated charcoal (charcoal cloth).[27]

Metal shelving units are the most widely used storage system for filing boxes of prints or negatives. They must be functional, safe for the photographs, and suited to the storage location. It is advisable to verify that objects placed on the racks of a shelving unit are secured at the rear and are not likely to fall

or cause objects on an adjacent shelving unit to fall. The units should not be placed directly against walls, so that air circulation can limit mold growth due to condensation or water runoff. In areas that are at risk, it is preferable to leave the lowest rack empty or to raise it so that the photographs may be spared in the event of a flood.

When justified by the size of the collection, a compact-shelving system may be used. This consists of mobile shelving units, mounted on rails, that can be placed against one another, saving considerable space. The units are moved by a motor or manually. The limitations of such a system are its cost and the floor load, which sometimes requires reinforcing the floor. Furthermore, with this system, the number of persons who may have simultaneous access to photographs is limited. The Canadian Centre for Architecture in Montreal opted for this solution, slightly modifying the structure of the side panels. Openings were made in the sides to allow air to circulate, even when the shelving units are "compacted." For the same reason, the architects of the U.S. National Archives building in College Park came up with a plan for automatically moving the compact-shelving system at night in order to aerate it. A similar "fire mode" plan spaces out the compact shelving in the area where a fire is detected to allow water sprayed by the sprinkler system to reach the fire.

Many institutions use metal filing cabinets for storing file folders and binders and metal cabinets with drawers for storing slides, microfiches, and microfilm. In the 1960s some of the microfiches at the Munich Archives in Germany were seriously damaged by plastic tile dividers.[28] File folders or dividers provided by the manufacturer should not be used unless they have been tested. The same applies to plastic gaskets around openings. If there are sliding elements, such as drawers, choose mechanisms mounted with Teflon rollers or stainless steel bearings rather than metal systems that require lubrication. When photographs are laid flat in a drawer, the drawer height should not exceed 5 cm, to avoid placing too much weight on the items at the bottom. When the storage room has an environment controlled for pollutants and relative humidity, it is best to use cabinets with openings for ventilation; otherwise, a microenvironment may be created inside the cabinet. Cabinets coated with thermosetting powder paint (see p. 59), such as those supplied by SpaceSaver, Interior, Delta Designs, and Hahn, are currently the most reliable. Monitor and repair any rust spots and blistered paint on metal furniture as they occur.

Creating a Microenvironment in Storage Furniture

Cabinets

Cabinets are enclosed spaces where protection may be adapted to the potential risks. Most are designed to be safe from theft, dust, and light. This spectrum may be extended to other types of risks, such as moisture, water, heat, fire, and pollution. For example, the U.S. National Archives has isolated its water-sensitive collodion negatives collection in waterproof cabinets to protect it from accidental immersion (Fig. 52). Fire-retardant cabinets are available for microfiches and electronic media. However, when using airtight cabinets, one must be vigilant for accumulations of harmful vapors

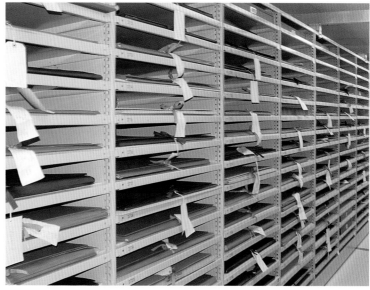

1

2

3

4

FIGURE 52

Photographic storage areas at various
institutions.
(1) Storage of collodion plates, National
Archives, College Park, Maryland
(2) Storage of prints at the J. Paul Getty
Museum, Los Angeles
(3) Glass negatives in the photographic
archives at the Ministry of Culture and
Communication, France
(4) Compact shelving at the J. Paul Getty
Museum, Los Angeles

and excessive relative humidity. Relative humidity can be regulated with
silica gel (Fig. 53), and pollutants can be adsorbed by activated charcoal or
molecular sieves.[29] These substances are placed in containers covered with
a gas-permeable (nonwoven) fabric to avoid the risk of disseminating
microparticles. ArtSorb silica gel, for example, is sold in 85-gram trays with
Gore-Tex lids.

Refrigerators and freezers

The life expectancy of unstable materials increases when the storage temper-
ature is lowered. For extensive holdings, appropriate cold storage vaults can
be built. For smaller collections, when the size of the photograph permits, a
domestic refrigerator or freezer may provide a solution.[30] These appliances
are simple to use, and their cost is relatively low. However, they have certain
limitations, since they can have moisture problems. Protecting photographs

Silica gel.

This is a highly hygroscopic compound that is colorless and fairly nonhazardous. Often cobalt chloride is added to it, which changes from blue to pink when the silica gel is saturated with humidity. Because cobalt chloride is dangerous to humans and the environment, it is advisable to use uncolored silica gel or silica gel with a nontoxic indicator. Silica gels are sold in granule form and should be placed in containers covered with a permeable material, such as Tyvek, to limit the dispersion of abrasive particles while providing the largest possible surface area. Silica gel is used in two types of applications, as a desiccating agent to eliminate humidity and as a buffering agent to stabilize humidity at a given level. In the former case, it is used after complete dehydration in an oven; in the latter case, after being conditioned to the desired humidity level. To be effective, the quantity of silica gel used should be proportional to the volume of the area to be treated, and the area should be sufficiently sealed. The weight of the gel to be used depends on its properties, the renewal rate of the air, the temperature and humidity conditions, and the storage time. Therefore, it is difficult to accurately specify the quantity of gel to be used per unit of volume. G. Thomson recommends using 20 kg of silica gel per cubic meter to be treated for a period of one year, but—once again— this value must be corrected depending on tightness of the area and the quality of the adsorbent used.[34] With the availability of improved products, such as ArtSorb®, it may be possible to considerably decrease the quantity.

in bags that are impermeable to water vapor—polyethylene may be appropriate for this application—seems essential, since this prevents surface condensation when they are removed to room temperature. Vapor-proof packaging also provides protection from the phenomena that may occur inside a refrigerator or freezer, such as fluctuating or excessive relative humidity, formation of frost on the surface of objects, or runoff of water in the event defrosting occurs during a power outage. H. Wilhelm recommends using frost-free refrigerators, and several North American institutions, such as the Museum of Modern Art, in New York, have adopted this storage method (Fig. 54).[31] In this type of refrigerator, air is cooled to −29°C in a separate compartment, and the fresh, dry air is blown into the refrigerator, where it heats to a temperature of approximately 2°C. This maintains the relative humidity at 20% to 30%.

For acetate- and nitrate-base films, some archives are using a domestic freezer to achieve lower storage temperatures. To prevent excessive relative humidity, T. Padfield and J. Johnsen suggest placing an insulating box, whose temperature is maintained at −8°C by heating resistors, inside the freezer. This provides a relative humidity of 44% in the box, even though it may be 100% in the freezer.[32] M. McCormick-Goodhart suggests controlling relative humidity with an adsorbent material, such as silica gel or sheets of cardboard. The photographs are placed in a cardboard box, which is enclosed in a polyethylene bag. The bag is then placed in a second polyethylene bag containing a buffer material and a colored relative humidity indicator (Fig. 55).[33] The sheets of cardboard are first dried for a few minutes in an oven at 100°C. When inserted into the bag, these regulate the relative humidity inside it. It is then possible to check whether the relative humidity is excessive at any time by viewing the color of the relative humidity indicator through the bag. Using a freezer with a glass door facilitates verification. The relative humidity inside the bags should remain at an acceptable level for some fifteen years, since PE's permeability to water vapor is very low at low temperatures. It is necessary

FIGURE 54

The use of a refrigerator for preserving color photographs.

to allow several hours before opening the bags (see p. 97) once they are removed from the freezer.

For acetate- or nitrate-base slides and negatives, storage at such low temperatures should entail no risk of acid vapor formation. However, for nitrate film, it is advisable to choose spark-proof freezers.

FIGURE 55

Storage of color slides and photographs on a cellulose nitrate base in a freezer, using the method recommended by M. McCormick-Goodhart.

Photo by M. McCormick-Goodhart

STORAGE FACILITIES (LEVEL III)

Storage facilities play an essential role in preserving artworks and documents by protecting them from unfavorable climatic conditions. A well-designed storeroom layout reduces collection maintenance costs, and a larger initial investment (e.g., to improve insulation) can result in lower operating costs.

It is not the purpose of this chapter to rehash all of the recommendations relative to the topographic location, construction, and equipping of a storage facility, which may be found in other specialized reference works.[35] Instead, a few basic principles will be reviewed and the essential factors that determine the quality of a storage facility will be emphasized.

Designing a Storage Facility

If you have only a small collection of family photographs, you may be content to conserve them in a cool, dry place. However, if resources allow, you should endeavor to comply with the stricter instructions found in the remainder of this section.

Managing a sizable photographic collection requires an appropriate and spacious facility that should reflect certain safety and organizational criteria (Fig. 56). Before moving a collection into a recently constructed or renovated facility, allow a monitoring period of several months, so that paints and adhesives will have time to dry and the moisture and volatile products released by construction materials will have time to dissipate. Also, verify that the temperature and relative humidity conditions indicated in the construction specifications have been met. Unfortunately, construction delays and material or political imperatives often mean sacrificing this period, at the expense of the collections, which then bear the brunt of a bumpy startup.

Choosing a location

The collection storage area should be separate from the working or viewing room, but for practical considerations, these areas should not be far apart. If the collection is very large and composed of different types of photographs (e.g., prints, negatives, and microfilms), it is best to group them by category and archive them in separate compartments. Sufficient space should be allowed for handling large-format photographs without jeopardizing them. However, a compartment's surface area should not exceed 200 m². Access through an airlock limits air exchanges when entering and exiting, and doors equipped with piston closures close automatically. Areas containing valuable works should be protected with an anti-intrusion security system (motion detectors and door and window alarms), an access control system, and possibly a procedure for monitoring the removal and return of the artworks.

The ceiling should be at least 2.6 meters high. Suspended ceilings, which are difficult to access for cleaning and invite infestation, should be avoided.

The area should preferably be above the ground floor, located in the center of the building or facing north (in the Northern Hemisphere), to avoid temperature variations. It should face a courtyard rather than a street. Heavy traffic can cause pollution and constant vibrations that may have deleterious effects on the photographs and their housings.

FIGURE 56

View of the former autochrome archive room at
the Albert Kahn Museum, Boulogne-Billancourt,
Hauts-de-Seine, France. A collection storage
system can be of historical interest. The Albert
Kahn Museum has endeavored to preserve the
appearance of the autochrome plate archive
room. The autochrome plates have been
transferred to a new storage area designed
for long-term preservation.

© Photograph by J.-P. Gandolfo, Albert Kahn Museum,
Boulogne-Billancourt, Hauts-de-Seine, France

Pipes containing fluid or vapor should not pass through the storage area. These can heat the atmosphere when they contain hot water or vapor and cause condensation when they contain cold water. In the event of a leak or rupture, they can seriously damage collections. If pipes cannot be eliminated, they should be heat insulated. Verify that the collections will be out of reach in the event of a rupture, and provide a floor outlet or drain. Prevent potential leaks from above by using waterproof flooring.

Because of space constraints, storage is often relegated to undesirable areas such as attics and basements. Storing a collection in a basement has the advantage of temperature stability. First, make sure the environment is safe (eradicate microorganisms and insects, verify that there is no water leaching, etc.), protected from flooding (pipes, leaks from above), and noxious emanations (sewer

Figure 57

The climate control system of the new autochrome storage room at the Albert Kahn Museum.

© *Photograph by Jean-Paul Gandolfo*

TABLE 15

Some materials contraindicated or
recommended for preserving and
storing photographs.

Type	Not Recommended	Recommended
cellulose materials	paper of unknown composition, containing products capable of migrating or damaging images	archive-quality paper and cardboard*
polymers	• cellulose acetate • cellulose nitrate • polyvinyl acetate • poly(vinyl chloride)/PVC • vulcanized rubber (rubber bands) • plastic materials of unknown composition • polymers containing chlorine • polymers containing plasticizers	• polyester* • polyethylene* • polypropylene* • extruded polystyrene* • poly(tetrafluoroethylene)* • poly(methyl methacrylate)* (Plexiglas) • polycarbonate* • ABS*
foam	PVC foam polyurethane foam	polyethylene foam* polypropylene foam*
furniture	wood: solid, particleboard, plywood, etc.	metal with baked-on enamel, anodized aluminum, stainless steel
floor coverings	carpet, parquet, particleboard, PVC tiles, porous and friable stone	semi-stoneware, stoneware, two-component epoxy resin
paint	organic solvent paint alkyd resin	acrylic paint vinyl paint acrylic emulsion
varnish	polyurethane cellulose nitrate	acrylic

* Each category and each batch of these materials should be checked for suitability according to ISO Standard 14523 and ISO Standard 10214.

gases). The relative humidity should be controllable. The air exchange in the room should occur naturally, or, if insufficient, an exhaust fan should be used.

By their very nature, attics are the least propitious locations for proper storage. Even when insulated, they are subject to great temperature and relative humidity variations. Therefore, they require not only effective insulation but also good temperature and relative humidity control (Fig. 57).

Floor and wall coverings

It is inadvisable to leave walls and floors bare. Plaster and concrete can crumble and fill the atmosphere with corrosive alkaline dust. Concrete floors should be tiled or covered with an epoxy-type resin. Semi-stoneware or stoneware tiles are preferable to natural stone (e.g., marble, slate, limestone) and terracotta tiles, since they are hardier, less porous, and easy to maintain. Before painting, clean concrete walls with a trisodium phosphate solution.[36] The emanations from certain alkyd paints are known to be corrosive to silver images. Therefore, when collections are already on-site, it is preferable to use vinyl, acrylic, or latex paint on walls (Table 15).[37] Before moving a collection into a freshly painted area, proper ventilation needs to be provided. The standards

recommend waiting three months for organic solvent-based paints. By then, no odor should be detectable (note that an absence of odor does not mean that the air is safe for the collection).

Climate-controlled rooms with low temperature and relative humidity often have metal walls or contain a layer of polyethylene film that keeps water vapor from passing through walls.

Lighting

In storage areas, it is not necessary to systematically use light levels as low as those that are recommended for exhibition. On the contrary, light that is too weak can lead to accidents when transporting or handling objects. In addition, it is less easy to perform maintenance on the area and there is a potential for missing an infiltration problem or microorganism growth. For these reasons, it is preferable to opt for light-colored wall and floor coverings. If all of the artworks are shielded from light in packaging, jackets, or boxes, it is possible to use light levels of 100 to 300 lux. Fluorescent tubes are frequently used, since they do not give off much heat and consume less energy than incandescent bulbs. In cases in which the artworks are not shielded (e.g., large formats, bound albums, portfolios), the intensity of the lighting in the storage room should be limited. The lighting system may be remotely controlled by a motion detector.

Environmental Engineering

Thermal insulation

The room should be properly thermally insulated in order to avoid temperature fluctuations and condensation on cold surfaces, and airtight to reduce air infiltration. Some archive buildings, such as those in Coblenz and Schleswig-Holstein, Germany, have been designed with brick walls from 49 to 86 cm thick, which provides excellent temperature and relative humidity regulation. Proper orientation, insulation, and air-tightness reduce air-conditioning costs. Windows are not essential. On the contrary, if there are existing windows, they should be properly thermally insulated (double panes or double windows). Be sure that the light-blocking system (shutters, curtains, etc.) is working correctly. Heat from sunlight may be reduced by 35% with curtains or venetian blinds on the inside and by 75% if protection is placed on the outside. Moisture in the walls accelerates heat exchange, since water is twice as conductive as air (Table 16).

Water vapor retarder

Entry of air, whether intentional (aeration) or unintentional (openings that are not airtight) interferes with the relative humidity conditions in a room (Fig. 58). Other factors can also influence ambient relative humidity (Table 17). In older buildings, the infrastructures are composed of a significant mass of extremely hygroscopic materials (wood, plaster, brick, limestone, etc.), which provide a degree of relative humidity stability by absorbing or releasing water vapor.[38] This has the advantage of naturally regulating the relative humidity in storage areas where there is no climate control. But natural humidification may be excessive in regard to preservation requirements for photographs. Moisture can also

TABLE 16

Sources of heat exchange.

Method of Propagation	Source	Remedy
convection	air infiltration	improve air-tightness
	ventilating	heat exchanger
conduction	poor insulation of surfaces (walls, floors, ceilings), heat bridges	improve insulation
radiation	heating/human presence	regulation (HVAC)
	windows exposed to sun	protect openings (shutters, curtains)

migrate, through capillarity, from the foundations or facade into porous materials when it rains and evaporate inside the building. In modern buildings, there is less material mass. Since the walls are relatively thin, extensive fluctuations may occur. In summer, moisture diffuses through the walls from the outside and humidifies the interior; in winter, the reverse phenomenon occurs, dehydrating the interior (see Table 17).

Therefore, when building a preservation facility, one should give priority to thermal insulation and preventing water vapor infiltration or moisture diffusion, to stabilize ambient conditions and prevent condensation from forming on or inside walls whose temperature may be lower than the dew point (the temperature at which the water vapor in the air condenses). Moisture transfer can be limited by using floor and wall coverings, such as polyethylene film or waterproof paint, that have low permeability to water vapor. These coverings, or vapor barriers, reduce air-conditioning usage.

Ventilation

The ventilation system should provide uniform air exchange and circulation. Stagnant air promotes an accumulation of emanations that are harmful to both collection material and personnel. It has been reported that low but constant ventilation can also limit microbiological infestations, but no clear explanation has been given for this phenomenon. Either it reduces or prevents the settling of spores, or it dissipates microclimates around highly hygroscopic materials (see p. 133).[39] Studies are in progress to determine the optimal air speed for preventing microbiological growth. Recent publications indicate that a rate of 0.2 to 0.5 air change per hour (ACH) can arrest microbial activities if the ventilation is sustained for more than forty-eight hours.[40]

Ventilation will occur naturally if a low aperture and a high aperture are created in the facade. The difference in pressure caused by wind and the indoor/outdoor temperature differential create movement and renew the air. This air exchange is not controllable, since it depends on atmospheric conditions. If the properties of the incoming air (temperature, relative humidity, pollution) are very different from the desired conditions, this may interfere with the stability of the environment in the facility.

FIGURE 58

Photographs are composed of
hygroscopic materials that react
to changes in humidity.

When the air is dry, the print rolls up.

Source of variations in humidity.

Method	Source	Remedy
diffusion of water vapor	diffusion of humid air through surfaces (walls, floors, ceilings, and cracks)	moisture barrier
	bringing in materials with a high moisture content	
infiltration of water vapor	infiltration of air through openings and poor seals	insulation, slight overpressure
condensation-evaporation	human presence	regulation, climate control
	condensation on cold surfaces, water leak, evaporation from humid surfaces, capillary action of water	retrofitting

In this case, a mechanical ventilation system can be used which expels or draws in air. Some models have a heat recovery system with optional filtration and recirculation. Other devices force the air through damp blotter paper, producing filtered, cooled air through water evaporation, at a lower cost. In this case, relative humidity and biological contamination need to be monitored.

Climate control

Buildings that naturally have optimal climatic conditions for archiving photographs are rare indeed. The air in an archive storeroom must often be treated, that is, heated, cooled, humidified, dehumidified, purified, and/or circulated (Fig. 59). While temperature control systems are intended to cool and heat the air and, to some degree, control its relative humidity and filter it, climate control (air-conditioning) systems must further provide stable temperature and relative humidity, air ventilation, circulation, and filtration to meet specifications that vary depending on the types of materials stored. Recent constructions have different zones, with conditions customized for each of the collections they house. For example, the National Archives of Canada in Gatineau has eight zones, each of which has a specific environment, including cold storage vaults.

Installing a climate control system is not a decision to be made lightly. At first glance, this may seem to solve a great number of problems, but it is necessary to examine its long-term impact on the budget and evaluate the potential dangers if it malfunctions. Theoretically, it is easy to maintain an ideal environment with a climate control system. In practice, in some buildings, the temperature and relative humidity variations in rooms equipped with a climate control system are of the same magnitude as in those that are not.[41] Admittedly, these observations are based on sites that are frequented by the public and therefore experience traffic, leading to exchanges that may sometimes be intense, which is not the case with a storage vault. Furthermore, it sometimes seems difficult to achieve even temperature and relative humidity conditions.[42] However, experience should make us pragmatic and realistic. In the long run, a poorly designed or defective system has the potential to do

Air treatment.

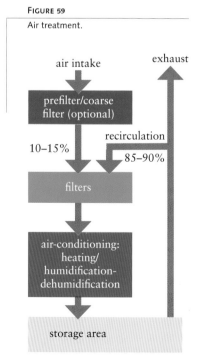

more harm than imperfect but stable natural conditions. The impact of the climate of a specific storage room on the life expectancy of the collection can be extrapolated and compared to other storage environments by using the Permanence Index and Time-Weighted Preservation Index (see p. 120 and http://www.climatnotebook.org).

Climate control systems represent significant expenditures with respect to initial investment, operation, and maintenance, since they must be in constant operation. They take up a good deal of room, which presents a problem if there is limited space available or if it would compromise the historic character of the building in which the collection is housed. Some systems currently in operation were designed during periods of economic abundance and may attach little importance to energy consumption. The life expectancy of an installation is some twenty years.

The difficulty of controlling technical and financial problems causes some people to question the very principle of climate control. Some have a tendency to prefer low-cost devices that consume less energy[43] and new emerging technologies.[44] Some feel that seasonal temperature variations are permissible, for example, in a temperate climate (18°C in winter and 22°C in summer). Still others take advantage of favorable natural conditions and phenomena (ventilation, orientation, etc.) or create microenvironments that may not provide ideal conditions in a small space but at least avoid the worst. It is in that spirit that the American Society of Heating Refrigeration and Ventilation Engineers (ASHRAE) recommendations (Applications Handbook 1999) suggest five levels: AA, A, B, C, D. The strictest are AA and A, whereas levels B and C allow more extensive fluctuations.

Going too far in the opposite direction and rejecting all types of air treatment is not desirable. In some cases, photographic collections require storage conditions that are impossible to achieve naturally, even in temperate climates. Furthermore, we can now benefit from many innovations and improvements, such as thermal insulation and recirculation of tainted air through filtration and purification, which provide significant cost savings. There is no universally applicable model of an installation for maintaining a storage area at predefined conditions. In a building, a year-round climate analysis can determine whether the air needs treatment and, if so, the level of treatment required. Specialists can conduct an evaluation based on the extremes of temperature and relative humidity,[45] the building's infrastructure, the limitations involved in a historic building, the amount of space and traffic, heat loss, the nature of the collections, and so on. Computer simulation programs can evaluate the cost of different options.

There are various systems for heating and cooling facilities. Some use a circulating fluid, such as water, while others force treated air through ventilation ducts. The latter are most often recommended for collections. There are small HVAC units that regulate relative humidity and temperature. A separate or appurtenant device can purify an atmosphere that is overly laden with pollutants (see p. 104). To prevent the entry of pollutant gases and dust when one enters the facility, the storage area may be slightly pressurized (1 to 2 pascals) with purified air.

The air should be exchanged regularly, partially through a fresh air supply (10% to 15%) to limit the accumulation of carbon dioxide but primarily

Ceiling Height	Volume/Hour in an Area with Human Traffic	Volume/Hour in an Area without Human Traffic
under 3 m	8	4
4 to 5 m	6	3
6 to 8 m	4	2

by recycling exhaust air, which saves energy. For occupied areas (offices), American regulations require a minimum flow of 8 liters per second per person. For storage areas, the hourly rate depends on the ceiling height and amount of traffic, but a rate of at least two air exchanges in the empty area every hour is acceptable (Table 18). At the U.S. National Archives, a rate of six times an hour is used. The air exhausted from the diffusers should not deviate from the selected temperature and relative humidity conditions by more than ±1°C and ±3% RH. The movement of air inside the entire storage facility should be at least 0.01 meter per second.[46] Ventilation outlets should be far enough from the collections so that they will not create drafts on the surface of the stored objects. Air diffusers mix the treated air with the air of the facility. The temperature and relative humidity conditions are constantly recorded and regulated. Thermohygrographs, thermostats, and humidistats should be placed in the environment closest to the collections, away from sources of heat and moisture, and should be calibrated periodically.

When a centralized climate control system is not a feasible solution, individual, independent units dedicated to one area, which are very flexible, should be used. Here again, water vapor and thermal insulation of the area must be controlled and reinforced, if necessary.

Fire Prevention

In the past, film and motion picture film archives have been severely damaged by fire. They have long been more vulnerable than any other type of archive because of the nature of the stored materials, particularly cellulose nitrate bases. Acetate film catches fire after twelve minutes at 300°C, whereas nitrate film ignites at that temperature in seven seconds.[47] The rate of combustion of cellulose nitrate is fifteen times greater than that of wood, and it is difficult to extinguish cellulose nitrate film fires. Spraying water is the only effective method. Cellulose nitrate sheet film as well as cellulose nitrate motion picture film should be isolated in a suitable storage area under tighter protection with automatic sprinklers (Fig. 60).[48]

Such bases are no longer manufactured. Today, the recommendations for contemporary photographic archives are similar to those for archives and libraries.[49] The stored materials are relatively similar. Among others, these include cellulose- and polymer-based documents, which are highly flammable.

There are various sources of fire, for example, arson, poor maintenance or overloading of electrical circuits, and smoking. The risk of fire and the extent

Preservation of nitrate motion picture
films in safety storage at the Film
Archives in Bois-d'Arcy, Yvelines, France.
Archives du film, CNC, Paris. Photo: Jim Purcell

of its spread can be reduced if preventive measures are taken. Noncombustible construction materials should be selected for new construction. Storage areas should be limited in size and separated by fire barrier walls and fire doors. Plaster, brick, and concrete are relatively flame resistant. Metal, however, is not. In a storeroom, heat may deform metal shelves and spill their contents. More serious still, the weakening of metal beams and joists causes buildings to collapse. Fire is spread by finishing materials (wall coverings and paint), dust, and insulating materials. Certain storage items, such as corrugated cardboard, catch fire more rapidly than do compact materials, such as thick laminated board.

Maintenance of storage areas, electrical circuits, and fire detection systems and regular inspection of extinction devices are essential. The severity of the damage depends on how quickly the fire is detected and the alarm sounded, how long it takes to respond, and the extinguishing methods used.

Therefore, the quality of the fire prevention and response system and the existence of an emergency plan are of primary importance.

The design of a fire system should focus on six components:[50]

- independent power supply for other systems, including alarm transmission (e.g., generators, storage batteries)
- detection system
- warning and alarm system for notifying occupants
- extinguishing system
- automatic control system (e.g., to close fire doors, to shut down elevators and air conditioners)
- alarm system for rescue response agencies and fire department

Fire detection systems

There are several different types of fire detectors: smoke, flame, and heat detectors (Table 19). Smoke detectors are the most sensitive and detect the initial stage of a fire, when materials are being consumed without flames and it is not giving off much heat. Flame detectors react when fire is at a more advanced stage. Heat detectors react belatedly, when the temperature is sufficiently high (thermal lag). These detectors, which are generally placed on the ceiling away from walls, may be used in combination, that is, a smoke detector and a flame or heat detector. Most detectors are small devices. Some come in the form of a cable or tube, several meters long, placed on a wall or ceiling. The system is often connected to an audible or visible alarm. When a fire is detected, it also transmits the alarm to an outside alarm company, fire department, or emergency service. It may trigger an automatic extinguishing system.

TABLE 19

Types of fire detectors.

Family	Type	Detection Principle
smoke detectors	ionization	change in conductance of ionized air
	light diffusion photoelectric	detection of light diffusion by smoke
	cloud chamber	formation of a cloud by water condensing on smoke
	light attenuation photoelectric	decrease in light intensity due to smoke
gas detectors	semiconductor	change of semiconductor conductivity
	catalytic	oxidation of gas by a catalyst
flame detectors	infrared	cell sensitive to infrared radiation
	ultraviolet	cell sensitive to ultraviolet radiation
heat detectors	fuse link	fusion of a metal or insulating material
	bimetal	curving of a bimetallic strip
	metal	dilatation of a metal
	pneumatic	dilatation of a gas
	semiconductor	change in resistivity

TABLE 20

Extinguishing agents.

Type	Compound	Method of Action	Advantage	Disadvantage
solid	powders and foams	reaction inhibitor, smothering	harmless to humans	residues, unknown action on photographs
liquid	water (+ additives)	cooling, flushing, smothering	inexpensive	damages photographs and facilities
gas	hydrocarbons, halogens	reaction inhibitor, smothering	harmless to humans and photographs	expensive, CFCs are illegal
gas	carbon dioxide	smothering, cooling, flushing	harmless to photographs	asphyxiant at concentrations greater than 9%
gas	inert gases (Inergen®)	smothering	harmless to humans and photographs	expensive, requires large space for storage

Extinguishing agents

Fire spreads as a result of a chain reaction that requires a combustible material (fuel), oxygen (oxidizer), and a source of ignition. To extinguish a fire, one of these three components must be eliminated. In this case, the combustible material is the collection to be protected. Therefore, one thing that can be done is to reduce the percentage of oxygen by removing or diluting it. Below 15% oxygen (air contains 21%), combustion stops. That is why the technique of "flooding" areas with a gas was developed. The second principle for fire extinction consists of energy absorption. Water is the most usual method, but certain chemical products (gases and powders) are just as effective. The latter harness energy through a chemical reaction, thereby breaking the chain reaction (Table 20).

When used in a gas flooding technique, these agents[51] do not constitute a great hazard to collections, but they present the danger of asphyxia to humans. Therefore, they are reserved for locations that are not open to the public, such as storerooms. Extinguishing a fire with liquids or solids is effective and not hazardous to humans but often damages collections.

Water As it cools burning materials, water absorbs heat and vaporizes. The water vapor that is formed displaces an equivalent quantity of air, and the oxygen deficit promotes fire extinction.

Water is an excellent extinguishing agent, and few other compounds possess all of its qualities. It is low in cost, it is easily accessible (in temperate climates), and it is not hazardous to humans. But it also has potentially dangerous effects. When released in enormous quantities in an uncontrolled manner by fire hoses or automatic sprinkler systems, water does not simply extinguish the fire but also floods locations that have not been affected by the

FIGURE 61

Automatic CO_2 fire extinguisher system
at the French National Patent Institute.

fire and, consequently, the collections that are stored in them. It is possible to
limit these drawbacks by reducing the quantity of water dispersed by an auto-
matic sprinkler system. Generally, a smoke detector triggers an alarm that alerts
a security guard, who evaluates the situation and possibly attempts to extin-
guish the nascent fire. If, despite this, the fire spreads, water is automatically
sprayed above the source of the fire.[52] The most recent and promising tech-
niques use water mist or Hi-Fog. Systems of this type are described below. To
increase the extinguishing capacity of water, wetting agents, surfactants,
emulsifiers (foaming agents), and fire retardants are sometimes added.
Although these compounds are generally intended for use in mobile, water-
spraying extinction units, they may be injected into automatic systems by a
pump. They are not recommended for use in museums because of the residue
they can leave behind.

Carbon dioxide For manual use in portable extinguishers, carbon dioxide
(CO_2) is a gas that is primarily intended to extinguish fires in combustible
liquids, gases, and electrical circuits. To protect sensitive sites, such as com-
puter archives, museum storerooms, and other types of archives (Fig. 61), when
an alarm is triggered, automatic extinguishing systems flood the area with an
atmosphere of 30% to 35% carbon dioxide. Carbon dioxide acts by smoth-
ering and also absorbs a portion of the heat. Its cooling capability is superior
to that of inert gases (nitrogen, helium, argon, etc.). This is amplified by the
temperature drop that is caused as the gas decompresses. However, its cool-
ing capacity is still inferior to that of water. Carbon dioxide does not have a
deleterious effect on photographs, but at concentrations greater than 9%, it
causes choking followed by asphyxiation in humans. Therefore, personnel
must be evacuated before it can be used. In automatically triggered systems,
automatic extinction procedures are designed to avoid accidents involving per-
sonnel. Gas discharge is preceded by a lag period, with audible and visible

alarms. Nevertheless, fear that the system will be triggered at the wrong time has created a feeling of insecurity[53] and has prevented the widespread use of this type of system.

Halogenated hydrocarbons Halons are gases obtained by halogenating hydrocarbons. One or more hydrogen atoms are replaced by chlorine, fluorine, or bromine. Halons have long been recommended for extinguishing fires in areas containing water-sensitive objects (computer hardware, electronics, artworks). Because they are reaction inhibitors that absorb combustion energy, they are more effective than carbon dioxide and inert gases. They are relatively costly extinguishing agents and are especially used in automatic extinguishing systems.

An atmospheric content of 4% to 6% halons will extinguish a fire. The human body can safely tolerate concentrations of up to 7% for some fifteen minutes. Halons are not harmful to stored objects (however, when the gas comes in contact with white-glow heated metals, this may lead to the formation of hydrofluoric or hydrobromic acid).

Halon 1301 (bromotrifluoromethane), one of the most effective and least toxic halons, is in widespread use, both in portable extinguishers and automatic systems. The Canadian Centre for Architecture, the Historic New Orleans Collection, and numerous museums and archives have been equipped with Halon 1301 extinguishing systems. Under the Montreal Protocol on Substances That Deplete the Ozone Layer (see p. 140), this gas has not been manufactured since 1994, but recycled halon will be available until 2005. Great Lakes Chemical has introduced a substitute that is less harmful to the environment, FM 200, or HFC 227EA (1,1,1,2,3,3,3-heptafluoropropane). It is more costly than Halon 1301 and must be used in higher concentrations, on the order of 8% (volume/volume), which means storing a quantity 1.7 times greater.[54] It is not hazardous to humans at a concentration of 9%. Like Halon 1301, it breaks down at high temperatures, generating corrosive by-products. Other substitutes, such as Halotron (2,2-dichloro-1,1,1-trifluoroethane) and HCFC-123 have also been suggested.

Inert gases Inert gases such as helium, nitrogen, and argon are used as extinguishing agents since they prevent combustion through smothering, by absorbing a portion of the heat that is given off. To replace halons and carbon dioxide, the Mather & Platt company has developed a gas, called Inergen®, composed of a mixture of nitrogen (52%), argon (40%), and carbon dioxide (8%) (Table 21).[55]

These gases are used in automatic extinguishing systems. When a fire breaks out, the area is flooded with an amount of gas equal to 40% to 50% of the volume of the area, which means storing a large quantity of gas.

Inergen® gas is safe for the environment and artworks. Its low toxicity is an additional benefit. In fact, the small quantity of carbon dioxide added to the mixture stimulates the respiratory tract, thereby compensating for the oxygen deficiency. The major drawback of Inergen® is its cost and the large volume of the gas that must be stored.

Powders and foams Powders are made with potassium bicarbonate, sodium bicarbonate, potassium carbamate (urea potassium bicarbonate), ammonium

TABLE 21

Composition of air before and after
using Inergen®.

Component	Composition of Air	Composition of Inergen®	Composition of Air after Injecting 40% Inergen®
oxygen	21.00%	0%	12.6%
nitrogen	78.07%	52%	67.7%
carbon dioxide	0.03%	8%	3.3%
argon	0.10%	40%	16.0%

sulfate, potassium chloride, or ammonium phosphate, mixed with several additives to prevent the powder from caking when stored. The compounds are selected based on the category of fire (combustion of solids, liquids, or gases). These powders act by isolating the combustible material from the oxygen in the air and by chemically inhibiting combustion. They are most commonly used in portable extinguishers. While such powders are less harmful to collections than water, they leave behind powdery deposits or sticky residues that can be difficult to remove, some of which may be abrasive or corrosive (e.g., ammonium phosphate breaks down into metaphosphoric acid). Foams used to extinguish fires may be protein based or synthetic. "Physical" foam extinguishers hold an aqueous solution containing 6% to 30% emulsifier. When it is released, air causes the solution to expand up to 1,000 times its original volume, depending on the type of foaming agent used.

Automatic fire suppression systems

Automatic extinguishing systems, connected to a fire detection and alarm system, are intended to protect sensitive areas without human intervention. There are systems that use water, halogenated hydrocarbons, carbon dioxide, or Inergen®. The use of a gas-based automatic extinguishing system is reserved for small-volume enclosed areas (less than 1,400 cubic meters). This requires the immediate shutdown of ventilation and air-conditioning systems since the fire will break out again if oxygen suddenly enters the area.

No doubt because of budgetary considerations and the volume of the spaces to be protected, most systems use water. Sprinklers, which are nozzles affixed to the ceiling, are supplied by pipes. In *wet-pipe automatic sprinkler systems*, the heat thrown off by the fire melts or explodes a cap that seals the closest sprinkler, which then deluges the space with pressurized water. While this technique is commonly used in high-occupancy locations, it is feared that untimely triggering may flood collections in storage areas. Today, this fear is mostly unfounded, since modern systems are increasingly reliable. The U.S. National Archives chose this system in its new construction at College Park. *Dry-pipe automatic sprinkler systems* have been developed in which pressurized air or nitrogen, rather than water, is placed in the pipes. If a fire breaks out, the sprinkler operates, the gas escapes, and the low pressure trips an upstream valve, allowing water into the pipes and propelling it to the source of the fire. These dry-pipe systems are essential when there is a risk of freezing

and in low-temperature storage areas. But there is a lag time between the opening of the sprinkler and the arrival of the water, and when fire breaks out, the faster the reaction, the more effective it is. To reduce the lag time, *preaction automatic sprinkler systems* have been designed. The pipes contain air that may or may not be under pressure. In case of a fire, the smoke or the fire detector triggers an alarm and opens a valve that allows water to fill the pipes. The water remains inside them until heat causes the sprinkler head to open. When the temperature reaches a critical threshold, water is instantly released. This system was used to equip the new buildings of the French National Library. Its advantage is its rapidity, but once the sprinkler is open, there is no automatic water shutoff system.

That is why *preaction on-off automatic sprinkler systems* were developed. The principle is similar to the one just described, but, in addition, these systems include a temporary automatic water shutoff control that is activated when the heat decreases. Some experts have great reservations about such systems, which are costly to acquire and maintain. In addition, because of their complexity, the reliability of these systems can be an issue.[56]

Water mist projection systems are currently being developed. Their effectiveness is apparently equivalent to that of the usual sprinklers, even though they use a markedly smaller quantity of water. A fog of droplets not exceeding 400 microns is released at a pressure of 10 bar, at a rate of at least one liter of water per minute. In the future, such equipment will probably be competitive with standard water and gas systems. They represent a good compromise. The very small quantities of water used considerably limit the related problems and, unlike with gas, the area need not be sealed and evacuated. In addition, water mist "washes" ambient smoke from the air.[57]

TABLE 22

Mobile extinguishers.

Type	Extinguishing Agent	Advantage/Disadvantage	Class
solid (powder)	ammonium sulfate, monoammonium phosphate (blend)	multipurpose agent but residues	A, B, C
solid (powder)	potassium bicarbonate or carbamate or potassium chloride	effective but residues and corrosive powders	B, C
foam	expansion foam	foam less deleterious than water but less effective (re-ignites)	A, B
liquid	water	effective but damages documents	A
	AFFF (aqueous film forming foam)		A, B
gas	CO_2	no residues; less deleterious than water but less effective (re-ignites)	B, C
gas	Halon 1211	being phased out	—

Portable extinguishing devices

Regularly distributed throughout the areas to be protected, portable extinguishing devices allow personnel to act rapidly at the onset of a fire, thereby limiting its spread and avoiding triggering automatic fire suppression systems. Portable fire extinguishers may contain some of the extinguishing agents described above (Table 22). There are water, foam, powder, and carbon dioxide extinguishers. The choice of type depends on the category of fire to be extinguished (Table 23). Photographic archives fall in Class A.

Foam and carbon dioxide extinguishers have limited effectiveness on Class A fires. Powder extinguishers containing a mixture of ammonium sulfate and ammonium phosphate are versatile (Class A and B fires). These are recommended for collections of graphic documents.[58] These powders are not hazardous to personnel. However, they can sometimes cause mild choking and a loss of visibility due to excess powder suspended in the atmosphere. As mentioned above, the major drawback of powders, which may limit their use, is the presence of residues that may be corrosive. Therefore, water mist extinguishers are preferable.

TABLE 23

Fire classification.

Fire Class	Type of Fire
A	solid organic materials: wood, paper, cloth, rubber, plastics
B	combustible or flammable liquids
C	electrical
D	combustible metals: magnesium, sodium, potassium, etc.

Environment

Air quality, temperature, and relative humidity determine the life expectancy of photographs, and these factors often act in synergy. Fragile images may survive for many decades if preserved under strictly regulated relative humidity and temperature conditions. Even images considered among the most stable may be severely damaged if the atmosphere is too polluted or too humid.

RELATIVE HUMIDITY AND TEMPERATURE

The human comfort zone is 21°C to 25°C in summer and 18°C to 21°C in winter.[1] Figures for relative humidity are less well established. Depending on the author, they vary from 25% to 70% RH.[2] These differences illustrate our lack of sensitivity to ambient relative humidity and its variations, since a range of 30% is imperceptible. Our feeling of comfort is more closely linked to air speed, which is ideally between 0.10 and 0.25 meter per second. The "comfort zone" for objects (i.e., the conditions that do not promote their deterioration) is very different (Table 24), and it is difficult to establish recommendations appropriate to all collections. In the laboratory, we can understand and model the behavior of a material, but for actual objects, we must factor in many parameters linked to their complex structure, their history, the way in which they are assembled, their reaction speed, the damage caused by climatic changes, and the effects of short cycles of changing humidity and temperature.[3]

Factors affecting photographic
deterioration.

Factor	Cause	Sensitive Items	Type of Deterioration
humidity	• low humidity (<20%)	• cellulose acetate bases, paper prints, gelatin, albumin, glass negatives	• physical: desiccation, brittleness, breaking, deformation, delamination
	• high humidity (>50%)	• cellulose acetate and nitrate bases	• chemical: hydrolysis
		• silver image, residual chemical agents	• chemical: oxidation-reduction silver mirror, sulphiding, loss of transparency in glass
	• very high humidity (>70%)	• protein (gelatin, albumin), paper	• biological: microorganism growth
			• physical: softening and adhesion of gelatin
			• chemical: hydrolysis
temperature	• room temperature	• cellulose acetate and nitrate bases, chromogenic dyes	• chemical: hydrolysis, oxidation
	• variations in temperature and humidity	• paper prints, film, gelatin, albumin	• physical: condensation, differential expansion/contraction, deformation, desiccation, crazing
			• chemical: oxidation
pollutants	• oxidant gases	• silver image	• chemical: oxidation-reduction
	• dust	• plastic surfaces, film and prints	• physical: spots, abrasions, scratches
light	• visible	• dyes	• chemical: fading, yellowing
	• ultraviolet	• dyes, resin-coated paper	• chemical: fading, yellowing, oxidation stains, crazing
disasters	• fire	• all bases	• destruction
	• flood	• all bases	• deformation, dissolution, adhesion, migration, stains, delamination, microorganisms

Relative Humidity

Absolute, specific, and relative humidity of air

There are three units that define the quantity of water vapor in the air: specific humidity, absolute humidity, and relative humidity. Specific humidity is expressed in grams of water vapor per kilogram of dry air, absolute humidity in grams per cubic meter of air. Contrary to absolute humidity, specific humidity is not linked to variations in temperature, pressure, or volume (as long as there is no change in state, condensation, or evaporation).[4]

These values are not pertinent for the preservation of objects, since they do not indicate the level of saturation vapor of the air; the materials react to air saturation levels. Thus, at 25°C, 10 grams of water vapor per kilogram of air corresponds to air that is half saturated and at 14°C, to air that is totally

saturated. Therefore, it is preferable to use the concept of relative humidity, which is the ratio between the quantity of water vapor in the air and the maximum quantity of water vapor that the same volume of air could potentially contain at the same temperature. So relative humidity is a percentage; for example, 50% RH means that the air is half saturated with water vapor. Five categories can be established:

very low relative humidity	0% to 20% RH	very dry air
low relative humidity	20% to 40% RH	dry air
moderate relative humidity	40% to 60% RH	temperate air
high relative humidity	60% to 80% RH	humid air
very high relative humidity	80% to 100% RH	very humid air

The relative humidity of a vapor-tight enclosure changes with its temperature (Fig. 62). Any cooling results in an increase in the relative humidity level, and on excessive cooling, it reaches saturation level (100% RH). Then vapor condensation occurs, and fine droplets of water appear. The temperature at which this phenomenon occurs is called the dew point. In winter, water vapor frequently condenses on the inner side of windows whose temperature is lower than the dew point. The same phenomenon may occur when an object is removed from cold storage: condensation may occur on its surface.

Heating a location lowers its relative humidity level, provided it does not contain too large a quantity of hygroscopic materials, which act as "buffers," releasing or absorbing water vapor.

Adsorption of water vapor by materials and equilibrium moisture content

When the room temperature or relative humidity changes, organic materials react by taking on or giving off water vapor (Fig. 63). The rate of this process depends on the speed at which water diffuses into the material and the mass

FIGURE 62

Temperature and humidity variations in an exhibition gallery, recorded between May 4 and June 7, 1999, in Paris. Despite the air-conditioning system, there are daily temperature variations and fluctuations in humidity due to an inadequate climate control system and a design defect in the equipment.

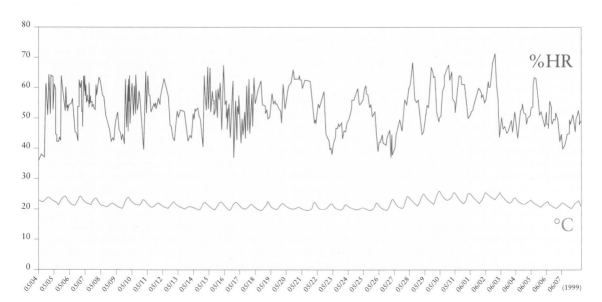

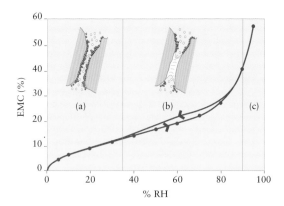

FIGURE 63

The various phases of water vapor adsorption.

When the moisture content curve for a substance is plotted as a function of the ambient relative humidity (sorption isotherm), the result is not a straight line but an S-shaped curve for which there are various explanations. According to Brunauer, Emmett, and Teller, a physical phenomenon appears in each part of the curve. Part (a) corresponds to the binding of a layer of water molecules (monomolecular or polymolecular layer). An increase in the humidity (Part b) results in capillary condensation in pores whose radius becomes increasingly larger (Table 25). Part (c) is the site of condensation in the larger pores or external surfaces. Furthermore, the sorption isotherm varies according to whether it is plotted from data obtained by increasing or decreasing the relative humidity. In other words, the EMC values for a given humidity level depend on prior condition. If two identical fiber-base photographs, one preserved in a dry attic and the other in a humid cellar, are placed together in a room at 50% RH, after equilibrium is reached, one will contain 6% moisture and the other 8%. This hysteresis phenomenon, which may be described as material "memory," has a physical explanation. The condensed water that occupies pores with a radius of 1.5 to 10 nanometers, which roughly corresponds to Part (b) on the curve, vaporizes at a humidity below the humidity at which it condensed.

of the object. We know from experience that not all materials react in the same way. Just to mention three extreme examples, paper and gelatin absorb much more water than polyester. At each relative humidity level, the maximum quantity of water taken on is called the equilibrium moisture content, or EMC. It is expressed as a percentage, in grams of water per 100 grams of dry material. At 40% RH, film on a cellulose triacetate base contains approximately 2% water by weight,[5] whereas for a paper print, this figure is on the order of 7% (Fig. 64). As the relative humidity in a storage area decreases, organic materials give off water vapor and their EMC decreases. As the temperature decreases, the EMC increases, since organic materials absorb water vapor from the storage area.

These phenomena may be observed in storage areas where a decrease in temperature results either in an increase in relative humidity or in a decrease if hygroscopic materials, such as wood, cellulose, or plaster, are present in sufficient quantity.[6]

Physical and chemical effects of relative humidity

The moisture content of materials has a direct effect on their properties. In a humid environment, the water contained in photographs increases and

FIGURE 64

Sorption isotherms of gelatin alone and of a photographic emulsion (gelatin + base).

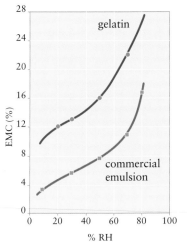

TABLE 25

Capillary condensation as a function of
relative humidity at 20°C.

Relative Humidity	35%	70%	80%	90%	97%	99.9%
radius of cylindrical pores (in nanometers) where water vapor condenses	1 nm	3 nm	4.8 nm	10 nm	35 nm	1,000 nm

certain materials expand. Cellulose and cellulose ester bases react more or less markedly to relative humidity variations, whereas polyester bases show little reaction. Gelatin is one of the most reactive components. It can absorb up to 20% of its weight in water vapor, depending on its degree of hardening and the room temperature. This is followed by extensive expansion, accompanied by softening and vulnerability to mold attacks if the relative humidity is maintained above 75%. Beyond a critical point, called glass transition, gelatin has a tendency to change to a gel state, promoting adherence and migration of chemical compounds, which results in deterioration of the silver image.[7]

Residual fixing salts are transformed into harmful compounds that corrode the silver image. Pollutants in the atmosphere become much more reactive, and unstable materials (poor-quality mounting boards, adhesives) generate much larger amounts of harmful products. Some components are especially subject to hydrolysis reactions. The dyes in color photographs fade and cellulose acetate bases break down (vinegar syndrome). Studies indicate that dyes deteriorate four times faster at 60% RH than at 15% RH. The life expectancy of cellulose triacetate bases can be tripled (at 21°C) by decreasing the relative humidity from 60% to 20%.[8] Simply stated, halving the relative humidity level doubles the life expectancy of these materials.

However, an atmosphere that is too dry should be avoided. Desiccation of materials leads to a loss of flexibility and curling, caused by the difference in contraction between the base and the image layer. Although reversible, such changes weaken photographs and, if the photographs are improperly handled

FIGURE 65

Delamination of the image layer on a color print and on a gelatin silver bromide glass plate negative.

or treated, may cause cracking and delamination (Fig. 65). Some types of bases, such as glass plates and Ilfochrome Classic prints,[9] may be irreparably damaged by too great a drop in the relative humidity level, and stresses created between the layers produce crackling and separation of the various layers. Repeated fluctuations in relative humidity expose photographs to premature mechanical degradation. Experiments show that after 150 cycles of 10% to 70% relative humidity, the emulsion develops microcracks.[10]

Acclimation

When the ambient relative humidity changes, acclimation of materials to the environment occurs very slowly, since water vapor must diffuse through enclosures and through the contained materials. The lower the temperature and the greater the mass and density, the longer this takes. Albums and reels of film become acclimated more slowly than individual items (Table 26). Acclimation of motion picture film may take several months.[11]

TABLE 26

Time to reach moisture equilibrium.*

Type	80% Balance	100% Balance
single filmstrip or film	30 minutes	90 minutes
16 mm roll	5 days	3 weeks
35 mm roll	1 week	4 weeks

* J. Pouradier, "Le traitement et la conservation des documents photographiques," Photo-revue, November 1976, 575–81.

Determining the right relative humidity

For the reasons discussed above, it is advisable not to exceed 50% RH. The standards tend to recommend a relative humidity between 20% and 30% for film on a cellulose triacetate base. However, this range may be extended to 50% RH if the temperature is lowered.[12] It is difficult to determine the relative humidity level for a mixed collection containing prints, film, and glass plates; as Table 27 shows, the recommended levels vary according to the base and the type of image, which may require grouping materials of the same type in separate compartments. But since it is not always possible or even desirable for practical or historical reasons to separate the items in a holding or a collection, 30% to 40% RH is appropriate for the majority of photographic records. For glass plate photographs and paper prints, especially those that are old and weak, one must watch for any detachment or deformation that may occur due to dry conditions or excessive fluctuations in temperature and relative humidity.

Stability of relative humidity

Pronounced relative humidity variations may occur from season to season. In winter, cool outdoor air does not contain much water vapor. When heated indoors, its relative humidity decreases. In summer, the reverse phenomenon occurs. The outdoor air is warm and has a higher water content. When it cools

to the temperature of a storage room, the relative humidity increases. Other factors, such as human presence, heating devices, and sunshine, can temporarily modify the characteristics of the air. Variations over a twenty-four-hour period may sometimes be significant. While it is advisable to limit such fluctuations, the standards relative to photographic records are not always explicit on this point. Variations over a brief period (less than one hour)[13] have little impact, since the water vapor scarcely has time to diffuse, and the effects inside enclosures are more attenuated. A study conducted by C. Shahani[14] at the U.S. Library of Congress indicates that a 20% variation in relative humidity over a two-hour period has practically no impact inside a book, whereas twenty-four-hour cycles have marked effects. These results can be applied to photographs and film stored in enclosures. Therefore, it is important to ensure that relative humidity conditions remain stable over long periods. The recommended variation thresholds are linked to the quality of the insulation and the climate control system. While under optimal conditions it is possible to achieve the ideal limits of ±2% or ±3%, it is more realistic and less costly not to exceed ±5% RH over a twenty-four-hour period, so as not to endanger collections.

Using modeling based on a study of the mechanical properties of materials, the Conservation Analytical Laboratory in Washington, D.C., has suggested relaxing these conditions and finds that a tolerance of ±15% RH is acceptable.[15] In fact, it is dangerous to generalize this requirement. The

TABLE 27

Recommended temperature and humidity conditions for indefinite preservation.

Image	Base	Process	Maximum Temperature	% RH*
black-and-white	glass plate	gelatin silver glass plate, collodion, albumin, etc.	18°C	30–40%
	paper	gelatin silver, carbon	18°C	30–50%
	nitrate film	gelatin silver	2°C	20–30%
	triacetate film	gelatin silver	7°C 5°C 2°C	20–30% 20–40% 20–50%
	polyester film	gelatin silver, thermal silver, vesicular	21°C	20–50%
color	paper	silver dye bleach (Cibachrome), imbibition (Dye-Transfer), diffusion transfer (Polaroid), pigment (Fresson, etc.), diazo	18°C	30–50%
	paper	chromogenic	2°C –3°C	30–40% 30–50%
	triacetate or polyester film	chromogenic, diazo	2°C –3°C –10°C	20–30% 20–40% 20–50%

* Relative humidity should be within this range.

TABLE 28

Fluctuations in relative humidity and associated risks for collections.

Deviation	Risk
±5% RH	none
±10% RH	minimal
±20% RH	slight
±40% RH	high

relative humidity range must be appropriate for the type of material, its nature and structure, as well as the acceptable level of risk. A scale of risks associated with various fluctuation levels has been published (Table 28).[16]

Dehumidification

Dehumidification is often necessary in areas located underground, where the temperature is both constant and low but where the relative humidity is often too high for storing a photographic collection. The causes of the excessive relative humidity should first be determined. If it is linked to infiltration of water or diffusion of moisture, it is desirable to first seal the area from the moisture. Reducing the relative humidity level by heating the area is not an option, since this would eliminate the benefits derived from cool storage. Putting desiccant compounds (silica gel, anhydrous calcium sulfate) in the storage area is not recommended. These are not very effective in large spaces, and their short-term action requires monitoring and onerous replenishment. Two types of dehumidifiers may be used—refrigerants and desiccant systems (Figs. 66, 67, 68; Table 29). Determine which is the most appropriate based on the water vapor tightness, the characteristics of the area, goals, and energy cost.[17] In a refrigerant system, the air is cooled in a refrigeration unit. When the temperature reaches the dew point some water condenses and is eliminated. Then the air is returned to the area after being reheated by the unit. There are commercially available self-contained dehumidifiers that are relatively inexpensive. The higher the air temperature, the better the performance of refrigerant dehumidifiers. If the air is cooler, they are less effective, and a dehumidifier that operates with desiccants should be chosen. The cut-off point for determining which type of dehumidifier to use is a dew point of 4.5°C (see Fig. 66). Desiccant dehumidifiers use silica gel or lithium chloride. Regardless of the type of desiccant used, it must be periodically replenished.

To maintain low relative humidity when the temperature is low, predehumidification by refrigeration may be combined with a desiccant system.

FIGURE 66

This curve makes it possible to determine the appropriate type of dehumidification system. The boundary is established based on air with a dew temperature of 4.5°C. To achieve the region recommended for preservation of photographs on a CTA base, it is necessary to treat the air using dehydrating compounds. Using a condensation dehumidifier system would be ineffective in a cold storage area.

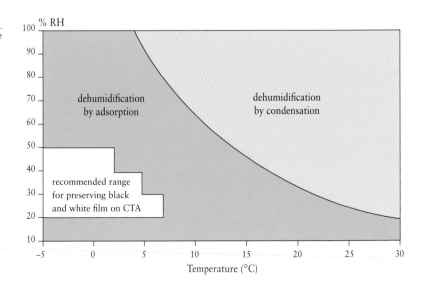

FIGURE 67

Structural diagram of
a desiccant dehumidifier.

Diagram: Munters

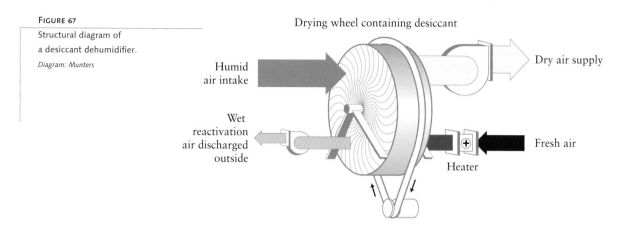

Drying wheel containing desiccant

Humid
air intake

Dry air supply

Wet
reactivation
air discharged
outside

Fresh air

Heater

Generally, such devices are incorporated into a climate control system. There
are also self-contained dehumidifiers. If these are used, they must be equipped
with a high-efficiency filter capable of filtering suspended particles with a diam-
eter greater than 0.3 micron.[18] Some U.S. photograph and motion picture film
archives use a desiccant wheel (Cargocaire Engineering Corporation and
Munters). The principle of the device is that the air passes through a cylinder
containing a honeycomb structure lined with a desiccant, such as lithium chlo-
ride, lithium fluoride, or silica gel. The air to be dried passes through only a
portion of the cylinder. Simultaneously, to reactivate the desiccant, hot air
(130°C) is blown into the remaining portion and then exhausted. The regu-
lar rotation of the cylinder provides constant renewal (see Fig. 67). The opti-
mal condition for preserving black-and-white film on cellulose ester bases is
in the relative humidity and temperature range most appropriate to the use
of desiccant wheels.[19]

FIGURE 68

Structural diagram of a refrigerant
dehumidifier.

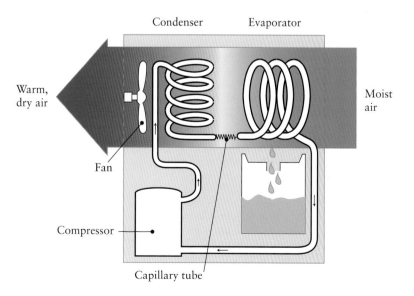

Condenser Evaporator

Warm,
dry air

Moist
air

Fan

Compressor

Capillary tube

TABLE 29

Dehumidification.

Type	Principle	Application	Cost
dehumidification by condensation	water vapor is condensed in a cooling system	ambient-temperature storage >18°C (dew temperature to 4.5°C)	low
dehumidification by desiccant wheel	adsorption of water by desiccant product in a rotary wheel; a portion is constantly regenerated by a current of warm air	low-temperature storage (dew temperature to –23°C)	moderate
	absorption of water by lithium chloride in a rotary wheel, as above	very low temperature storage (dew temperature to –48°C)	high

Humidification

In some modern buildings, the relative humidity level is very low in winter and handling photographic prints becomes problematic. In that case, the air must be humidified. Humidification with bowls of water or saline solution is dangerous and unsuited to large spaces. It is preferable to use devices designed for this purpose. There are three types. Humidification may be achieved by vapor produced by boiling water, nebulization (producing a cold water mist), or surface evaporation (Table 30). Such devices require monitoring and should be used with caution. With the two latter types of humidifiers, there is a poten-

TABLE 30

Portable humidifiers.

Type	Device Principle	Features
nebulization	production of water microdroplets by a nozzle or ultrasound disc nebulizer	• abrupt humidification • danger of saturating the atmosphere • risk of biological contamination • volatilizes mineral salts in water (if water is not demineralized) **Not recommended**
evaporation (cold vapor)	air is pulsed over or through a surface saturated with water (rotary drum, sponge, etc.)	• "natural" humidification • risk of biological contamination; UV sterilization possible, but verify absence of ozone production **Recommended**
by boiling (hot vapor)	an electric heater boils the water in a tank	• consumes more energy • danger of saturating the atmosphere • less risk of biological contamination **Recommended, but must have a humidistat in good working condition**

tial for biological contamination. If microorganisms develop in the tank, they can spread to the atmosphere. One must be alert to this possibility or use devices that contain a sterilization unit, which generally consists of a uv bulb (e.g., Defensor model ph26). And it is important to be aware that if steam jet and nebulizer devices are not properly adjusted, they can very quickly saturate the atmosphere. There is less risk of this with a natural evaporation humidifier, whereby air is humidified on contact with a water-covered surface. If these malfunction, the relative humidity will not exceed 70%.[20] The latter system seems most suited to preservation requirements. These devices should not be placed in proximity to photographs, which can be severely damaged by an accidental release of vapor or water. Finally, chemicals (e.g., disinfectants, rust inhibitors) should not be added to water that will be used for humidification unless they are harmless to the stored materials and fairly nontoxic (rarely the case with the available products).

Measuring relative humidity

Various types of hygrometers are listed in Table 31. These devices lose calibration and must be checked regularly. This is done by placing a solution saturated with salt in a small airtight enclosure with the hygrometer (Table 32). Electronic hygrometers are often sold with containers of salt solution to

TABLE 31

Several types of hygrometers used in conservation institutions.

Type	Principle	Measurement Range (RH)	Optimal Temperature	Features
hair or hygroscopic strip hygrometer	increase in humidity dilates an organic material	20–80%	ambient	• inexpensive • precision: ±5% to ±15% • precision decreases at low temperatures • equilibrium time required • calibrate twice monthly
wet/dry bulb psychrometer (aspirated or whirling)	compares the temperature indicated by two thermometers, one of which, wrapped in a wick saturated with distilled water, is ventilated	5–100%	0°C–100°C	• calibrate yearly or every two years • precision: ±2% to ±4% • requires a slide rule to determine the RH
electronic hygrometer	the resistivity or capacitance of a hygroscopic compound changes depending on the RH	5–95%	–30°C–60°C	• easy to use • precision: ±3% (depending on the model) • calibrate twice yearly • sensitive to chemical contamination
chemical uptake	the oscillation frequency of a quartz crystal, covered with a hydrophilic substrate, is modified			• very small volume • precision: ±3%
colored indicators	compounds gradually change color in a humid environment	20–80%	ambient	• inexpensive • indication is very approximate (±10% to ±20%) • sensitive to chemical contamination

TABLE 32

Humidity control (at 20°C) with
saturated salt solutions (according
to the Merck Index).

Saturated Solution	Salt Formula	Relative Humidity at 20°C
lithium chloride	$LiCl, 6H_2O$	11% RH
calcium chloride	$CaCl_2, 6H_2O$	32% RH
zinc nitrate	$Zn(NO_3)_2, 6H_2O$	42% RH
potassium carbonate	K_2CO_3	45% RH
magnesium nitrate	$Mg(NO_3)_2, 6H_2O$	55% RH
sodium nitrite	$NaNO_2$	65% RH
sodium chloride	$NaCl$	76% RH
ammonium sulfate	$(NH_4)_2SO_4$	80% RH
potassium chloride	KCl	86% RH
zinc sulfate	$ZnSO_4, 7H_2O$	90% RH
sodium carbonate	$Na_2CO_3, 10H_2O$	92% RH
disodium hydrogen phosphate	$Na_2HPO_4, 12H_2O$	95% RH
potassium sulfate	K_2SO_4	98% RH

be used for calibration. These hygrometers can then be used as a reference to calibrate other hygrometers.

In archive or exhibition areas, it is not sufficient to take occasional measurements. Variations must be monitored over long periods, in proximity to the stored works, hence the advantage of acquiring recording hygrometers. The model most commonly used by institutions is the recording thermohygrograph. It contains a drum covered with a chart on which pens record fluctuations in temperature and relative humidity in the shape of a curve. The device is placed in a representative location under actual conditions, avoiding proximity to heaters, ventilation outlets, outside walls, and apertures.

Large compartmentalized storage areas require measurements at several locations. Computers and electronics have made it possible to develop systems composed of individual sensors, distributed at various significant locations. The measurements are regularly transmitted, via cable or wirelessly, to a central processing unit in the building control system room. Similar stand-alone detectors, called data loggers, can be placed in individual enclosures. Some of them are battery operated and take readings, at intervals determined by the user, that they store in memory. Before the memory is full, data are downloaded to a computer for analysis. This type of device is frequently used to track temperature and relative humidity variations when artworks are shipped and exhibited. Sling hygrometers, relative humidity indicating cards, and small hygrometers are also used for immediate measurement in galleries or showcases.

Temperature

Determining the right temperature

According to the Arrhenius relationship, the speed of a chemical reaction is exponentially linked to temperature (see Fig. 33). A small temperature increase may considerably accelerate the breakdown of dyes in a color image. Likewise, cooling the environment by a few degrees is sufficient to increase the longevity of an unstable material. As a rule of thumb, we tend to say that decreasing temperature by 10°C doubles the longevity of a material, but this is just an approximation. The gain in stability conferred by a drop in temperature is linked to a constant called activation energy, which is specific to each reaction (the lower the activation energy, the faster the breakdown). Table 33 provides a calculation, based on the data in the literature, for the increase in longevity of materials as a function of the drop in temperature. Depending on the material, a 10°C decrease multiplies life expectancy by a factor ranging from 3 to more than 5.

TABLE 33

Factors relative to increased stability at decreasing temperatures. For example, decreasing the temperature from 20°C to 10°C increases the life of color film by a multiple of three.

| Temperature | k_1/k_2 | | | |
	Color Film Cyan Dye* (Ea = 76 kJ/mole)	Cellulose Triacetate[†] (Ea = 90 kJ/mole)	Cellulose[‡] (Ea = 108 kJ/mole)	Polyester[§] (Ea = 117 kJ/mole)
20°C	1	1	1	1
15°C	1.7	1.9	2.2	2.3
10°C	3	3.7	5	6
0°C	10	15	26	35
−10°C	36	70	163	248
−20°C	144	357	1,167	2,085

$log_{10}(k_1/k_2) = (Ea/19) [(T_1 - T_2)/(T_1 \times T_2)]$, Ea = activation energy in joules, T = temperature in kelvins.

* B. Lavédrine, C. Trannois, and F. Flieder, "Étude expérimentale de la stabilité dans l'obscurité de dix films cinématographiques couleurs," Studies in Conservation 31, no. 4 (1986):171–74.

[†] P. Z. Adelstein and J. L. McCrea, "Stability of Processed Polyester Base Photographic Films," Journal of Applied Photographic Engineering 7, no. 6 (1982):160–67.

[‡] T. P. Nevell and S. H. Zeronian, eds., Cellulose Chemistry and Its Application (Chichester: Ellis Horwood Ltd., 1985), 274.

[§] D. W. Brown, R. E. Lowry, and L. E. Smith, Prediction of the Long-Term Stability of Polyester-Based Recording Media, NSBIR 83-2750, August 1983.

Here we see the advantage of storing vulnerable artifacts, such as film on cellulose acetate bases and color photographs, at low temperatures, while stabler photographs (e.g., black-and-white prints, Dye-Transfer prints, Ilfochrome Classic prints) do not require such low storage temperatures. For this reason standards for long-term storage of film and color prints indicate 2°C as the maximum temperature. Moreover, there is no contraindication to lowering that temperature even further. Studies on this subject have shown that motion picture film can withstand freezing (at −15°C) and thawing cycles with no risk of thermal shock, mechanical degradation, or formation of ice crystals in the emulsion.[21] There have been no in-depth studies on cold

storage of composite or complex structures (laminates, large formats, mounted and framed photographs, etc.) composed of various assembled layers, each with different physical properties. Of course, extreme and repeated temperature variations affect the moisture content of materials and may therefore subject objects to stress and even, in the case of a framed photograph, deformation or condensation. However, while mechanical damage is a possibility at low temperatures, storage at room temperature inevitably leads to rapid, irreversible chemical degradation (e.g., of chromogenic color images).

Cold storage

Cold storage is the only way to ensure the survival of vulnerable photographs in a condition as close as possible to their original state. Creating a cold environment makes use of reliable technology that is not prohibitively expensive, especially in comparison to the cost of duplication and the limited possibilities of restoration. Maintaining low relative humidity in cold storage is more costly, but this cannot be avoided. If uncontrolled, relative humidity has the potential to reach excessive levels (greater than 70%) and the photographs would then run the risk of physical and biological deterioration. There are two possibilities in cold storage vaults, that is, either regulating the relative

TABLE 34

Examples of low-temperature film and photograph preservation conditions.*

Institution	Temperature	Relative Humidity
John Fitzgerald Kennedy Library (Boston, Massachusetts)	−18°C	30%
NASA (Houston, Texas)	−18°C	20%
Historic New Orleans Collection (New Orleans, Louisiana)	−18°C	30%
Jimmy Carter Library (Atlanta, Georgia)	−18°C	30%
Quebec Film Library (Montreal, Quebec)	1.7°C	35%
Art Institute of Chicago (Chicago, Illinois)	4.4°C	40%
Smithsonian Institution, Photographic Services (Washington, D.C.)	4.4°C	27%
National Archives at College Park, Maryland	−3.9°C	30%
National Gallery of Canada (Ottawa, Ontario)	15°C	40%
Canadian Centre for Architecture (Montreal, Quebec)	4.4°C	40%
Paramount Pictures (Hollywood, California)	4.4°C	25%
German Federal Archives in Coblenz	−6°C	25%
Archives du film (Bois-d'Arcy, France)	16°C	50%
Staatliches Filmarchiv (Germany)	−7°C	30%
Norwegian Film Institute	−5°C	20%
Tokyo Metropolitan Museum of Photography	5°C	50%
National Archives of Canada (Gatineau, Quebec)	−18°C	25%
Maison européenne de la photographie (Paris, France)	4°C	40%

* H. Wilhelm and C. Brower, The Permanence and Care of Color Photographs: Traditional and Digital Color Prints, Color Negatives, Slides, and Motion Pictures (Grinnell, Iowa: Preservation Publishing Company, 1993), 714; L. F. Karr, Proceedings of the Conference on the Cold Storage of Motion Picture Films, American Film Institute and Library of Congress, Washington, D.C., April 21–23, 1980 (Washington, D.C.: American Film Institute [AFI], 1980).

humidity or using airtight containers (boxes, cabinets) where the relative humidity is maintained at a suitable level using desiccants.

Large, well-funded collections usually have recourse to cold storage vaults. The most imposing of these are for preservation of motion picture film, since, in general, they take up much more space than artworks stored in museums and are not often accessed (Table 34). The Art Institute of Chicago, the Canadian Centre for Architecture in Montreal, and the Maison Européenne de la Photographie in Paris, among others, use a cold room and a cool room to archive color photographs and black-and-white photographs separately. It is interesting to note that low-temperature storage is not limited to photographic records. In 1993 the National Library of Norway set up storage areas containing 40 kilometers of shelving in mines near the Arctic Circle (in Mo i Rana), where the temperature is naturally 8°C but the relative humidity has to be reduced from 100% to 35%. Studies are in progress to determine the possibility of using standard cold storage vaults with no relative humidity regulation, where photographs are placed in airtight cabinets whose relative humidity is stabilized with buffering agents.[22] For small or medium-size collections, it is possible to use domestic refrigerators or freezers (see p. 61).

Cold storage limits access to photographs, inasmuch as they cannot be viewed without first acclimating them; removing a photograph from cold storage may cause water vapor condensation on its surface. To prevent this phenomenon, an intermediate-temperature acclimating chamber is used. The time required for a roll of 35 mm motion picture film stored at 0°C to stabilize at a temperature of 21°C is approximately five hours. For a carton containing ten rolls, multiply this time by ten.[23] For individual photographic prints, the time is much shorter. It is common practice to insulate the photograph in a polyethylene (Zip Lock–type) bag. Once the bag is outside the vault, it should not be opened for a period of from one hour to one day, depending on the mass of the object, the packaging, and the difference in temperature. This will allow the temperature of the object to stabilize at the room temperature (or at the least, its temperature will be above the dew point). Packaging (possibly vacuum packaging) of photographs in envelopes impermeable to water vapor has the major advantage of not requiring relative humidity regulation in the cold storage vault and provides protection from water damage and pollutants, but the photograph must be repackaged after each use (see p. 62). While lowering the temperature undeniably improves life expectancy, optimal conditions have yet to be determined. For an equivalent storage cost, is it better, for example, to store film at −10°C and 50% RH than at 2°C and 30% RH? Isopermanence graphs (see p. 119) can provide answers to such questions. However, the choice of conditions is also based on the stored materials and how frequently they are used, since cold storage makes sense only if the items are not brought to room temperature for viewing too often. Otherwise, the benefits of cold storage are considerably reduced or, at worst, totally lost (Fig. 69).

Thermal stability

Any change in temperature may lead to a change in relative humidity and in the movement of air within containing spaces (boxes or areas). A several-degree decrease in an area causes extraction of a portion of the air from the boxes.

There is little experimental data to determine whether it is better to limit temperature variations to 1°C (±0.5°C) rather than 6°C (±3°C). In theory, in an area at 40% RH (24°C), a 1°C temperature variation modifies the relative

Effect of time spent outside of cold
storage at room temperature (20°C,
50% RH) on the life expectancy
of photographs. For example, if
photographs are removed from cold
storage for more than 30 days per
year, storage at –10°C or –20°C has no
significantly different effect on their
life expectancy.

TABLE 35

Example of the effects of temperature
variation on relative humidity in a facility
at 20°C and 50% RH. For example, when
the temperature rises from 20°C to 22°C,
the relative humidity drops from 50%
to 44%.

humidity by about 3% (Table 35). At a range of 6°C, the relative humidity
may change by as much as 16%.[24] However, other factors may intervene and
attenuate the relative humidity variation, particularly the presence of a large
mass of hygroscopic materials. A variation range as low as ±0.5°C is realistic
only for storage areas that are perfectly insulated and climate controlled. ISO
Standard 6051 recommends limiting variations to 4°C (±2°C) over a twenty-
four-hour period.

Temperature	16°C	17°C	18°C	19°C	20°C	21°C	22°C	23°C	24°C	25°C	26°C
RH	64%	60%	57%	53%	50%	47%	44%	42%	40%	37%	35%

Measuring temperature

Sensors for monitoring temperature are generally thermistor or platinum resis-
tive thermal devices (RTD) with accuracy on the order of one-half degree. As
with hygrometers, their location has to be selected carefully and the calibra-
tion checked. Temperature is constantly recorded, either on paper or trans-
mitted and managed by software. In the event of a malfunction, particularly
in cold storage vaults, an alarm procedure should be triggered.

AIR POLLUTION

Pollutants

Air quality has become a major concern in large urban centers. The general
feeling that an environment is polluted is based primarily on the presence of
dust and odors. However, a number of pollutants are odorless and just as much
a threat to the preservation of organic and inorganic materials.

TABLE 36

Correspondence between concentration in ppm and concentration in micrograms per cubic meter at 0°C. Concentration in micrograms per cubic meter equals F multiplied by concentration in parts per million:

$$C_{\mu g/m3} = FC_{ppm}$$

Pollutant (various names)	F^* (conversion factor)
acetaldehyde (CH_3CHO) (ethanal)	1,964
acetic acid (CH_3COOH) (ethanoic acid)	2,679
hydrochloric acid (HCl)	2,321
formic acid (CHOOH) (methanoic acid)	2,053
hydrogen sulfide (H_2S)	1,518
sulfur dioxide (SO_2)	2,857
formaldehyde (CH_2O)	1,339
nitric oxide (NO)	1,339
nitrogen peroxide (NO_2)	2,054
ozone (O_3)	2,143
carbon monoxide (CO)	1,250
carbon dioxide (CO_2)	1,964

$$^*F = \frac{273}{22.4} \times \frac{\text{molecular weight}}{\text{temperature in kelvins}}$$

Experiments have demonstrated the harmful effects of pollution on artifacts located in cities. In a less polluted atmosphere, outside of urban areas, artifacts show less deterioration. However, we should not conclude from this that rural areas are spared; rather, the pollutants are often merely different.[25] Urban air contains harmful gases, including sulfur dioxide (SO_2), nitrogen oxides (NO_x), ozone (O_3), reduced sulfur compounds, and volatile organic compounds (vocs). Some of these are present only in minute quantities, usually expressed as parts per million or parts per billion (ppb). Respectively, 1 ppm and 1 ppb are equivalent to 1 mL and 0.001 mL of gas in a volume of 1 cubic meter. These concentrations are also expressed as micrograms per cubic meter (Table 36). These low levels are sufficient to threaten photographs.

Sources of pollutants

A large amount of air pollution is generated by the combustion of petroleum fuels and coal (exhaust gases from automotive vehicles and furnaces, discharges from industrial plants). Released into the atmosphere, these pollutants may be transformed, interreact, and, under the influence of sunlight, lead to the formation of other harmful chemical compounds. Some of these pollutant gases can be found in storage areas.

Official agencies provide information about outdoor pollution levels in different cities (Table 37), and it would be interesting to have samples taken inside storage areas by specialized companies, since there are different relative amounts of pollutant gases indoors and outdoors.[26] For example, in buildings, certain pollutant gases are adsorbed or neutralized by construction or coating materials. Indoor measurements taken at several institutions in Washington, D.C., and the Netherlands[27] clearly indicate lower levels of ozone and sulfur dioxide.

TABLE 37

Air pollution levels in the city of Paris.

Data: Airparif

Pollutant	Average Annual Levels
sulfur dioxide	20 $\mu g/m^3$
nitric oxide	36 $\mu g/m^3$
nitrogen peroxide	57 $\mu g/m^3$
ozone	18 $\mu g/m^3$
dust	24 $\mu g/m^3$
black smoke	21 $\mu g/m^3$

TABLE 38

Mean concentration of carbonyl pollutants.*

Pollutant	Readings from 17 Institutions
formaldehyde	42 ppb
formic acid (methanoic acid)	14 ppb
acetaldehyde (ethanal)	23 ppb
acetic acid (ethanoic acid)	32 ppb

* C. M. Grzywacz, "Using Passive Sampling Devices to Detect Pollutants in Museum Environments," in ICOM-CC, 10th Triennial Meeting, Washington, D.C., USA, August 22–27, 1993, Preprints (Paris: ICOM–Committee for Conservation [ICOM-CC], 1993), 2:610–15.

TABLE 39

Sources of indoor pollution in facilities.

Pollutant	Source
acetone	solvents, cleaning solvents
acetic acid	wood, wood glue, paint, gaskets
formic acid	wood, particleboard, adhesives
ammonia	cleaning products, adhesives, emulsion paints
formaldehyde	plywood, adhesives
ozone	electrical equipment, photocopiers, laser printers
peroxides	wood, poor-quality adhesives, oil paints
sulfur derivatives	human presence, wool, rubber vulcanized with sulfur

Inside buildings, the quantity of volatile organic compounds is considerably higher. Insulating materials, wall and floor coverings, and furnishings can release acid or alkaline vapors, aldehydes, peroxides, and reduced sulfur compounds, whose release rate decreases over time. Some plywood and particleboard, for example, release up to 55 milligrams of formaldehyde per square meter daily.[28] Synthetic foams and resins also generate various pollutants.[29] There are many more indoor gases, but most of them are harmless to photographs.

Finally, human activity is a source of pollution. Some wool fabrics,[30] when exposed to light, can release sulfur derivatives (hydrogen sulfide, carbonyl sulfide), and tobacco releases carbon monoxide, nitrogen oxides, hydrocarbons, ammonia, and formaldehydes and other aldehydes. Cleaning and do-it-yourself products produce organic by-products such as chlorinated and fluorinated hydrocarbons, benzene and other aromatic compounds, aldehydes, and ammonia. Electronic air cleaners, photocopiers, and laser printers produce ozone. Analyses conducted by the Getty Conservation Institute in seventeen museums and institutions showed that carbonyl compounds are frequent indoor pollution agents, and of these, formaldehyde predominates (Table 38). In buildings, formaldehyde concentrations range from 12 to 1,400 ppb. The less the ventilation, the greater the quantity. Cabinets are the most polluted areas. Many other organic compounds have been identified in public buildings and motion picture film archives. These include not only acetic acid but also acetone, n-butanol, cyclohexane, trichloroethane, dichloromethane, and propylene dichloride. Several of these solvents are used in manufacturing film bases, and their residues are slowly released into the atmosphere.[31] Some of these VOCs may have detrimental effects on black-and-white photographs stored in the vicinity, but health hazards can also be a concern. Measurements taken in photographic archives indicate nitrogen dioxide levels of up to 83 ppb, whose origin is linked to the presence of cellulose nitrate negatives. All of these volatile compounds are obviously undesirable in a storage area and may also have harmful effects on the personnel (Table 39).

Dust is created by human activity and natural phenomena. It is composed of organic particles such as soot (smoke), fibers (constructions materials, fabrics), pollen, and spores and inorganic particles such as metals (lead, iron, etc.), salts (maritime air), and construction materials (concrete, plaster, etc.). Particles are categorized based on their diameter. Fine particles have a diameter of less than or equal to 2.5 microns and coarse particles have a diameter of between 2.5 and 10 microns (Table 40). Two additional categories are used to distinguish particulate matter: particles of biological origin (pollens, fungal and bacterial spores, algae, insect parts, hairs, skin cells, etc.) and particles from nonliving matter (fibers, organic waste, soot, metallic particles, sulfates, nitrates, etc.).

TABLE 40

Air pollutants.*

Phase	Example	Size of Particles
solid	cigarette smoke, fibers, pollen, spores	0.003 to 100 microns
liquid	dispersed aerosol paint solvents	1 to 9 microns
gaseous	volatile organic compounds, NO_2, SO_2, etc.	0.0003 to 0.006 micron

* ASHRAE Standard 62-1989, Ventilation for Acceptable Indoor Air Quality.

Effects of pollutants

The danger of pollutants depends on the photographic process and on storage conditions, for example, if the images are protected by proper-quality sleeves and enclosures or if they are large-format photographs exposed on a wall. The interactions of pollutants with photographic materials have not been fully elucidated, nor have their effects on other materials. In most cases, these gases have synergetic effects.[32] Admittedly, gelatin protects the image, but that protection rapidly decreases as the relative humidity increases. The higher the relative humidity, the greater the effect of nitrogen oxides on photographs. Also, hydrogen peroxide and hydrogen sulfide are more damaging to the silver image above 35% RH.[33] Acid gases or those capable of forming acids, such as sulfur dioxide and nitrogen oxides, break down gelatin,[34] weaken paper, and accelerate the decomposition of cellulose ester bases. As we have seen, the combined action of reduced sulfur compounds (H_2S, OCS, CS_2, $(CH_3)_2S$, etc.) and oxidants, such as peroxides, leads to silver mirroring as well as redox spots on black-and-white photographs (see pp. 8, 10).

Silver gelatin photographs are more sensitive than color photographs to pollutants. However, certain dyes in color photographs are discolored by sulfur dioxide and oxidants such as ozone and nitrogen oxides.[35] Behaviors differ a great deal, depending on the process (Fig. 70). For example, Ilfochrome Color Classic microforms are more resistant than are chromogenic films.[36] Yet ozone can rapidly fade some ink-jet print dyes.[37]

The effects of volatile organic compounds are less well known. However, paint solvents have deleterious effects on gelatin silver photographs (Table 41). Formaldehyde reacts relatively rapidly with certain metals; for example, lead "coupons" are used to detect formaldehyde in storage areas.[38] Current thinking is that the formaldehyde is oxidized to formic acid, which then reacts with lead. Formaldehyde in solution has been used in the past for hardening gelatin or stabilizing color images. As an airborne pollutant in photograph storage areas, formaldehyde might reduce some silver ions to colloidal silver and result in discoloration of black-and-white photographs. However, the threat of formaldehyde pollutants to artworks and photography has been reconsidered.[39] The main concern today is the health hazard to humans.

As dust is deposited on the image, it causes chemical, mechanical, biological, and aesthetic deterioration. Deposited soot need only cover 2.4% of the white areas of a paper document for it to appear soiled.[40] The effect of these particles depends on their size, and certain dust particles smaller than

Daguerreotypes are particularly
sensitive to atmospheric pollutants and
tarnish quickly if not protected.

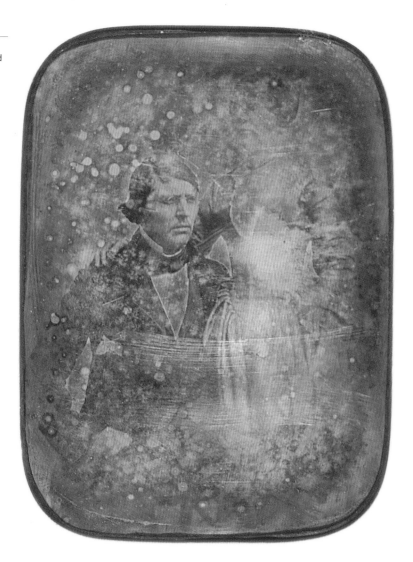

Effect of several families of solvents on
photographs.*

Families of Solvents	Effect of Solvents
ether, ketones: methyl isobutyl ketone	may produce peroxides
alcohol, esters, ketones	penetrate wet gelatin
halogenated hydrocarbons, hydrocarbons	do not penetrate wet gelatin

* *Kodak,* How Post-processing Treatments Can Affect Image Stability of Prints on Ektacolor Paper, *Kodak Pamphlet No. E-20, 1982.*

1 micron have more of an effect than those that are larger. They embed in cracks or paper fibers on the surface of the photographs and cause damage.

Recommendations

Pollutant levels

Degradation by pollutants is often considered cumulative and proportional to concentration and time. Therefore, it is advisable to eliminate pollutants to the extent possible based on the available technology and the acceptable risks to the collection. To meet the demands of contractors for archives and libraries, the National Bureau of Standards has specified strict recommendations for some pollutant levels.[41] Originally intended for graphic documents, the recommendations have been adopted for photographic archives (Table 42).[42] These specifications cover only the most common outdoor pollutants. For other specific gases, the recommendation is to use the best current technology available or affordable. However, in its 2002 edition, ASHRAE included a larger set of indoor pollutants in its recommendations for museum, gallery, library, and archival collections, using different quantitative risk assessment parameters.[43] The "no observable adverse effect level" (NOAEL)—that is, the highest level of a specific pollutant that does not cause any physical or chemical damage to an object—is given for different periods of time (1 year, 10 years, and 100 years). The fractional reductions of outdoor levels for buildings with and without HVAC filtration systems are also mentioned. Another interesting concept is introduced, namely, the "lowest observable adverse effects dose" (LOAED). The LOAED reflects the role played by the duration of exposure to a given airborne pollutant. The LOAED represents a cumulative dose, the "lowest observable adverse effects levels" (LOAEL), multiplied by the duration of exposure to the pollutant (LOAED = LOAEL × time). For instance

TABLE 42

Air quality recommendations for archival document storage.

Pollutant	G. Thomson*	Thresholds National Archives of Canada (Gatineau)	National Archives of the United States (College Park, Md.)
sulfur dioxide (SO_2)	10 µg/m³	1 µg/m³	1 µg/m³
nitrous oxides (NO_x)	10 µg/m³	5 µg/m³	5 µg/m³
ozone (O_3)	2 µg/m³	2 µg/m³	25 µg/m³
hydrochloric acid (HCl)	NS	NS	NS
acetic acid (CH_3COOH)	NS	NS	NS
formaldehyde (CH_2O)	NS	NS	5 µg/m³
volatile organic compounds	NS	NS	NS
suspended particles	NS	75 µg/m³	75 µg/m³

NS = not specified.

* G. Thomson, The Museum Environment (London: Butterworth, 1978), 158.

FIGURE 71

Installation of a self-contained air
purification unit.

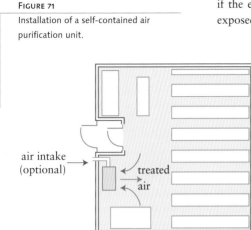

air intake
(optional) → ← treated
 ← air

if the experiment gives a LOAED of 43.8 mg.m^{-3}.hour for an ink-jet print exposed to ozone, the same deterioration should be obtained after one year with 5 µg.m^{-3} of ozone.

Suspended particles

The atmosphere in storage rooms should contain fewer than 75 micrograms of suspended particles per cubic meter. This criterion provides no information about the morphology or type of the particles. Thus there may be a larger number of small particles or a lesser quantity of larger particles. The standards indicate that 95% of particles with a diameter greater than 1 micron and 50% of particles between 0.5 and 1 micron should be eliminated. This relatively low figure takes into account the difficulty of eliminating such fine particles. It can be achieved if a specific set or series of filters is used.

Achieving Good Air Quality

Air purification components of climate control systems

In storage areas, air of insufficient quality undergoes various filtrations. Large spaces require complex systems with air purification components integrated into the climate control system. Such equipment is costly, and maintenance costs can be considerable as well.

Air filtration should eliminate suspended particles and remove pollutant gases to the extent possible. This purifies the air entering from the outside, but the system should also recycle a portion of the ambient air in the storage area. In fact, it is advantageous to treat air that has already been rid of urban pollutants by filtration and then by adsorption using internal materials. This places less stress on the climate control system and increases the life of the filters.

To avoid undesirable ingress of pollutants when one enters a storage room, it is advisable to slightly pressurize the area (1 to 2 pascals), which also helps to keep the relative humidity stable (Fig. 71).[44]

FIGURE 72

Purafil PPU self-contained
purification unit.

Photograph: Purafil

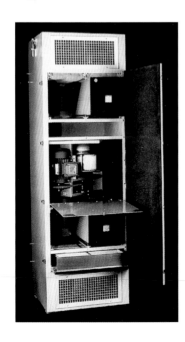

Self-contained units

In small spaces, if there is no climate control system, it is possible to use a self-contained air recycling unit that also pressurizes the area, such as Purafil's Positive Pressurization Unit (PPU) (Fig. 72). This device has an optional inlet for outside air.

Particle filtration

Most filters are composed of a fibrous medium, for example, fiberglass or synthetic fibers made of polyester, polypropylene, and polyurethane. To improve their efficiency and longevity, they come in the form of a pouch, modeled on a vacuum cleaner bag, or have a panel-pleated structure, which provides a larger surface area. There are also electrostatic filters that eliminate more than 95% of organic and inorganic particles larger than 1 micron by ionizing them and trapping them on an electrode. Electrostatic filters in which the fibers are electrostatically charged by the air passing through them are less efficient.

TABLE 43

Recommended particle filtration levels.*

Area	Filtration Level[†]
public viewing area	60–80%
temporary storage	90–95%
permanent storage	greater than 95%

* A. J. Sebor, "Heating, Ventilating, and Air-Conditioning Systems," in C. L. Rose, C. A. Hawks, and H. H. Genoways, eds., Storage of Natural History Collections: A Preventive Conservation Approach (Grinnell, Iowa: Society for the Preservation of Natural History Collections [SPNHC], 1995), 135–46.

† ASHRAE Standard 52, Method of Testing Air-Cleaning Devices Used in General Ventilation for Removing Particulate Matter; Atmospheric Dust Spot Efficiency Procedure.

The efficiency rating of a filter indicates the percentage of particles that it removes. Efficiency values may differ considerably, depending on whether the percentage is based on the number or the weight of the particles removed by the filter. The first is much more accurate, particularly for high levels of filtration. To avoid any ambiguity, the standard used to determine efficiency should be specified (American ASHRAE Standard 52, European Eurovent Standards 4/5, etc.). The test methods described in these documents are based on the use of a sodium chloride, methylene blue (MBT), or dioctylphthalate (DOP) aerosol. The DOP method is used to evaluate very high efficiency filters.

The filtration level is selected based on precise recommendations. It is necessary to differentiate storage areas from spaces open to the public, where it is practically impossible to maintain a high level of air quality. For libraries, it is advisable to use fine filters with an efficiency[45] of 60% to 80% (70% on average).[46] For archiving photographic records, 85% appears to be the minimum.[47] ASHRAE has directives recommending a filtration level greater than 95% for storage areas (Table 43). In low-traffic locations where the air is recycled, it seems easier to achieve and maintain very low levels of particles. For that purpose, a combination of appropriate filters is used, combining a coarse filter (medium efficiency) with a fine filter (high efficiency) or an ultrafine filter (very high efficiency). High-efficiency filters remove a large portion of suspended spores and bacteria. The fibrous media should be replaced regularly, since they get clogged, which can prevent air from passing through. This causes an extensive pressure drop across the filters. Typically, prefilters have a lifetime of 2,000 hours, while others last for 5,000 to 8,000 hours.[48] Electrostatic precipitator filters do not have this drawback, but due to the electrical field in the filter, a portion of the oxygen is transformed into ozone. For that reason, such filters are not recommended for storage areas.[49] An electrostatic filter that does not produce ozone (Futura filter) has been marketed in an attempt to remedy this drawback. However, adding a downstream active charcoal filter is advised.

Filtering pollutant gases

Filtering air by passing it through a water spray is a method that is less and less used. It is not effective at removing ozone, and there is the greater risk of potential biological contamination. Instead, filtration with absorptive substances is used.[50] Typically, the air is purified by absorption of gases on the surface of a very porous solid. One advantage of this method is that it uses a relatively inexpensive compound with a large, accessible surface area. Such is the case for activated charcoal,[51] which is produced by burning organic

TABLE 44

Active charcoal adsorption numbers for
several compounds.

acetic acid	4
ammonia	2
camphor	4
carbon dioxide	1
carbon monoxide	1
carbon tetrachloride	4
chlorine	3
ethylene oxide	4
formaldehyde	2
gasoline	4
hydrochloric acid	2
hydrogen sulfide	3
nitrogen dioxide	2
ozone	4
sulfur dioxide	2
sulfuric acid	4
tetrachloroethane	4
tetrachloroethylene	4

material such as coconut shells or bitumen. Its porous structure, obtained by special processing, gives it a specific surface area of up to 2,000 square meters per gram of charcoal. Pollutant gas molecules are adsorbed by macropore walls and condensed in micropores. Activated charcoal is packaged in the form of granules distributed between perforated plates, or in powdered form in non-woven bags, which are placed in the path of the air. It is widely used in filtration units.

Activated charcoal's efficiency increases as the temperature and relative humidity decrease. Not all gases have the same affinity for activated charcoal. This is expressed by an index of 1 through 4:

1—No adsorption (less than 1% of gas adsorbed relative to the weight of the charcoal)
2—Poor adsorption (less than 5% of gas adsorbed)
3—Good adsorption (10% to 15% of gas adsorbed)
4—Very good adsorption (20% to 40% of gas adsorbed)

Table 44 provides the figures for the most common pollutants. While several gases, including ozone, are well adsorbed by activated charcoal filters, some common atmospheric pollutants (nitrous oxide, carbon oxides, formaldehyde, hydrochloric acid) are less well adsorbed. In an efficient filtration unit (Fig. 73), activated charcoal filters are combined with specific filters that work

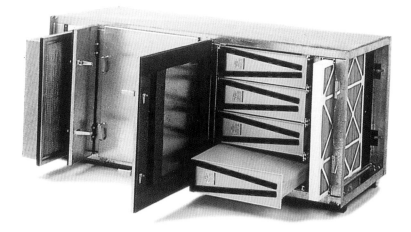

FIGURE 73

Air purification filters.

Photograph: Purafil

prefilter (dust) chemical filters high-efficiency filter

air intake clean air

TABLE 45

Examples of Purafil filters for air
pollutants.

Type	Composition	Efficiency
Puracarb PP1505 or Carasorb	active charcoal on an alumina substrate impregnated with potassium hydroxide	SO_2, H_2S, NO_2, Cl_2, O_3
Purafil II chemisorbent	activated alumina impregnated with potassium permanganate	SO_2, SO_3, H_2S, NO, CH_2O, O_3
Puracarb AM	active charcoal on an alumina substrate impregnated with phosphoric acid	NH_3, O_3, organic acids
Purakol	active charcoal	O_3, Cl_2, organic acids

TABLE 46

Examples of air cleaning recommended
by Purafil.*

Air Intake	Type of Filter	Action	Rack Length
treatment of fresh air (primary air)	dust prefilter (efficiency: 30%)	retention of airborne particulates	203 mm
	active charcoal filter Puracarb PP or Sonoxcarb	retention of gases NO_2, SO_3, formic acid, etc.	460 mm
treatment of recirculated air	electrostatic filter or prefilter	retention of airborne particulates	203 mm
	Puracarb	retention of gases NO_2, SO_3, formic acid, etc.	460 mm
	Purafil II	retention of gases NO, O_3, H_2S, SO_2, CH_2O	460 mm
	high-efficiency filter	retention of airborne particulates (from filters)	216 mm

* Delta Plan Preservation of Cultural Heritage, *Final Report on the Air Purification Pilot Project.*

by chemisorbing certain types of pollutants. These are substrates impregnated with a reagent that neutralizes noxious gases. In this way, activated charcoal can be impregnated with sodium or potassium hydroxide to neutralize acid gases (SO_2, H_2S, NO_2). Activated alumina impregnated with potassium permanganate or bicarbonate is also used (Table 45).

The purchase and maintenance of such filters represent a substantial investment (Table 46). In some institutions, activated charcoal filters, while not optimal, provide a real improvement and give satisfactory results. It is not easy to determine the life expectancy of "chemical filters," since this is linked to the pollution level and to the presence of dust, which can clog micropores. Therefore, suspended particles must first be removed from the air. Usually, filters are periodically changed by a maintenance service.

Measuring Pollutants

The recommendations specify extremely low pollution levels, and reliable measurement instruments for monitoring such low levels are expensive. Each gas must be analyzed according to a specific procedure that must be performed by a specialized technician. Accurate knowledge of the nature and quantity of pollutants in the air is helpful for monitoring changes in the environment of a collection. However, this provides little information about the effects of the gases on the items stored. In fact, even if the quantity of the pollutants is minute, some gases act synergetically and may cause extensive damage. As explained earlier, it has been established that at low relative humidity hydrogen peroxide causes little deterioration in silver microfilm. However, when the relative humidity increases, that same quantity can be much more destructive. Therefore, work is currently in progress to develop corrosion indicators composed of materials such as lead, silver, copper, and certain types of glass, which are sensitive to pollutants. After exposure in storage or exhibition areas, the corrosion of the indicator is evaluated visually or by taking physical measurements (optical density, piezoelectric measurement, mass, resistivity, etc.). This provides a qualitative estimation of the degree of air quality. It is necessary to ascertain that the reactivity of the indicators is representative of the reactivity of the stored materials.[52]

Evaluating the damaging effect of an airborne pollutant

Colloidal silver A method developed by E. Weyde[53] is sometimes used to indicate the presence of pollutants that are capable of damaging photographic collections. This involves exposing strips of colloidal silver film (manufactured by Agfa; see p. 37) in the areas in question, such as archival areas and storage cabinets. The color of the film darkens in proportion to the degree of pollution (Fig. 74). The strips are checked after two weeks and six weeks, and the test may be extended to one year. Strips are evaluated by comparing them

see p. 37

FIGURE 74

Colloidal silver film exposed to air for several years. The darkening of the exposed parts reflects the action of pollutants.

TABLE 47

Assessing the corrosiveness of air.

Thickness of Corrosion Layer on Silver Coupon after 30 Days	Thickness of Corrosion Layer on Copper Coupon after 30 Days	Air Quality for Conservation Institutions*	Air Quality for Industry, according to the ISA[†]
<40 angstroms: class S1	<90 angstroms: class C1	very pure	
40–99 angstroms: class S2	90–149 angstroms: class C2	pure	
100–199 angstroms: class S3	150–249 angstroms: class C3	clean	
200–299 angstroms: class S4	250–349 angstroms: class C4	contaminated	
≥300 angstroms: class S5	≥350 angstroms: class C5	polluted	
	<300 angstroms: class G1		mild pollution
	300–999 angstroms: class G2		moderate pollution
	1,000–1,999 angstroms: class G3		harsh pollution
	≥2,000 angstroms: class G4		severe pollution

* R. Vosteen, Guidelines and Recommendation Regarding Air Quality in Repositories and Exhibition Rooms of Archives and Art, State Buildings Service, Directorate of Design and Technology, Department of Climate Technology, the Netherlands.

[†] Instrument Society of America (Standard ISA-S71-04-1985).

with an unexposed reference sample. This process can be refined by using a densitometer to quantify the changes. If a marked change is observed after several weeks or months, the air is considered polluted. If darkening occurs after one or two years, the air is considered not damaging to collections. However, no scale yet exists for establishing a more accurate relationship between optical density changes and air quality. Finally, this test is applicable only if temperature and relative humidity conditions are controlled. In fact, if the atmosphere is too humid, the results are questionable. This monitoring method has been used successfully in the photographic storage areas at the Art Institute of Chicago.

Purafil coupons Manufacturers and users of electronic equipment need to deal with the problem of air pollution, which quickly damages integrated circuits. One method of qualitatively evaluating air quality, developed in 1985 by the Instrument Society of America (ISA Standard s71-04-1985), consists of measuring the thickness of the corrosion layer on metal plates exposed to the air for at least thirty days.[54] Levels of air quality are classified based on the thickness of the layer (Table 47). For photographic archives, air quality should be Class s1/c1. This principle has been used to check air quality in exhibition rooms and storage areas. Strips of silver are exposed for thirty to ninety days, and air pollution is determined based on the thickness of the layer of oxidized silver. Purafil, which markets these indicators (Corrosion Classification Coupons and Silver 6 Paks), measures the thickness of the corrosion layers (silver chloride, sulfide, and oxide) and determines the pollutants that are most likely responsible for the corrosion.

Glass sensors Glass sensors were developed by Fraunhofer-Institut für Silicatforshung in Germany.[55] The institute uses silica potash-lime glass, which is very sensitive to atmospheric pollutants. Small glass slides are exposed at the sites, and the degree of corrosion is measured using infrared spectrometry at 3,300 cm^{-1}.

Quantitative evaluation by a laboratory

To evaluate air quality in storage areas over the course of a year, air quality measurements are periodically taken at various locations. Specialized companies can be hired to do this work. To analyze inorganic gases, air is pumped through a liquid or solid reagent. Sulfur dioxide, nitrogen oxides, and ozone levels are then assayed by colorimetry. Carbonyl compounds are trapped on substrates (paper, chromatographic cartridges, silica gel plates) impregnated with 2,4-dinitro-phenylhydrazine for aldehydes and ketones, or potassium hydroxide for carboxylic acids.[56] They are analyzed by high-performance liquid chromatography. Gas chromatography/mass spectrometry makes it possible to identify a much broader range of volatile organic compounds[57] in a single operation. These are collected on adsorbents marketed by various companies (e.g., 3M organic vapor monitors, Dräger, Carbosieve sIII and Tenax TA badges). The tubes are placed in the locations to be checked for from several hours to several days, which allows a sufficient quantity of the pollutant gases to be adsorbed by the substrate. Solid phase microextraction (SPME) is an emerging technique that addresses this problem.

Quantitative evaluation by direct reading

Dräger and Gastec[58] market reagent tubes for direct reading. Air is sucked with a manual or automatic pump through a glass tube filled with a reactive substance. After a certain volume of air has passed through the tube, the degree of discoloration directly indicates the concentration of pollutant gases, based on a graduated scale on the surface of the tube. Such tubes are intended to measure concentrations that are often much higher than the maximum recommended limits for collections, but they are useful, nevertheless, for measuring pollutants that may be present in excessively high concentrations (e.g., acetic acid, formaldehyde).

So-called diffusion tubes may be used to take passive measurements in storage areas, display cases, cabinets, and boxes (Fig. 75). These tubes operate on the same principle as those described above, except that no pumping is required. Air naturally diffuses into a sampler. Typically, exposure times are twenty-four to seventy-two hours. The concentration is then determined by dividing the concentration indicated on the tube by the number of hours of exposure (with less precision, since other factors, such as relative humidity, can distort the measurements over long periods) (Table 48). However, it should be noted that doing an analysis in an enclosed, unventilated space (box, cabinet, display case, etc.) that is opened for testing purposes may affect the measurements.[59] There are many passive dosimeters on the market for measuring formaldehyde. While Dräger Bio-Check F badges indicate formaldehyde concentrations on the order of one-tenth ppm in a few hours, those marketed by GMD are capable of detecting values of a few tenths of a ppb after one day of exposure.

FIGURE 75

Dräger diffusion tube for measuring pollutant gases.

TABLE 48

Diffusion tubes for measuring pollution.

Pollutant	Measurement Range (Gastec)	Measurement Range (Dräger)
acetic acid	—	1.3 to 25 ppm
hydrochloric acid	1 to 100 ppm	1.3 to 25 ppm
sulfur dioxide	0.2 to 100 ppm	0.7 to 19 ppm
nitrogen peroxide	0.1 to 30 ppm	1.3 to 25 ppm
formaldehyde	0.1 to 3.5 ppm	—
hydrogen sulfide	0.2 to 200 ppm	1.3 to 40 ppm

Continuous air quality evaluation

The devices described above are useful for evaluating overall air quality over several weeks or months but are not very efficient for detecting a sudden abnormality in the environment. The time required for exposure and analysis does not allow for rapid determination of the source of the pollution and for taking the necessary steps to resolve the problem. Continuous analyzers have been developed to monitor urban pollution levels, but they are unsuitable for checking air quality in storage areas since they are too bulky and costly. In addition, the range of pollutants they measure is limited. Purafil markets an electronic instrument, the Onguard 2000 (Fig. 76). The detectors it uses are copper- or silver-plated quartz crystals. As they corrode, the mass of the plating increases and the resonance frequency of the quartz crystals changes. This signal is converted to a corrosion level and is displayed on an LED or saved on a computer. This device is used in some archive centers in the Netherlands and the United States. Other systems that work by modifying the resistivity

FIGURE 76

OnGuard 2000 electronic atmospheric corrosion monitor.

Photograph: Purafil

TABLE 49

Semiconductor gas sensor (Capteur
Sensor & Analysers Ltd).

Pollutant	Continuous Monitor Accuracy
ammonia	±0.5 ppm
nitrogen dioxide	±0.01 ppm
sulfur dioxide	±0.05 ppm
aliphalic hydrocarbons	±0.5 ppm
aromatic hydrocarbons	±0.05 ppm
hydrogen sulfide	±0.05 ppm
carbon monoxide	±2 ppm
ozone	±10 ppb

of a silver- or copper-plated resistor are available. These sensors are designed for urban pollutants. They are not standardized, and their sensitivity to organic volatile compounds, particularly those found in collections, is not well known. Finally, there are sensors composed of a heated semiconductor whose conductivity decreases when the atmospheric gas concentration increases. Each type of pollutant requires a specific sensor. These devices are already in use for industrial and domestic applications. However, although they are accurate to several hundreds of a ppm (Table 49), they still lack the sensitivity to meet preservation standards and are therefore reserved for use as warning devices rather than monitoring devices.

Monitoring Collections

Every collection is subject to a set of constraints, for example, the size and diversity of holdings, use and access, budget, the nature of the facility, and the number of staff members. Systematic implementation of recommendations that do not take these factors into account can lead to catastrophic results. So rather than provide a set of rules to be strictly followed step by step, it is preferable to provide the means to develop an appropriate strategy in which every action is intended to promote preservation over conservation, and indeed to prevent the need for the latter.

However, this commonsense concept—an ounce of prevention is better than a pound of cure—has implications that can be difficult to manage. Murray Frost rightly stated that in preventive conservation, we must follow the rule of the 4 "C's":[1]

> Conflict between the need to communicate and the need to preserve, which are sometimes contradictory;

> Complexity, because recommendations that seem simple can be complex to implement;

> Cost, because complex implementation is costly;

> Compromise, because it is always necessary to balance theoretical aspirations with practical and financial realities. The job of a collection manager often consists of finding a compromise, clearly determining the most favorable preservation conditions while remaining aware of the fact that in this field our knowledge is constantly evolving.

FIGURE 77

Regular inspection of collections makes it possible to evaluate their condition and determine conservation priorities.

Proper collection management should facilitate access to the photograph for consultation, exhibition, and reproduction without endangering its integrity. It must also allow for solving common preservation problems and for reacting to any exceptional events that may occur. To achieve these objectives, the risks involved must be identified and the appropriate procedures established. Then responsibilities must be assigned to the various participants. Because it involves very diverse fields and skills, preventive conservation also requires a frame of mind that promotes reflection, dialogue among the various participants involved with the collection, training, and education (Fig. 77).

SETTING CONSERVATION PRIORITIES

A large collection of photographs cannot be managed without an overview of its specific conservation problems. First, a preservation specialist writes an assessment of the environment (facilities and climates) and the condition of the collection (Table 50). A document, arranged in the form of a checklist, published by S. Wolf, makes it possible to analyze methodically all the factors and to write a structured report, itemizing the deficiencies relative to the structure of buildings and storage areas, the environment, and the warning and protective devices.[2] To aid collection managers, the Canadian Conservation Institute (CCI) has published a guide for preservation of museum collections.[3] This is a chart with nine rows and seven columns, showing the various agents of deterioration, the vulnerabilities of objects, and the means of controlling them. For each of the nine listed agents of deterioration, the approach consists of five stages of response, from prevention through recovery, under the headings Avoid, Block, Detect, Respond, and Recover/Treat. This is a remarkable working tool that provides for a systematic and organized study, leading to a diagnosis.

An in-depth study of the collection made during cataloging or by analyzing a representative sample of the photographs and their condition makes it possible to establish priorities, from storage conditions that require upgrading of standardized recommendations to conservation treatments of photographs. The images or holdings may then be ranked according to condition, as follows:

A: Good condition, stable.

B: Average condition, deteriorating. To be monitored.

C: Poor condition, degradation in progress. Urgent action: conservation treatment, duplication, cold storage, and so on.

These categories are misleadingly simplistic. They can be approached either from the chemical and physical condition of a photograph or from its aesthetic appearance. The evaluation may be difficult. For instance, how do you rank a photograph in good condition but on potentially unstable material, or a photograph that is stable but in poor condition? More complete evaluation systems have been proposed,[4] using three criteria: the value of the object, its vulnerability, and its level of deterioration. A scale of 1 to 5 has been established for each of these criteria. The total of these three assigned values, ranging from 3 to 15, determines the priority of the required actions (Table 51).

TABLE 50

Inventory for prioritizing preservation
requirements.

Area	Type of Action
environment	rehabilitation of premises, maintenance, safety, and management of major risks
documentation	identification of assets, inventory, cataloging, and indexing
inspection of collections	analysis of contents and reconditioning, if necessary
	identification of bases and supports, determination of deterioration, and monitoring of degradation
process	separation of incompatible documents, duplication program, stabilization of vulnerable photographs, conservation and restoration
education	training of personnel and users

This system has been recently adapted to calculate a "priority preservation action index." The value of the object (or collection) is ranked from 1 to 100, 100 being the highest value, and this number is multiplied by the risk factor for adverse effect over a period of one century (from 1 = low chance to 100 = highest risk). The priority preservation action index is the logarithmic value of the product.

These systems are not as simple to implement as it might seem. It is not always possible to assess the various criteria, and even if it is, skills may be required in a wide variety of fields and it may be necessary to consult experts. Optimal knowledge and physical organization of a collection also require preparation of the personnel through internships or specific instruction focusing on preservation problems.

All of these activities contribute to determining the priorities for action, depending on the intended purpose of the collection—archive repository, photographic stock agency, museum collection, and so on. For example, for photographs endangered by frequent handling, duplication or scanning may be

TABLE 51

Evaluating action priorities and
establishing priorities by adding
three figures.

	Object Value		Object Susceptibility		Presence of Each Agent*		Priority for Preservation Action
very low	1		1		1		3
							4
							5
low	2	+	2	+	2		6
							7
average	3		3		3		8
						=	9
high	4		4		4		10
							11
							12
very high	5		5		5		13
							14
							15

Merges intensity or incidence of an agent with deficiency of control of an agent.

considered a priority, whereas in the case of an exhibition of a museum collection, priority may be given to conservation treatment.

Risk Analysis and Emergency Planning

Natural disasters, fire, and vandalism have devastating consequences for our cultural property that prevention alone can mitigate or, indeed, prevent. Following the example of personnel safety programs, major institutions have developed risk management policies to protect their holdings. The first step is to conduct an inventory of the dangers and an evaluation of the degree of probability associated with each. In fact, the risks differ according to region, construction technique, type of collection, and amount of traffic. Once the major risks are determined, the next step is to examine prevention and warning devices, as well as intervention and rescue techniques. Rapid detection of a destruction process, accompanied by an appropriate reaction, can contain the damage and stabilize endangered works until they can receive appropriate conservation treatment.

Such a risk management policy should be concretely expressed in an emergency plan whose objectives cover the aforementioned points. The first of these is preventive; that is, the emergency plan lists periodic checks and maintenance tasks (detection and security systems, etc.) to decrease risks. The second objective is to ensure that the personnel have the necessary information to prevent a catastrophe. The final objective is curative; in the event of a disaster, the emergency plan provides the basic actions and emergency tasks to be accomplished in order to rescue the artifacts. Of course, the goal is to safeguard the physical integrity of the collection but also to maintain its organization. Recovering artifacts that have lost their indexing or accession numbers can delay reopening and may devalue the collection.

TABLE 52

Constructing an emergency plan.

Phase	Action
1. identification	determine the nature of the hazards:
	• topographic: sudden flood, forest fire, earthquake
	• climatic: storm, lightning, rain, humidity
	• location and access: pollution, vandalism, terrorism
2. evaluation	evaluate the severity and probability of hazard based on structures and collections
3. prevention	evaluate optimal prevention systems for human and/or automatic monitoring
4. action	plan for the safety of people and collections:
	• assign tasks and responsibilities
	• prioritize tasks
	• set up salvage and recover procedures

Thus the instructions contained in emergency guidelines can limit the misguided initiatives that often occur in a panic situation. They provide clear, detailed, and organized information on the "first aid" to be provided to collections (Table 52).

There are numerous North American examples that may be used as source documents and customized to meet the individual needs of each collection.[5] The lessons that may be derived from the sometimes hard experiences of other institutions can further sensitize the various participants to the risks. Institutions would do well to distribute the contents of their plans very widely to the personnel in charge of collections. This distribution should be accompanied by training, and those personnel who will be responsible for certain actions should receive specific training. It is important also to train the staff in the implementation of the plan, as no one will be taking the time to read a detailed plan during a disaster. Although flexibility is essential (since disasters never go the way we may have planned), these training sessions should be repeated once each year so that some of the basic responses become second nature.

Most large institutions have a specialized crisis intervention team. The team can inform firefighters of priority areas in the event of a fire, for example, the location of the most valuable holdings, and proper handling procedures.

Monitoring and Maintenance

Collections should be monitored through regular inspections of the holdings and their environment (Table 53). This work must be conducted methodically. It may be guided by a form describing each task, with blank space provided for reporting the results of the inspection or for comments.[6] The inspection report should lead to specification of urgent actions needed, if applicable.

Infrastructure
Monitoring and maintaining storage areas and buildings are basic preservation measures. Such tasks, which are all too often neglected, require frequent

TABLE 53

Monitoring air quality in storage areas.

Type of Measure	Factor	Frequency
measuring contaminant levels	microorganisms	regular
	corrosiveness of air (pollutants)	constant
	dust	regular
measuring temperature and humidity	temperature	constant
	humidity	constant
kinetic measurements	air velocity	regular
	air renewal	regular

and attentive examination of the building infrastructure, to detect water seepage, defective gutters, and so forth. Inspection, testing, and maintenance of security systems (theft, fire, flood) need to be planned.

Environment

The air quality in storage areas must be monitored. In sophisticated climate control systems, electronic sensing devices constantly report temperature and relative humidity variations to a central processing unit, sometimes with an audible alarm system and a modem connection to alert the person on call in the event of a problem.

In the absence of a monitoring system, temperature and relative humidity conditions must be checked on a regular basis, recorded, and analyzed. The measurement devices should be verified regularly and calibrated if necessary (Fig. 78). Filtration units, air ducts, humidifiers, and dehumidifiers must be inspected and cleaned regularly. There is a risk of accumulation of mois-

FIGURE 78

Calibration of thermohygrometers.

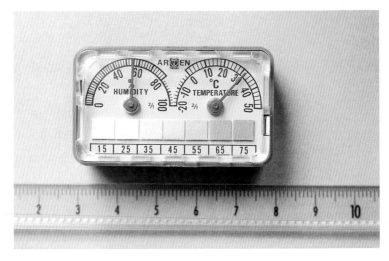

ture and dust in the air-conditioning system that promotes colonization by microorganisms. These could contaminate all climate-controlled areas and result in the "sick building syndrome." Specialized companies are usually hired to maintain climate control systems and, particularly, to clean ducts. However, it is important to know about the corrosion inhibitors or bactericides and fungicides that such companies may use, since some of these products (such as Hatacide 19) are corrosive to silver materials.[7] Placing a doormat at the entrance to the building is a simple and effective means of eliminating a large portion of the dust carried on the soles of visitors' shoes. Its effectiveness is linked to its size, and one 3-meter-long mat or two 1.5-meter-long mats are recommended. Electrostatic or sticky mats may be placed at the entrance to storage areas. As with all systems, the mats require maintenance and eventual replacement to remain effective.

It is not advisable to wash floors with copious amounts of water, which is a source of moisture, or even to sweep them, which disperses particles. Dust should be removed from storage areas at least once a year with a vacuum cleaner, and it is highly recommended that vacuum cleaners be equipped with HEPA filters to avoid dispersing microorganisms throughout the storage areas. Shelves should be dusted with electrostatic cloths. Appropriate cleaning products should be used; those that contain organic solvents or ammonia (see Table 41) can damage photographs.

FIGURE 79

Isoperm diagram for an organic material (e.g., cellulose), calculated for activation energy of 100 kJ.

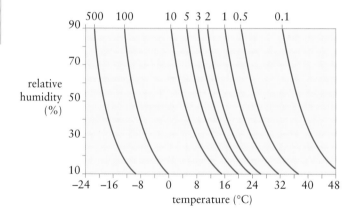

Curve 1 was selected as the reference curve. As we move along that curve, the life expectancy of the materials is the same as if they were preserved at 20°C and 50% RH. On curve 5, the life expectancy is five times greater. However, on curve 0.1, the climatic conditions are such that the life expectancy is divided by 10.

Isopermanence curves

Isopermanence curves are invaluable tools for analyzing environmental conditions and their repercussions. They serve as guides when one makes choices about or changes temperature and relative humidity conditions in storage areas. They provide a quick overview of the effects of relative humidity and temperature on the stability of materials. Isopermanence curves are equally applicable to paper,[8] motion picture film on cellulose triacetate bases,[9] and magnetic tape (Fig. 79).

In these graphs the x axis represents temperature and the y axis represents relative humidity. The graph contains a set of curves, each of which indicates the life expectancy of a given material. As we move along a curve, varying the temperature and relative humidity, the life expectancy of the material remains the same, hence the name "isopermanence curves." Thus we can quickly determine how many degrees to lower the temperature in order to maintain the stability of a material when the relative humidity increases and vice versa. For any decrease in temperature, the improvement in stability can be immediately assessed. By processing these data on a computer, it is possible to measure the impact of cyclical, daily, or seasonal variations and thereby determine the best archiving location in a building.

However, values calculated based on isopermanence curves should be considered useful theoretical information for comparative purposes only. In

fact, the curves are established based on simplified mathematical models and extrapolations that do not always reflect the complexity of deterioration reactions under extreme climatic conditions. With certain materials, the chemical reaction sequences that come into play during deterioration may change depending on the relative humidity level. Giles and Haslam, for example, showed that the deterioration mechanisms of dyes in color photographs are different, depending on whether the relative humidity is low or high.[10] Furthermore, the potential for biological deterioration linked to excessive relative humidity is not factored into these calculations. Finally, it is possible that theoretical calculations may indicate a marked improvement in the longevity of artifacts when there is a regular decrease in temperature, but we know that major temperature and relative humidity cycles can cause physical degradation in photographs or objects.

The Image Permanence Institute offers several practical tools for analyzing storage conditions based on isopermanence curves (see http://www.climatenotebook.com). One of them, the Preservation Environmental Monitor (PEM), constantly records temperature and relative humidity variations and calculates the corresponding stability of a reference material (cellulose triacetate). This value, expressed as a number of years, is called the Permanence Index (PI). Since storage conditions change in an area that is not climate controlled, the PI changes regularly. The PEM then establishes the average PI, which is known as the Time Weighted Preservation Index (TWPI). After one year, the influence of the storage conditions on the life expectancy of the collection can be clearly seen and compared from one storage area to another. This is also a decision-making tool.[11]

Photographs

The standards (ISO 18911, 18920, etc.) recommend inspecting collections every two years. This can reveal changes in the deterioration of photographs and lead to modification of their storage conditions or to the development of a duplication program. For large collections, of course, there is no question of reviewing all of the images, so a representative sampling from the various lots of photographs from different periods or provenances is studied.[12] Particularly sensitive artworks should also be regularly inspected, and if it is desirable to monitor changes in deterioration, baseline samples identified during the initial inspection can be subsequently reexamined.

Monitoring photographs The monitoring of photographs is intended to identify deterioration of the image or its enclosure. Visual examination is sufficient when changes—deformation of bases, delamination, discoloration, microorganisms, staining, silver mirroring, and so on—are extensive. Hydrolysis of triacetate bases may be characterized using A-D Strips (see Fig. 50). A density change is not always visually detectable or quantifiable. In that case, it is necessary to use an appropriate device, such as a densitometer, colorimeter, or spectrophotometer. Further, densitometry and colorimetry readings are very useful for monitoring the effects of treatment, exhibition, and loan on the artworks.[13] Many major art museums and other lending institutions take densitometry measurements of photographic prints before and after traveling exhibitions (Fig. 80).

The two difficulties with this method are locating the exact same measurement areas and the reliability of the measurement device over time. First,

FIGURE 80

Measuring the optical density of a photograph after exhibition.

it is necessary to ensure that the readings are always taken at the same areas on the image, since a slight shift can distort the results. Measurement ranges are located using as a template a sheet of polyester (PET) with small circular holes whose diameter is equal to the aperture of the measuring instrument. Minimum, middle, and maximum density areas, as well as representative colors in a color image, are selected. To be sure that the polyester is correctly positioned during subsequent measurements, several characteristic shapes from the photograph are drawn on the PET sheet with a marker. Over the years, some conservators have found that when there are several users, it is preferable to cut a square hole and do the alignment by matching the four cardinal points on the instrument with similar markings on the PET.

When measurements are taken several years apart, the device must be properly calibrated, so that its aging or replacement does not interfere with the measurements. It is necessary to have stable samples to use as a reference; there are ceramic tiles and enamel plaques designed for that purpose. Colored photographic patches may be used as a reference but must be kept in cold storage and then removed when needed to check the calibration of the device.

With the advent of digital technology, it is much easier to locate ranges and take measurements. After digitization, it should be possible to obtain tristimulus values for any portion of the image. These are fully locatable provided the scanner was calibrated before scanning. This method has given good analysis results with paintings.[14] It has yet to be applied to photography.

Color images are usually measured using the densitometer's blue, green, red, and visual filters. For black-and-white photographs, the visual filter and blue filter are sufficient (provided that the print is not toned or tinted). Spectrophotometry provides a more complete set of data (curves) but, conversely, is more difficult to use than densitometry.

H. Wilhelm has suggested deterioration thresholds that should not be exceeded for color prints.[15] For example, in a neutral gray scale with a density of approximately 0.45 (or within a range of 0.35 to 0.60), the loss of density as measured with the densitometer's red, green, and blue filters should not exceed 0.04, 0.04, and 0.06, respectively. In areas of maximum image density (dark areas), these variations, expressed as a percentage, should not exceed 9%, 9%, and 13%. With respect to discoloration (staining) of the light portions of the image (minimal density), this should be limited to a gain in density of 0.04 (red and green filters) and 0.08 (blue filter).

However, evaluation of the deterioration of a color photograph cannot be limited to these measurements, since the respective ways in which dyes break down can have synergistic or compensatory effects. Therefore, variations in color balance should also be taken into account (Table 54).

Surveying a collection

A collection may be examined for several reasons, for example, to determine the types of photographic processes, the size of the collection and its state of preservation, or to monitor deterioration processes (Fig. 81). Such determinations are crucial but problematic when the collection is composed of a considerable number of photographs that cannot undergo an exhaustive examination. In that case, a representative sample should be selected that will provide an idea of the entire collection. It is always preferable to hire a statistician to establish a procedure and to analyze the results. Some simplified procedures have been standardized, but they are not entirely error-free.[16]

TABLE 54

Maximum allowable deterioration of color photographs (according to H. Wilhelm).

Optical Density of Measured Area	dD Red	dD Green	dD Blue	Red/Green Density	Red/Blue Density	Blue/Green Density
neutral gray D = 0.45	≤0.04	≤0.04	≤0.06	$D_{n\,(r-g)} \leq 7\%$	≤11%	≤11%
D_{max}	≤9%	≤9%	≤13%	$D_{max\,(r-g)} \leq 7\%$	≤11%	≤11%
D_{min}	≤0.04	≤0.04	≤0.08	$D_{min\,(r-g)} \leq 0.03$	≤0.04	≤0.04

* dD = difference in density, before and after deterioration.

$$D_{n\,(r-g)} = \frac{100 \times (Dr - Dg)}{0.5 \times (Dr + Dg)} \;;\; D_{max\,(r-g)} = \frac{100 \times (Dr - Dg)}{(Dr + Dg)} \;;\; D_{min\,(r-g)} = (Dr - Dg)$$

FIGURE 81

(1) Paper negative (calotype) with (2) its period print (salted paper) and (3) a later nineteenth-century print (aristotype). Monitoring collections and their storage conditions makes it possible to prevent deterioration.

© Pillet Collection, Collège de France

1

2

3

Several recommendations may limit the most common errors. First, the purpose of the operation must be defined (e.g., determining the condition of the collection, quality control of the environment, recommending priority actions, establishing the frequency of inspections). Depending on the goal, we then take stock of the variables to be analyzed (e.g., silver mirroring, mold growth, abrasions, enclosure condition, formats) by filling out a standard questionnaire. The questions should be simply and easily answerable (yes/no) to avoid too much interobserver variation, or reference photographs should be established to characterize a deterioration scale. The few examples of statistical studies that have been conducted by cultural property institutions involve archives, collections of books,[17] film, microfilm,[18] and photographs.[19]

Sample selection Samples may be selected systematically, that is, by selecting items at regular intervals, or randomly. The latter technique, which is the most frequently used to analyze collections, consists of choosing a certain number of samples at random. For example, if a photographic library includes ten thousand images numbered from 1 to 10,000, images are arbitrarily selected by drawing lots numbered from 1 to 10,000. Fairly simple computer programs can be developed to establish a random list of images to be examined.

Large collections, which are generally formed by combining holdings of different origins and types, are rarely uniform. To prevent over- or underrepresentation of specific holdings when doing random sampling, a technique called stratified sampling is used. Each holding is handled separately and the number of samples taken is proportional to the size of the holding.

Number of samples The number of samples to take is the first issue to address in this type of analysis. Actually, this depends on the desired confidence interval and tolerance. The meaning of these terms may be summarized as follows. For example, if a statistical analysis indicates that the quantity of images in poor condition in a collection equals 12% with a tolerance of ±5% and a confidence level of 95%, that means that if the same sampling is repeated twenty times, nineteen of those times we will find that between 7% (12% − 5%) and 17% (12% + 5%) of the photographs have deteriorated.

To determine the optimal sample size, it is best to know the approximate condition of the collection. Thus when a previous sampling or study indicates that 20% of the photographs in a collection meet the criteria, we can see, by referring to Table 55, that 256 random samples must be selected in order to determine, with ±5% tolerance and a confidence level of 95%, the percentage of affected images in the entire collection. Conversely, if after examining 400 samples from a collection, we find that 20% are damaged, the percentage of deteriorated images will be between 16% and 24% (with a confidence level of 95%), as shown in Table 55.

Conservation Treatment

Conservation treatment of photographs relies on the same philosophical and ethical principles as are used in other conservation disciplines, including the use of conservation methods and materials that to the best of current knowledge do not adversely affect the photograph or its future examination,

TABLE 55

Number of samples to take and accuracy
(for a 95% confidence interval).*

Accuracy	Percentage†					
	5%	10%	20%	30%	40%	50%
±0.5%	7,600	14,400	25,600	33,600	38,400	40,000
±1%	1,900	3,600	6,400	8,400	9,600	10,000
±2%	475	900	1,600	2,100	2,400	2,500
±3%	211	400	711	933	1,066	1,111
±4%	119	225	400	525	600	625
±5%	(76)	144	256	336	384	400

* P. Ardilly, Les techniques de sondage (Paris: Éditions Technip, 1994).

† Estimated percentage of items in the population in question.

scientific investigation, or treatment. Conservation treatments must be judged suitable for preservation of the aesthetic or physical characteristics of the photograph. Compensation for loss should be carefully documented and detectable by common examination methods, and the unique character and significance of the photograph must be considered. Damage repair that may appear simple to the uninitiated is typically the result of a complex decision-making process. Cultural artifacts such as photographs are not simple objects. They have intangible values that interventionist actions may ruin forever. The value of photographs is not limited to the visual content of the image; the photograph is physically embodied in the artifact.[20] All the materials play a role in the visual appraisal. The thin structure of an albumin paper and the surface texture of the print have an impact on our image perception that is very different from the effect of a modern D.O.P. or a salted paper photograph. C. Brandi expresses this by making a distinction between two types of fundamental elements, material as structure—the component materials—and material as appearance, encompassing the essence of the object.[21] This dichotomy is not clearly visible, and interactions between the two are constantly evolving. Material as structure has reality not only in space but also in time and evolves through a natural aging process and as a result of use. Some photographs may fade, while others may exhibit silver mirroring or be degraded by being mounted on a poor-quality board. Many such changes are unique and inseparable from a specific photograph's history and may contribute to its cultural, sentimental, or evidential value. The mark of time must be accepted and if, unlike G. Salles, who "often preferred to the precise individuality of the new object, the faded piece that age has condensed into its essential form,"[22] we cannot appreciate it, we must respect it. So the conservator's task can be a complex one. It is an operation that is never purely technical or manual, and, above all, it is one that requires critical evaluation in order to reestablish the unity of a work by respecting the subtle balance between aesthetic and historical requirements. It is even less a return to an idealized original condition. The changes that objects undergo are mostly irreversible processes.

In his presentation, "Science and Conscience," to conservation students at the Institut de formation des restaurateurs d'oeuvres d'art, France (IFROA), in 1993, Georges Brunel defined these basic concepts to perfection:

> Objects and monuments also require physical care. We call those whose job it is to provide such care conservators. A belief that one only need know the techniques used to produce artworks in order to be able to fully or partially restore them, if necessary, is an exceedingly superficial view of the conservator's trade. Their work is of a different nature entirely, since it is necessary to affect the physical composition of the objects, and possibly to modify it, while respecting the values associated with them. The task is all the more tricky in that these values do not necessarily match well. Placing too much emphasis on the value of age (the charm of a ruin) or on historical value (the interest of the document), for example, has the potential to result in sacrificing artistic value (the pleasure of contemplating an uncompromised object), and vice versa. Therefore, more than physical work, restoration is a resolve to strike a balance among the various values of the object. It follows that a dialog between art historian and conservator is a necessary condition for any act of conservation treatment, including doing nothing.

In an institution, photographic conservators play an essential and complex role. Their task is not limited to working on photographs but encompasses advocacy for photographs and their preservation while recognizing and supporting the needs of access. Conservators must adhere to a code of ethics found in the bylaws of various associations, such as the International Institute for Conservation or the American Institute for Conservation of Historic and Artistic Works. Conservators' knowledge of photographic processes and the inherent fragility of photographs makes them invaluable participants in the preventive conservation, exhibition, and documentation of these artworks. They play an active role in evaluating needs and in informing the public as well as institutions. This broadening of the conservator's mission is a profound sign of the evolving mind-set that is leading a new generation of practitioners to lay claim to the status of conservator (in some countries, conservator-restorer) to express their preservation mission, rather than seeing themselves as restorers having a more focused mission on a specific object-related problem.

Photograph conservation is a discipline that is taught in specialized curricula at universities and other schools. It is a several-year program through which students acquire knowledge, skills, and abilities.[23] The subjects studied are varied and include art history, physics, chemistry, re-creation of historical photographic processes, and hands-on application of conservation techniques (Fig. 82). While the role of the photographer as restorer is historically recognized, great damage can be wrought by individuals not fully aware of the repercussions of their actions. This includes the use of chemical treatments, which are ethically questionable and should be implemented only in exceptional cases. Photographs are composed of a delicate balance of different materials whose composition changes over time. Decisions about treatments, even if some types may seem harmless, are the purview of a conservator. Images that require direct action are studied on a case-by-case basis. There are standards in treatment but no standard treatment for any one object. A

FIGURE 82

Photograph conservators receive specialized training in museums as well as in universities. Here, a photograph conservator supervises an intern, at the J. Paul Getty Museum, in Los Angeles.

TABLE 56

Examples of treatments requiring the skill of a restorer.

Priority actions
treatment of mold
consolidation of peeling
treatment/elimination of poor-quality tape and adhesives
treatment of severely damaged supports and mountings
Secondary actions
cleaning of photographs and mounting substrates
flattening of prints
Actions for exhibition
compensation of loss, inpainting
cleaning of surfaces
mounting

conservator makes a diagnosis in writing, accompanied by a treatment proposal (Table 56). Some photographs are simply physically stabilized, while others may undergo more radical treatment. Whatever the case, all treatments must respect the integrity of the artifact.

Intervention should be minimal and in accordance with certain principles. Actions of an aesthetic nature (compensation of loss, inpainting, etc.) must be fully documented and should be detectable by common examination methods. The added materials must be tested for short- and long-term safety to photographs and must be removable without causing damage. Each treated work should be documented by a conservation report that itemizes the methods and materials used and, in some cases, photographs showing the condition of the work before, during, and after treatment, as well as recommendations for its preservation.[24]

Lending and Shipping

Lending of photographs for an exhibition should be subject to certain requirements intended to ensure their protection, but not to utopian restrictions.[25] Many institutions use lending agreements. These include a physical description of the work and its condition, as well as a list of provisions with which the borrower agrees to comply. They specify provisions such as courier requirements; responsibility for expenses; insurance; conditions for shipping, storing, exhibiting, reproducing, and disseminating the work; a commitment not to remove framing, dismantle, or treat the work without the express consent of the lender; and so on. By signing such an agreement, the borrower is bound to comply with its various provisions.

Condition report

A condition report is part of the permanent documentation that must accompany an exhibited photograph. It includes a descriptive portion—the "identification card" of the work—and regularly updated information about condition, conservation treatment, loans, and exhibitions. Each institution

develops its own condition report, in hardcopy or electronic format. It includes the following points:

- name of the artist, title and description, date of acquisition, provenance
- dimensions, type of photographic process, mounting
- state of preservation, presence of deterioration
- records of prior conservation treatment
- previous exhibitions, duration, light exposure

The condition report contains the results of densitometry or colorimetry measurements performed on the work as well as the results of any analysis (XRF, FTIR, GC/MS, etc.) or other tests (solubility, etc.) that have been performed. This makes it easier to detect any change in the photograph after exhibition or shipping. If damage is observed, future lending agreements should be modified accordingly.

Packaging for shipment

Framed works are shipped in appropriate containers that protect them from physical impact and vibration due to handling or shipping[26] and that also serve to attenuate variations in temperature and relative humidity (Fig. 83). During shipping over long distances—in airplane baggage holds or trucks, for example— and during storage in transit, there can be extreme variations in climatic conditions, causing thermal shock and the potential for condensation.

FIGURE 83

During shipping, artworks should be protected with specially designed packaging.

Wooden crates are widely used, since they can be made individually in a customized format for the artifacts. It is advisable to coat the inside of the crate with a barrier layer of varnish or plastic/aluminum foil laminate film to protect the work against emanations from the wood[27] (see p. 58) and against ingress of moisture. If seals are needed, silicone with no acetic acid should be used. A safe solution consists of wrapping or sealing the objects in bags. It is also possible to use ready-made aluminum or polypropylene cases, which are lighter and do not have the drawbacks of wood but are quite costly and may be limited in size.

Traveling crates must be thermally insulated by a double wall containing expanded polystyrene or any other substance with low thermal conductivity that does not produce harmful emanations.

The works should be protected from impact and vibrations by immobilizing them with synthetic foam shims or pads.[28] A group of framed photographs with the same format may be inserted vertically and maintained by a system of wooden slots or a polyethylene foam spacer system (Ethafoam, Dow Chemical). Polyurethane, neoprene, and PVC foams should be avoided.

Relative humidity should be regulated with silica gel or similar substances, but the container must be sufficiently impermeable to minimize ingress. Silica gel is sold in nonwoven pouches (polyethylene/polypropylene) or cartridges, and it must be preconditioned for the desired level of relative humidity inside the crate. This conditioning has been simplified by the advent of products such as ArtSorb®, which is conditioned simply by adding the quantity of water specified by the manufacturer. The weight of silica gel to be inserted is based on the volume of the space to be treated and the type of gel. With ArtSorb®, approximately 750 grams of dry granules per cubic meter are needed.

Pollution control is achieved through impermeable packaging and ensuring that there is no internal source of contamination. As a precautionary measure, a liner board such as MicroChamber® (see p. 53) may be used. It is risky to use an adsorbent such as activated charcoal, since there is always a possibility that if the packaging breaks due to an impact, it may spill carbon black particles. It is less risky to use molecular sieves of the same type used for film preservation.

Data loggers

A number of different indicators may be placed in the crates to monitor and provide a record of shipping conditions. Electronic temperature and relative humidity recorders (see p. 93) are now commonly used for this type of monitoring. When the works arrive at their destination, data are downloaded to a computer for analysis. The same type of equipment exists for recording any impacts or upending of the packages. There are also irreversible relative humidity and impact indicators, which are simpler and less expensive and which make it possible to determine whether the works experienced any adverse conditions, but they cannot indicate the duration or frequency of such conditions.

DISASTER RESPONSE

Fire, water, and biocontamination pose serious threats to collections. In the worst cases, the damage is compounded. For example, the water used to extinguish a fire may flood the collections, leading to mold growth.

Fire is, first and foremost, a matter of prevention (see p. 73). Fire safety measures are already subject to stringent regulations. Safety instructions, including emergency telephone numbers, evacuation plans, and priority actions, should be conspicuously posted and rehearsals planned. Water damage prevention should also be subject to the same measures.[29]

Water Damage

Drying a facility

Once water is evacuated, possibly using pumps, the facility should be dried as quickly as possible to avoid mold growth. Using ventilation and aeration is preferred. Turbodryers provide the best drying control. This system is commonly used in the construction industry to accelerate the drying of construction materials and after flooding. Mobile drying units may be leased and installed outside the building. The air, which is dried by passing it through a

FIGURE 84

Drying a storage area after a flood.

Photograph: Munters

dehumidifier, is blown into different segments of the building through ducts. Smaller units may be placed directly in the damaged areas (Fig. 84). Air movement using ventilation or natural air convection can also limit mold development by speeding up the drying process.

Rescuing soaked photographs

Vulnerability of photographs Photographs contain hydrophilic materials. In the presence of water, the paper and gelatin expand and weaken, and the inks and dyes bleed. Damage varies depending on the immersion conditions and the state of the photographs. In the worst cases, with old, brittle photographs on an acetate or cellulose nitrate base, or if the temperature is elevated as a result of a leak in a hot water pipe, for example, the gelatin softens and may solubilize. Deteriorated acetate and nitrate bases, collodion plates, and autochromes cannot withstand prolonged immersion. Paper prints are more vulnerable than negatives on a flexible base. Color photographs may be severely damaged. With certain processes, such as Dye-Transfer prints or ink-jet prints, the dyes bleed in the event of immersion. This is also the case with the cyan and magenta dyes in Ilfochrome Classic prints (Table 57).

 After a fire or flood, it is necessary to act rapidly to prevent wet photographs from developing mold and to keep photographs from sticking together or irreversibly adhering to their enclosures (Fig. 85).

Preliminary operations Under the supervision of a photograph conservator, the most vulnerable photographs should be given priority treatment by individual air drying.[30] When photographs have been soiled by dirty water, they should be rinsed in cold water (preferably distilled water at a temperature of less than 18°C). It has sometimes been recommended to harden gelatin emulsions with a 1.5% formaldehyde solution (this product is carcinogenic)[31] or to apply stabilizer baths to chromogenic slides. However, there is a dearth of experience in this area, and it is better to avoid questionable treatments without the advice of a conservator.

 Prints should be naturally air dried on blotter paper, polyethylene racks, or sheets of blank newsprint paper, image side up (Fig. 86). Touching the surface of the image should be avoided. The area should be well ventilated and protected from dust. Negatives on flexible bases (polyester, acetate, etc.) should be unrolled or removed from their jackets and hung to dry. Film wound on reels (microfilm, motion picture film, etc.) may be rinsed in cold water and dried in a motion picture film processor if its physical condition allows such mechanical treatment. In no event should film be allowed to air dry wound on reels. Sheet film should be dried vertically. Glass mounts should be removed from slides (Fig. 87).

TABLE 57

Resistance of photographs to accidental immersion.

Resistance to Immersion	Process	Treatment
	autochromes	immediate air drying
	color dye imbibition prints (Kodak Dye-Transfer or Fuji Dyecolor)	
	ink-jet prints	
very sensitive, rapid degradation	collodion glass plate prints (negatives, ambrotypes)	
	ferrotypes	
	stabilized black-and-white prints*	
	Cibachrome (Ilfochrome Classic)	
	deteriorated photographs (gelatin attacked by microorganisms, deteriorating acetate and nitrate bases, etc.)	
	monochrome carbon or pigment color prints	air drying or freezing
	color photographs	
	gelatin silver glass plate negatives	
	black-and-white silver prints on RC paper	
less sensitive, better resistance	black-and-white gelatin silver prints on baryta paper	
	acetate and polyester negatives, 19th-century prints	

* Black-and-white photographic process dating from the 1940s, in which the processing sequence was shortened by incorporating developing agents into the paper.

FIGURE 85

In the event of disaster, it is important to protect the collection from disorganization.

Freezing The operations described above require work space and labor and are not always practicable. Therefore, after the photographs are rinsed, if needed and possible, it is advisable to group them in tightly closed polyethylene bags and place them in a freezer or quickly send them to an industrial firm for freezing. If trained staff are available, the photographs may be kept separate with waxed or silicone-coated paper, which will facilitate subsequent recovery operations.

Recovery As trained staff become available, photographs should be thawed at room temperature. As soon as they are unfrozen and flexible, they should be separated and naturally air dried. Freeze drying, which consists of placing the frozen prints (−21°C) in a vacuum for several days to sublime the ice, is not recommended, because it may cause a whitish veil to develop on the photographs. Nevertheless, in extreme cases, when there are no other suitable solutions, it is a possibility to consider. Frozen photographs should not be vacuum dried at a temperature greater than 0°C, since this would cause the photographs to adhere to one another.[32] Regardless of the chosen recovery technique, the

FIGURE 86

An attempt to save photographs after a flood.

FIGURE 87

Emergency treatment procedure for photograph collections after a flood.

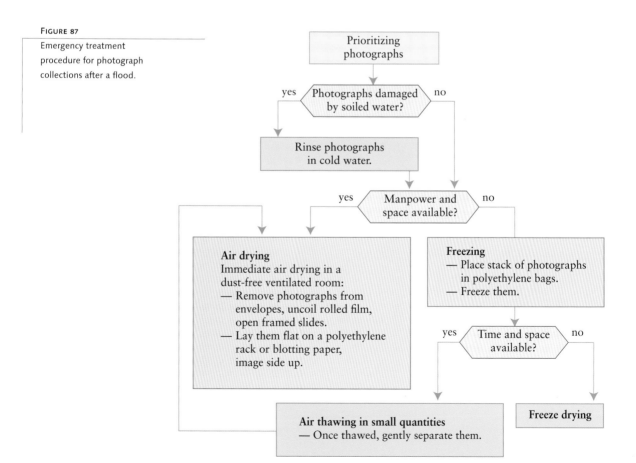

FIGURE 88

FIGURE 88

Photographs freeze-dried after a flood. Some deformations and surface changes may occur. However, this technique made it possible to dry a large number of water-damaged prints after freezing them and also prevented them from adhering to one another.

prints will be physically distorted and a conservator will need to put them through a relaxation treatment to regain planarity (Fig. 88).

Rescuing water-damaged magnetic tapes[33]

In some audiovisual archives, photographs are stored along with magnetic media. Therefore, information about the precautions to take for such objects is provided here. Tapes that have been flooded should be gently agitated in ice-cold water to rinse away any surface dirt and then rinsed again in a fresh ice-water bath. The physical condition of the tapes permitting, they should be carefully, loosely rewound while still wet, preferably in a cool location. Since heat sources cannot be used, the tapes need to be dried in a vacuum chamber. This operation takes two to five days, depending on the format. The tapes should then be left for several days at ambient conditions to come to equilibrium. They should then be carefully rewound. Before attempting to read them, it is advisable to delicately wipe the surface of the tape. Tapes that have been immersed in cold water (at a temperature of less than 11°C) should not sustain much damage, but others may have serious adhesion problems.

Molds

Air contains suspended mold spores (properly known as conidia). The quantity of airborne mold spores in buildings varies, depending on the geographic location, the season, the dust accumulation in the rooms, and the internal climatic conditions. This may vary from a few dozen to several thousand spores per cubic meter of air. From 0.2 to 2 microns in size, spores mingle with dust. Furthermore, they commonly become bound to suspended particles. Air is therefore an important source of contamination in storage areas. However, such spores are harmful only when they settle on photographs under conditions favorable to their germination. Mold development then proceeds with the spawning of mycelia, followed by sporulation (Fig. 89). There seems to be no limit to the number of spores a mold can produce. As molds grow, they

FIGURE 89

Diagrammatic representation of the
life cycle of *Aspergillus* species.

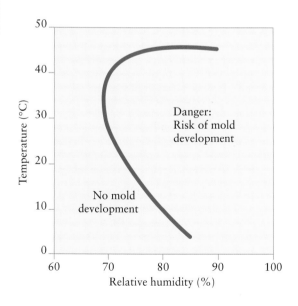

Conidia
maturation

Conidia

Germination

Sporulation
cycle

Mycelium

FIGURE 90

This curve, provided by Ayerst,[34] indi-
cates the temperature and humidity
conditions that promote the develop-
ment of mold on a nutrient substrate.

Danger:
Risk of mold
development

No mold
development

Temperature (°C)

Relative humidity (%)

release volatile metabolic by-products (mold volatile
organic compounds, or MVOCs) such as alcohols and
ketones, which may have a distinctive mushroom-
like or mildewy odor. Spores are organs of repro-
duction and propagation and may survive for
decades under extremely dry conditions.

Conditions for mold growth

Mold growth depends on the species and the strains,
as well as on various environmental factors (Fig.
90). However, the only really decisive factor in the
growth of such microorganisms is relative humid-
ity. When the ambient relative humidity is
sufficiently high, the cellular metabolism of the
spore is activated and a germination tube forms.
Once germination takes place, mold growth can
proceed at a lower relative humidity but not below
a certain threshold.

To grow, mold also requires nourishment.
The initial stages of mycelium formation occur using
reserves contained within the spore. These reserves
are very rapidly depleted, and the fungus must derive organic material from
the substrate on which it is growing. It also draws water—the solvent in which
all metabolic reactions occur—from the substrate. The amount of moisture that
can be extracted from a substrate (and promote the proliferation of molds) is
expressed as a water activity number. In fact, water activity (a_w) is a ratio of
the pressure of the water vapor above the substrate to the pressure of distilled
water vapor. Water activity is between 0 and 1. It is different from equilibrium
moisture content (EMC), which represents the mass of water contained in the
material. The majority of microorganisms grow on substrates whose water
activity is close to 0.99, and while some species may need less, the minimum
is 0.61, below which growth is impossible.[35]

Most types of molds proliferate at ambient temper-
ature. These are termed "mesophilic." While a lower tem-
perature may interfere with the growth of certain species
(termed thermophilic), it can promote the growth of oth-
ers (termed psychrophilic). Furthermore, air movement
inhibits the development of molds, so good ventilation lim-
its fungal growth.

A potential health risk to humans, mold is also a seri-
ous cause of degradation in still photograph and motion
picture collections (Fig. 91). Molds feed on gelatin, extract-
ing carbon and nitrogen through an enzyme hydrolysis
reaction that weakens the image layer and can destroy it
completely.

Of the fifteen species most frequently identified in
collections, the most representative belong to the genera
Aspergillus, Penicillium, Mucor, Rhizopus, Epicoccum,
and *Alternaria*.[36] Other strains have been isolated from
samples taken from various audiovisual materials.[37]

FIGURE 91
Mold on a
photograph.

Biocontamination of storage areas

Evaluating contamination in storage areas To determine the degree of bio-logical contamination and identify the species in the air and on surfaces, sam-ples should be taken from several locations. This operation is generally undertaken by a microbiologist but can also be performed successfully by trained technicians. When the storage facility is too large, it is divided into conceptual zones of 20 square meters. These are numbered and a certain num-ber of zones are selected at random for analyzing the biocontamination (NFX Standard 06-022).

There are several methods for identifying the type of mold present on shelves, boxes, and furniture, such as collecting spores by wiping the surface or by using various other methods. The simplest of these consists of sampling with a piece of scotch tape or swabbing the surface to be analyzed and then transferring the sample to a nutritive agar medium. After incubating for sev-eral days, the isolated strains can be identified by the microbiologist. Another variant consists of applying agar medium in a petri dish or on film (3M Petrifilm™) directly to the surface to be analyzed. The drawback of taking such samples resides in the random nature of the sampling. Several variables that are difficult to control, such as the surface texture and the amount of pres-sure that is applied, can affect the quality of the samples. In addition, this method does not provide quantitative information about the contamination level in the area since the settling of conidia takes an unknown period of time. Therefore, an analysis of the ambient air is done.

The simplest air analysis method consists of placing a culture medium (Petri dish or 3M Petrifilm™) in the open. Spores settle onto the medium by "sedimentation." However, this method gives only an approximate idea of

the contamination level. The precipitation of spores depends on their size (the lightest ones remain in suspension), the ambient relative humidity, and air turbulence. Therefore, this method cannot reliably establish the quantity of spores per volume of air. More reliable methods require a device to draw in air and then filter it onto a membrane (cellulose, fiberglass, or polycarbonate filter) or liquid medium, or precipitate it onto a medium (Air-O-Cell™ cassette, adhesive, etc.). Because of its simplicity of use and its efficiency, mechanical precipitation remains the technique most frequently used by specialists. A specific volume of air is pumped through a perforated opening at a high rate of suction. Behind the opening is a Petri dish containing an agar medium onto which the collected spores settle. There are several portable air sampling pumps on the market that use this principle, for example, the SAS Compact and Osi Ochlovar samplers and Merck MBV-MAS-100 Air Samplers (Fig. 92).

After several days of incubation, the spores develop, resulting in colonies that are visible to the naked eye and can easily be counted (Fig. 93). The airborne contamination level can then be expressed numerically as the number of colony-forming units per cubic meter (CFU/m^3).

Note, however, that certain factors bias this method. The suspended spore concentration is affected by different parameters, such as human activity and climate. For example, as the relative humidity increases, the apparent contamination level decreases. This may seem paradoxical, since, as we have seen, relative humidity promotes the growth of microorganisms. Apparently spores settle when weighed down by the water they have absorbed, whereas they are much more volatile in a dry atmosphere. Furthermore, the culture medium can be more favorable to the growth of certain species, while some others cannot be detected.

For these reasons, other methods for evaluating contamination are used or are currently being developed. Some experts collect airborne spores by pumping or by sedimentation and count their number using a light microscope, providing a TSC/m^3 value (total spore count per cubic meter). The time between sampling and obtaining results has led some biologists to experiment with faster techniques based on biological luminescence.[38] Collected

FIGURE 92

Analysis of the degree of air contamination using an air sampler (MAS 100).

FIGURE 93

Culture medium after inoculation and incubation. The colonies of microorganisms are visible.

microorganisms produce luminescence, if viable, by reacting with an enzyme. The quantity of light they emit, measured in relative light units (RLUs), is proportional to the degree of biological contamination. While this technique is used for bacteriological control in the food industry, that it works for molds has yet to be demonstrated.

Recommendations There are no standardized data specifying the acceptable level of biocontamination in storage areas. On average,[39] outdoor air contains from 1,000 to 10,000 CFU/m^3. T. Godish indicates that in residences the atmosphere is relatively uncontaminated when the level is below 100 CFU/m^3 and very contaminated when it is above 1,000 CFU/m^3.[40] A level below 500 CFU/m^3 can be achieved without too much difficulty by air filtration. However, maintaining a level below 100 CFU/m^3 requires more cumbersome methods.

Disinfection of facilities When contamination is deemed excessive, facilities can be treated with a fungicide. Before any disinfection treatment, it is advisable to remove collections in order to avoid all contact between the photographs and the fumigant. The dust is removed from floors and surfaces with a vacuum cleaner equipped with a HEPA filter; these are then cleaned carefully with a detergent solution to eliminate any adherent dirt and visible mycelia. No personnel should remain on the premises while the air is being disinfected, as all fumigants are a health hazard (Table 58).

Destruction of a microorganism is defined as rendering it incapable of reproducing when placed in conditions favorable to its growth. To be considered an active fungicide, the product must reduce the number of revivable spores by at least a factor of 10,000 (in other words, it must reduce the initial contamination by 99.99%). Before the product is marketed, its efficacy must be tested according to standardized procedures. A first series of tests verifies the product's fungicidal or sporicidal activity. Then it is tested for efficacy on surfaces such as glass, stainless steel, and plastic materials.[41] A product intended for air treatment should be tested according to current standards. Once all such tests have been passed, it is necessary to ensure that there are no risks to the objects or artifacts kept in the museum if any contact occurs. This is not an easy task and often requires investigation by a conservation science laboratory.

There are several broad families of active compounds that are used in facilities for their fungicidal properties. These include aldehydes (formaldehyde, glutaraldehyde, etc.), halogenated derivatives (chlorine, iodine compounds), phenols (thymol, orthophenylphenol, etc.), and quaternary ammonium.

TABLE 58

Airborne disinfection.

Method	Type	Principle
heterogeneous	directed spray	spraying a substance on a surface
	spray (aerosol spraying, fogging, nebulization, etc.)	dispersion of microdroplets (under 5 microns) into the atmosphere
homogeneous	vapor	vaporization by sublimation or boiling an azeotropic compound or mixture

Not all of these are suitable for use in storage areas. Quaternary ammonium is used to make solutions that have both detergent and fungicidal properties. Among the fungicides that have been used in archive storage facilities, libraries, and museums in France are Vitalub QC 50 (a benzyl dimethyl ammonium chloride product that is diluted to 2% in water) and thiabendazole. These products are dispersed into the atmosphere in a fine spray.[42] Maximum efficacy is achieved with droplets of between 1 and 2 microns in size; the product remains suspended in the air longer and thus gains in efficacy. There is currently some interest in using essential oils extracted from plants such as rosemary, thyme, pine, eucalyptus, and citronella. These natural essences contain phenol and terpene derivatives, which have antiseptic, bacteriostatic, and fungistatic properties.[43] They are used in hospitals,[44] and studies are being done to determine whether some may be used in storage areas through encapsulation techniques that would allow their active ingredients to be released slowly into the air. Studies have not yet been done on the safety of all of these chemicals for use in collections or on the problems related to their residues.

Biocontamination of photographs

Detecting microorganisms on photographs　　When seeking to determine the source of degradation or suspicious marks on a photograph, it is necessary to take a sample to verify whether there is microorganism growth. Nondestructive sampling consists of taking a smear with a sterile platinum loop or cotton swab, which is used to seed a culture medium. After incubation (21 days at 25°C), colony growth on the medium confirms the viability of the spores and the biological contamination of the work (Fig. 94). The species are identified by examining them under an optical microscope. The samples may be taken by the museum staff themselves, thanks to commercially available swabs. The swabs must then be quickly sent to a microbiologist for culturing.

Fumigation of photographs　　Developing a treatment that is both effective against microorganisms and harmless to humans, the environment, and photographs seems an impossible feat. Physical treatments, whether they make use of heat or electromagnetic radiation (ultraviolet rays, gamma rays, or microwaves), have not provided satisfactory results so far. The conditions necessary to the destruction of microorganisms are such that the photographs themselves are damaged.

Numerous chemical treatments have been tested for reduction of mold on artifacts. These are generally alkylation agents (formaldehyde, ethylene oxide), organobromines (methyl bromide), quaternary ammonium, or phenol derivatives (thymol, orthophenylphenol, etc.) (Table 59). The latter, which have long been recommended for graphic documents, are not very active on spores, and their safety for photographs does not seem certain. Therefore, quaternary ammonium products, such as zinc fluorosilicate and Hyamine 1622 (Röhm & Haas), have been recommended for disinfecting photographs. Hyamine 1622, which is apparently usable on black-and-white images, is harmful to certain color photographs, since it reacts with cyan dye. Zinc fluorosilicate does not appear to be harmful to photographs, whether black-and-white or color.[45] Nevertheless, these compounds are applied by artifacts being immersed in an aqueous solution, and water has the potential to cause serious damage if microorganisms have rendered the gelatin soluble. Furthermore,

FIGURE 94

(1) Surface sampling from an artifact
for biological testing. This consists
of doing a smear with a sterile swab and
then inoculating the culture medium.
(2) View of culture medium after
incubation.

1

2

TABLE 59

Disinfecting photographs.

Disinfection Agent	Method of Application and Action	Advantage	Disadvantage
ethylene oxide (and propylene oxide)	gas fungicidal, bactericidal, insecticidal	• broad spectrum of action • no apparent danger to artworks • mass treatment	• potential action on proteins (alkylation) • not advisable for wet materials • toxic to humans; use is regulated • extensive retention by plastic materials **Prohibited in many countries**
formaldehyde	gas or solution bactericidal, fungicidal	• formerly used in photography as a hardening or stabilizing agent in certain chromogenic processes	• toxic to humans • produces formic acid • reacts with proteins • does not penetrate as well as ethylene oxide **Not recommended**
phenol derivatives (thymol, orthophenyl-phenol, etc.)	fumigation (by sublimation) or spray fungicidal		• not much action on spores • damages artworks **Not recommended**
methyl bromide	gas fungicidal and insecticidal		• toxic to humans • interaction with organic materials and retention • poor fungicidal activity **Not recommended**
radiation: high-frequency, microwaves, UV rays, gamma rays, electron beams	irradiation fungicidal, insecticidal, bactericidal	• no by-products	• cumulative effects • side effects: radiation interacts with organic materials and can cause deterioration (depolymerization) • no studies on disinfection of photographs **Not recommended**

these compounds have the drawback of not being usable for mass treatments. Of the fungicide treatments that are still used in some countries, such as France and Italy, ethylene oxide constitutes the most acceptable compromise, but its use is prohibited in such countries as the United States. The current reluctance to use it is based on the health hazards to users.

Ethylene oxide, or oxirane, is a powerful fungicidal, bactericidal, and insecticidal gas. It is very toxic to humans and is a suspected carcinogen. In addition, it is highly reactive and can burn or even explode at a concentration of greater than 3% in the air. Its handling and discharge into the atmosphere are therefore strictly regulated. It is used diluted in an inerting gas such as nitrogen or a hydrochlorofluorocarbon (HCFC) (Table 60). Objects are sterilized in an autoclave under low pressure to avoid gas leakage. The treatment is conducted at room temperature (approximately 20°C) with a relative humidity level of 50% in the autoclave. Ethylene oxide, at a concentration of 500 g/m^3, is placed in contact with the objects for six hours, and the gas is then evacuated. The objects must then be air-scoured to eliminate the residual ethylene oxide. After treatment, the residual ethylene oxide in the chamber that otherwise would be discharged into the atmosphere is trapped by activated charcoal or hydrolyzed. It is also necessary to be careful about the residual quantity of gas in the photographs. This is essential for the safety of the users, and regulations on the subject are quite strict. In France, the residual ethylene oxide content in objects must be less than 2 ppm.[46] It is easy to lower the residual ethylene oxide in fiber-based photographs to less than 2 ppm by air scouring three times. However, in polymer bases, such as resin-coated paper and cellulose triacetate, retention is much greater[47] and requires ventilation of objects in an aerated location for at least thirty days.

To check the efficacy of the fumigation, there are biological indicators in the form of strips that contain spores of particularly resistant species (e.g., 3M Attest™, Raven Biological Lab Inc. Bacterial Spore Tests Strip). These strips are placed among the artifacts to be treated. After treatment, a fairly simple

TABLE 60

Deadlines established by the Montreal Protocol. In 1987 the Montreal Protocol and the provisions adopted during subsequent meetings established a calendar for the progressive elimination of compounds dangerous to the ozone layer. These new regulations also apply to the field of conservation, since certain treatments use such harmful products. For example, to replace chlorofluorocarbons (CFCs), less harmful products, hydrochlorofluorocarbons (HCFCs), have provisionally been adopted. Less stable than CFC, they break down in the lower atmosphere before reaching the ozone layer. While awaiting an entirely harmless product, we accept them as a transitional substitute, but their use should be limited to situations in which there is no substitute substance or technique.

Compound	Application	Phaseout	Substitute
CFC	inertant for disinfection with ethylene oxide	2010	HCFC-124
HCFC	inertant for disinfection with ethylene oxide, provisional substitute for CFCs	2030	—
halon	extinguishing agent	1994	FM-200 (Great Lakes), FE-13 (Du Pont), HCFC-123
1,1,1 trichloroethane	film cleaner	1996	trichloroethylene
methyl bromide	insecticidal gas	2005	anoxia, freezing

procedure is used to verify that the microorganisms on the strip are no longer viable. Indicators impregnated with a reagent that changes color in contact with gas are also available (3M Indox 1224, PyMatH Corp. Thermalog G,[48] etc.). When inserted into a stack of photographs, they indicate whether the ethylene oxide has properly penetrated the pile.

In some countries, institutions and companies allow the public to use their disinfection facilities to treat large masses of objects without having to remove them from their packaging. In more than ten years of treating different types of photographs, no degradation due to ethylene oxide has been reported. Propylene oxide has been introduced as an alternative in Japan.[49]

Once the microorganisms have been killed, it may be necessary to remove or reduce mold residues. Unfortunately, there are few treatments that are effective for photographs. Mold growth breaks down gelatin and renders it soluble, and aqueous treatment may result in dissolving the image. The conservator should determine the most appropriate technique, whether a dry technique or one that uses an organic solvent, based on preliminary testing (Fig. 95).

Intervention policies

In response to the dangers linked to the use of ethylene oxide and other chemicals, two courses of action have emerged. In some countries, including France, it is deemed dangerous to leave highly contaminated objects even in a safe atmosphere or to bring them into close contact with uncontaminated areas. When there is the slightest disfunction in temperature and relative humidity, spore germination resumes at an even greater rate, and the seriousness of the effects

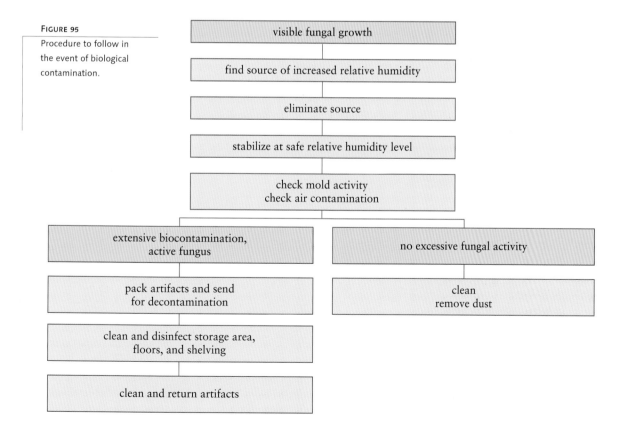

FIGURE 95
Procedure to follow in the event of biological contamination.

increases in proportion to the size of the spore population. That is why eth-
ylene oxide is still used, on the condition that the storage area to which the
artifacts are returned has been properly cleaned and the relative humidity con-
trolled. The remaining question is whether the possibility of using efficient cura-
tive treatment will lead to lack of attention to preventive strategies.

The very stringent regulations for ethylene oxide use and the lack of an
alternative treatment have led many specialists to take a different approach.
They stress the development of an emergency response. In the event of an acci-
dent, any germination and proliferation of microorganisms is prevented solely
by controlling relative humidity and ventilation. Timely intervention, guided
by a disaster plan, limits the damage and entirely eliminates the need for chem-
ical treatments.

Insects

Conditions for insect growth

Since insects cannot regulate their own temperature, they are dependent on
ambient conditions. Many insects that are harmful to collections reproduce
and grow rapidly above 25°C. Their activity decreases between 15°C and 20°C
and ceases entirely below 10°C.[50] Moisture, darkness, and a food source pro-
mote proliferation. Some insects derive nourishment from the organic
materials that make up photographic images, such as gelatin, starch,
and cellulose.

Silverfish, firebrats, psocids, German cockroaches, furniture bee-
tles, and termites are the species that most frequently damage collections.

Detection

Insect infestation is detected by the damage they have caused to art-
works, by the discovery of dead insects and insect droppings, or by
finding living specimens. An effective detection technique consists of
placing sticky traps on the floor, alongside walls. These traps consist
of small cardboard boxes that are open on several sides and coated on
the inside with a substance in which the insects become stuck (Fig. 96).
These traps may be designed for specific species, for example, furni-
ture beetles, cockroaches, or beetles. They attract the insects with food
odors, reinforced by the addition of pheromones.[51] Pheromones, chem-
ical substances that are secreted by insects and are specific to each
species, make it possible to selectively attract insects of those species
and can make a detection system an effective trap. Sticky traps are very
useful for identifying areas that are at risk, serving as a warning sys-
tem, or checking the efficacy of a disinfection treatment. For flying
insects, hanging sticky strips serve the same purpose. Light traps that
emit ultraviolet light, which attracts flying insects and electrocutes
them, have been tested, but most conservation specialists prefer the
sticky traps.

Eradication of insects in collections

In the past, many chemical products, such as ethylene oxide, sulfuryl
fluoride, and methyl bromide, were used as fumigants for eradication
of insects in collections. Such treatments are no longer used because

FIGURE 96

Sticky traps. These traps are useful for
detecting the presence of insects and
identifying species.

they have possible long-term detrimental effects on artifacts, human health, and the environment and because two effective and safe techniques are now available, freezing and anoxia. Low temperatures are fatal to insects. To eliminate them, the objects need be kept at −30°C for a least two days,[52] after first sealing them in polyethylene bags to prevent water from condensing on their surface when they are removed from the freezer. It is advisable to bring the objects back to ambient temperature very slowly (over at least eight hours), in stages. If it is not possible to bring them to −30°C, the temperature at which cryoresistant larvae are destroyed, the objects may be kept at −20°C for one week. This treatment should be repeated after leaving them at ambient temperature for one week. Similarly, the Harry Ransom Center at the University of Texas at Austin treats infested photograph collections and cameras twice at −20°C for 72 hours.[53]

Anoxia, or oxygen deprivation, which consists of asphyxiating insects in an oxygen-free environment, is currently used. This technique is simple and quite suitable for a small quantity of objects. Therefore, it is used by many conservation professionals. Recent research has extended this to treatment of large collections. The objects are placed in airtight polyvinylidene chloride or polychlorofluoroethylene bags.[54] The oxygen level is lowered using an adsorbent (Mitsubishi Gas Chemical Company Ageless® or Standa-Industrie Atco) (see p. 52) and/or an inert gas (argon, helium, or nitrogen). An oxygen concentration not exceeding 0.1% for two weeks at 20°C was originally recommended. Subsequently, studies have shown that 0.3% at 25.5°C for 10 days or 0.6% at 30°C for 6 days also provides good results.[55] Objects may be treated statically or dynamically. In the latter case, the inside of the bag is flushed with a flow of inert gas. The constant gas supply prevents an increase in the oxygen level, even if the bag is not perfectly airtight. These gases from cylinders and gas generators are dry, so the gas must be humidified to prevent excessive drying, or the relative humidity level must be maintained with silica gel.

Based on the same principle and method, air enriched with carbon dioxide (greater than 60%) has been used by Rentokil (Fig. 97) to treat insect infestation. Carbon dioxide has the advantage of being as effective as inert gases at lower concentrations. It is used at low relative humidity

FIGURE 97

Insect control through oxygen deprivation (anoxia). In the Rentokil® system, artifacts are treated with CO_2 in a bubble.

to prevent the formation of carbonic acid. Care must be taken because if there is a leak, excessive CO_2 constitutes a potential danger to humans in an unventilated space.

Eradication of insects in storage rooms

It is essential that storage areas be monitored and maintained, for example, by sealing openings, cleaning facilities with a vacuum cleaner, or washing surfaces without leaving wet spots, to prevent or limit the proliferation of insects. In the event of an infestation, the storage areas should be treated empty; wait several weeks before returning the collections, which should be treated separately to avoid possible damage (Table 61).

Insects may be eliminated by fumigation with pyrethrins.[56] No personnel should remain on the premises during these treatments. These disinfestation treatments do not prevent reinfestation, so it is wise to develop good housekeeping and maintenance programs and strict monitoring procedures.

Integrated pest management

Integrated pest management (IPM) is a global approach introduced to the field of cultural heritage in the 1980s to solve pest problems. It encompasses not only preventive actions and monitoring and control methods but also treatments to effect long-term change, that is, to develop a strategy to avoid or minimize the use of pesticides in accordance with good conservation practice.

IPM programs developed at various institutions can serve as models, since the program must be built or adapted to the needs and the structure of each collection. Checklists can serve as a starting point for building an IPM program (Table 62).

TABLE 61

Controlling and eliminating insects from facilities.

Type of Insect Removal	Nature of Treatment	Advantage	Disadvantage
chemicals	insecticidal fumigation	uniform treatment	treating empty facility
sticky traps	sticky substance	inexpensive, not harmful	limited effectiveness if the infestation is extensive: more a means of detection
light traps	light attraction and electrocution	inexpensive, not harmful	works only on flying insects

TABLE 62

Combating infestation (according to
Pinniger, *Pest Management*)

Phase		Observation-Reaction
identification		is there damage?
		are there signs of insect presence?
		are they alive or dead?
		what are the insect species?
		what do they feed on?
evaluation		number of insects?
		are they found in traps?
		where are they?
		were there previous infestations in the same place?
		are they multiplying?
		are they in the furniture?
		are they in the walls or floor?
		is there proper cleaning?
		is it humid?
		is it hot?
possible actions	documents	no action necessary
		cleaning
		transfer
		observation/quarantine
		treatment
	furniture	no action necessary
		cleaning/destruction
		treatment
	buildings	no action necessary
		cleaning
		drying
		lowering of temperature
		treatment
treatment		verify performance of treatment
		protect against toxicity
		documentation
monitoring		monitor effects on artworks and documents
		monitor effects on insects
		monitor effects of insects at site

Exhibition

Light

Our eye perceives electromagnetic radiations with wavelengths (λ) in a range of approximately 400 to 780 nanometers (nm). This infinitesimal part of the electromagnetic spectrum constitutes what is called light. As Y. Legrand points out, "in this ensemble that, to use a musical analogy, has a range of more than 70 octaves . . . , light does not occupy even one octave."[1]

Artificial and daylight sources are not limited to the emission of visible radiation, which is usually accompanied by infrared (IR) and ultraviolet (UV) radiation, located on either side of the visible spectrum. For example, the sun emits UV rays with wavelengths between 13 and 400 nm. Only the rays whose λ is greater than 290 nm reach the Earth (Table 63). The others are absorbed by the ozone layer.

Classes of UV radiation.

UV-A	315 to 400 nm
UV-B	280 to 315 nm
UV-C	100 to 280 nm

QUALIFYING LIGHT

Color Temperature

When an incombustible object is heated, it emits light. At approximately 1000°C, a piece of metal glows red. As the temperature rises, it turns yellow. This is the principle behind the incandescent bulb. The flow of electric current raises the temperature of the filament and causes it to glow (Fig. 98). To qualify the appearance of such light, physicists use an idealized reference tool, the blackbody radiator, which, when heated, transforms any input energy into a continuous spectrum of radiation. The color temperature (CT) of a light

FIGURE 98

Illustration of color temperature.

When an incombustible object is heated, it emits light. At about 1000°C, a piece of metal glows. As the temperature rises, the light turns yellow. Sunlight has a color temperature of 6500 K above the atmosphere. As it passes through the atmosphere, it drops to approximately 5400 K, which is the mean between the 5077 K measured at noon in winter and the 5740 K measured in summer. The light of the sky, which is much richer in blue radiation, has a color temperature that ranges between 10,000 and 20,000 K. It also contains a significant amount of UV and IR radiation.

| 1800 K | 2900 K | 3400 K | 4300 K | 5000 K | 6000 K |

source is the temperature to which the blackbody must be heated for it to emit light with the same spectral distribution. Conversely, the blackbody can be described as a body capable of absorbing all of the light radiation it receives and of transforming it into heat in order to reach the CT. This is expressed in kelvins (K; to calculate the temperature in degrees Celsius, subtract 273 from the temperature in kelvins) and provides important information about the quality of light. As the CT increases, the color of the emitted light changes from warm tones (reds) to cooler tones (blues).

A 100-watt (W) incandescent bulb has a CT of 2900 kelvins. The most intense emission (λ_{max}) is in the infrared region. For sunlight, a CT of 6500 K corresponds to a peak emission in the blue region (Table 64). In the case of fluorescent bulbs, no analogy with a blackbody is possible. In fact, the light produced by fluorescence has a specific, discontinuous spectral distribution that cannot be reproduced by heating any material. For this, the concept of correlated color temperature (CCT), or equivalent color temperature, is used. This is the correlated temperature to which a blackbody must be heated to produce the same quality of light. However, this conceptual extrapolation can be a source of errors. Two fluorescent tubes with the same CCT may have totally different effects on colored objects. That is why the concept of the color rendering index (CRI) is used.

TABLE 64

Color temperature of several light sources and maximum emission wavelength.

Light Source	Color Temperature	λ_{max}	Spectrum
candle	1800 K	1,602 nm	infrared
100 W bulb	2900 K	994 nm	infrared
tungsten halogen bulb	3400 K	848 nm	infrared
150 W metal halide bulb	4300 K	670 nm	red
250 W metal halide bulb	5000 K	577 nm	yellow
electronic flash	6000 K	480 nm	blue
sunlight	6500 K	444 nm	blue
skylight	8000 K	360 nm	ultraviolet

Color Rendering Index (CRI)

While color temperature provides qualitative information about the appearance of light, it does not determine how an observer will perceive objects illuminated by the source of that light in comparison to a reference light source. To resolve this problem, one uses the CRI. Eight color samples are measured by colorimetry under the light source, and the results are compared with measurements taken under a reference light source having the same CCT. When the sample colors match under the two light sources, the tested source has the highest CRI value, 100. Color rendering indices have been grouped into five categories (Table 65). A light source with a CRI of 90 is entirely satisfactory to an observer.

TABLE 65

CRI classification.

Group	Corresponding CRI
group 1a	90 < CRI ≤ 100
group 1b	80 < CRI ≤ 90
group 2	60 < CRI ≤ 80
group 3	40 < CRI ≤ 60
group 4	20 < CRI ≤ 40

QUANTIFYING LIGHT

In addition to color temperature and the color rendering index, which describe a light source qualitatively, there are units of measure for quantifying emitted, reflected, and transmitted light. Two kinds of units are used, one based on our perception of brightness (illuminance) and the other based on the energy of visible radiation (irradiance) and its potential to cause damage. The units of measure used for energy are watts—watts per square meter and watts per steradian (an angle subtended at the center of a sphere by an area on its surface equal to the square of its radius). These are objective values that represent radiation power but do not convey the sensory impact of this radiation. Therefore, subjective values have been developed for an entirely selective spectral receiver, the human eye. These units measuring visual response to light are the lux, the lumen, and the candela. They constitute the tools of photometry. As a convenience, these photometric units are widely used in lighting recommendations for museums. This should not obscure the fact that identical illuminance or light exposure can produce different deteriorating effects, depending on the spectral distribution of the source. To decrease irradiance without reducing illuminance, it has been suggested that white light, composed of three spectral bands, corresponding to blue, red, and green light, be used. This eliminates wavelengths that contribute nothing to vision.[2]

Luminous Intensity

Luminous intensity is the quantity of light emitted by a light source in a given direction, expressed in candela (cd). The value of one candela corresponds to the luminous intensity of the blackbody radiator, measured through an opening with a surface area of 1/60th of a square centimeter, heated to 2042 K (the temperature at which platinum solidifies).

A bulb does not emit light uniformly in space. There are certain preferred directions in which luminous intensity is stronger. Bulb manufacturers sometimes provide diagrams of polar coordinates that schematically represent the intensity of a light source in space (Fig. 99).

Examples of photometric curves
of incandescent bulbs.

Diagram: Osram

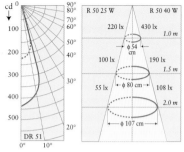

R 50 Spotlight, 30°, 25 and 40 W

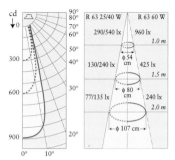

R 63 Spotlight, 30°, 25, 40, and 60 W

TABLE 66

Luminous flux from various sources.

Source	Luminous Flux
100 W bulb	1,380 lm
200 W bulb	3,150 lm
fluorescent tube	600 to 6,000 lm

Luminous Flux

Luminous flux is the quantity of light produced by a 1 cd light source, measured in a steradian. It is expressed in lumens (lm) (Table 66).

Our visual sensitivity is optimal only at about 555 nm (yellow-green light). This is where all of the energy transported by a light ray is transformed into light sensation. Above or below that value, the efficiency of the eye decreases. A simple 40 nm deviation from that value reduces the eye's "performance" by approximately 50% (Fig. 100). A photopic efficiency factor, or visibility factor, has been calculated for each wavelength. This allows energy values to be converted into photometric values.[3]

FIGURE 100

Luminous efficiency for the eye. The
maximum sensitivity is in the yellow-
green spectrum.

Spectral distribution of a
halogen bulb: 3100 K

Spectral distribution
of daylight: 6500 K

Illuminance

Illuminance is a measurement of the luminous flux received by a surface. It is expressed in lux. A one-square-meter wall uniformly irradiated by one lumen of luminous flux receives one lux of illuminance (1 lux = 1 lm/m²). This unit was established based on visual perception. It is also used in recommendations for exhibition of light-sensitive artworks. However, objects may absorb nonvisible radiant power that has significant deteriorating effects.

Illuminance depends on the intensity of the light source and the distance between the artwork and that light source. It is proportional to the inverse square of the distance. Thus an object placed three meters from a light source receives one ninth the illuminance of the same object at one meter (Fig. 101).

FIGURE 101

Some photometric units.

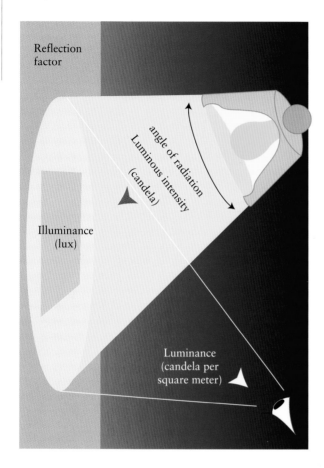

Luminance

Luminance is the luminous intensity per unit of surface area of a light source or light-reflecting surface. It is expressed in candelas per square meter (cd/m^2). The luminance of a surface determines its brightness. A light source or light-reflecting wall with a surface area of one square meter that emits an intensity of one candela has a luminance of 1 cd/m^2.

Light Exposure

Exposure is the product of illuminance times duration of exposure. It is expressed in lux-seconds (lx.s) or lux-hours (lx.h). This unit is used when exhibiting artworks to record the amount of light received by the object while it is exhibited. In that case, it is also called total light dose (TLD).

Quantity of Ultraviolet Radiation

With identical illuminance values, light sources may have varying harmful effects on exhibited works, depending on their ultraviolet radiation content. The proportion of ultraviolet in the light is expressed in microwatts per lumen. It is the ratio between the radiant power of UV in the light source and luminous flux.

Fluorescent bulbs are more apt than incandescent bulbs to emit UV radiation (Table 67). Nevertheless, some are designed for museum applications and emit little UV radiation. However, the UV radiation in a halogen lighting source is often underestimated (see p. 155). Metal halide bulbs, which generate high levels of UV radiation, must not be used without filters.

TABLE 67

Comparison of UV-A, UV-B, and UV-C values of various sources.

Source	UV-A μW/lumen	UV-B μW/lumen	UV-C μW/lumen
100 W incandescent bulb	62.5	0.985	0.003
Osram Halostar 64425 U UV-stop 20 W 12 V tungsten halogen bulb	48.2	0.012	0.019
Osram 64425 Ax 20 W 12 V tungsten halogen bulb	91.5	5.86	1.29
36 W fluorescent tube	93	6.9	0

TABLE 68

Luminous efficacy of various sources.

Source	Life	Luminous Efficacy
tungsten bulb	1,000 hours	15 lm/W
tungsten halogen bulb	3,000 hours	25 lm/W
fluorescent bulb	8,000 hours	95 lm/W
metal halide bulb	10,000 hours	120 lm/W

Luminous Efficacy and Quantity of Infrared Radiation

A portion of the energy of a light source is dissipated as ultraviolet radiation but also as infrared radiation, which generates heat. Luminous efficacy is the ratio between luminous flux and the energy consumed by the lighting source. It is used to evaluate the efficiency of a light source and is expressed in lumens per watt (lm/W). The greater the luminous efficacy, the more efficient the light source and the lower the energy loss in the form of IR radiation. In incandescent bulbs, luminous efficacy is low, since approximately 80% of the energy is dissipated in the form of IR radiation. Efficacy increases with the temperature of the filament, and halogen lights are more efficient than simple incandescent bulbs (Table 68).

ARTIFICIAL LIGHT

Artificial light sources can be divided into two families, incandescent bulbs and discharge bulbs. Some of these are not used for domestic applications or in galleries, and I will not describe them in detail. These include high-pressure xenon bulbs, whose spectrum is close to the solar spectrum; sodium vapor bulbs, which produce practically monochromatic yellow-orange light (589 and 596 nm); magnetic induction bulbs; and mercury vapor bulbs, which generate high levels of UV radiation. Certain mercury vapor UV bulbs, called black lightbulbs or Wood's lamps, generate UV-A.

Incandescent Lamps

Incandescent lamps are composed of a tungsten filament in a glass bulb containing an inert gas (argon, krypton, nitrogen, etc.). The electric current passing through the filament heats it to incandescence and produces light. Incandescent bulbs produce a large amount of infrared radiation and can considerably raise the temperature in enclosed spaces and spaces with poor ventilation.

FIGURE 102

Diagram of a tungsten bulb.

Diagram: Osram

Inert gas (Ar, N$_2$, Kr, or vacuum)
Molybdenum support wire
Filament
Glass bulb
Stud
Current
Stem
Lead weld
Socket base
Stem press

Tungsten bulbs

In a tungsten bulb, the filament is heated to approximately 2600°C (Fig. 102). The color temperature of the light it produces varies between 2700 K and 3200 K, which are the maximum values since the temperature of the filament cannot increase indefinitely. A tungsten filament melts at 3650 K. At lower temperatures, it is consumed through an evaporation phenomenon that results in a black deposit on the sides of the bulb. The life expectancy of such bulbs is approximately one thousand hours, but this may be considerably reduced by power surges. These bulbs generate fairly little UV radiation (under 75 microwatts per lumen).

Tungsten halogen bulbs

Tungsten halogen bulbs are also called quartz iodine bulbs. The insertion of a small quantity of a halogen gas (iodine) makes it possible to raise the temperature of the tungsten filament without causing it to be consumed rapidly (Fig. 103). When the filament is heated, part of the metal evaporates and reacts with the iodine to form tungsten iodide, which breaks down into iodine and tungsten when it comes in contact with the filament. Thus, the metal is constantly regenerated, increasing the life of the bulb. Because quartz can withstand higher temperatures, it is generally used instead of glass. However, quartz is more transparent to UV radiation, and since the CT of these bulbs may be as high as 3400 K, this also results in an extensive increase in the amount of UV radiation (Fig. 104). With this type of bulb, it is advisable to check the UV levels and, if necessary, use filters. Some low-voltage halogen bulbs are appearing on the market without UV-B and UV-C radiation and with their UV-A reduced by half. The use of low-voltage halogen bulbs with dichroic reflectors has become widespread in homes and galleries. These allow each object to be aesthetically equipped with its own light, which is sometimes an integral part of the hanging system. The light beam is intense and narrow. The dichroic reflector should direct the most harmful radiation rearward. It is also necessary to check the illuminance and the heat, which may be dangerous if the bulbs are placed too close to the objects (see also Fig. 116).

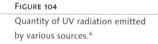

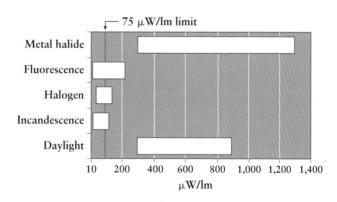

Discharge Bulbs

These tubular or oval glass tubes contain a gas (mercury, sodium, xenon vapor, etc.) and have an electrode at each end. In this case, light is not produced by heating a metal filament. When the bulb is turned on, electrons are ejected from the cathode toward the anode at the other end of the tube. As they travel, they collide with gas atoms, and radiation is emitted as a result.

Fluorescent tubes

A fluorescent tube[5] contains mercury vapors, and its inner walls are covered with fluorescent substances, such as calcium halophosphate (Fig. 105).

The mercury atoms, excited by colliding with electrons, return to their original energy level by releasing UV radiation, which then hits the walls of the tube and causes the coating substance to give off light. The spectrum of the light that is emitted depends on the coating substance. It is a continuous spectrum with added monochromatic radiation in the UV and visible range.

In contrast to incandescent bulbs, such tubes provide varied qualities of light. In addition, they have the advantage of dissipating much less energy in the form of heat than do incandescent bulbs, but they can generate much greater levels of UV radiation and, consequently, require the use of filters.

Fluorescent tubes are grouped into several categories based on the color of the light they produce. The qualifier "cool" refers to lighting that generates little red light (high CT), whereas the qualifier "warm" applies to lighting that generates little blue light (low CT) (Table 69).

Fluorescent bulbs come in straight and angular shapes. The latter may be contained in a bulb (compact fluorescent lamp). The size of the tubes varies from 13.6 to 150 cm and their diameter from 7 to 38 mm, while their power ranges from 4 W to 215 W. At equivalent power, the luminous efficacy of a fluorescent tube is at least five times greater than that of a tungsten bulb, so the luminous flux of an 18 W fluorescent tube is identical to that of a 100 W tungsten bulb (Table 70).

Metal halide bulbs

Metal halide bulbs contain mercury vapor. The small quantities of thallium, indium, scandium, dysprosium, or sodium iodide that are added to them allow them to produce a more balanced white light, with a better color rendering index, without the need for a fluorescent layer. Their life expectancy is greater

Socket base • Electrode • Mercury atom • Fluorescence • Mercury ion • Electron • Stem press/stem

Contact pin • Ar, Kr, N$_2$ gas • Glass tube

Tube Type	Equivalent Color Temperature	CRI
warm white	3000 K	95
cool white	4200 K	96
daylight white	5400 K	98

TABLE 70

Summary of characteristics of several
light sources.

Type of Bulb	Purchase Price	Lighting Efficiency	Length of Use	UV Content	Heat Generated	CRI
tungsten	Ⓛ	L	M	Ⓛ	H	L to H
tungsten halogen	M	M	M	M	H	L to H
fluorescent	(L to M)	Ⓗ	Ⓗ	M to H	Ⓛ	L to H
metal iodide	H	Ⓗ	Ⓗ	H	H	Ⓗ

L = low, M = medium, H = high; advantages circled.

than that of other bulbs, and they consume less energy. However, for illuminating light-sensitive items, the very high level of uv radiation they emit limits their use to light sources for optical fiber devices.

Fiber Optic Lighting

Use of this type of device is currently becoming widespread, since it solves certain difficult lighting problems. Strictly speaking, optical fibers are not a light source but a lighting device. Optical fibers and optical cables (composed of a few dozen to several hundred fibers) are the only means of propagating light from a conventional tungsten halogen or metal iodide source. Using that light source, placed in a removed but accessible location, makes it possible to illuminate several items with different angles (display cases, objects, photographs). Bulbs can be changed without risk of disturbing the direction of the lighting. This also makes it possible to avoid the mishaps that can occur when sources are placed above or in proximity to vulnerable objects (Figs. 106, 107).

FIGURE 106

Fiber optic lighting at the exhibition
*The Pictorialist Schools in Europe and
the United States, circa 1900,* at the
Rodin Museum, Paris (1993).

*Photograph © S. Engbrox and J. Manoukian.
Courtesy Rodin Museum, Paris*

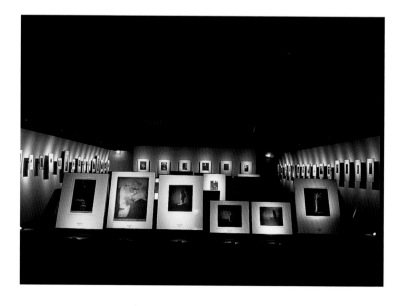

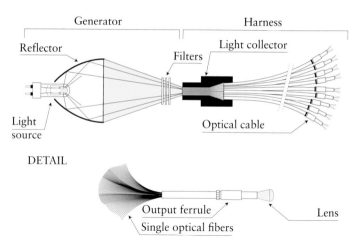

An optical fiber is often composed of a silica core with a diameter of 0.005 to 0.1 mm, surrounded by cladding with a lower refractive index. When light is applied to one of its ends, the light is propagated inside the fiber by reflecting on the walls, as on a mirror. This allows the light to be conveyed to the other end, regardless of the length of the fiber. The flexibility of the fibers allows the light to be transported to precise points, whose distance from the source may be as much as 15 m. While the light may still contain infrared radiation, its passage through the fiber rids it of UV rays. Adding filters and lenses makes it possible to modify the appearance and focus the beam of light at the end of the fiber.

Flash Units

The flash units[6] used as booster lighting for photography are discharge bulbs, commonly called electronic flash units. In a fraction of a second they emit light with a CT of approximately 6000 K. A large portion of the UV radiation is generally stopped by a built-in filter. The quantity of light provided by a bulb is indicated by its guide number, which increases with the power of the flash. Common values range from 20 to 60. Therefore, the intensity of the radiation depends on the model. The number of flashes capable of providing an exposure equivalent to one hour of exposure at 50 lux varies from 9 to 220, depending on the type of bulb.[7] Because the effect of the more powerful flash units is cumulative, the frequency with which they are used on vulnerable artworks should be monitored.[8] To date, there has been no reported deterioration of photographs caused by flash photography.

Photocopiers and Scanners

Halogen lamps are usually the light sources in photocopiers, but some photocopiers are equipped with fluorescent tubes and xenon flashbulbs. Regardless of the model, the quantity of UV radiation and light is far from negligible. Certain photocopiers emit radiation doses corresponding to one hour of exposure at 50 lux (incandescent bulb) after only five photocopies.[9] Therefore, it can be very dangerous to photocopy vulnerable photographs intensively without taking into account the fact that after repeated use, the photocopier glass heats up and increases the potential for photograph degradation. Although such information is not available for office scanners, it can reasonably be assumed that the problems are of the same order. At high-resolution levels on some powerful scanners, the image is scanned more slowly and the exposure may reach several hundreds of thousands of lux-seconds, that is, the equivalent of more than one hour of exposure at 50 lux.[10]

Mounting and Exhibition

The very purpose of most photographs is to be exhibited and disseminated to a wide audience. The improvement of preservation conditions has no goal other than to make images accessible for as long as possible. However, it is during exhibitions that works may undergo rapid changes if minimal precautions are not taken. For this reason, highly vulnerable historical images are sometimes replaced with facsimiles or replicas, and museums implement a system of intermittent exhibition or rotation of the most sensitive works. However, photochemical degradation does not occur only during exhibition in galleries. This can also occur when works are exposed to powerful lighting in conservation workshops or reading rooms. Some standards, prescribing lighting levels from 1,000 lux to 2,000 lux for viewing photographs[1] and about 500 lux for lighting work areas,[2] do not take preservation requirements into consideration.

LIGHTING RECOMMENDATIONS

Deleterious Effects of Light

Collection managers have become aware of the deleterious effects of light on cultural property, and various publications have been devoted to the subject.[3] The Canadian Conservation Institute in Ottawa has developed a light damage slide rule that makes it possible to quickly visualize the relationship of deterioration, illuminance, and length of exposure. Exhibitions of vulnerable objects should be given special attention, and measurements (e.g., colorimetry,

FIGURE 108
FIGURE 108
Redox blemishes on resin-coated paper.

densitometry) of the photographs should be taken. Such measures, among others, have made it possible to better evaluate the alteration of different types of photographs during exhibition.[4]

In a photographic collection, some images are by nature more sensitive to light than others. Although silver (black-and-white) images are generally considered light stable, degradation during exhibitions is regularly reported. Such degradation is manifested by the appearance of a yellow color, accompanied by a pattern of spots and cracks, particularly on resin-coated prints (Fig. 108).[5] Traditional fiber-based prints are fairly resistant, since the cellulose is protected against light by the baryta layer. However, to increase the whiteness of such bases, manufacturers add optical brighteners to them. Light tends to break these compounds down and the base loses its whiteness. This degradation is particularly visible in the margins of a print when the image is displayed in a window mat. The slight coloration taken on by the exposed portion then contrasts with the intact areas that are protected by the window mat.

Gelatin seems relatively resistant to light. This is not the case with prints on albumin paper. In albumin (the binder used in nineteenth-century prints), light leads to the formation of chromophoric compounds, which causes yellowing. But it is the action of light on the materials that compose the image and on residual processing products that remains the most common cause of degradation of photographic images. The photochemical stability of color prints depends on the process that was used. Each color photographic pro-

cess is associated with a family of dyes that are more or less light fugitive. Thus, azomethine dyes (chromogenic processes) are considered less stable than azo dyes (Ilfochrome Classic), and when a dye fades, it produces a shift in color balance. Silver dye bleach processes (Cibachrome, Ilfochrome Classic) are among the most stable. Light fades chromogenic prints, although their quality has much improved over the past twenty years. Computer printouts (ink-jet prints) are still far from showing proof of better performance in terms of light stability.

The quality of the processing plays a significant role. Depending on whether it was correctly processed, an image may prove quite resistant or especially vulnerable. When black-and-white prints are not adequately fixed, during exhibition light can break down residual silver salts into metallic silver, resulting in staining. An example of this phenomenon, which is quite rare, occurred in 1989 during the exhibition of a photogenic drawing titled *Linen Textile Fragment,* attributed to William Henry Fox Talbot. This photograph, dating to the 1830s, was stabilized with chlorides or iodides, as sodium thiosulfate had not yet come into use. The silver salts that are thereby formed remain light sensitive. During the exhibition, the light parts darkened and the image was badly damaged.[6]

Thus, photographs are classified as light-sensitive objects (Table 71). The relative stability of different types of photographs is presented in Table 72. A more precise classification by brand and type of emulsion is more difficult to establish.

Category	Maximum Illuminance
objects particularly sensitive to light	50 lux
objects very sensitive to light	75 lux
objects sensitive to light	150 lux
objects not very sensitive to light	300 lux

Spectral Composition

Daylight properties change, depending on time of day, time of year, and location. Therefore, when vulnerable objects are exhibited, it is preferable to avoid direct daylight and to use a more easily controllable artificial source. Not all radiation found in white light has the same activity. Short wavelengths have more energy and are more apt to cause chemical transformations in organic materials. The primary preventive action consists of reducing, even eliminating, ultraviolet rays, that is, those under 400 nm, which are useless as illumination as well as harmful. The generally accepted recommendations for museum-type institutions specify that uv radiation should not exceed 75 microwatts per lumen. That limit, suggested by G. Thomson some twenty years ago, was based on the quantity of uv radiation emitted by a standard tungsten bulb. With the filters that are now commercially available, the limit can be lowered to 10 microwatts per lumen.

While ultraviolet radiation is a source of photochemical degradation, infrared radiation accelerates chemical deterioration processes and dries or softens materials by elevating the temperature. To prevent excessive heating,

good ventilation and even an IR radiation filter should be provided. The magnitude of this radiation is measured by the heating it causes on the surface of an object. It is recommended that this not exceed 1°C after several hours of exposure.

Illuminance versus Exposure Time

Even once it is rid of UV radiation, light is dangerous, and it is necessary to limit its illuminance and the exposure time of objects. Our visual comfort requires a minimum of approximately 50 lux, and the recommendations that have been specified for museums and galleries are based on that value. Four light-sensitivity categories have been created for artworks (Fig. 109). Each of these is associated with a maximum illuminance.[7] Brightness sensation does not increase linearly with lighting. An increase of a few lux can considerably improve one's ability to see an artwork in weak lighting but be totally imperceptible in strong lighting. Thus, above and beyond these recommendations, it is necessary to strike a proper balance between illuminance and duration of exposure in order to enhance the viewer's experience while reducing the potential for degradation.

Rather than determine duration of exposure in weeks or months, it is advisable not to exceed a certain light exposure, or total light dose. Each time a photograph is loaned for an exhibition, the collection manager can determine the exposure time, multiply it by the illuminance value, and verify that the totals do not exceed the annual limit value. For example, assuming that a photograph is exposed to light 40 hours per week in a gallery, a chromogenic color print should not be exposed for more than 3 weeks per year at 100 lux ($40 \times 3 \times 100 = 12,000$ lx.h), in accordance with Table 72.

Total light exposure is a system that can be implemented for an exhibition, since it allows flexibility in either duration of exposure or illuminance level. It is based on two laws. In fact, the action of light follows a law of reciprocity, and briefly exposing a photograph to very strong luminous intensity has effects that are equivalent to long exposure at weak intensity. In the context of displaying photographs, 30 hours of exposure at 50 lux produces the same degradation as 10 hours of exposure at 150 lux. The destructive effect of light is also cumulative. Six 10-minute exposures produce the same effect as one hour of exposure.

Different total light dose thresholds are found in the literature.[8] These differences reflect the impossibility of obtaining exhaustive experimental data, in view of the myriad commercial products and processes. Under these conditions, we have often had to be satisfied with assigning total light dose values to different types of photographs based on an empirical estimation of their light stability. Total light dose values are estimates that it is advisable to respect, but they are not sufficient to ensure the survival of an exhibited photograph. Photographs thought to be stable have sometimes rapidly shown signs of deterioration when exposed to light, while others have exceeded the threshold of 400,000 lx.h without the slightest visible sign of degradation.[9] This problem, which is linked to the diversity of the objects and the uncertainty with regard

FIGURE 109

Series of blue-wool standard samples. The upper half has been exposed to light. The most sensitive sample (right) has been totally bleached.

To create an international classification for the light-fastness of textile dyes, series of eight pieces of wool fabric dyed with blue dyes with increasing light stability have been marketed. The second blue wool sample is twice as stable as the first, the third is twice as stable as the second, and so forth. The series is exposed under the same conditions as the specimen to be tested for stability. By correlating the degradation of the specimen and that of one of the eight blue reference pieces, an ISO sensitivity (from 1 to 8) can be assigned to the tested dye. Category 1 comprises ISO sensitivity levels 1 through 3. Category 2 comprises sensitivity levels 4 through 6. And Category 3 comprises sensitivity levels 7 or greater. By analogy, these categories have been used to categorize photographic processes, based on their lesser or greater light-fastness.

TABLE 72

Light exposure recommendation for collection photographs.

Category	Process	Annual TLE
category 1 particularly sensitive	19th-century photographs, instant photographs, chromogenic development color photographs	12,000 lx.h
category 2 very sensitive	Dye-Transfer photographs, dye bleach color photographs (Ilfochrome Classic), black-and-white photographs on RC paper	42,000 lx.h
category 3 sensitive	black-and-white photographs on baryta paper, monochrome or pigment color photographs	84,000 lx.h

to their light sensitivity, is not limited to photography. Research is currently being conducted to develop a method for evaluating the sensitivity of colored materials. This involves subjecting a minute portion of an artwork to very intense light, using a microbeam of strong light, until a measurable change is observed. This provides quantitative data on the light sensitivity of objects.[10]

Projecting Slides

As a general rule, it is best to avoid projecting original slides regularly. The heat and high illuminance inside a slide projector quickly result in color fading. Originals should not be projected for longer than a few dozen seconds, and the power of the projector bulb should not exceed 200 W. An IR filter and an efficient ventilation system are also essential. Some types of slides are more sensitive than others, and it is important to note that the slides that have the best dark stability may be the most light sensitive and vice versa (Table 73). This is the case with Kodachrome film. While it is much more stable for dark storage than its counterpart Ektachrome, it is much less resistant to

TABLE 73

Loss of density (ΔD) and color change (ΔE*) in color slides after two hours of projection (periods of 20 seconds, every 20 minutes) in a projector equipped with a 24 V 250 W halogen bulb.[†]

Film	Least Stable Dye (a)	ΔD	ΔE* (CIELab)
Kodachrome 64	cyan	3.1	7.52
Ektachrome 100	cyan	2.6	3.04
Fujichrome 100	cyan	3.1	2.32
Agfachrome 200	cyan	5.6	1.89
3M 100	yellow	20.4	7.94
Polachrome CS 135	blue	5.7	8.46

(a) Measured on a neutral gray scale with a density of 1.0.

† E. Fujii, H. Fujii, and T. Hisanaga, "Evaluation of the Stability of Light Faded Images According to Color Difference in CIELAB," Journal of Imaging Technology 14, no. 2 (April 1988):29–37.

prolonged exposure to light. When valuable slides are involved, it is advisable to project only duplicates, which may be made using Ektachrome (5071, 6021, so-366), Agfachrome CRD, and Fujichrome CDU duplicating films.

EXHIBITION SPACES

Visual Comfort

In the conceptualization and design of a photograph exhibit, it is important to take the visitor's visual comfort into account (Fig. 110). While some light-toned imagery is perfectly legible at 50 lux, darker images, and especially color prints, require higher light. The eye adapts to low lighting, but visual acuity decreases with age, and older visitors may have trouble distinguishing the details of photographs in low light. Major exhibitions are organized by specialized firms that establish optimal viewing conditions for the visitor as well as the safety of the artworks, based on the museographic imperatives. Thus, the task of lighting involves more than simply complying with a few technical recommendations. Visual subjectivity makes the job of the lighting designer a difficult compromise, in which compliance with recommendations should be perceived by the visitor as an art rather than as a constraint. But approaching such a complex subject is not within the scope of this book, and I will limit the discussion to a review of a few basic concepts. Setting up an exhibition and choosing and arranging the lighting involve several types of architectural requirements. The positioning of the light sources must take reflection into account. Low lighting levels require a transition area at the entrance to the exhibition, to allow the visitor's vision to adapt progressively. Decreasing the color temperature of the lighting sometimes makes it possible to offset low lighting, since there is greater brightness sensation and color rendering is more pleasant. The color and type of floor and wall coverings must be taken into account. The panels that support the works should generally have a neutral or low-saturation color, with a matte appearance and a reflection factor (ratio of reflected flux to incident flux) of close to 0.5. Since in most cases photographs are small, flat objects, excellent results can be achieved with lighting that faces the object and is oriented at approximately a 30° (or between 15° and 40°) vertical angle. Finally, for long exhibitions, the most vulnerable works should be rotated and the possibility of installing intermittent lighting systems—triggered by a timer, motion detector, or photoelectric cell; protection with a removable curtain; and so on—should be considered.

Environment

Setting up an exhibition is often an opportunity to restructure the premises using movable partitions. The works are often hung while the paint is still fresh and newly installed materials are still emitting volatile compounds. I cannot stress strongly enough the need to wait until drying is complete and to

FIGURE 110

Exhibition of photographs by Gustave Le Gray, July 2002, at the J. Paul Getty Museum, Los Angeles.

© J. Paul Getty Trust.
Photo: Rebecca Vera-Martinez

FIGURE 111

When setting up an exhibition, one must pay attention to paint quality. Also, the paint must be allowed to dry completely and proper ventilation provided.

FIGURE 111

provide good ventilation before hanging the works (Fig. 111). Unfortunately, this does not seem very realistic, since exhibition galleries operate on tight schedules. Therefore, the use of acrylic or latex paints becomes mandatory, and to avoid any risk, photographs may be protected with sealed glass frames.

The temperature and relative humidity conditions of the exhibition room must remain as stable as possible. The best compromise to ensure both the safety of the photographs and the comfort of the visitors consists of a margin of 30% to 50% RH and 18°C to 21°C. Ideally, air quality should be controlled, but this is a utopian recommendation at present, since most galleries and exhibition facilities are not climate controlled and do not have air purification systems. Here again, impermeable framing provides good protection.

MONITORING DEVICES

Measuring Color Temperature

Thermocolorimeters use a photoelectric cell to compare luminous intensity at various wavelengths and to deduce color temperature from the data. This value is reliable for continuous spectra (incandescent bulbs), but one should be aware that it may be erroneous for discontinuous spectra (fluorescent lighting). Color temperature is often specified on the data sheet for the light source.

FIGURE 112

Measuring illuminance with a luxmeter.

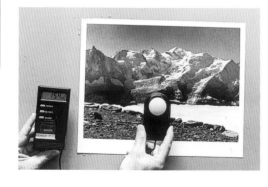

Measuring Illuminance

Illuminance is measured with a luxmeter, a device that contains a photoelectric cell of the type found in cameras. The spectral sensitivity of a luxmeter is theoretically aligned to that of the eye. Therefore, this measurement emphasizes radiation at the center of the visible spectrum (Fig. 112).

FIGURE 113

Measuring the quantity of UV radiation.

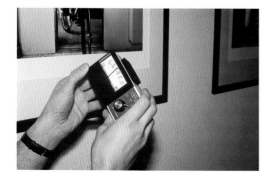

Measuring the Ratio of Ultraviolet Radiation

This measurement is taken using a luxmeter, which contains a photoelectric cell that measures the quantity of radiation between 300 and 400 nm (UV-A) in ambient light. It is expressed in microwatts per lumen (µW/lumen) or in W/m². Some measurement devices contain adjustable cells that allow them to switch between functioning as a light meter and as a radiometer, as needed (Fig. 113).

TABLE 74

Infrared emissivity of various materials.

Materials	Emissivity
aluminum	0.02 to 0.4
glass	0.85
clay, concrete, wood, rubber, ceramic, gravel, paint, plaster, paper, plastic, fabric	0.95
limestone	0.98

Measuring Infrared Radiation

Lighting and infrared radiation can damage photographs by heating them. The simple way to evaluate this effect is to measure the increase in surface temperature during exhibition. Such a measurement is not easy to perform with a standard thermometer. An infrared thermometer is easier to use. The instrument is pointed at the object, and the temperature value is read. This is also a valuable tool for detecting colder walls, where condensation may occur. The only limitation is the calibration of the instrument, which must be set based on the emissivity of the measured surface. This value is known for a good many materials (Table 74). For metals, this may vary considerably depending on their nature, their surface treatment, oxidation, and so on. For photographs, this has yet to be determined accurately. Nevertheless, as with most organic materials, a value of approximately 0.95 may be used.

Measuring Light Exposure: Dosimeters

Dosimeters are photocell data loggers that are placed in proximity to artworks so that they may be subjected to the same lighting conditions (Fig. 114). These devices keep a running total of the illuminance they receive and thereby provide light exposure and UV dose information (Hanwell dataloggers).

Various studies have been conducted on dosimeters that use a light-sensitive dye, but none is yet commercially available.[11] Their color changes in proportion to the amount of radiation and allows us to estimate the total light dose. R. Feller suggested using a dosimeter based on blue-wool standards.[12] This system, often reduced to one or two of the most sensitive wool samples, is now used in some historical houses (see also Fig. 109).[13] Blue-wool standards have the advantage of being commercially available and are useful where there are extensive levels of illuminance. However, they are not sensitive enough to

FIGURE 114

Using a light dosimeter, composed of a substance that fades rapidly when exposed to light, makes it possible to ensure that vulnerable photographs are not excessively exposed.

provide information when dealing with low light exposure. Therefore, they are not appropriate for use in monitoring exhibitions of works with sensitivities of 1 to 3 (Table 72). More recent studies have been done on a dosimeter whose color changes from blue to purple, then to pink, and finally to white after more than 100,000 lx.h.[14] For uv radiation between 290 and 400 nm, N. Tennent has suggested using a dosimeter composed of poly(vinyl chloride) film doped with phenothiazine, whose color turns yellow.[15]

FILTERING LIGHT

This section deals with means of eliminating harmful radiation without excessively altering the quality of the light. Therefore, I do not discuss color filters intended to set a particular mood or photographic filters used to improve contrast or change color temperature.

Filters for Ultraviolet Radiation

Ultraviolet radiation is particularly deleterious to exposed photographs and adds nothing to visual comfort. Therefore, it must be eliminated using a filtration system. A uv filter must possess three qualities:

- It should stop radiation under 400 nanometers; some filters may not stop near-ultraviolet radiation, which is sufficient to deteriorate vulnerable photographs.
- It should not excessively modify color rendering, as is the case with the yellow filters placed against shop windows to mitigate the effects of sunlight, which denature the color of the objects.
- It should have a degree of longevity. It is advisable to check its efficiency regularly.

Filtering artificial light
Cutting off harmful radiation as closely as possible to the source that generates it reduces the required surface area of the filters, thereby lowering the cost of the filters and the design of the filtration system.

For fluorescent bulbs, there are two types of filters. The first is polyester or cellulose acetate film, packaged in sheets or tubular jackets in the shape of the fluorescent tubes, containing organic substances capable of absorbing uv radiation (Fig. 115). The second is polycarbonate or acrylic plates used as screens (Table 75). These can reduce the quantity of uv radiation to below 5 microwatts per lumen.

Most of these polymers are not able to withstand the high temperatures that prevail in proximity to incandescent bulbs. In that case, it is better to choose glass filters. Filters to which the manufacturers have added uv absorbants (metal oxides) are not the ideal solution. When they are effective, they have parasitic absorption in the visible range (color yellow), which considerably decreases the color temperature of the light source. On the other hand, those that do not significantly affect color temperature are often too transparent to uv radiation. The advent of interference filters has solved this problem. Their action is based not on absorption of certain wavelengths by

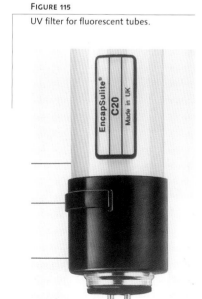

Filter	CRI	UV (μW/lm)
reference source: Thorn Kolor-Rite 3930K	89	85
Erco fluorescent filter sleeve	89	2
Encapsulite fluorescent filter sleeve	89	1
Chamberlain fluorescent filter sleeve	89	<1
Morden fluorescent filter sleeve	89	12
Plexiglas 201 acrylic sheet 3 mm	89	11
Plexiglas 209 acrylic sheet 3 mm	89	12
Lexan polycarbonate sheet 3 mm	90	2
Perspex VE acrylic sheet 3 mm	89	<1
Makrolon 281 polycarbonate sheet 3 mm	89	<1

* D. Saunders, "Ultraviolet Filters for Artificial Light Sources," National Gallery Technical Bulletin *13* (1989):61–68.

a chemical compound but on the physical phenomenon of interference. Successive fine layers of metal oxides with very different refractive indices are deposited on a glass slide. This eliminates harmful radiation through refraction and interference phenomena; that is, certain wavelengths are transmitted, while others are reflected. These filters are also called dichroic filters, because they have two colors when viewed under transmitted or reflected light.

Dichroic UV filters are particularly effective in protecting photographs. Very selective, they stop 99% of the radiation under 400 nanometers, and the quantity of UV radiation drops to under one microwatt per lumen; their color rendering index is 99, and visible light is more than 85% transmitted. In addition, these filters are durable and heat resistant (Bausch & Lomb Optivex UV filters, Balzers filters).

Other types of dichroic filters are used for low-voltage halogen bulb reflectors. Unlike those previously mentioned, these filters are designed to reflect visible light and to transmit infrared and ultraviolet rays. The reflector reflects only visible light toward the object and eliminates UV and IR radiation rearward (Fig. 116).

FIGURE 116

Halogen lamp with dichroic reflector.

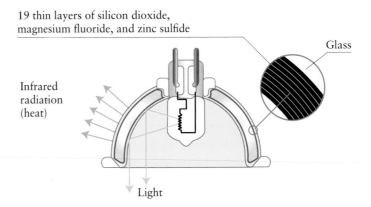

19 thin layers of silicon dioxide, magnesium fluoride, and zinc sulfide

Glass

Infrared radiation (heat)

Light

Filtering daylight

While it is very pleasant, daylight has the drawback of being changeable and sometimes too aggressive. Photographs should not be placed facing windows, in particular, sunny windows. Shutters, curtains, and neutral gray glass can mitigate the effects of excessive daylight. Sheet glass blocks uv radiation under 310 nanometers from sunlight but does not eliminate near-ultraviolet radiation. Therefore, uv filters should be applied to windows. These may be packaged as sheets or adhesive plastic film that clings to windows. They are available in various shades of neutral gray.

Applying uv-absorbing varnishes to windows is not without its difficulties. It must be applied uniformly, and care must be taken not to damage it during cleaning. Furthermore, the life of these varnishes is limited, and they are not always easy to remove.

Venetian blinds have the advantage of deflecting light to the ceiling, if necessary. They can be coated with white paint that contains titanium dioxide as a pigment, which has the property of absorbing uv radiation.[16] This makes it possible to create reflected light from which the most harmful radiation has been eliminated.

Coating photographs

Various studies have been done on lacquers for photographs and film,[17] and some spray uv lacquers are marketed for use on prints. Their use should be limited to prints whose life we want to increase, when we know full well that they are doomed. In fact, applying and then eliminating old, deteriorated lacquer are operations that can be difficult and dangerous to the image.[18] The same applies to uv-cured lacquers (Scotchguard, Photoguard) and plastic laminates.

Some studies have shown that simply isolating photographs from oxygen with 100-micron polyester film slows the deterioration of dyes. Several companies offer pressure-sensitive coating films (e.g., MACtac Permacolor, Filmolux) or heat-sealable films (e.g., Duraseal, Durafilm) for application to color prints. For valuable photographs or fine collection prints, such processes are never used, since they are irreversible. Replacing the framing glass on photographs with treated glass or uv-filtering polymers is a more appropriate solution. Although this does not eliminate every possible danger, it comes close to the recommended conditions. M. MacDonald at the Canadian Conservation Institute advises several products (Table 76).[19]

TABLE 76

UV protectant materials for artwork framing.

Plastic Sheets	Glass
Acrylite: OP-3, FF-OP-3, FF-OP-3P99	Tru Vue Conservation Glass
Lexan: 9034, MR-5	Tru Vue Conservation Reflection Glass
Lucite: UF1, UF3, UF4	Amiran TN (Schott)
Perspex UVA-5	Mirorgard Protect (Schott)
Picture Saver UVF	

Filters for Infrared Radiation

Placing localized lighting close to artworks (as is often the case with low-voltage halogen bulbs) may lead to heating, which has the potential to degrade photographs. The light source should be moved away so as to limit heating, or infrared radiation should be filtered out with interference filters or traditional glass IR filters.

MOUNTING FOR EXHIBITION

An exhibition is an opportunity to enhance photographs using various display modes. Certain mounting techniques, such as the window mat, have been widely used for graphic arts and photographs. It has the advantage of being totally reversible and of providing the best protection during exhibition, handling, and storage. With the window mat, photographs with the most diverse formats can be given standardized dimensions, facilitating their storage. However, while this is suitable for small and medium formats (up to 50 × 60 cm), for large formats, it poses challenges relative to flatness, which has led some photographers to laminate their prints using industrial techniques (heat-activated adhesives, pressure-sensitive adhesives) whose long-term effects are questionable, as is their reversibility.

Mounting in a Window Mat

A window mat mount is composed of two sheets of cardboard—the window mat and a backing board to which the print is usually mounted—that have the same format but may have different thicknesses, joined by a hinge along their long side. One of the sheets has a window whose size is greater than or equal to the size of the image. The edges of the window may be beveled (Fig. 117). The window mat is not solely decorative. It prevents the photograph from coming into contact with the glass during exhibition and with potentially damaging surfaces during storage. For formats larger than 30 × 40 cm, the thickness of the paperboard of the window mat should be on the order of several mil-

FIGURE 117

Window mat mounting and types of hinges.

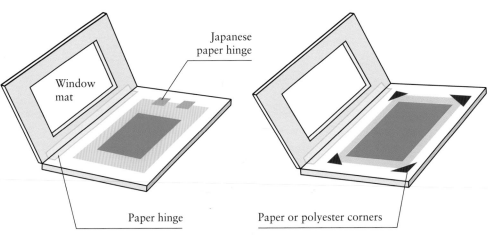

Japanese paper hinge

Window mat

Paper hinge

Paper or polyester corners

limeters. The photograph is held in place on the backing board with photo corners or hinges made of Japanese paper (such as 100% Kozo paper). Photo corners may be used to mount most contemporary prints, insofar as the margins permit and if the image is not too large. Photo corners made of good-quality paper or polyester can be custom-made large enough to effectively keep the print in place without risk. If the margins are too small or nonexistent, hinges made of Japanese paper with an appropriate adhesive should be used.

Choosing materials

The mountboard should meet the same criteria as the cellulose materials used for conservation (see Table 10). Its color may be white, cream, gray, or another neutral tone. If colored mountboard is used, ascertain that the coloring material will not be a source of degradation (acidity, migration, etc.). Adhesives for use in mounting are those that are traditionally used for graphic arts. They should be tested according to current standards and criteria for photographic preservation purposes (Fig. 118).

FIGURE 118

Photographs degraded by a window mat made of cardboard not in conformity with ISO Standard 14523.

Photographs by J.-H. Lartigue, © Ministère de la Culture, France/A.A.J.H.L.

Overall Mounting

Although this practice is not recommended for conservation, many artists prefer to glue their prints on a secondary support for practical and aesthetic reasons. In addition to imparting flatness to the prints, it eliminates the need for frames and margins, which are not always neutral with respect to the relationship that artists may wish to establish between the public and their works. Many industrial techniques are available, including overlamination with clear PVC, PET film, or Plexiglas (Diasec).

Adhesives

Water-based glues (e.g., methylcellulose paste, starch), which are the most chemically stable, are infrequently used for such mounting. They are not effective on resin-coated paper, and on baryta-coated papers they may create stress and distortion as they dry (Fig. 119). Photographers often use spray adhesives or other commercially available processes, such as dry-mounting tissues (heat-activated or pressure-sensitive adhesives). We have little information on the long-term behavior of mounted photographs, which essentially depends on the adhesive used and on the support. The practice of lamination goes back several dozen years, and some photographs have come down to us in perfect condition. The reason for rejecting these types of mountings in a conservation workshop, even when the adhesive and support are reliable, resides in their poor reversibility. When they need to be dismantled because of physical or chemical deterioration, conservation treatment becomes a complex affair and is sometimes impossible without endangering the work. A mounting that is "removable," albeit not entirely reversible, has been suggested. It consists of inserting a layer of polyester with one silicone-coated side between the aluminum support (or any other support) and the back of the image. The photograph is first mounted using pressure-sensitive adhesive on the polyester film, which is in turn mounted, using the same adhesive, to the mounting support. The silicone-coated side of the polyester allows the photograph to be detached from the support.[20]

Supports

The most common supports are matboard, aluminum, PVC, and sheets of acrylic. For long-term archiving, a high-quality mountboard is used, which is also the simplest to remove. For large-format photographs, aluminum is preferred for its physical (lightness, solidity) and chemical (stability) properties, but it bends and makes dismantling a complex affair. Despite this, it is preferable to using PVC or a plastic support whose nature is unknown.

Framing

Framing is a specialized discipline that goes beyond the scope of this book. Here, a few precautions to avoid endangering prints will be provided.

Frame structure

It is preferable to use metal rather than wood frames, which are capable of generating harmful compounds (see p. 58). However, the photograph can be protected from emanations by isolating it from its mounting or by applying

FIGURE 119

Fiber-base print pasted onto plywood.
Temperature and humidity variations
generated cracking.

a sealant coating on the inner edges of the frame. Paints and varnishes (see also Table 15) are a practical solution, but one that is not satisfactory due to their lack of impermeability over the long term and because they contain solvents. Isolation with polyester or aluminized polyethylene tape is more effective. In the latter category, there are some very interesting heat-sealable products, such as Marvelguard® and Marvelseal 360®.

The hanging system should be taken into consideration when mounting. For example, one should use tabs that will allow the frames to be screwed onto the walls (Fig. 120).

Glazing

Protective glazing is most often made of glass, which poses few short-term maintenance and preservation problems, other than fragility and weight. When moving an exhibition without dismantling the artworks, the glazing should be covered with pieces of adhesive tape to limit the movement of shards in case of breakage. In that case, it may be preferable to use a polymer plastic glazing. In addition, when it is not possible to completely rely on the lighting conditions, using UF1- or UF4-type Plexiglas protects against UV radiation (see Table 76). In addition to their high price, plastics have the drawback of being electrostatic to varying degrees and of scratching easily. Some have a slightly yellowish tinge.

The glazing of a framed image should be cleaned with alcohol solutions that leave no residue, such as antistatic products. The solutions should be applied by wetting the cleaning cloth; they should not be sprayed on the frame. If a synthetic glazing material such as Plexiglas is used instead of glass, it is necessary to ascertain that the cleaning solvent is compatible.

Isolation

The photograph should not come in direct contact with the glass. This is generally taken care of by using a window mat or a spacer (a frame of board hidden under the frame rabbet). Even if the print is firmly maintained and isolated, there is some risk that it will deform and stick to the glass in the event there

Example of glass-framed photograph.

Acid-free board

Photograph

Passe-partout

Frame

Glass

FIGURE 121

Gelatin silver print framed under glass without a window mat. Water condensation caused the gelatin layer of the photograph to adhere to the glass and destroyed the image in those areas.

are great fluctuations in relative humidity, especially when the window mat is of insufficient thickness (Fig. 121). This type of problem has been known to occur, and separating the print from the glass is difficult. There are several mounting techniques intended to isolate the photograph from external contaminants. Some use a sheet of polyester film on the back of the window mat and a glass plate on the front. This assembly is then sealed on the edge with a pressure-sensitive tape suitable for archiving. This "sandwich" is then placed in the frame. A moisture barrier, such as laminated aluminium foil/PE (Marvelseal 360®), can be sealed on the back of the frame.

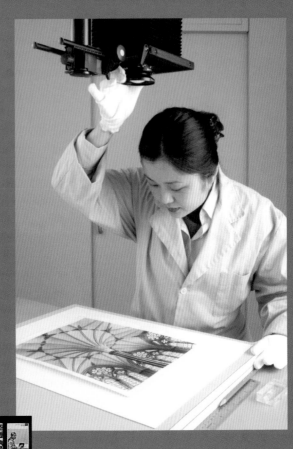

Dissemination and Access

Analog Reformatting

Repeated handling and exhibition of artworks can cause irreversible deterioration—especially because many materials are unstable and contain the elements of their own destruction. Therefore, to the extent possible, it is necessary to promote the transfer of information in order to safeguard and disseminate it to a broad audience. This is a widespread practice with printed matter and manuscripts. For many years, microfilming has been in use in archives and libraries as an effective alternative to viewing originals and a means of preserving information. Systematic copying of cellulose nitrate films has made it possible to save a portion of our motion picture heritage. However, it is estimated that 90% of all silent films and 50% of sound films produced before 1950 have been lost to us.[1] Duplication is a much less common practice in the field of photography, since the methods and procedures are not standardized and have not been thoroughly mastered. Only a few institutions have developed contractual duplication standards (see the U.S. National Archives specification at www.archives.gov).

A policy for reformatting photographs should depend on the nature of the danger to the artifacts. If uncontrolled or excessive use is leading to their deterioration, making copies (digital or analog) for dissemination is an absolute necessity to preserve the originals. In cases in which the images are intrinsically unstable (cellulose ester bases, color photographs), priority should be given to placing them in an appropriate environment in order to ensure optimal longevity. This is certainly less costly and more reliable than systematic duplication. A copy can never truly replace the original, but if it is correctly done, it may satisfy most needs.

DUPLICATING PHOTOGRAPHS

The reproduction of photographs is subject to a set of technical constraints that are too often overlooked. In theory, what could be easier than taking a photograph of another photograph? In reality, each type of photograph (e.g., negative, positive, reversal) has individual characteristics. The transfer medium must be appropriate. For example, prints are not reproduced with the same tools that are used for negatives or slides. The terminology reflects that difference by distinguishing between "copying," that is, the act of reproducing an image that is visible in reflected light (paper prints), and "duplicating," that is, the act of reproducing an image that is viewed by transparency (negatives, slides, transparent prints).

A fundamental aspect of analog copying or duplicating methods, whatever they may be, resides in the deterioration of the information that occurs with each generation. The challenge is in minimizing information loss. If the best possible quality is not achieved, the copy will be no substitute for the original because of its poor technical quality or the amount of information lost as a result of poor tone reproduction and poor resolution. In severe cases, this image degradation can affect the aesthetic appeal of the image. Photographic emulsion does not reproduce every luminance that is naturally perceived by the eye with the same scale. With a paper print, whether it is black-and-white or color, the midtone areas of the subject are rendered in a mode that can be termed linear. The same does not apply to areas of highlight or shadow. In these extreme parts, the photographic recording causes compression of the tones of the subject. If this phenomenon is accentuated by an incorrect exposure setting, inappropriate selection of the duplicating photographic emulsion, or improperly controlled development, the qualities of the image are degraded. Then those subtle areas of tonal gradation, resolution, depth, and detail originally present in both the shadow and the highlight areas are not captured. The same phenomenon can occur when a photograph is reproduced and can increase the distortion.

Special emulsions are used to distinguish duplicating or copy film from conventional photographic film. With the spread of digital technology, photographic companies have started to reduce the range of conventional products offered. Unfortunately, this trend will increase because of the small market share of these specialty products.

Format

The quality of reproduction is naturally linked to the format of the film used for duplication. It is advisable to use a sufficiently large format in order to best reproduce the information from the original photograph. However, the progress that has been made by film manufacturers since the invention of the silver bromide gelatin emulsion in the late nineteenth century has constantly reduced the size of the grain structure of the photosensitive materials while, overall, maintaining the quality of the images that are produced. The film formats used for photography and duplication are divided into three broad categories:

- Small format: Today, this is essentially 24 × 36 mm (35 mm, perforated film; format code: 135), packaged in light-proof cartridges of 12 to 36 exposures, in 30 or 120 m strips for duplication cameras.
- Medium format: This includes all formats from 4 × 4 cm to 6 × 9 cm. The film is packaged in rolls (format codes: 120 and 220) of 8 to 24 exposures or in cartridges for duplication cameras.
- Large format: This includes sheet film from 9 × 12 cm to 20 × 25 cm or larger formats (30 × 40, 40 × 50, 50 × 60 cm, etc.) as well as rolls.

Resolving Power

Detail rendering reflects the ability of the photosensitive layer to record a certain level of information. It is influenced by several criteria, including resolving power, or resolution, of the film (and the lens if used in optical or camera duplication systems). This measures the ability of a photosensitive layer to clearly record the finest details of a subject. To evaluate this, a test pattern composed of parallel lines forming networks with varying spatial frequencies is photographed. After the photograph is developed, the image is viewed under a microscope to determine the finest pattern distinguished by the test emulsion. Resolving power is measured in line pairs per millimeter (Table 77).

Reproduction Techniques

Conventional photographic reproduction (Table 78) makes use of two techniques, contact copying and optical copying.

TABLE 77

Seven categories of resolving power.*

Resolving Power (R) in Line Pairs per Millimeter	Resolution
$R \leq 55$	low
$56 \leq R \leq 68$	fairly low
$69 \leq R \leq 95$	moderate
$96 \leq R \leq 135$	high
$136 \leq R \leq 225$	very high
$226 \leq R \leq 600$	extremely high
$R > 600$	ultra high

* Kodak, Feuillet technique photo professionnelle, caractéristiques générales des films noir et blanc, February 1975.

TABLE 78

Duplication parameters.

Option	Possibilities	Comments
choice of exposure	• contact • still camera • motion picture camera	A contact copy provides good image quality. The other systems must have good optical characteristics and be shielded from vibration.
choice of format	• 1:1 • reduction • enlargement	The entire image must be reproduced. The ideal format is larger than or the same as the original. It is not advisable to reduce more than 25%.
choice of film	• direct positive • reversal • negative-positive	The "negative-positive" method is recommended. The film's specifications and performance must meet the requirements for duplication (color rendering, values, details, and permanence).

Contact duplication

With contact duplication, the original (which must be transparent) and the light-sensitive film are placed in direct contact with each other. This technique makes it possible to preserve the exact size of the original while reducing information loss during transfer. The photographic quality of the reproduction is linked to the closeness of the contact between the two films. The copy is made "emulsion-to-emulsion" to prevent diffusion due to the thickness of the base. When this is done correctly, the contact copy provides a very high level of equivalence of the details from the original.

Optical copying

With optical, or camera, copying, a lens is used to focus an image of the original onto duplicating film. Under these conditions, it is possible to vary the size of the reproduction (reduction, 1:1 copy, or enlargement). In optical copying one can harmonize a heterogeneous collection made of different processes and formats to a common size. When the original is opaque (e.g., photographic print, printed document), this is the only practicable method. Optical systems also are ideal for duplicating fragile originals, such as brittle degraded cellulose acetate films, warped photographs, and tacky nitrate film, that could be damaged by the pressure of contact printing.

In terms of productivity, optical systems offer several advantages. Since they offer the possibility of working on strips of film packaged in rolls several dozen meters long, in various widths (35 mm, 70 mm, 105 mm, etc.) (Fig. 122), there are fewer manipulations during the shooting process and there is no need to handle originals and duplication film in total darkness. The larger formats provide better duplication quality than 35 mm while providing a uniform size for storage. It is possible to process the roll of film—rapidly and with more reliable quality—in an automatic developer and then copy it in an automatic contact printer (the type used to copy microfilm and motion picture film). Having a collection of negatives in roll film form could feasibly facilitate digitization using automated scanners. The National Archives in Washington, D.C., and companies that specialize in duplication have been using this procedure for black-and-white copying and have found that one operator can produce 100,000 copies per year, which is much more than one could produce by contact copying.[2]

The final choice is a compromise, and it is quite understandable that each situation constitutes an individual case whose constraints and objectives must be analyzed.

Regardless of the system used, the lighting of the artifact to be reproduced should be perfectly uniform. For photographing with reflected light, a stand equipped with two or four identical lights (depending on the object's format), angled at 45°, is used, and the item should be sufficiently well ventilated to avoid heating. It is advisable to use electronic light (flashes) for very vulnerable artifacts, which also provides a color temperature balance compatible with daylight-balanced color films.

Restitution Techniques

It is possible to improve the characteristics of an image during duplication. Negatives that have too much contrast to be printed properly on modern paper can be softened, stains on photographs can be mitigated, and faded prints and degraded colors can be corrected. In the recent past, the word "restoration" (optical or digital) designated such operations. G. Brunel has clarified the terminology inherited from past practices.[3] He believes we should avoid using the incorrect term "restoration" and instead use the term "restitution" when the original work is not directly affected and when the duplicate is a subjective reconstitution of what we believe the original image to have been. With the same circumspection, we should be careful not to attempt to create "perfect" photographs by eliminating defects linked to the very nature of the process or technique used by the photographer. Optical restitution of images requires in-depth knowledge of the renderings specific to each process and their characteristics. Of course, the operator should produce the best possible copy of the original with the available technical resources, but out of respect for the artist, the artwork, and its history, he or she should also limit interventions and document them accurately, so that subsequent users will have information about the methods and materials used in the process.

Black-and-white photographs

When a deteriorated image is copied, the appearance of the reproduction sometimes can be improved by using corrective filters. For example, the contrast of a faded, yellowed print can be improved by using a blue filter (Table 79). A colored filter allows light that matches its own color to pass through while arresting the radiations from complementary colors. For black-and-white prints, the most common filters are Wratten filter numbers 15, 16, 21, 22, 24, 25, 47, 47B, 58, 70, and 72B.[4] Filters can be combined, but it is advisable not to use more than two on a camera, as this can result in a loss of light and sharpness. Filters may be placed on either side of the camera lens, one filter

TABLE 79

Optical restitution of black-and-white photographs.

Defect in Original	Filter to Use	Type of Emulsion
image uniformly discolored with loss of contrast	Wratten No. 47 or 47B blue filter	panchromatic or orthochromatic
silver mirroring (in reflected light)	polarizing filter on lens or lighting	panchromatic or orthochromatic
reddish stains	Wratten No. 25 red filter	panchromatic
yellow stains, silver mirroring (in transmitted light)	Wratten No. 15 yellow filter	panchromatic
green stains	Wratten No. 58 green filter	panchromatic
blue or blue green stains	Wratten No. 47 blue filter	panchromatic or orthochromatic

against the inner surface of the lens and the other on the outside. For contact copying, the light source should be equipped with a filter housing. The developer can be selected based on the desired restitution (increased or decreased contrast). Before any reproductions are made, it is advisable to order the originals based on their individual characteristics (format, overall density, density range, etc.) so as to work efficiently.

Color photographs

Deterioration of a photograph is generally manifested by two phenomena, yellow staining that is most visible in the lightest areas (highlights and the margins of paper prints) of chromogenic processes and color fading evidenced by the appearance of a color shift. Color restitution is achieved by using filters when shooting. The effect of a filter or combination of filters can be determined by previewing the image through the filter(s). The loss of color may depend on the original density, and the density loss is not the same in dark areas and light areas. In that case, masks must be used, making the operation quite involved. In the 1980s Kodak published several optical restitution procedures for color slides. The proposed solutions were very broadly based on methods developed for optical restoration of motion picture copies.[5] Today, digital processing, with its much greater flexibility, has replaced these traditional methods and provides an interesting and effective alternative when one is attempting to replicate the original condition of deteriorated images.

These new digital tools allow a degree and ease of intervention that were not available with conventional photographic methods. The sharpness, colors, perspective, areas of loss, and appearance of depicted individuals can now be reprocessed. Algorithms have been developed to automatically eliminate scratches and mechanical degradation on the film.[6] Such methods, which are currently in development, are still too recent for us to be aware of all their possible deleterious effects. Systematic colorization of black-and-white film, for example, is one of the uses that have already been decried, including by some of the filmmakers whose works have been colorized. Depending on one's point of view, all of these enhancement techniques constitute either a betrayal or a reinterpretation of the original work, or the creation of a derivative artwork. G. Romer has conducted an experiment that provides a wealth of lessons.[7] He asked a computer artist to "restore" the image of a deteriorated daguerreotype using digital tools. The resulting image had the appearance of a modern photograph and had lost all of the characteristics of a daguerreotype. Certain types of deterioration typical of such photographs had been poorly understood or even misinterpreted. For example, tarnishing was mistaken for vignetting. As with optical restitution, digital restitution requires not only a certain level of know-how but also knowledge of the history of techniques and the historical context.

For several years, software has been available for professionals and the general public (e.g., Photoshop®), in addition to specific application software developed by institutions and laboratories. Digital restitution of deteriorated color photographs and film is one of the most cogent examples of its use (Fig. 123). But let there be no mistake, when digitally processing very faded color images, although it is theoretically possible to accurately reproduce the original colors, there is little chance of succeeding without colorimetric references. The current trend is to limit subjectivity in color restitution by taking a math-

FIGURE 123

Digital reconstruction of a
deteriorated color slide.

R. Gschwind

ematical approach that seeks to establish the matrices that govern color fading. Then it is possible to extrapolate the original values. Such work has been done both on motion picture film and on still images.[8]

MICROGRAPHY

Micrography is not an appropriate technique for duplicating photographs. It is used in archives and libraries for preservation and viewing of printed material and manuscripts, which sometimes include photographs. I will briefly review the various types of microforms and then discuss a few preservation principles specific to that medium.

Formats

Photosensitive materials are generally sold as 16 mm, 35 mm, and 105 mm film, in lengths of 30 or 60 meters.[9] After film is shot and processed, the microforms are packaged in various formats, the most common being rolls (16 or 35 mm microfilms), microfiches (105 × 148 mm), aperture cards, where a microfilm image is mounted in an opening in a punch card (187.3 × 83 mm), and jackets containing strips of 16 mm film. The "data compression" possible with microfilming can be as high as 95%, depending on the reduction ratio, which can be up to 1:50. In the latter case, it is possible to copy 420 pages in A4 format on a single microfiche (105 × 148 mm) (Table 80). The reduction ratio is determined by the size of the characters in the document, the most common being 1:24. For poorly legible or rare documents, the reduction ratio is usually limited to 1:9.

TABLE 80

Capacity of microforms.

Format	Recording Capacity
16 mm (30 m)	2,500 A4 documents
16 mm (duo 30 m)	5,000 A4 documents
35 mm (30 m)	550 A4 documents
A6 microfiche	up to 420 A4 documents

Shooting is done with a camera or a computer output imager. Microfilms generated from digital files are referred to as COM, or computer output microforms.

Processes

Silver processes

The silver processes used in micrography are most often silver gelatin processes of the same type used in traditional photography, except that these are able to produce very high resolutions. Silver gelatin polyester film is considered the best for preservation purposes due to its stability. There are also dry silver films that are developed using a heat source. Because of the susceptibility of the image printed out in high temperatures, these materials usually are not considered adequate for preservation and are commonly used for access copies.

Vesicular processes

Exposing a thermoplastic film containing diazonium salts to light breaks down the salts, releasing gases (nitrogen and carbon dioxide), which remain trapped in the matrix. The film is then heat processed. The heat softens the polymer and dilates the gases until bubbles (vesicles) are formed. An image is produced as light passing through the film is diffracted by the bubbles. This process is rarely used today. It was commonly used for access copies. Older vesicular films retain acids in the vesicles, which can degrade both the film and the adjacent records.

Diazo processes

In diazo processes, the diazonium salts contained in a layer combine, in an alkaline environment, with a coupling agent to form a dye. Exposure to a source rich in UV radiation destroys the diazonium salts. Therefore, during development, no dyes form in the exposed areas. These salts are not light-fast, and the diazo process is most commonly used for inexpensive access copies.

Color processes

Color processes are similar to those used in traditional photography. These generally use reversal chromogenic emulsions (e.g., Ektachrome or Kodachrome) or dye bleaching emulsions (e.g., Cibachrome or Ilfochrome Classic) (Fig. 124). Ektachrome microfilm is commonly used for motion picture stock and suffers from dye stability problems; silver dye bleach color film is much more stable.

AB Dick process

In the AB Dick process the image is obtained using an electrophotographic process (xerography). This system is rarely used today.

FIGURE 124

Cibachrome color microfiche (silver dye bleach process).

Life Expectancy of Microforms

With respect to stability over time, only silver-based microfiches (silver bromide gelatin emulsion) are suitable for long-term archiving (Table 81). The base must be polyester. Microfilm can still be found on triacetate base, but it should not be used for long-term archiving. Silver microfiches have no major structural differences from traditional photographic film.

To reinforce the resistance of the images to pollutant gases, a treatment that includes a polysulfide toning bath is highly recommended. The residual thiosulfate and silver salt levels should be checked. For microforms that have undergone a reversal process (as is done for certain COMs), the bath sequence may not include fixing. In that case, obviously, checking the residual thiosulfate content is not necessary (Table 82).

Paper sleeves with an alkaline reserve are recommended for storing microfiches (glued seams should not be allowed to come in contact with the emulsion side). The paper sleeves are placed vertically, and if several microfiches are stored in a single jacket, a paper interleaf of proper quality may be inserted to avoid any possibility of sticking. The films should be placed in archival-quality cardboard, polyethylene, or metal boxes (see p. 54) that meet ISO 18916 and 18902 (formerly, ANSI IT9.16 PAT and ANSI IT9.2). Rubber bands should not be used to hold the film. Instead, one can wrap the roll with a strip of proper-quality paper, for example, and affix the end with a tested adhesive tape or use a cotton string tie. Boxes containing film wound around a flangeless core should preferably be stored flat to avoid deforming the film. Others may be stored on edge in drawers or on shelves.

Appropriate cabinets should be used for storage (see p. 60). When fire-resistant cabinets are used, there is the potential for creating an endangering microclimate. Because they are generally poorly ventilated, these cabinets can promote an accumulation of harmful vapors and raise the relative humidity level.

In general, in storage the temperature should not exceed 21°C and the relative humidity should be between 30% and 40% (Table 83). A relative humidity level of 30% is suitable for mixed collections. However, one must be careful not to mix different types of microfiches. A release of hydrochloric acid has been reported with early vesicular films.

Since backup microfiches are not frequently used, they should be stored separately, and it is even advisable to store a copy in a different physical location so that it will be available in the event of a disaster. Every two years, 1% of microforms in the collection should be selected at random and their contents examined visually. If this examination reveals that deterioration is in progress, a sampling plan should be developed for analyzing the collection in detail.

Institutions use a monitoring procedure consisting of making a "master" silver gelatin microform on polyester base to be preserved and never distributed. Two generations of copies are printed from the master microform. The working copy can be used subsequently for duplication, and the viewing copy (e.g., diazo or vesicular) can be used for distribution in place of the original.

TABLE 81

Microfilming processes and their durability.

Type	Nature of Image	Application	Polarity	Life Expectancy*
chemically developed silver image	silver	• exposure • duplication • COM	reversed or preserved	>100 years
micrographic Ilfocolor color	azo dyes	• exposure • duplication	preserved	>25 years
thermally developed silver image	silver	• duplication • COM	reversed	>25 years
diazo	azo dyes	• duplication	preserved	>25 years
vesicular	nitrogen microbubbles	• duplication	reversed	>25 years
electrographic (AB Dick)	toner particles	• duplication	preserved	>10 years

* Minimal life expectancy under controlled temperature and humidity conditions. Deterioration due to handling not taken into account.

TABLE 82

Review of standards on processing and storing microforms.

Reference No.	Title	Application	New Reference No.
ISO 5466	Photography—Processed safety photographic films—Storage practices	storage	ISO 18911
ISO 9718	Photography—Processed vesicular photographic film—Specifications for stability	processing	ISO 18912
ISO 8225	Photography—Ammonia processed diazo photographic film—Specifications for stability	processing	ISO 18905
ISO 10214	Photography—Processed photographic materials—Filing enclosures and storage containers	storage	ISO 18902
ISO 14806	Imaging media (film)—Thermally processed silver microfilm—Specifications for stability	storage	ISO 18919

TABLE 83

Conditions for storing microforms for an indefinite period of time, according to ISO Standard 5466.

Type of Image	Base	Temperature	Humidity
gelatin silver	cellulose ester	less than 7°C less than 5°C less than 2°C	20–30% RH 20–40% RH 20–50% RH
gelatin silver	polyester	less than 21°C	20–50% RH
thermal silver	polyester	less than 21°C	20–50% RH
diazo chromogenic color	polyester or cellulose ester	less than 2°C less than –3°C less than –10°C	20–30% RH 20–40% RH 20–50% RH
Cibachrome, Ilfochrome micrographic	polyester	less than 21°C	20–50% RH
vesicular	polyester	less than 21°C	20–50% RH
electrographic (AB Dick)	polyester	less than 21°C	20–50% RH

Digitization

The purpose of this chapter is not to deal with the issue of digitizing collections from a technical perspective but to consider some of the problems posed by using and preserving digital data. Computerized management of photographic documents, that is, using a computer to quickly retrieve, view, and disseminate images, is one of the undeniable contributions of digital technology. There are extraordinary possibilities for access to photographic collections using networks and new media. Digital technology is arousing a great deal of enthusiasm, and many arguments have been put forward in favor of developing digitization programs, including for preservation purposes. While it is true that accessing a digital image keeps the original free from the dangers of handling and exhibition, it can lead to more frequent requests for exhibition and viewing of the original. As for ascribing greater life expectancy to digitized images than to photographs, as I argue below, nothing could be more questionable. For now, digital media cannot be considered a substitute for purposes of long-term preservation. Furthermore, no CD-ROM of paintings or drawings from a fine art museum has ever claimed to totally substitute for access to the originals. The same applies to museum photographs and graphic art collections. Photographic works are composed of materials that vary according to the artist and the period in which they were created. Preservation of the original work takes precedence, and any digitization program should be accompanied by a preventive conservation program for the original.

However, digital media can be used for much more than just digitizing collections. Digital technology is currently undergoing rapid development in the field of traditional photography for image processing as well as image

capture. Digital image processing has become a tool for many artists and even a mandatory one in photography laboratories for producing contemporary works. Some photographers have resolutely abandoned silver halide–based photography, and the number of original digital works that we may expect to receive for preservation will only increase.

PRESERVING ACCESS TO INFORMATION

A digital file is composed of a set of computer data organized in such a way that it represents the artifact that it has been created from. The unitary element of such files is the bit, which has a value of 0 or 1. Bits are generally joined in series of eight bits, which form a byte. However, the basic sequence may be longer or shorter than an eight-bit byte. The sequences of binary data that constitute a file always begin with a code key whose function is to inform the user—or the computer—about the length of the sequences used to compose the artifact. Without this information, it is impossible to use the associated artifact. Deciphering the binary sequence that constitutes the file leads to multiple representations, depending on the length of the sequence. Knowing the code key is an essential step in the file access process, but it is not sufficient. A single sequence of binary characters may describe a text message in a variety of different alphabets, sounds, or numbers or a photograph, diagram, and so on, whence the need for an application, that is, the software that generated the file. This should preferably be a relatively close version, to limit the problems of partial incompatibility that may arise. In most cases, the companies that publish computer programs retire older versions of their software and replace them with new versions. The same reasoning applies to the central processing unit's processor and operating system, which process the data contained in the files and the software application that allows them to be used.

Thus, the problems posed by preserving digital files go far beyond the issue of the life expectancy of the digital storage media. With digital media, it is necessary to take into account the tools for accessing the information—the computer and the software—as well as the format and the software driver. Paradoxically, the instability of media is not the worst of the problems. It is possible to estimate their life and to copy them or store the most vulnerable ones in an appropriate environment. Even if they are ephemeral, their life expectancy has so far proven greater than the other elements of the computing system. In fact, many formats are doomed to obsolescence.

In 1995 *Scientific American* published an article by J. Rothenberg titled "Ensuring the Longevity of Digital Documents," which, given the ripples it generated, may be considered a point of departure for a broad examination of the problems of digital archives.[1] Admittedly, for several decades, archives had been confronted with the problem of the obsolescence of analog magnetic tape drives, and professionals had already begun working on this issue. With the development of digital technology, they naturally warned users about its inherent risks,[2] but their warnings often went unheeded. At the time, the emphasis was on ease of copying. Indeed, contrary to analog magnetic documents, by their very nature, digital media lend themselves to rapid transfer to another medium or to a network without losing data. New standards were developed, intended to ensure that certain formats would endure. The years

that followed caused some doubts in the minds of users. The repeated and accelerated appearance of new generations of computers and higher-performance software made it necessary to scrap versions that were just a few years old. Information stored in the early 1980s became difficult to access if it had not been copied regularly onto new media and also converted so that it could be read by the new software. This meant making major, ongoing hardware and software investments and, sometimes, devoting considerable time and effort just to opening files. This experience, which was not limited to the preservation field, brought about a more general awareness, reflected in the Rothenberg article and others that followed.[3] In 1996 a group of twenty-one experts, brought together by the Commission for Preservation and Access, arrived at the disturbing conclusion that there was not yet any way to ensure the preservation of digital information. So far, experiments in this field have not met with success. The materials (media, formats, software, and computers) are changing rapidly. The DVD is already replacing the CD, and we have no assurance about the compatibility of the systems or the stability of the media.

The many constraints that a user of electronic media must deal with to access recorded information confirm the relevance of the terms "human readable" and "non–human readable" used by archivists to describe the artifacts in their care. Far from constituting a reason for mistrusting the new technologies, these constraints should encourage us to use greater circumspection in our procedures for using media that cannot be read directly by humans. In the digital world, preservation and access to artworks are no longer actions that are difficult to reconcile. They are now inseparable interests, since guaranteed access is guaranteed preservation. Today, preservation of "digital cultural heritage" is a dynamic process that requires technology watching and ongoing financing for data transfer to new systems and updating of information. To Rothenberg's dismay, the time is past when forgotten manuscripts and musical scores are discovered one hundred years later. Digital information that is forgotten today may be lost forever.

Transfer

Several countermeasures have been suggested. One consists of printing the documents on paper, shooting a film or a photographic substrate (using an "imager"), and keeping the printouts as backup copies. However, this solution is satisfactory only when the data are not linked by an interactive system, as is the case with CD-ROMs. It is also necessary to find a printing substrate for computer output that is stable over time and does not degrade the quality of the information. This is possible for text and still images but not for multimedia sequences. Since digital data currently include and combine all such forms, to reduce a digital document to paper form would be to denature it. The functionalities and "boundaries" of some digital information have no correspondence with traditional documents. It has also been suggested that the bits be printed out in order to preserve them (PaperDisk program),[4] which would mean storing miles of pages covered with 0's and 1's! Software and hardware backup centers that would allow any document to be read in the future have been proposed, similar to those used in the audiovisual field (film,

video, and audio), where old equipment is maintained in working order. This technology preservation strategy does not seem very realistic for digital media. It is uncertain whether digital information can be preserved on its original medium for several decades. Furthermore, software and hardware versions are extremely numerous, and, unlike with film and tape, the format of the recorded information cannot be determined visually. If nothing is indicated on the diskette or CD, decoding can take time. Finally, even if it is possible to access the files, the fact that this can be accomplished only with devices preserved in museums limits access and, consequently, benefits. The solution to digital preservation cannot be found in technology of the past. It must be developed concurrently with research on the tools of tomorrow.

Two concepts have been introduced, refreshing and migration. Refreshing consists of copying information onto a similar or new storage medium. This was done at the National Library of France, where DAT tapes were copied onto ODD-WORMs for use and onto glass CDs for archiving. The Archives of the Indies in Seville has already had to transfer its data onto no fewer than four generations of digital media. So the term "refreshing" can be interpreted as copying. This operation makes it possible to compensate for the obsolescence or lack of stability of a recording medium. This can be automated by using optical disk "JukeBox" systems. It is estimated that CDs should be renewed every five years. This mandatory step, which requires skills and resources, should be included in data backup plans. Migration is a more radical and complex method. The data are converted so that they can be read and processed using another software or computer generation. This change of format is not always innocuous and may entail a loss of data or document organization. For a large and varied digital collection, we do not yet have sufficient experience to determine the feasibility of migration, which cannot be automated and whose results are uncertain. Although standardization may facilitate such operations, the existence of numerous "proprietary" software packages and a concern that losses may be too extensive as well as cumulative make it questionable whether this type of data preservation will be acceptable over the long term.

With these new cultural practices, the issue of cost arises, since the cost of reformatting and transfer operations must be included in management plans. The financial impact of such programs, which are similar to mass treatments when large volumes are involved, is still largely undetermined. Simulations that have been done for libraries indicate that in the initial years digital storage is more costly than traditional storage. It is not until the fourth year that the trend starts to reverse.[5] Some authors believe the cost of preserving digital archives exceeds the cost of creating them by a factor of ten.[6] An analysis at the U.S. National Archives shows that an investment of 50% to 100% of the initial cost must be made over the first ten years to ensure backup of digital data. But all of these estimates are tainted by uncertainty regarding the cost of copying, of migration, and even of emulation. In addition, for museum collections, the cost of digital technology cannot be deducted from the cost of traditional storage but must be added to it, since the artifacts themselves must be preserved. Thus, while we might expect to be able to bear the costs during prosperous times, there is the risk that such archives will cease to be a priority during an economic crisis and that all hopes of preserving them could be obliterated in a few short years.

Emulation

A promising approach that is currently being hinted at is emulation,[7] in other words, the possibility for any new computer system to run obsolete software and thus open documents recorded with such software. This requires that certain information be preserved: the digital document as it was originally recorded, the original software, and the operating system. It also requires saving explanations that in the future will enable anyone to access and use all of the information "encapsulated" with the document. In a manner of speaking, this consists of a table of contents and operating instructions for the data. Such metadata will be enriched over time (metadata wrappers, metadata spiraling), since it may also include historical information, annotations, and so on. Standardization should contribute to keeping such information readable. The integrity of an encapsulated document should be protected against any access violations and changes, to guarantee the authenticity of the digital information. It has yet to be proven that this strategy of preservation through emulation is feasible. Other, more "futuristic," suggestions have been put forward based on using the Internet. Disseminating information on a large scale should make it possible to preserve it. This can occur randomly; that is, we can hope that at least one person will have had the foresight to save on his or her computer the document we are searching for. A more organized approach has been proposed, whereby each computer could serve as a relay to keep forwarding the information, which would then circulate indefinitely on the network—the converse of the very concept of storage. Digital tools are recent, and it is difficult to find landmarks in a landscape that is continually changing. There are committees that are working on these problems, and the standardization of formats and metadata should provide certain guarantees. However, the imperatives of financing and technical development do not always jibe with standards and conservatory measures. Therefore, it is up to the preservation community to be on its guard in order to prevent anarchic development and see to it that such archives are preserved.

Authenticity

From these new practices there also arises the need for a legal and ethical framework. Physical preservation of artifacts is the basis of traditional preservation work. In graphic art archives and collections, this applies to manuscripts, engravings, prints, drawings, photographs, and so on. If we compare digital works to this type of cultural property, the recorded file and its medium (diskette, tape, CD) filed in a collection constitute the authentic artifact that must be preserved indefinitely, even though we know there is little chance of being able to read the recorded information after a few years. But an object such as a photograph cannot really be compared to an electronic document. Actually, the move from analog photography to digital photography has changed the essence of the image artifact. Nelson Goodman distinguishes *autographic* art, such as painting and sculpture, from *allographic* art, such as music and literature.[8] An art form is allographic if the most exact duplication is considered genuine. Conversely, it is nonallographic, or autographic, when the most exact duplication cannot be considered genuine. For example, a copy of

a Rembrandt painting cannot be considered an authentic Rembrandt, but a reprint of a Shakespearean poem is an authentic poem by Shakespeare. In the same manner, while a copy of a computer file of a photograph can be genuine, a copy of an Ansel Adams print cannot be considered genuine. This clearly shows that digital and analog photographs belong to different areas, and there are practical consequences for the way we can preserve them. For autographic art—analog photography—authenticity rests in the material object itself. That is the reason we must preserve the object itself. We assign a probative value to the materiality of an object that, as a last resort, may serve to verify its authenticity. We have inherited this concept, which links authenticity and matter, from archaeology, art history, and, since the nineteenth century, the restoration of monuments. For allographic imaging—digital photography—where each copy is genuine, it logically ensues that this concept of authenticity is meaningless. To avoid this ambiguity, it is appropriate to consider the digital document as we would an immaterial datum or sequence of numbers that is embodied in any new recording, on the condition that it be authentic, using the primary definition of authenticity: "Authenticity implies unabridged conformity with a verbatim original."[9] As R. Lemaire sums it up, a message is authentic if it is transmitted unaltered, down to its nuances, from a sender to a recipient.[10]

Thus, the issue of preserving an original physical electronic substrate is no longer germane. The only important factors that guarantee authenticity are the quality, fidelity, and integrity of the copy of the file and its accessibility. In fact, it is not sufficient for the data to be properly copied. The logical structure of the document, its layout, and its operating mode must also be retained. It is to that area that we must direct all of our efforts, since a digital file can be easily transformed—intentionally or unintentionally—without it being perceptible. In extreme cases, it may become unreadable. We already know that there is no standardized migration system for all applications. So digital files must be made self-contained, by attaching all necessary information in the metadata and by keeping up with technical advances, such that any migration maintains their authenticity.

The ISO Joint Photographic Experts Group (JPEG), which is working on encoding and compression protocols for still and moving images, has provided some guidelines for protecting files containing digital images. It suggests four levels of coding:

- first level (code 1): The first existing version of the file; the master. No manipulation of the data is allowed in this document.
- second level (code 2): An excerpt from the original file with no manipulation of the data it contains.
- third level (code 3): The original file that has undergone total or partial, irreversible processing.
- fourth level: (code 0): A file whose level is unknown. Its authenticity relative to the original document is undetermined.

The first three levels are protected. A header specifies the name of the creator, the level (1, 2, 3, or 0), the copyright, the persons to contact for use, and possibly a history of the file, accompanied by technical and commercial information.[11]

DIGITAL IMAGE CAPTURE

Images are usually captured using a digitizer—either a digital camera or a scanner. Many models are commercially available and their cost depends on their performance. Drum scanners are the most expensive. Used for professional applications, they make it possible to process large formats with high resolution. The photograph to be digitized is affixed around a clear cylinder and therefore must be sufficiently flexible. Flatbed scanners are tools commonly used in offices. They digitize flat, opaque or transparent photographs ranging in size from slides to A3 format. For very large or nonflat artifacts, there are digital cameras and cameras equipped with digital backs, although such artifacts are often shot with traditional cameras on film and then digitized.

The difficulty lies in the choice of resolution: how far do you go? At present, there are no standardized recommendations (Fig. 125). Too low a resolution results in the user having to go back to the original for any exhibition or publication, and low resolution cannot be used to produce a backup copy. High resolution, intended to produce a substitute photograph, generates voluminous digital files that are difficult to manage.

Since the interest of a text document resides more in its semantic content than in the continuous tone of the image (except for such documents as illuminated manuscripts), it is rarely useful to aim for a resolution greater than that which is necessary for good legibility of the alphanumeric characters. To achieve this, a resolution of 200 to 400 dpi with two gray levels (black or white) is often sufficient. This allows approximately 12,000 documents to be

FIGURE 125

Before proceeding with digitization, one should define the objectives.

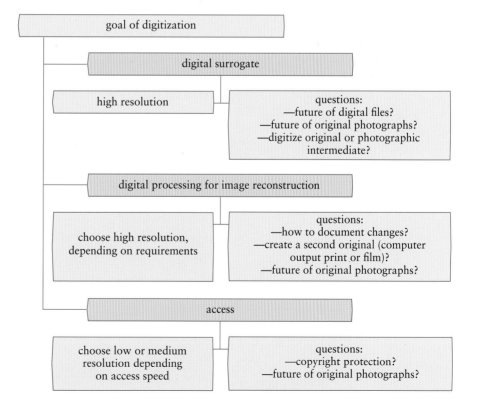

placed on 600 MB after compression. Studies have made it possible to establish recommendations and to determine a quality index similar to the one used for microfilming.[12]

Digitization of continuous-tone photographs requires a higher resolution than is used for text, since when done under the same conditions, it would result in disappearance of the details and poor reproduction of the halftones. Digitization quality is linked not only to resolution but also to value rendering. For black-and-white images, users are satisfied with a sampling depth of 8 bits per dot, that is, 256 gray levels, but are more demanding with respect to resolution. For color images, observers are less concerned with resolution and more with color. But, to re-create them, the size of the file must be tripled, to $3 \times 8 = 24$ bits per dot. Thus, it is possible—at least in theory—to achieve 16.7 million nuances.[13] We often have a tendency to want maximum resolution (Table 84). However, we must realize that this increases the digitization time and the file size. Phototypesetting already requires a resolution greater than 1,000 dpi. It is simple to determine the file size of a 24×36 mm color slide with a resolution of 2,540 dpi (or 100 dots per mm). One calculates how many dots there are to be recorded on the surface of the photograph $(24 \times 100) \times (36 \times 100)$ and then multiplies that value by 24 (bits) for color. The result is 207 million bits, that is, 26 MB. In practice, with professional equipment, acquisition is in 10, 12, or even 16 bits per color.

More generally, we consider that optimal digitization for a 24×36 mm slide on standard emulsion requires approximately 35 megabytes; only 18 images will fit on a 650 MB CD.[14] With larger slides (6×6 cm or 4×5 in.) or 30×40 cm prints, the size of the image file increases using the same calculation principle. All of these parameters have a direct impact on the memory space used. When the resolution doubles, the stored file size quadruples.

Digitizing photographs is a difficult and costly process. Some managers do it only once at the highest possible resolution and then later generate the files they need. This requires more time for scanning and very large storage capacity for very large files. Note that it does not prevent the photographs from being rescanned after a few years when the performance of scanners has improved and higher quality can be achieved.

The other way is to digitize using a level that meets one's needs. If an image is intended as a substitute for the original, in the event it is lost, the resolution should be as high as possible, or at least equivalent to that of the original document. Of course, such sophisticated performance is well beyond what is required for simply viewing a good-quality image on the screen. To evaluate the quality of a digitized image, the original (print, slide, negative, etc.) should be compared to a similar photographic printout of the digital file. The goal is to achieve a faithful reproduction. Digitization can also be used to

TABLE 84

Resolving power of three types of Kodak film. Since resolving power varies depending on contrast, it is measured under two extreme conditions, one calculated with a high contrast test target (1,000:1) and the other with a low contrast test target (1.6:1), simulating normal exposure conditions.

Emulsion	High Contrast Test Target	Low Contrast Test Target
Technical Pan (ISO 16/13°)	400 line pairs/mm = 20,080 dpi	125 line pairs/mm = 6,350 dpi
Plus X (ISO 125/22°)	125 line pairs/mm = 6,350 dpi	50 line pairs/mm = 2,540 dpi
Tmax (ISO 100/21°)	200 line pairs/mm = 10,160 dpi	63 line pairs/mm = 3,200 dpi
Tri X (ISO 400/27°)	100 line pairs/mm = 5,080 dpi	50 line pairs/mm = 2,540 dpi

"restore" or "re-create" a deteriorated image, to correct an imperfect photograph (e.g., one that is underexposed, overexposed, or too contrasty). Any manipulations, if justified, should be documented (see p. 184).

Because of the large file size, compression systems are used. Reducing the size of the images increases the number of images on a storage unit and the speed of data transmission over a network. The Union Internationale de Télécommunications (UIT) and the Joint Bi-level Image Group (JBIG) have issued several recommendations for the compression of text documents, but these are not always appropriate for photographs. Standards better suited to continuous-tone images have been introduced by the JPEG for still images and by the Moving Picture Experts Group (MPEG) for animated images and audio. They allow very high compression levels (100 times and greater). However, above a ratio of 3:1, information is lost, and therefore there is image deterioration. Above 10:1 to 20:1, the loss of information is perceptible. The effects of compression may be illustrated, for example, by an image depicting an aircraft flying across a uniformly blue sky at a high altitude. After nondestructive compression, when the file is reopened the aircraft can be seen; destructive compression may cause it to disappear. Several companies have developed their own compression algorithms, which are not always compatible with current standards. This is the case with Kodak's Photo CD system (Photo YCC compression, 100 images per CD) and Netimage's Scopyr software (400 images per CD). Digitizing large photo libraries and motion picture films (one and a half hours of film is equivalent to 129,600 images) requires very large storage capabilities, and compression techniques are currently being refined and standardized. It is not advisable to compress files intended for long-term archiving.

STORAGE ON MAGNETIC TAPE

Digital information may be stored in optical or magnetic format on discs, tapes, or cards. Magnetic tapes are potentially capable of storing quantities on the order of several hundred gigabytes, but this involves wasting a lot of time unwinding and rewinding tapes (sequential access).

Structure of Magnetic Tape

The media used for digital as well as analog magnetic recordings generally comprise three elements, the base, magnetizable particles, and the binder (Fig. 126). With few exceptions (e.g., hard disks), the base is made of polyester, packaged either in tape form (e.g., audio/videocassettes, rotary digital audiotapes [R-DAT], digital compact cassettes [DCC]) or in disk form (diskettes). The magnetizable particles are composed of transition metal oxides (iron, chrome, or cobalt oxide, or iron metal particles [MP]). To ensure that these particles adhere to the polyester, a binder made of polyester urethane resin is applied. The most recent type of magnetic videotape, metal evaporated (ME) tape, no longer contains a binder. The magnetic layer is produced by condensation on the tape surface of a magnetic alloy of cobalt and nickel, dispersed in a nonmagnetic matrix of cobalt and nickel oxides.[15]

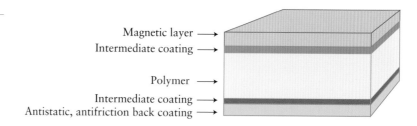

Magnetic layer ⟶
Intermediate coating ⟶

Polymer ⟶
Intermediate coating ⟶
Antistatic, antifriction back coating ⟶

Signal Degradation

Signal stability is linked to the magnetic remanence and the coercivity of the magnetic particles. Magnetic remanence is the capacity of particles to retain a magnetic field over time, while coercivity is their capacity to resist demagnetization. Iron and iron-cobalt oxides have good remanence but poor coercivity, hence the concern that recordings placed in proximity to a magnetic field will be demagnetized. This accidental risk has been overestimated for traditional environments. In a field on the order of 2,500 gauss, the signal loss is less than 5%. Nevertheless, safety regulations recommend avoiding magnetic fields with an intensity greater than 10 gauss. Certain magnetic fields, such as those generated by metal detectors and transformers, may alter the signal.

A rise in temperature exceeding a limit known as the Curie temperature may cause a loss of magnetic properties. Of all the magnetic compounds, chrome oxides have the lowest Curie temperature (120°C). Only a fire is capable of causing such an increase in temperature, but under those conditions, the polyester base will already have undergone changes that render the tape unusable. War-related disasters may lead to the destruction of archives of all sorts, but magnetic media are particularly sensitive to radiated electromagnetic fields created by high-altitude nuclear explosions. The effect of the so-called electromagnetic pulse (EMP) of nuclear origin is so powerful that it can damage magnetic recordings for thousands of miles.

Iron oxides are chemically more stable than the metal deposits on MP or ME tapes. While iron rapidly oxidizes in air, it is also sensitive to corrosion and to chlorine and sulfur compounds. The several tests done on DAT tapes lead us to anticipate a life of approximately eight years. However, many reading systems have automatic error correcting, which does not prevent degradation of the recorded signal but masks it for a time.

Deterioration of the Binder and the Base

The stability of magnetic media under ambient storage conditions essentially depends on the chemical stability of their components, that is, base, binder, backing layer, and lubricant.[16] These problems have been studied for several years with respect to audio and video recordings.[17] The unstable cellulose acetate bases of magnetic tapes from the 1950s have been replaced with polyester, which, as discussed earlier, is entirely suitable for long-term preservation (see p. 47). However, any exposure to high temperatures (greater than 80°C)—however brief—may lead to sufficient contraction to make them

unreadable. Degradation of magnetic media is essentially associated with hydrolysis of the binder, originally made of cellulose nitrate and then of vinyl, acrylic, or epoxy resin; today, polyurethane is used.[18] Under controlled storage conditions, the quantity of hydrolysis by-products reaches equilibrium at 6.7% by weight. When these sticky, hygroscopic breakdown products reach 14%, the damage becomes perceptible.[19] Adherence to the polyester decreases, the tape windings adhere to each other, or a residue sticks to the magnetic heads as the playback continues, causing deterioration of the signal (sticky shed syndrome).

Note that the hydrolysis phenomenon in polyurethane binders is reversible and that the condition of a deteriorated base can be improved by storing it in a dry atmosphere. However, the storage time required is considerable. Studies at the Jet Propulsion Laboratory show that the effects of storage for three months at 100% RH and 35°C can be corrected by treatment for 27 weeks at 0% RH and 35°C. This time can be reduced to several days at 50°C, but such a treatment has the potential to cause further damage if the source of the deterioration is something other than hydrolysis of the polyurethane.

Deterioration of a recording is very often the result of abrasion or inappropriate handling, for example, touching the recording surface, or defective or poorly maintained reading hardware. Friction between the reading head and the magnetic track is a source of abrasion that becomes even more harmful when dust is present. With magnetic tape, sequential access and the stretching that occurs during the winding-unwinding cycles constitute an additional deterioration factor.

Preservation of Magnetic Media

The information that is currently stored on magnetic and optical media includes analog and digital audio and video recordings, as well as computer data. Whether the data are analog or digital does not fundamentally affect the life of the materials, which is estimated at several decades at best. ISO 18923 contains standardized recommendations for storing magnetic tape on polyester base. Since the deterioration factors with respect to magnetic media are excess relative humidity and temperature, to slow the hydrolysis of the binder, it is advisable that the relative humidity be less than 50% and the temperature less than 20°C with variations of no more than ±5% RH and ±2°C over a 24-hour period (Table 85). Until more in-depth research has been done, temperatures below 8°C should be avoided, since some experts fear that the polyurethane layer may exude its lubricant.

TABLE 85

Recommended temperature and humidity conditions for long-term storage of magnetic tape.*

Maximum Temperature	Relative Humidity
20°C	20–30%
15°C	20–40%
10°C	20–50%

Variations limited to ±5% RH and ±2°C over 24 hours.

* ANSI/NAPM IT9.23-1996: Polyester base magnetic tape storage; ISO 12606-1997.

The recommendations for air quality are similar to those recommended for photographic collections (see p. 103). The air must be rid of suspended particles (see p. 105) and corrosive gases. Protection against magnetic fields is provided by grounded shielding of the storage area or by creating a Faraday cage using hardware cloth.[20] Maintain a distance from strong magnetic fields. The intensity of the stray magnetic field should not exceed 50 Oersteds (4kA/m) for alternating current and 10 Oersteds for direct current.

Disks, diskettes, and videocassettes are protected by their original plastic wrapping, but they should also be placed in a protective container. The container should be chemically stable, should not create dust, and should be able to withstand a temperature of 150°C for four hours. The material may be one of those recommended for preserving photographs (see p. 48). Diskettes should be placed in protective jackets and stored vertically. Cassettes should never be stored flat, to prevent deforming the edges of the tape. They should be rewound and stored vertically. The tension of the tape should be checked periodically to prevent deformation. That is why it is advisable to unwind and rewind the tape at regular intervals—once every three to five years—to restore tension. In practice, this is not always feasible. In that case, as a minimum precaution, after prolonged storage the tape should not be used until it has been acclimatized for several hours (if the climatic conditions in which it will be used are different from those in the storage area; see Table 86), and prior to playback the tape should be unwound and rewound.

Maintenance of reading hardware plays a major role. With magneto-optic disk readers, it is advisable to clean the optical head of the laser every three months to maintain the performance level of the device. Do not allow dust to accumulate. The standards recommend filtering particles 0.3 micron in size and larger.

Recordings should be copied onto high-quality media, and it is advisable to make duplicates and store them in different locations.

Magnetic media should be transported in the same position used for storage. The packaging should protect them from impact and excessive variations in temperature and relative humidity. Five centimeters of nonmagnetic insulating material is sufficient. The X-ray scanning devices used in airports are not harmful to them, but hand-held metal detectors can be harmful.

STORAGE ON OPTICAL DISKS

The primary advantage of optical disks resides in rapid access to information (random access) without having to search through everything that precedes it (sequential access), as is the case with magnetic tape. There are various for-

TABLE 86

Acclimatization time for magnetic media after a change in environmental conditions.*

Type	Time to Reach Temperature Equilibrium	Time to Reach Humidity Equilibrium
audiocassette	1 hour	6 hours
VHS cassette	2 hours	4 days

* J. W. C. Van Bogart, Magnetic Tape Storage and Handling: A Guide for Libraries and Archives (Washington, D.C.: Commission on Preservation and Access [CPA], 1995).

TABLE 87

Families of optical disks.

Family	Diameter	Acronym	Name	Data Stored
molded disks	• 30 cm	LVD (videodisc)	laser video disk	analog: audio/video
	• 12 cm	CD-DA CD-A	compact disk digital audio compact disk audio	digital: audio
	• 12 cm	CD-ROM	compact disk read-only memory	digital: audio, images
	• 12 cm	DVD-ROM	digital versatile disk read-only memory	digital: audio/video
writable optical disks	• 9–13 cm • 30–35 cm	ODD-WORM	write once read many	digital
	• 12 cm	Photo CD CD-R DVD-R	photo compact disk (Kodak) compact disk recordable digital versatile disk recordable	digital; 100 images digital digital
rewritable optical disks	• 8 cm • 12 cm	CD-RW DVD-RW DVD+RW DVD-RAM	compact disk rewritable digital versatile disk rewritable digital versatile disk rewritable random access memory	digital digital digital digital

mats, the most popular being the compact disk (CD) and the digital versatile disk (DVD). Optical disks are divided into two categories (Table 87). One type—audio compact disks (CD-A), DVD-ROMS and CD-ROMS (Read Only Memory), which are stamped from molds—is used for publishing media intended for mass production. The other type consists of writable disks on which the user can record his or her own data. The latter are becoming very popular and are often used as a storage and preservation medium for digital files. There are two types of writable disks: those that cannot be modified after recording (CD-R, DVD-R) and rewritable disks (CD-RW), which can be modified after initial recording (Table 88).

Structure of Optical Digital Disks

An optical digital disk is generally composed of a transparent polycarbonate plastic wafer, with one side coated with a reflective surface. The digital recording is created by modifying the reflectivity of the surface.

The CD
Prerecorded disks (CD-ROM and CD-A) are produced by injecting molten plastic into the cavity of a mold under pressure in order to form a plastic disk 1.2 mm thick and 12 cm in diameter. The reflective metal layer applied to the surface is made of gold, aluminum, or a chrome-aluminum alloy. The recording is created by a succession of pits and lands on a spiral-shaped track (Fig. 127). It is

FIGURE 127

Structure of a CD-ROM or CD-A
(Kodak document).

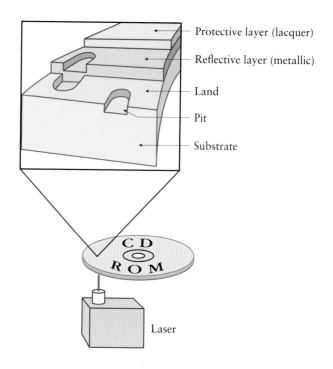

Protective layer (lacquer)

Reflective layer (metallic)

Land

Pit

Substrate

Laser

read using a laser beam that rotates over the surface of the disk. Every time
it moves from a pit to a land, or vice versa, the beam is deflected and the sys-
tem assigns the signal a value of 1. Otherwise, all along the pit or land, the
beam is reflected by the reflective layer and the system assigns the signal a
value of 0. These changes in the reflected light are monitored by a photoelectric
cell and converted into a series of numbers (bits) with a value of 0 or 1, which
compose the digital file.

These disks are usually sold in transparent polystyrene cases. Digipress
has developed the Century Disk, which is made of tempered glass with a
reflective layer of titanium nitride or gold. This makes it a highly mechani-
cally and chemically resistant medium. In the same concern for permanence,
the Los Alamos National Laboratory in the United States has developed the
HD-Rosetta, which can hold 165 GB, written by etching, on a nanometer scale,
with a focused ion beam and read with a particularly fine laser beam.[21] CD-Rs
use various techniques and may be read with standard CD readers. They are
recorded using the energy given off by a laser beam, whose heat modifies the
structure of a heat-sensitive compound (dye, polymer, or metal alloy), which
is uniformly spread over the surface of the disk. These modifications change
the reflective properties of the surface, and the same laser beam is used, at
lower power, for reading. Thus, common blank CD-Rs are composed of a poly-
carbonate wafer coated with a fine layer of a blue green organic dye in the
azo, cyanine, or phthalocyanine family, followed by a metal layer made of
gold or silver, which is protected with varnish (Fig. 128). The polycarbonate
has a molded, spiral-shaped groove, along which information is etched.
During recording, a laser beam passes through the polycarbonate layer and
the light energy is absorbed by the dye layer and transformed into heat (250°C).

FIGURE 128

Structure of a blank CD-R.

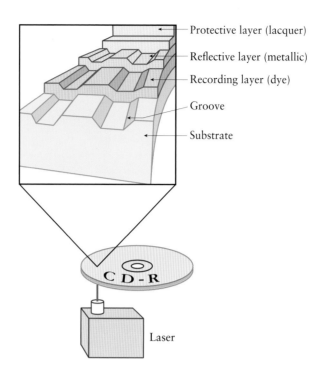

Protective layer (lacquer)
Reflective layer (metallic)
Recording layer (dye)
Groove
Substrate

C D - R

Laser

This temperature increase breaks down the dye and causes microdegradation of the polymer (Figs. 129, 130). During reading, the laser beam runs along the groove and is reflected on the metal layer, except where the alterations have occurred. That is how the recorded digital file is reconstituted. The longevity of a CD-R depends on the quality of the CD itself (type of dye, metal layer, etc.) but also on the quality of the recording, which may differ from one CD burner to another.

Rewritable disks are primarily magneto-optic (MO) disks, which use a hybrid technology. The signal is stored magnetically, but recording and reading are optical. The surface of the disk is coated with a film composed of transition

FIGURE 129

Translation of pits into binary scale on a CD or DVD.

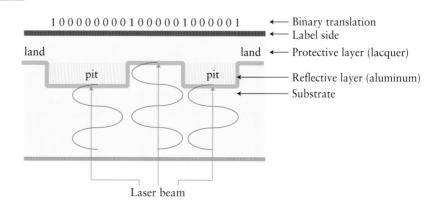

1 0 0 0 0 0 0 0 0 1 0 0 0 0 0 1 0 0 0 0 0 1 ← Binary translation
← Label side
land land ← Protective layer (lacquer)
pit pit Reflective layer (aluminum)
Substrate

Laser beam

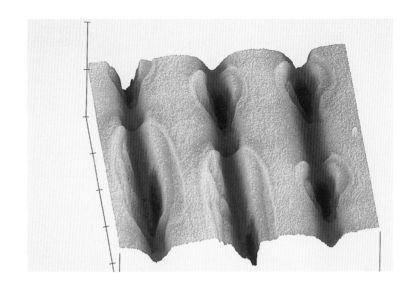

metal alloys, which have the property of changing the polarization of the reflected
light depending on their magnetic orientation (Kerr effect). The alloys that are
used have strong coercivity, and a magnetic field—even a powerful one—is
insufficient to change their direction. A laser beam is focused on the surface,
which is a few microns thick, raising the temperature above the Curie point,
allowing the material to be aligned by a magnetic field. As it cools, the struc-
ture becomes permanent and, depending on the alignment of the field, the
reflected light is polarized in a given direction. The laser beam, at lower power,
is used for reading. Another technique is based on phase change. The heat (500°C
to 700°C) provided by the laser beam melts the crystals of a silver, tellurium,
indium, or antimony alloy, and cooling quickly sets the compound in an amor-
phous state whose reflexion factor is lower. To erase data, the alloy need only
be reheated to a lower temperature (200°C) using the laser beam to restore the
crystalline structure (Fig. 131). Magneto-optic and phase-change CDs require
dedicated readers.

FIGURE 131

Principle of phase change.

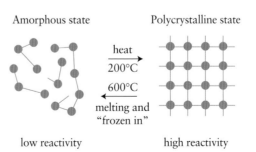

Amorphous state Polycrystalline state

heat
200°C

600°C
melting and
"frozen in"

low reactivity high reactivity

The DVD

DVDs, or digital versatile disks, sometimes incorrectly called digital video disks, are optical digital disks introduced in 1996, which should eventually replace CDs. They have the same size as a CD (12 cm in diameter and 1.2 mm thick), but their storage capacity is much greater, from 7 to 26 times that of a standard CD. They find applications in audio (DVD-Audio), video (DVD-Video), as publishing media (DVD-ROM), and for recording and storing digital data (DVD-R, DVD-RAM, DVD-RW, etc.). To achieve this high data density, it was necessary to bring the signals (pits) etched on the disk closer together and reduce their size. On molded DVDs, there is the possibility of superimposing two layers of data (two-layer DVDs). In the first layer, the metal surface is semitransparent, which allows the second layer to be correctly read by focusing the laser beam. Finally, sticking two 0.6 mm thick disks back to back (two-sided DVDs) doubles the data storage capacity. DVD-Rs have a capacity of 4.7 GB. Their recording principle is the same as that of CD-Rs. With rewritable DVDs, recording is based on the principle of a phase change in an alloy (Ag-In-Sb-Te or Te-Ge-Sb), which is identical to the one described for CDs (Fig. 132). Several formats are currently in competition, and for the time being, there is no standard. DVD-RWs are discs that can be used on DVD-R readers. However, their layer can withstand no more than 1,000 writing-erasing-rewriting cycles. DVD-RAMs (random access memory) were introduced in 1997. They can withstand 100,000 writing-erasing-rewriting cycles, and they provide faster access to information. DVD+RW (rewritable) is a format developed by a group of manufacturers that is not compatible with DVD-RAMs, but their reader can also read DVD-ROMs, video DVDs, and CDs.

TABLE 88

Capacity of several optical disks available at the end of the twentieth century.

Type	Diameter	Feature	Capacity
CD-ROM	12 cm	—	650 MB
CD-R	12 cm	writable	650 MB
CD-RW	12 cm	rewritable	650 MB
DVD-ROM	12 cm	single layer, single side	4.7 GB
		double layer, single side	8.5 GB
		single layer, double side	9.4 GB
		double layer, double side	17 GB
DVD-R	12 cm	writable	4.7 GB
DVD-RW	12 cm	rewritable	4.7 GB
DVD+RW	12 cm	rewritable	3.0 then 4.7 GB per side
DVD-RAM	12 cm	rewritable	2.6 then 4.7 GB per side

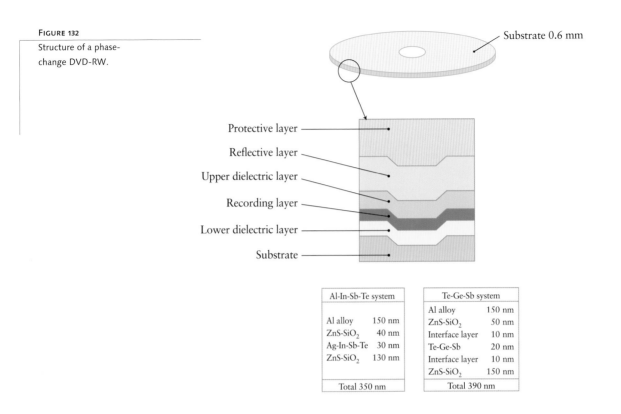

FIGURE 132

Structure of a phase-change DVD-RW.

Substrate 0.6 mm

Protective layer
Reflective layer
Upper dielectric layer
Recording layer
Lower dielectric layer
Substrate

Al-In-Sb-Te system	
Al alloy	150 nm
ZnS-SiO$_2$	40 nm
Ag-In-Sb-Te	30 nm
ZnS-SiO$_2$	130 nm
Total 350 nm	

Te-Ge-Sb system	
Al alloy	150 nm
ZnS-SiO$_2$	50 nm
Interface layer	10 nm
Te-Ge-Sb	20 nm
Interface layer	10 nm
ZnS-SiO$_2$	150 nm
Total 390 nm	

Physical Deterioration of CDs

Improper handling may cause rapid deterioration of CDs. Scratches can interfere with reading, particularly if they are around the circumference of the disk. During storage, environmental conditions play a major role in media longevity (Table 89). Most commercial CDs (CD-ROMs and CD-Rs) have a polycarbonate substrate that is molded at a high temperature and rapidly cooled, which creates internal stresses. At high temperatures, they deform, rendering the disk unreadable.[22] Rapid environmental changes (i.e., relative humidity and temperature cycles) can cause the same effects, such as cracks and delamination of the layers, due to the differential expansion of the various components or lack of adhesion between the layers. No stability studies have yet been published on DVDs. Their more complex structure, formed by assembling two PMMA wafers, raises questions about their behavior over time.

Chemical Deterioration of CDs

The chemical stability of the polymer substrate (polycarbonate or polymethyl methacrylate) does not seem to be at risk when stored in darkness. The problems reside in the reflective layer and the varnishes that are used on it. In fact, it is dismaying that early CD-As, which were marketed in 1985, were coated with a lacquer of cellulose nitrate, an unstable polymer known for causing problems in photographic and motion picture archives. And we do not yet know what problems the other varnishes hold in store for us.

Oxidation spots on the silver reflective
layer of a CD-R.

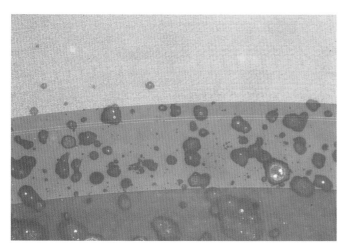

Aluminum layer of a CD-A corroded by
atmospheric pollutants.

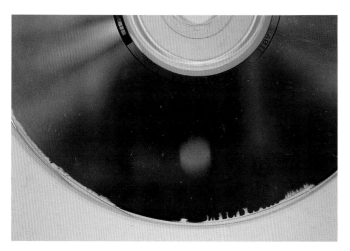

Residual manufacturing impurities, present on the reflective surface, eventually cause surface defects. It has also happened that the inks applied as labeling on CD-AS have migrated and corroded the metal layer.[23] The water vapor diffuses into the polycarbonate and induces oxidation of the aluminum metal layer. Atmospheric pollutants—nitrogen oxides and sulfur dioxide—attack the metal and render the layer transparent. Silver layers tarnish in the presence of sulfide, and this corrosion has the potential to compromise the ability to read the data (Figs. 133, 134). To prevent such deterioration, specific alloys, protective layers, and passivation techniques have been used. While they do retard these phenomena, they cannot prevent them. Only CD-RS with a layer of gold are resistant to this type of degradation. The life expectancy of CDs for dark storage is determined using standardized methods (see p. 32). Depending on the type of optical disk, estimates range from five to more than one hundred years (Table 90).[24] The performance claimed by the manufacturers is sometimes greater, for example, 217 years at 25°C and 40% RH for the Kodak Writable CD (recorded on a Kodak PCD Writer 200).[25] These estimates are for thermal stability. Several light-aging tests have been conducted, and we know, for example, that CD-RS manufactured with cyanine are very sensitive to light. They should not be left exposed to light.

Preserving CDs

It is generally accepted that optical digital disks have a life expectancy greater than that of magnetic media. From the perspective of use, they have an important advantage; that is, reading with a laser beam eliminates all mechanical contact and the corresponding risk of abrasion. However, the types of optical disks are too varied and recent for us to know how they behave during natural aging. Today, there are various qualities of CD, which almost certainly have different performances. As with any object, their behavior over time depends on the materials used and their conditioning. Only artificial aging tests, which have now been standardized but which have implicit uncertainties, can give us an approximate idea of their durability.

ISO Standard 16111 specifies storage conditions for optical digital disks. These include avoiding temperature and relative humidity extremes and maintaining stable temperature and relative humidity conditions. As with traditional materials, storing these discs in a cool, dry environment slows the mechanisms of degradation. It is advisable to acclimate discs progressively when they must be transferred between very different environments. Temperature and relative humidity gradients need to be limited, and water vapor should not be allowed to condense on the surface of the disk when it is heated or cooled. About 12 hours is sufficient for such acclimatization.

Air quality recommendations are the same as those recommended for photographic collections. Because dust constitutes a significant source of abrasion, it is important to keep facilities clean, by eliminating suspended particles (larger than 0.3 micron) and by not touching the surface of a disk when it is accessible. It is advisable to use lint-free gloves when handling optical digital disks. Most disks need to be protected from light, since visible and ultraviolet radiation can break down organic components such as dyes, varnishes, and polycarbonate. If dust must be removed from the surface of the disk, use an air or nitrogen jet, or else use a soft brush or damp cloth, gently wiping radially, from the center to the edges of the disk. Organic solvents should not be used for cleaning. Therefore, envelopes should be opaque and protect the disk from impact and dust (Table 91).

Magneto-optic disks, which are less sensitive than magnetic tapes to magnetic fields, should not be exposed to a magnetic field greater than 600 Oersteds. The polystyrene cases in which the disks are sold are acceptable for long-term storage, as is polypropylene and polycarbonate. Jackets made of paper, cardboard, PVC, and plasticized polymers are not recommended, because these materials can release particles or harmful emanations. Adhesive labels can cause long-term problems and affect the balance of the disk during reading, so they should be used with circumspection. However, if the disk already has a label, it should not be removed, as this can damage the metal layer. Inks, solvents, and heat can potentially damage disks, so it is advisable to consult the manufacturer before writing on the surface with a felt-tip pen or using a heat process. Some laser engraving systems are available and used

TABLE 89

Recommended temperature and humidity conditions for storing CDs.*

Environmental Factors	Polymer Substrate	Glass Substrate
temperature	5°C to 20°C fluctuations limited to ±1°C over 24 hours, ±3°C over 1 year	−5°C to 50°C
relative humidity	30% to 50% fluctuations limited to ±5% RH over 24 hours	5% to 95%
temperature gradient	maximum 4°C per hour	maximum 15°C per hour
relative humidity gradient	maximum 10% RH per hour	maximum 10% RH per hour

* NF Draft Standard 242011-2:1999, Imagerie électronique — Contrôle des informations conservées sur CD; also ISO 16111.

in libraries to write accession numbers on the center edge.[26] Optical disks should be stored vertically. At least once every five years, the collection should be inspected for physical appearance and legibility. Testing CDs requires professional equipment and expertise. The block error rate is measured, as are other parameters that may inform us about the nature of the signal deterioration. In the event there is degradation or if the system becomes obsolete, the data should be transferred to new media.

MICROGRAPHY VERSUS DIGITIZATION

With the development of optical digital storage, microfilming of books and archival records often competes with information storage on optical digital disks. Although many people deny wanting to abandon the microform as a backup medium for preservation, the temptation is great, when funding is short, to give priority to a technology of the future at the expense of microfilming, which seems somewhat outdated and whose prospects are less appealing. The possibilities offered by digitization are inconceivable with traditional media. Information is rapidly accessible and transmissible. It can be processed (annotation, selection of portions of text, use of character recognition software), improved (increased legibility), sorted, reproduced, and transferred with a low error rate, viewed (color and half-tone documents), and so on. Preliminary studies conducted at the U.S. National Archives have shown that there is no alternative for quality reproduction of documents whose

TABLE 90

Writable optical digital disks (1993).*

Type of ODD	Recording Principle	Estimated Life (per manufacturer)	Manufacturers
tellurium layer	removal of tellurium film by a laser beam	10–40 years	Fujitsu, Hitachi, Mitsubishi, Toshiba, Laser Magnetic Storage Int.
colored polymer	deformation of a heat-sensitive polymer by a laser beam	100 years	Eastman Kodak, Pioneer, Ricoh, Mitsui
dual alloy	fusion of two alloys by a laser beam to form a new one, made with selenium, tellurium, antimony, and bismuth	100 years	Sony
phase change	phase change (noncrystalline→crystalline) in an alloy by a laser beam	15–30 years	Matsushita, Eastman Kodak, Hitachi, Pioneer
thermal bubbles	formation of bubbles in a collodion layer by a laser beam	50 years	New ATG Gigadisc
magneto-optic	polarization change in an alloy by the Kerr effect	10–30 years	Canon, Hewlett-Packard, Hitachi, IBM, LMSI, Matsushita, Maxoptix, Mitsubishi, Pioneer, Ricoh, Sharp, Sony, Toshiba

* W. Saffady, Optical Disks vs. Micrographics (Westport, Conn.: Meckler, 1993).

TABLE 91
Recommendations for storing CDs.*

- protect CD from scratches, abrasion, dust, and pollutants

- protect CD from light and store under stable temperature and humidity conditions

- do not touch surface of CD; use gloves (hold by edges)

- do not apply solvents

- do not write on surface with ballpoint pen or pencil; do not attach labels

- do not remove any self-adhering labels from surface

* *Kodak,* Permanence, Care, and Handling of CDs *(Rochester, N.Y.: Kodak Imaging, 1995).*

writing is very faded. Microfilm provides only flat images with lower resolution. The document is digitized at a resolution of 200 dpi and indexed and the image quality is checked on-screen. If it is insufficient, the document is redigitized at a higher resolution (400 dpi) and supplemented with digital image processing to improve legibility. The data are then transferred to a temporary magnetic medium (ODD-WORMs).[27]

Clearly, microfilming has been largely surpassed by digital technology as a source of information access, but microfilming as a means of long-term preservation (in the event the original is destroyed) is much more reliable than is digital technology. The countless possibilities of digital technology must not be allowed to mask its major flaw, lack of durability. It is not certain that institutions can bear the costs of maintaining even the digital archives that are frequently used, and under those conditions, it is advisable to possess analog backup copies such as microforms.

Micrography techniques are now standardized and the equipment should not undergo any major changes. Startup and operating costs are easy to evaluate. Furthermore, microfilm has probative value, which digital documents, so far, do not. Moreover, many digital documents are created from microforms, and this process can be automated and therefore performed at low cost. Likewise, microfilm scanners allow high-speed, low-cost digitization, as required for access. For several more years, it will be necessary to ensure the coexistence of a proven technique such as micrography alongside the digital technologies. Everyone should concede their complementarity,[28] since digitization allows access to information, while microforms ensure its permanence. Therefore, where no microforms exist, it is desirable to generate them from the files, using an appropriate output method (such as COM). Some companies offer cameras that perform both operations (microfilming-digitization) simultaneously.

Undoubtedly, one day it will be necessary to definitively opt for all-digital, but, in addition to technological assurances, such a choice will require a cultural change involving acceptance of archiving nonmaterial information, at the risk of challenging some of the dogmas of traditional archive management. Finally, neither a microform nor a digitized image will provide rapid access to a document if it is not correctly indexed. A necessary step in both digitization and microfilming remains preparatory work and document organization, that is, sorting, cataloging, and, possibly, flattening and conservation treatments. These operations take time and skill, and nothing yet allows us to suppose that this will be less true in the future (Tables 92, 93, 94).

TABLE 92

Number of A4 pages contained on a
600 MB ODD.

Compression	8 pts/mm Resolution	12 pts/mm Resolution	16 pts/mm Resolution
CCITT* Group III compression ratio 10:1	12,020	5,340	3,005
CCITT* Group IV compression ratio 15:1	18,040	8,020	4,510

* Now UIT.

TABLE 93

Performance of different media.

Criteria	Paper	Microfilm (16 mm x 30 m)	CD (600 MB)
storage capacity* (number of A4 sheets)	1	2,500	12,020
reduction ratio of storage volume*	0	99.9950%	99.9988%
speed of access to data*	—	1.5 min. to 2 min. (by CAR)†	under one minute
life expectancy of medium	more than 100 years	more than 100 years	more than 10 years
permanence of data access	unlimited	unlimited	unknown: obsolescence of read interfaces

* According to W. Saffady, Optical Disks vs. Micrographics (Westport, Conn.: Meckler, 1993).

† CAR = computer-assisted research.

TABLE 94

Advantages and disadvantages of optical
digital discs compared to microforms.

Advantage	Disadvantage
• large storage capacity	• no experience with conservation
• rapid access to data	• non–human readable
• color or black-and-white documents, line or halftone	• no compatibility among all optical disks or tapes
• possibility of improving legibility of a document	• risk of obsolescence: format, medium, software, and computer
• can be read indefinitely without damage	• uncertain stability of medium (ODD or tape)
• foreseeable optical character recognition and word processing	
• image displayed rapidly without chemical processing (development)	
• remote transmission	
• rapid transfer, with practically no loss	

Technical
and Practical
Information

Processing Photographs for Permanence

BLACK-AND-WHITE PHOTOGRAPHS

Exposing a photographic emulsion to light results in the formation of latent image sites consisting of at least 4 to 10 atoms of metallic silver in the halide crystals. This deposit forms the latent image and remains invisible, as it is too small to be perceived by the eye. The role of the developer is to amplify this latent image, whose mass increases to as much as several billion times its initial size. The crystals that bear the latent images are transformed into metallic silver in the form of filament clusters. Then, in the fixing bath, the remaining light-sensitive silver halide crystals are dissolved and eliminated. The final washing rids the photographs of any residual thiosulfate salts.

The processing of black-and-white photographs intended for long-term archiving requires no complex or costly operations. Since the mid–nineteenth century, we have known that fixing, washing, and toning baths, if correctly applied, contribute significantly to print stability. There are no miracle formulas. Only careful work and meticulous monitoring of the various processing phases can ensure quality results.

Cleanliness is the sine qua non for producing long-lasting documents. The darkroom, tanks, washers, blotters, glazing presses, towels, and sponges must be regularly cleaned or replaced. Fingers can contaminate images during handling when they have been in contact with processing solutions (Fig. 135). Therefore, direct contact with these products should be kept to a minimum.

Developers

Developers, which transform the silver halide crystals exposed to light into metallic silver filament clusters, have a critical influence on the final structure of the image. The granulation, contrast, shape, and size of the filament clusters depend in part on the formula of the developer and the conditions under which the developer is used. No significant relationship has been established between degradation of the silver deposit and the use of a particular type of developer, even though some images are potentially less vulnerable than others because the filament clusters that compose them are larger in size. However, the high pH of developer baths (pH 9 to 11) causes swelling of the gelatin, leading to softening of that binder layer, which can result in physical damage from handling and agitation during processing.

FIGURE 135

Accidental stain on a glass-plate negative.

TABLE 95

Color changes of bromocresol green indicator.

pH < 4	yellow
4.5 < pH < 5	green
pH > 5	blue

Stop Baths

The stop bath (formula 1, see p. 239) stops the action of the developer absorbed by the image layer by lowering the pH. As it allows development to be strictly controlled, it is particularly recommended when one is using very powerful developers with relatively short developing times. A stop bath also prevents the formation of dichroic fog, an iridescent silver deposit that forms on the surface of prints when developing continues in the fixing bath.[1]

With respect to the permanence of photographic images, the essential benefit of the stop bath is to ensure proper fixation; omitting it can reduce the life of a fixing solution by half due to contamination from the developer. The pH of stop baths is generally between 3 and 5. Too acid a pH can cause irreversible degradation of the physical properties of the gelatin layer. Acetic acid is used to prepare stop baths, since it is compatible with the components of the fixing solution. For obvious safety reasons, it is preferable to use 28% acetic acid rather than the anhydrous form, called glacial acetic acid. Adding sodium sulfate (approximately 5%) limits swelling of the gelatin.

The photograph is immersed in a stop bath for a few dozen seconds. After repeated use, the stop bath progressively loses its potency. Therefore, it is advisable to check it regularly, by taking a piece of paper impregnated with a few drops of 5% bromocresol green alcohol solution or a commercially available colored indicator and dipping it into the bath. A blue color indicates an exhausted stop bath (Table 95).

Fixing

The fixing bath (formula 2, see p. 239) dissolves the residual photosensitive salts that remain in the photographic layer. Silver halides are eliminated with a solution of sodium or ammonium thiosulfate (formerly called hyposulfite, or hypo). Ammonium thiosulfate acts four times faster than sodium thiosulfate and is used in "rapid" fixing agents such as Ilfospeed and Hypam (Ilford) and Kodak Rapid Fixer (Kodak).

A fixing bath generally contains an acid for neutralizing traces of the developer; an antioxidant (sodium sulfite or bisulfite), which prevents the thiosulfate from breaking down in an acidic environment; and, sometimes, a hardening agent (potassium alum) to harden the gelatin layer (although a hardening bath is not recommended).

pH of the fixing bath

It is advisable to fix in an acid solution, to prevent any formation of dichroic stains. The pH of the fixing solution should be accurately adjusted in accordance with the formula. Too acid a pH (below 4) can lead to breakdown of the thiosulfate or the hardening agent, and too high a pH (above 5.5) inhibits hardening of the gelatin. The pH of the fixing bath affects the effectiveness of the washing step. The proteins that form the gelatin have acid (carboxyl) and basic (amine) functional groups. Depending on the acidity of the fixing solution, some of these groups ionize and form either negatively charged anions or positively charged cations. However, there is a pH value, usually about 4.9, called the isoelectric point, at which the positive and negative charges neutralize one another. A pH below 4.9 promotes the formation of positively charged ions in the gelatin. The negatively charged thiosulfate ions are then electrostatically attracted to them, and this interaction slows down their elimination during washing. The pH of fixing solutions is stabilized using buffers (the combination of a weak acid or a weak base with salt that has the property of limiting pH variations in a solution, e.g., acetic acid and sodium acetate). Stabilized fixing solutions maintain their pH longer due to their buffer capacity and thus last longer.

Fixing time

Agitation, temperature, and concentration affect fixing speed. Ineffective fixing produces an unstable image that has a tendency to stain when exposed to light. Photographers often allow photographs to fix longer than necessary. If paper prints remain in the fixer too long, the salts in the fixing solution penetrate deep into the paper base fibers and are also adsorbed by the gelatin (Table 96). It is then very difficult to eliminate them. Furthermore, ammonium

TABLE 96

Residual thiosulfate concentration in a print, based on fixing time,* after the same wash sequence.

Fixing Time	Thiosulfate in the Print (g/m^2)
30 seconds	0.0014
1 minute	0.0016
2 minutes	0.006
3 minutes	0.01

*M. Reed, "A Practicum on Print Washing," Photo Techniques, July–August 1996, 23–28.

TABLE 97

Processing sequences for archival fiber-based paper prints (Ilford).

Step	Process	Time
development	Ilfobrom developer (1 + 9)	1–2 minutes
stop bath	IN1 stop bath	5–10 seconds
fixing	Hypam fixer (1 + 4)	1 minute
wash bath	washing under running water	5 minutes
wash aid	Ilford Galerie Wash Aid (1 + 4)	10 minutes
wash bath	washing under running water	5 minutes

TABLE 98

Recommended processing sequences for film and prints (Kodak).

Step	Time
fixing bath	time indicated in instructions
wash bath	30 seconds
wash aid (hypo cleaning agent)	1 to 2 minutes
final wash	10 minutes (film) 20 minutes (paper)

TABLE 99

Recommended processing for archival prints.

Step	Time
stop bath	30 seconds
first fixing bath	3 to 5 minutes
second fixing bath	3 to 5 minutes
wash bath	5 to 10 minutes
wash aid	5 to 10 minutes
wash bath	5 to 10 minutes
selenium toning	3 to 15 minutes
wash bath	20 minutes
drying	

thiosulfate can have a dissolving action on the silver and lead to fading of the image. This phenomenon particularly affects fine-grain emulsions and warm-tone prints, since the fineness of the silver deposit makes them more sensitive to corrosion. The fixing time is fairly simple to determine for negative emulsions: one simply doubles the clearing time (the time it takes a negative emulsion immersed in the fixing bath to lose its milky appearance). The methods used to determine the fixing time for prints are more empirical. For example, with a fresh ammonium thiosulfate fixing solution, at 20°C, the fixing time for a print is one minute (with constant agitation). With a conventional sodium thiosulfate fixing solution, the mean processing time is 7 to 8 minutes. For manufactured products, the manufacturers indicate the appropriate processing times for their photosensitive surfaces in their documentation (Tables 97, 98, 99).

Solution exhaustion

Thiosulfate "captures" silver halides by forming silver thiosulfate complexes. The more the fixing solution is exhausted, the more these compounds become loaded with silver and the more insoluble they become. Then it is impossible, even with prolonged washing, to extract them from the gelatin layer. Over time, these compounds are capable of breaking down into sulfuric acid and silver sulfide. The white areas of a photograph are turned yellow by the deposit of the silver sulfide, while the silver is quickly corroded by the sulfuric acid. To prevent such accidents, only fresh or regularly tested baths should be used. It is also possible to use the old technique of double fixing, which is quite familiar to photographers. The photograph is immersed in a moderately exhausted fixing bath and then in a fresh bath. However, this is difficult to implement. It requires handling solutions and monitoring the status of the baths. Finally, the photograph remains in the solutions longer, which can facilitate the adsorption of chemical into the substrate, particularly with baryta paper prints.

FIGURE 136

Test strips marketed for determining
the concentration of residual silver
compounds in fixing baths (Tetenal).

Exhaustion of the fixing bath

It may be necessary to change the solution every time a given surface area of photosensitive layer has been processed. However, it is not possible to precisely determine the capacity of a fixing bath in square centimeters, since this varies depending on the density of the silver in the photographs. An image with predominant areas of high density exhausts the fixing solution less than does a very light image. Prints that have margins exhaust the bath more. The standard that indicates the maximum allowable amounts is currently being revised. G. Haist advises not exceeding 0.05 g of silver per liter of sodium thiosulfate fixing solution. This very strict limit barely allows for fixing three 13×18 cm prints per liter.[2] That amount can be raised to 0.5 g/l with no great risk to the durability of the photographs. The Tetenal company even allows values up to 5 g/l (Table 100).

For film, ISO Standard 10602 provides the following limit values:

0.5% (5 g/l) silver for a sodium thiosulfate film-fixing solution

0.8% (8 g/l) silver for an ammonium thiosulfate film-fixing solution

Tetenal markets test strips whose tip is dipped in the fixing solution and whose color changes depending on the degree of exhaustion of the bath (Fig. 136). This makes it possible to determine the silver content, as well as the acidity of the bath, at any time, based on a color indicator. Other methods have been published for determining the status of a bath and estimating its capacity, including the Kodak FT1 test (formula 3, see p. 240).

A rule of thumb that is sometimes used consists of changing the bath when the clearing time of a film is more than double the clearing time with a fresh bath. This method is not very reliable for ammonium thiosulfate baths.

Testing for Residual Silver Salts

To ascertain whether the image has been properly fixed—that is, that all of the silver salts have been eliminated—a destructive test is used, whence the

TABLE 100

Maximum silver concentrations in a
fixing bath recommended by Tetenal.

Type of Image	Sodium Thiosulfate Fixer	Ammonium Thiosulfate Fixer
black-and-white print	3 g/liter	5 g/liter
black-and-white negative	5 g/liter	8 g/liter
color processes	5 g/liter	5 g/liter

need to leave margins somewhat larger than the final margins. A sample a few square centimeters in size is cut from the edge of the margin and a drop of 0.2% sodium sulfide is placed on it. Then the degree of yellowing is evaluated visually, because the yellow color is proportional to the quantity of residual silver salts. If there is no noticeable color, this indicates correct fixing. ISO Standard 10602 recommends this test for film. Kodak suggests a similar method (formula 4, see p. 240).

Washing

Residual traces of the fixing solution must be eliminated by washing, to avoid potential subsequent decomposition and, therefore, degradation of the photograph. Too high a residual thiosulfate level eventually causes sulfiding of the silver image.

Washing can be performed adequately only if the fixing was done properly. Agitation, replacement, hardness, and temperature of the water are critical factors for correct washing. The water should be agitated and replaced regularly. The washing time varies depending on the types of substrates and processes used. The impermeability of resin-coated paper substrates allows for extremely short washing times, on the order of just a few minutes. Prolonged washing increases the risk of emulsion exfoliation inherent in such substrates. Prints on baryta paper require a longer washing cycle since the cellulose fibers become saturated with the processing solutions. Water that is too cold (below 15°C) considerably reduces the effectiveness of washing. A temperature between 15°C and 25°C is recommended, and the difference between the water temperature and the developer temperature should be no more than 3°C.[3] Washing with distilled or deionized water is much less effective than washing with mineralized water. However, the final rinse water should be quite soft to prevent the risk of salt deposits after drying.

G. T. Eaton and G. I. Crabtree demonstrated that five minutes of washing in seawater are sufficient, since in that situation the gelatin has a tendency to dehydrate rather than to swell.[4] That observation has been put to use in commercially available "washing aids," also called hypo clearing baths, which markedly reduce the washing time. These are generally saline solutions used for several minutes at the start of the washing step. The sodium chloride in seawater, which is more corrosive to the silver image, is advantageously replaced with sodium sulfate[5] or sulfite (a 1% to 2% solution). The sulfite or sulfate ions that replace the thiosulfate ions in the photograph are more rapidly eliminated during washing. The life of such baths is some fifty 18 × 24 cm prints per liter.

Cylindrical film processing tanks, where the film is loaded on a spiral reel, can be effectively washed by inserting a small water hose into the center of the reel so that the water overflows steadily from the tank. Sheet films can be washed in a tray by attaching a siphon device to the edge of the tray, in a sheet-film washing tank, or by using a vertical washer for paper prints.

Washing paper prints
Prints should never come in contact with one another, during either fixing or washing. With baryta paper, some of the optical brighteners in the barium sulfate layer of a print can migrate to the back of another print that was in

Figure 137

Back of a fiber-base photograph viewed under UV radiation. The fluorescent traces show that during one step of the processing, this print was in contact with others, which in some areas allowed optical brighteners to be transferred from the barium sulfate layer.

contact with it. The resulting yellow streaks are not stains but areas where no optical brightener has been transferred (Fig. 137).[6]

To prevent such phenomena and to improve the effectiveness of the washing, vertical washers can be used (e.g., Maco, Nova, Gravity, or ZoneVI), some of which are equipped with an air burst agitation device. The prints are placed individually in compartments, and pressurized water is sprayed into the lower part of the tank through a nozzle, which creates suction, causing a slight turbulence in the wash compartments and agitating the prints.

The prints can be washed effectively using a more conventional method. Place them, image side up, in sufficiently large tanks, one size larger than the format of the prints (e.g., a 30×40 cm tank for 24×30 cm prints) (Fig. 138). Run several (six to twelve) five-minute wash cycles while agitating the prints. A final rinse in a wetting agent solution (Kodak Photo Flo) facilitates the elimination of water droplets, which leave spots when they dry.

Whatever the procedure used, once the parameters are determined, it is advisable to verify its effectiveness by checking the quantity of residual salts. There are various methods for this, which are provided at the end of this chapter. It is also possible to qualitatively check for salts in washing baths with the Kodak HT-1a test solution (formula 5, see p. 240), whose color changes when thiosulfate is present.

Hypo eliminators

Hypo eliminators are different from the washing aids discussed above. A hypo eliminator (formula 6, see p. 241) works chemically and oxidizes thiosulfate into innocuous sulfate. However, this treatment can be harmful to photographs. There is a potential for chemical and physical image degradation. Nor is it practical, since the bath cannot be preserved. Recommended in the standards in the 1960s (ISO Standard R421-1965), it is considered highly inadvisable today. Experience shows that exposure to light causes reactions that discolor treated prints, imparting warm tones (from yellow and pink to red) that are particularly visible in the halftones. The oxidizing action of the bath affects not only residual salts but the silver image as well, by transforming a portion of the silver into silver salts that can be reduced by light. This photolytic reduction produces colloidal silver whose tone is warmer than the silver initially present in the layer. Therefore, if this treatment is applied, gold, selenium, or sulfide toning must be done to prevent adverse image reactions.

Other treatments, described in the literature of the past century, can have the same effects. While it is recognized that sodium hypochlorite (chlorine bleach) destroys thiosulfate, in an acidic environment it also converts a portion of the silver into silver chloride, which is reduced by light and produces a reddish color. In practice, using washing aids is the only viable alternative for shortening this phase of processing, and hypo eliminators should not be used.

Checking the Washing

Standards

Given the critical impact of residual salts on image permanence, it became necessary to standardize the maximum admissible levels of residual by-products in photographic documents intended for long-term archiving, as well as the

FIGURE 138

FIGURE 138

Rack-in-tank washer.

means of measuring those levels. The allowable threshold depends on the nature of the photographs (Table 101). However, the standards are not immutable. They have undergone modifications and are likely to undergo additional modifications in the future, based on the results of studies that are in progress. In fact, several studies have shown that traces of thiosulfate in a photographic image do not fundamentally affect its durability if it is preserved in a dry atmosphere. For example, the allowable limit for silver microfiche has been revised from 0.007 to 0.014 g/m². Fine-grain film should also be subject to these new levels. The standard for photographic prints is still being final-

TABLE 101

Thiosulfate content limits (ISO 10602: 1993).

Type of Film	Classification	Maximum Thiosulfate Concentration (g/m²)
X-ray film	medium term	0.100
	long term	0.050
	archival	0.020
microfilms	long term	0.030
	archival	0.014
other fine-grain films	archival	0.007*
other coarse-grain films	archival	0.020
resin-coated paper	long term	currently being revised
	archival	currently being revised
fiber-base paper	archival	currently being revised

* Value may be revised upward.

ized.[7] Currently, a print is considered correctly washed if no thiosulfate can be detected using the standardized test methods. The recommended level will most likely be in the range of 0.015 to 0.020 g/m².

A low thiosulfate content markedly improves a photograph's resistance to pollutant gases,[8] particularly when it is exhibited unprotected in an uncontrolled environment. Some scientists attribute this protective action to the transformation of the thiosulfate on the surface of the silver grains into silver sulfide during storage, which provides an anticorrosion barrier.[9] Others believe that the thiosulfate prevents the catalytic breakdown of peroxides on the silver.[10] Controlling the quantity of residual thiosulfate so that there is neither too much nor too little is not feasible in practice. The photograph runs the risk of discoloration due to moisture in the one instance and to oxidizing pollutants in the other. It is advisable to eliminate as much of the residual thiosulfate salts as possible and then treat with toner solutions or stabilizers to protect the image against oxidizing gases. Sistan, marketed by Agfa, is a thiocyanate stabilizer bath for negatives and for resin-coated paper.

Determining thiosulfate content

There are two problems with testing for residual thiosulfate salts. It is necessary to use a method that is quite sensitive in order to detect quantities on the order of one microgram (a thousandth of a milligram) in a few-square-centimeter sample taken from the surface of a photograph. Furthermore, thiosulfate is not stable and breaks down into polythionates (trithionate or tetrathionate), salts that are likewise harmful to the image but that are not always detectable.

There are several standardized methods, including those using methylene blue and iodine-amylose. However, these accurate testing techniques do not take polythionates into account. Therefore, it is necessary to apply them as soon as possible after processing, before thiosulfate decomposition can affect the results. The silver sulfide method measures the quantities of both residual thiosulfate and decomposition by-products, but it is less sensitive than the aforementioned tests.

These tests are destructive and must be done on areas that have no image (white margins). Using these test methods on paper that contains an activator (a reducing agent in the emulsion) can lead to erroneous results. The same applies to photographs that are toned with sulfur compounds. The test method does not distinguish between sulfide ions from the protective toning and those from residual thiosulfate. In the latter case, it is considered that, regardless of the source, the presence of sulfur compounds is undesirable, and the limit values recommended by the standard should be followed to the letter (Table 102).

The methylene blue method

In the presence of borohydride, residual thiosulfate is transformed into sulfide, which reacts with NND (N,N-dimethyl p-phenylenediamine) to form methylene blue. The greater the quantity of thiosulfate, the more intense the color.

$$2S_2O_3^{2-} + 3H_2O + BH_4^- \longrightarrow 2HS^- + 2HSO_3^- + H_2BO_3^- + 2H_2$$

$$H_2S + 6Fe(SO_4) + 2NND \longrightarrow \text{methylene blue}$$

TABLE 102

Standardized methods of testing residual
thiosulfate concentrations (ISO 417).

Method	Application	Range	Comment
methylene blue	film, glass plates, baryta paper, RC paper containing no activator, not sulfide toned	0.001 to 0.45 g/m²	method applicable within two weeks following processing
iodide-amylose	film, glass plates, baryta paper, RC paper	0.002 to 0.40 g/m²	method applicable within two weeks following processing
silver nitrate	film, glass plates, baryta paper, RC paper containing no activator, not sulfide toned	more than 0.009 g/m²	

The intensity of the color is measured with a spectrophotometer at a wavelength of 665 nanometers. By comparing the results to calibration curves, one can deduce the thiosulfate concentration.

This test is applicable for concentrations between 0.001 and 0.45 gram of thiosulfate per square meter.

The iodine-amylose method

With this method, introduced by D. Owerbach in 1986[11] and standardized in 1993 (ISO 417), residual thiosulfate decolorizes a blue solution created from the reaction of cadmium iodide with amylose. The greater the quantity of thiosulfate, the less intense the color (unlike with the previous method).

$$\text{starch + iodide} \longrightarrow \text{blue solution}$$

$$\text{blue solution + thiosulfate} \longrightarrow \text{decolorization of the solution}$$

The intensity of the color is measured with a spectrophotometer at a wavelength of 610 nanometers. By comparing the results to calibration curves, one can deduce the thiosulfate concentration. There is a similar method that uses zinc iodide, which is less toxic than cadmium iodide.

The silver densitometric method

Thiosulfate and its decomposition by-products react with silver nitrate to produce silver sulfide, which is easily detectable due to its brown color. The intensity of the color is proportional to the quantity of the residual salts.

$$S_2O_3^{2-} \text{ (and/or } S_3O_6^{2-}, S_4O_6^{2-}) + 2\,AgNO_3 + H_2O \longrightarrow Ag_2S + 2\,NO_3^- + H_2SO_4$$

By preparing reference samples containing known quantities of residual thiosulfate and tracing a calibration curve representing the thiosulfate concentration as a function of color intensity, one can deduce the quantity that is present in any sample.

This method, which is less sensitive than the preceding ones, is applicable for levels greater than 0.009 g/m² (0.9 μg/cm²).

Commercially available tests

Kodak markets an HT-2 test (formula 7, see p. 241) under the name Kodak Hypo Estimator. It uses the same principle as the one just described for the silver densitometric method.

Toning

Toning was popular in the nineteenth century because of the wide variety of colors it imparted to prints, but it progressively fell into disuse in the twentieth century. In recent years, there has been renewed interest in the technique, as it can markedly increase the permanence of black-and-white photographs, whether prints, negatives, or microfilm. However, while a change in image hue scarcely has any importance for a negative or microfilm, it is not always desired in a print.

A great number of toning bath formulas have been published in the technical literature since the mid–nineteenth century, but not all of them are beneficial when it comes to permanence, and some even have harmful consequences. Gold toning is often recommended for processing microfilm and negatives. Selenium and polysulfide toning provide excellent results. Platinum toning is rarely used, given the cost of the metal.

The element dissolved in the bath (gold, selenium, sulfide, etc.) combines with the silver to form a compound that is much more resistant to oxidation by pollutant gases. For large microfilm collections, polysulfide toning is becoming standard, since gold toning is too expensive and selenium toning, in addition to being toxic, is apparently less effective in protecting low-density areas.[12] Toning baths are applied after fixing. In some cases, it is necessary to wash the image first.

Gold toning

With gold toning (formula 8, see p. 241), gold is not deposited on the silver filament, but some silver atoms are replaced by gold atoms. An advantage of gold toning is that it does not excessively change the hue of the photograph, although black areas acquire a slight bluish tone. The cost alone considerably limits its use.

Selenium toning

The toned image is composed of silver, silver selenide, and selenium. This toning (formula 9, see p. 242) is less expensive than a gold bath, but selenium is extremely toxic (it carries the risk of thyroid cancer). Using sodium selenite rather than crystallized selenium limits the health risks. However, rather than attempt to prepare the bath, it is wiser to purchase commercially available solutions and to use safe practices when handling them.

Selenium baths can slightly intensify the image and can generate a purplish crimson tone, depending on the concentration of the bath. Commonly used dilutions range from 1:3 (one volume of bath to three volumes of water) to 1:20. When processing prints, one should keep an untoned reference print for comparison, to better evaluate any change in image hue. Tests have shown that Kodak Rapid Selenium, diluted at 1:19, does not change the characteristics of the image and provides good protection for microfilm.[13] However, more recent

1

2

Gelatin silver bromide print: (1) untoned, (2) toned with iron salt, (3) toned with sulfide.

3

studies indicate that there can be marked and unpredictable differences in the protection provided, depending on the type of photographic film.[14]

Sulfide toning

This low-cost toning treatment (formula 10, see p. 242) markedly improves the stability of the silver image. It is less toxic than selenium toning, although the hydrogen sulfide gas (which has the odor of rotten eggs) that such baths can produce is harmful and can fog the photosensitive surfaces. It is advisable to work under a hood or in a well-ventilated area. The silver is converted into silver sulfide, which can tone the images a sepia color, depending on the concentration, and causes a slight loss of density and contrast (Fig. 139). It can be applied either directly after fixation in one single bath or in a two-step process that includes a preliminary bleaching. In the latter case, the silver sulfide particles are larger than the original silver particles.

Since the high pH of some of these baths has a tendency to swell and excessively soften the gelatin, the images should be handled with care to avoid mechanical damage.

The Image Permanence Institute introduced the Silverlock toning bath (formula 11, see p. 243) in the United States to treat silver microforms intended for backup archiving. It is applied directly after the fixing bath and may be mixed with a washing aid. The film should then be washed.

Checking the Efficiency of Toning

A toned image's resistance to chemical corrosion is proportional to the conversion rate of the silver. The immersion time and the concentration and temperature of the toning bath are essential factors that determine how much silver will be converted. Not all images react to these treatments in the same way. The structure of the silver deposit and the nature of the emulsion affect the transformation kinetics as well as the conversion rate. Under identical operating conditions, we find only 10% conversion with Kodak T-max 100 film as compared to 70% with Kodak Plus 125 film.[15] To check the effectiveness of the toning, ISO Standard 12206 (or ANSI IT9.15) recommends oxidizing the image in a bichromate bleaching bath to eliminate any unconverted silver. Using Farmer's bleach (formula 13, see p. 243) prevents the residual coloration found with the bichromate bleaching recommended by the ISO standard and thus facilitates calculation of the conversion rate[16] in paper prints. These tests are destructive. The density of the residual image (measured with a blue densitometer-filter) should not decrease more than 35% after bleaching, which confirms that at least 65% of the silver image was converted during the chemical reaction (in fact, experiments show that with up to 35% loss of density, it is still possible to make satisfactory copies of the original image).[17] Another procedure has been recommended for polysulfides.[18] It consists of immersing a processed sample for 10 minutes in a 2% hydrogen peroxide solution. (To prepare a 2% hydrogen peroxide solution, dilute 6.7 ml of a commercial 30% hydrogen peroxide solution with distilled water to make 100 ml.) The loss of density (measured with the neutral filter of the densitometer) should not be greater than 0.05 and no discoloration should be perceptible.

Hardening

Hardening (formula 12, see p. 243) improves the mechanical resistance of the gelatin layer and insolubilizes it by forming bonds between the macromolecules. In photography, hardening baths are generally solutions of formaldehyde or chrome or potassium alums. *Note: Formaldehyde poses a serious health hazard. Chronic exposure may cause allergic reactions and respiratory disorders.*

Hardening solutions are effective in pH ranges that depend on the type of hardening agent that is used:

potassium alum: pH 4.3 to 5.4

chrome salts: pH 2.5 to 3.3

formaldehyde: pH greater than 8.5

In temperate climates, emulsions are sufficiently hardened at the manufacturing stage to withstand most standard treatments, and it is not necessary to do any further hardening. On the contrary, more hardening would be counterproductive to washing, since reticulation of the gelatin decreases its permeability to water and diffusion of the salts. Therefore, it is preferable to avoid hardening baths and hardening fixers.

Reducing

The widespread use of photoelectric cells in cameras and the great latitude with emulsion exposures have made overexposure during shooting a rare occurrence. With respect to prints, printers should redo a print or use masks to correct the intensity of a part of a print rather than use a chemical treatment. Where absolutely necessary, Farmer's reducer (formula 13, see p. 243) provides good results. It should be applied to a well-washed but untoned photograph.

Drying

Photographers should also use great care during drying, the final step in the normal processing sequence.

Drying film

After immersion in a wetting agent, film should be suspended in a dust-free atmosphere. The temperature in electric dryers should not exceed 50°C to 60°C. Mechanical squeegee systems can cause abrasion if not properly maintained.

Drying resin-coated paper

After drip drying, these papers are generally placed in warm-air dryers, but it is advisable to ascertain that the filter upstream from the ventilation system is effective. The use of an infrared dryer is an option, but high temperatures can damage the polyethylene layer.

Drying baryta paper

After a final wash, excess water is removed from the print with a rubberized squeegee, and the print is then placed horizontally on fiberglass screen racks (Fig. 140) or suspended vertically to air dry. After drying, the print is flattened. This step can be done without heat by weighting it down for several hours between blotters, or with heat using a dry-mounting press set to a temperature of approximately 60°C to 75°C. In cases in which the prints are too deformed by low relative humidity, they can be slightly rehumidified on the back using a vaporizer. For pressing, the photographs should be placed between sheets of blotter paper or cardboard suitable for that purpose. Such materials can be sources of contamination if they are stained with chemical solutions (e.g., developer, fixer), so they must be changed frequently. The use of print flattening agents should be avoided, as they are very hygroscopic products that can promote microorganism growth.

Ferrotyping dryers (glazing machines, flat or drum dryers) may be used. In all cases, all surfaces that come in contact with the prints must be kept perfectly clean.

Retouching

Today, retouching has nothing in common with the nineteenth-century practice, when negatives were reworked extensively using gouaches, pencils, and abrasives to eliminate the unsightly features of the subject or to change the

FIGURE 140

Drying fiber-base paper photographic prints on racks.

background. The retouching I am discussing here is limited to spotting out an occasional defect in a print (e.g., dust spots, grit, scratches).

The American photographer Edward Weston used a solution of solid India ink and gum arabic. A mixture of equal parts of those two compounds (by weight) is dissolved in a small quantity of water and then air dried. To use it, it is stroked with a damp brush. Before retouching, the brush is tested on a blank sheet of paper. The retouching can be made glossier by using two to three times more gum arabic.

Gum arabic may have a tendency to yellow slightly (if the retouched area is dark, this may not be visible), and it can be replaced with a methylcellulose solution or a 2% or 3% gelatin solution. However, this involves somewhat more complex preparation. Elvace 1874 and Acryloid B-72, which have also been reported as good media because of their innocuousness[19] to modern black-and-white photographs, are more difficult to use and to remove. The safest commercial retouching products are Winsor & Newton water colors (series 1), the Gamma photo retouching kit, and Schmincke gouache.

For color photography, in addition to these materials, there are those marketed by companies for retouching their own products (Kodak and Ilford). We do not have any information about their long-term behavior. Dye-based retouching solutions can be difficult to remove once set and tend to fade or discolor over time due to poor light-fastness.

Marking

Using inks, pens, or felt-tip pens to write information on the back or front of a photograph (signatures, stamps, etc.) requires particular care. The dyes can diffuse laterally or migrate through the base and damage the image. Many felt-tip markers are not light-fast and may fade over time. Certain components of inks can also release compounds that are harmful to photographs

(see p. 48). Also, the hardness of the point used for marking needs to be checked, to avoid scoring the image layer from behind. This comment also applies to writing on photo jackets.

Varnishes

Acrylic B-72 or purified beeswax is sometimes used for black-and-white fiber-base paper. However, varnishes, lacquers, and waxes should be used with caution. They should not be applied without full knowledge of how they behave over time. Some substances may indeed protect the image from abrasion, light, or pollutants, but they may yellow over time, break down, damage the image, and be difficult to remove. The same is true of all plastic laminates where a sheet of plastic (polyester or PVC) is irreversibly applied to the surface of prints (see p. 172).

COLOR PHOTOGRAPHS (CHROMOGENIC PROCESSES)

The processing of color chromogenic film—with the exception of Kodachrome—has been standardized under two designations, E6 and C41. E6 processing applies to reversal process transparencies, and C41 processing applies to negatives (Table 103). Today, standard processing of chromogenic color prints from negatives is designated RA-4, which was introduced in 1986. This processing has become a standard and has replaced its predecessor, EP-2. Processing color reversal paper to make prints from slides is known as R-3.

Compared to black-and-white images, there are far fewer possibilities for processing color photographs. Processing is standardized and automated, and it is not possible to change the time of the fixing and washing sequences. However, it is important to ensure that the bleaching and fixing baths are scrupulously maintained, so as not to risk compromising the stability of the dyes. Chromogenic processing sometimes includes a hardening-stabilizing bath, generally containing a formaldehyde derivative that inhibits the residual coupling agents and hardens the gelatin. Stabilized coupling agents have less potential for yellowing over time or for reacting with dyes, which accelerate deterioration of the image. This type of degradation is frequently encountered

TABLE 103

Standard color processes.

Symbol	Types of Photographs	Examples of Emulsions
E6	slides	Agfachrome, Ektachrome, Fujichrome, etc.
R-3	reversible paper (positive-positive)	Ektachrome, Fujichrome
C41	color negatives	Agfacolor, Kodacolor, Fujicolor
RA-4	color prints (negative-positive)	Ektacolor
P3-X	reversible paper (positive-positive)	Ilfochrome Classic
P4	reversible paper (positive-positive)	Ilfochrome Rapid

with E6 processing. Due to a lack of stabilizer, the magenta dye breaks down and combines with the residual coupling agents. The image then takes on a greenish hue.

As with black-and-white images, the presence of residual processing chemicals can be a source of degradation.[20] In 1981 T. Hisanaga and colleagues showed that an increase from 0.1 to 1 microgram of thiosulfate ion per square centimeter decreased the dark-stability of cyan dye.[21] While the nature of the fixer (sodium, potassium, or ammonium thiosulfate) can play a role in the deterioration process, the pH of the emulsion appears to be much more significant with respect to the extent of the deterioration.[22] The quality of the wash water (e.g., pH, chloride ion content) can also have an impact on dye behavior.

Over the past few years, new treatments have been introduced to facilitate setting up "minilabs" in locations where there is no running water and to shorten processing times. The final washing bath has been replaced with a stabilization treatment,[23] using so-called washless or waterless systems. Paradoxically, Konica has shown that photographs that are processed in this way are more stable than if they had been washed in the conventional manner.[24]

Because there are numerous parameters, it is difficult to formulate simple recommendations that are appropriate to each of the processes. Therefore, the only thing we can do is to strictly comply with the processing directions provided by the manufacturers.

COMPUTER OUTPUT PRINTING

Computer output prints often represent the end result of a digital processing sequence, the physical items that are disseminated and archived. Improperly named "digital photos"—they are neither photographs nor digital—are discussed here because it is helpful to briefly present the technology involved in this type of printing, as well as the preservation prospects they provide for documents produced in this manner.

Previously reserved exclusively for printing text documents on paper, printers have undergone marked improvements in recent years to adapt them for printing images. In the medium term, the goal of the manufacturers is to offer machines capable of producing images that are in all ways comparable to conventional photographs, in terms of appearance, cost, and stability. This application is almost exclusively monopolized by so-called nonimpact printers—those whose printing mechanism does not come into direct contact with the paper. The hardware in this category falls into three categories, electrostatic printers, ink-jet printers, and thermal printers for the transfer process and the dye diffusion process. For the sake of thoroughness, I should add that there is also equipment that uses proprietary technology (Fuji Pictrography or Thermo-Autochrome printers). Due to the relative newness of these printing processes, we have little information about their behavior over time, but a lack of light-stability as well as sensitivity to ozone has already been noticed for some of them.

Ink-Jet Printing

Ink-jet printing has greatly evolved and today practically monopolizes the market for entry-level personal printers. It is also found in specialized printing market segments, such as large-format printing (plotters) and deluxe printing on art paper. Finally, it is used by many artists and photography labs to produce prints, sometimes known as "giclée prints," for the art market.

There are two ink-jet printing techniques, cs, or continuous stream, and dod, or drop on demand (Fig. 141). The cs technique consists of releasing a continuous stream of droplets. Droplets that are not meant to reach the substrate are deflected into a gutter. Iris Graphics printers operate on this system. The dod technique releases ink droplets only required for printing. The ink is projected onto the substrate through a nozzle by thermal or piezoelectric phenomena. In piezoelectric mode, the ink is projected by deforming a crystal. In thermal mode, in a period of a few microseconds, a rapid rise in temperature (300°C) produces a bubble of water vapor that compresses and projects the ink through the nozzle. Common office printers such as the Canon Bubble Jet, Hewlett-Packard, and Epson operate in this way. The inks they use are not all packaged in the form of an aqueous solution. Tektronics has introduced a solid ink-jet (Tektronics Phaser), also called a phase-change ink-jet. The ink is stored in the print cartridge in solid form. It is liquified before being sent to the print head and then deposited on the paper, where it returns to a solid state as it cools. Some of these techniques will disappear and others will come into widespread use. Because of the volatility of the market, it is difficult to predict which will prevail.

The ink-jet has many advantages. It allows the user to select from a wide variety of substrates, including graphic arts papers, for both aesthetic and permanence reasons (Fig. 142). It also gives the user more direct control over the production of his or her work. While there are no extensive studies on the subject as yet, it is possible that the dark-stability of current generation ink-jet prints may be greater than that of chromogenic color prints. However, the few studies that have been done on ink-jet prints reveal several weak points. They could have poor light-fastness—

DOD ink-jet printing

Nozzle

Heat resistor

Ink

CS inject printing

Drop generator

Charge electrode

Deflection electrode

Gutter

Paper

TABLE 104

Light stability of computer output prints
(studies by the CRCDG, 2000).

Type of Printing and Medium	Most Vulnerable Dye	Estimated Life* under 300-lux Lighting (without UV), 10 hours/day
Iris Equipoise Inkset on Iris satin-finish paper	yellow	less than 2 years
Iris Equipoise Inkset on Iris commercial paper	yellow	less than 2 years
Iris Equipoise Inkset on Arches paper	yellow	less than 6 years
Fuji Pictography	cyan	less than 7 years
Fujicolor Crystal Archive	cyan	less than 23 years

* Predicted time to reach a 30% loss of density of the least stable dye, measured on a color patch of 1.0 density. This life expectancy is extrapolated from artificial aging under continuous 1,400-lux lighting with a metal halide bulb, at 25°C and 50% RH.

even lower than for chromogenic color prints (Table 104).[25] Light-stability depends on the type of ink (pigment vs. dye) and medium. On porous paper (matte prints), the prints show a lower light-fastness than on a swellable (glossy print) base. Six- and eight-color ink-jet systems, where a lighter shade of a color is added to the standard four colors, also tend to be less light-fast than four-color (yellow, magenta, cyan, and black; CMYK) dye sets. The print may also remain very sensitive to water damage and resultant dye bleeding, caused by excessive relative humidity (humidity-fastness) or by being splashed or immersed (water-fastness). These drawbacks may be ascribed to the newness of the technology and will likely soon be corrected. Manufacturers are endeavoring to develop inks (e.g., pigmented ink-jet inks) that have better light-fastness and inks that will not bleed, migrate, or transfer under humid conditions. Last, some ink-substrate combinations are more prone to chemical attack and resultant fading (and color shifting) of their dyes.

Electrostatic Printing

Electrostatic printing, or laser printing, is the digital application of the xerographic principle popularized by photocopiers. Its evolution toward color required the development of a complex technique, capable of handling a four-color application. In this process, the paper is electrically charged by an electrostatic device. It is then exposed to a laser source, which discharges all areas that will not be printed. The paper then advances over a hopper containing pigmented particles (toner) composed of a colorant (pigment or dye) and a binder, which adheres to the areas that are still charged, through electrostatic attraction.

The process is repeated four times to obtain a four-color print. After printing, the image is stabilized by heat or by lamination.

For preservation purposes, it is advisable to choose permanent paper substrates. As for the images obtained by laser printing, we do not know much

FIGURE 142

An ink-jet print (Iris) seen under an optical microscope. Depending on the type of base, the magnified image shows a different microstructure. At top, printing on a coated paper specially designed for the purpose; at bottom, printing on "graphic art" fiber base.

about their behavior over time. The binder, which provides cohesion and allows the colored particles to adhere to the paper substrate, may break down and lead to powdering of the ink. The problem that is most frequently encountered is ink transfer when the document is stored in contact with a smooth paper or plastic surface. One possible explanation for this mechanical problem might be insufficient "heat curing" of the toner. Light-stability does not seem to pose any problem, at least with black toners.

Thermal Wax Transfer Printing

The thermal wax transfer printing method uses a transfer roller covered with a wax pigment mixture. The wax is melted by localized heating and transferred to the printing paper, which must have a particularly smooth surface in order for the wax to adhere properly. Recording paper with the same structure as resin-coated paper is frequently used.

Dye Sublimation and Dye Diffusion Thermal Transfer Printing

Sublimation of a compound means that it passes directly from a solid state to a vapor state without transition through a liquid state. This property specific to certain compounds is used in dye sublimation printers. The colorant is in a solid state on a synthetic support. When heated, it passes to a vapor state and is deposited on the surface of the recording paper, where it returns to a solid state. In dye diffusion thermal transfer (D2T2), dye migrates from a color ribbon to the receiver sheet. Transfer of dye is proportional to the heating time. Achieving a "nonmechanical" image structure when the print head is controlled in "dot" mode is made possible by diffusion of the dye into the receiver layer of the surface to be printed. The surface of the receiver must be very smooth. Prints obtained with this process exhibit high optical density values. This method of printing makes it possible to achieve photographic rendering.

Appendix I. Formulary

Dissolve the products in the order indicated.

Formula 1
Kodak Stop Bath SB-1

28% acetic acid	48 ml
water to make	1,000 ml

Kodak Stop Bath SB-5a

sodium sulfate anhydrous	45 g
28% acetic acid	64 ml
water to make	1,000 ml

Formula 2
Kodak Rapid Fixer F-32

38% ammonium thiosulfate solution	180 ml
sodium sulfite anhydrous	15 g
glacial acetic acid	18 ml
crystallized boric acid	6 g
potassium alum dodecahydrate	15 g
water to make	1,000 ml

Kodak Fixer F-5 (hardening) for film and paper

water about 50°C	600 ml
sodium thiosulfate (pentahydrated)	240 g
sodium sulfite anhydrous	15 g
28% acetic acid	48 ml
boric acid (crystals)	7.5 g
potassium alum (dodecahydrated)	15 g
cold water to make	1,000 ml

Kodak Fixer F-6 (hardening) for film and paper
(formula for preparing an "odorless" fixing solution)

warm water	600 ml
sodium thiosulfate (pentahydrated)	240 g
sodium sulfite anhydrous	15 g
28% acetic acid	48 ml
kodalk (sodium metaborate)	15 g
potassium alum (dodecahydrated)	15 g
cold water to make	1,000 ml

Formula 3

Kodak Fixer Test Solution FT1

potassium iodide	19 g
water to make	100 ml

Add 5 drops of test solution to 5 drips of fixing bath and 5 drops of water. If a whitish yellow precipitate forms instantaneously, the fixer is exhausted and should be replaced.

Formula 4

Kodak Silver Test Solution ST-1

water	125 ml
sodium sulfide	2 g

Prior to using, dilute 1 part of this solution with 9 parts water. Wait 2 to 3 minutes, and then place 1 drop on a white area of the photograph. Blot the drop with a clean blotter. Any coloration that is more pronounced than a simple cream shade indicates the presence of residual silver salts. This test will result in a dark spot and must be used only on a control print or doomed photograph.

Formula 5

Kodak Hypo Test Solution HT-1a

distilled water	180 ml
potassium permanganate	0.3 g
sodium hydroxide	0.6 g
distilled water to make	250 ml

For film

Fill a glass container with 250 ml distilled water and add 1 ml of the HT-1a solution. Remove the film from the wash tray and allow to drip for 30 seconds onto the prepared solution. If there are small amounts of thiosulfate, the color changes from purple to orange in about 30 seconds. If the quantity is greater, the orange color turns yellow. Continue washing the film as long as the effluent colors the test solution.

For prints

Dilute 1 ml of the HT-1a test solution in 125 ml water. Pour 15 ml of the prepared solution into a glass container. Remove the print from the wash tray and allow to drip for 30 seconds onto the prepared solution. Residual thiosulfate salts change the color of the solution from purple to orange in 30 seconds. It becomes colorless again after 1 minute.

Formula 6

Kodak Hypo Eliminator HE.1

water	500 ml
hydrogen peroxide (3% solution)	125 ml
ammonia (3% solution)	100 ml
water to make	1,000 ml

Prepare the solution immediately prior to use. Wash the photograph thoroughly and immerse for 6 minutes at 18°C in this bath, which cannot be preserved and should not be placed in a sealed container (the gas released by the hydrogen peroxide solution may break the glass).

Formula 7

Kodak Hypo Test Solution HT-2

water	750 ml
28% acetic acid	125 ml
silver nitrate	7.5 g
water to make	1,000 ml

Immerse a piece of the photograph, taken from the edge of the margin, in the HT-2 test solution for 4 minutes and then in a 5% sodium chloride solution for 4 minutes. Last, fix it in a solution containing 19 g sodium sulfite and 50 g thiosulfate per liter. Compare the coloration of the treated area with a reference standard to determine the approximate thiosulfate content. If no reference standard is available, the paper may be considered properly washed when a densitometer (blue filter) indicates a difference in density less than or equal to 0.03 between the immersed area and the untreated area. Baryta paper on a thick base should be immersed longer in the test solution.

Formula 8

Kodak Gold Protective Toner GP-1

water	750 ml
1% gold chloride solution	10 ml
potassium or sodium thiocyanate	10 g
water to make	1,000 ml

The best results are achieved by preparing the solution immediately prior to use. Add the 1% gold chloride solution to water. Dissolve the thiocyanate *(warning: toxic product)* in 100 ml water, and then pour this solution into the gold chloride solution, agitating vigorously. After washing the print thoroughly, immerse it in the bath for 10 minutes at 20°C, and then wash it for 20 minutes. A more pronounced bluish tone can be obtained by immersing for 1 hour. One liter of solution will treat approximately 0.4 m². It is recommended that distilled water be used to prepare the bath.

Kodak Gold Protective Toner GP-2

distilled water	750 ml
gold chloride	0.5 g
tartaric acid	1 g
thiourea	5 g
sodium sulfate anhydrous	15 g
water to make	1,000 ml

Formula 9
Kodak Toner T-55

hot water	700 ml
dry sodium sulfite	150 g
selenium	6 g
ammonium chloride	190 g
cold water to make	1,000 ml

Dissolve the sodium sulfite in 700 ml hot water. Add the selenium, bring to a boil, and boil for 30 minutes. Wear proper protective equipment since at this stage of the preparation there is a risk of spattering. The vessel that is used should be reserved exclusively for this application. Filter if necessary, cool, and then add the ammonium chloride, followed by the cold water. To use, dilute 1 part of this solution with 5 parts water. The print should either be washed thoroughly or immersed as soon as it is removed from the fixer. Partial washing will cause staining. Immerse for 10 to 15 minutes at 20°C and then wash the print thoroughly. Selenium is a highly toxic compound.

Formula 10
Kodak Toner T-7a (two baths)

a) stock bleaching solution

water	2,000 ml
potassium ferricyanide	75 g
potassium bromide	75 g
potassium oxalate	195 g
28% acetic acid	40 ml

To use, dilute with water at a ratio of 1 part water to 1 part stock solution.

b) stock toning solution

sodium sulfide	45 g
water	500 ml

To use, dilute with water at a ratio of 8 parts water to 1 part stock solution.

If the photograph is not washed thoroughly, yellowish tones, loss of details, or stains may result. Bleach in the first bath for approximately 1 minute, rinse the image under running water for 2 minutes, and then tone in the second bath for some 30 seconds. Then wash and dry it.

Kodak Toner T-8 (one bath)

water	750 ml
potassium polysulfide	7.5 g
sodium carbonate monohydrate	2.5 g
water to make	1,000 ml

or

water	750 ml
potassium polysulfide	7.5 g
borax	2.5 g
water to make	1,000 ml

*Potassium polysulfide, formerly known as liver of sulfur, is composed of a mix-
ture of several sulfides in proportions that vary depending on the quality of
the product. This product, which is very sensitive to oxidation, must be stored
in tightly closed containers.*

Dissolve the products in the order indicated. The photograph should be washed
thoroughly, immersed for 15 to 20 minutes in the bath, and then rinsed under
running water, immersed for 1 minute in a 3% sodium bisulfite solution, hard-
ened in a hardening bath (e.g., Kodak F-5a), and then meticulously washed
and dried.

Formula 11
Silverlock

potassium polysulfide	495 g
water to make	1,000 ml
borax	20 g

Dissolve the potassium polysulfide in the water. Then add the borax. Cover
and allow to rest overnight. After decanting, dilute for use. For microfilm, use
a 1:25 dilution at 27°C for a few dozen seconds.

Formula 12
Kodak Special Hardener SH-1

water	500 ml
37% formaldehyde solution	10 ml
sodium carbonate anhydrous	6 g
water to make	1,000 ml

Formula 13
Farmer's reducer R-4a

a)

potassium ferricyanide (anhydrous)	37.5 g
water to make	500 ml

b)

sodium thiosulfate (pentahydrated)	480 g
water to make	2,000 ml

For negatives

Immediately prior to use, mix 30 ml of (a) with 120 ml of (b) and add water
to make up 1 liter. Immerse the negative immediately. Before the reducing effect
is complete, remove the negative, wash it under running water, fix it, and treat
it using the indicated procedures for archiving.

For prints

Mix 3 ml of (a) with 12 ml of (b) and add water to make up 1 liter. The print
may be immersed wet or dry. If dry, bleaching will be slower, and it is essen-
tial to agitate the bath well to distribute the solution homogeneously. Before
the reducing effect is completed, remove the print, wash it under running water,
fix it, and treat it using the indicated procedures for archiving. The solution
can also be applied locally to a wet print using a cotton swab or fine brush.

Appendix II. Water Treatment

Tap water may be suitable for ordinary use, but it contains a significant amount of impurities—suspended particles, dissolved organic and inorganic compounds, microorganisms, gases, and so on. For special applications, it is sometimes necessary to treat tap water, but it would be incorrect to assume that the water produced by such treatments is absolutely pure. Absolutely pure water exists only in theory (Fig. 143). Regardless of the type of treatment, trace amounts of impurities always remain. Water softening, which consists of using a resin to exchange the calcium and magnesium ions that cause hard water for sodium ions, is not a purification technique. Moreover, purification is not always desirable. On the contrary, in some cases it is inappropriate (washing photographs) or can have harmful effects (corrosion). The purpose of any treatment is to produce water whose composition is suited to a specific use (Table 105).

Water quality is commonly evaluated by measuring its conductivity or resistivity (resistivity is the reverse of conductivity). The purer the water, the more it resists conduction of an electrical current. The resistivity of very pure water at 25°C is 18.24 MΩ.cm, but this cannot be sustained, since the gases in the air (e.g., carbon dioxide) dissolve very quickly and lower that value.

Distillation

Distillation, one of the oldest techniques in use, requires a great deal of energy. Liquid is brought to a boil and the vapor is then condensed onto a cold surface. This purification process is effective in eliminating inorganic compounds, which are left behind in the distillation tank, but volatile organic compounds remain in the distillate.

FIGURE 143

The measurement of water resistivity gives an indication of water purity. High purity is not required for usual laboratory needs.

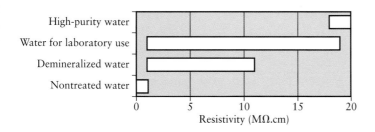

Water treatment.

Type of Pollutant	Example	Recommended Treatment
suspended particles	sand, colloids	micro- and ultra-filtration reverse osmosis
organic compounds	pesticides	reverse osmosis
mineral compounds	calcium and magnesium bicarbonates, sulfates, chlorides, nitrates, phosphates, iron, aluminum, etc.	cationic and anionic resins
microorganisms	bacteria	disinfectant
gases	oxygen, carbon dioxide	ion exchange resins

Demineralization/Deionization

Water is run over grains of resin, which electrostatically trap its charged chemical components. Anions (chloride, sulfate, nitrate, etc.) are trapped on anionic resins and exchanged for hydroxyl ions (OH^-), and cations (calcium, magnesium, sodium, etc.) are trapped on cationic resins and exchanged for hydronium ions (H_3O^+). The resins must be regenerated or replaced when saturated.

Reverse Osmosis

Reverse osmosis consists of running water through a membrane that is impermeable to impurities and then recovering the purified water on the other side. To accomplish this, a certain degree of pressure must be applied in order to overcome the natural osmosis process (i.e., water passing through the membrane to dilute the primary water), whose effects are the opposite of what is desired. Reverse osmosis provides highly pure water. It can be combined with ion exchange resins to pretreat the water.

Activated Charcoal Adsorption

Just as activated charcoal is used for air purification (see p. 106), it is also used in water treatment to trap organic compounds and dissolved chlorine.

Basic Vocabulary

Absolute humidity (AH). Mass of water vapor contained in a volume of air (grams per cubic meter).

Acid free. Commercial term used to describe archival materials whose pH is equal to or greater than 7.0. This does not guarantee that the materials are suitable for photograph conservation.

Acidic. Describes an aqueous solution whose pH is below 7.0. Many types of paper and cardboard acidify as they age. This acidity, which can be measured from the pH of their aqueous extracts, results in part from atmospheric pollution but especially from their manufacturing process. Such acidic paper and cardboard can be the source of photograph deterioration.

Actinism. The property of certain types of radiation by which chemical changes are produced. The red light in a photographic laboratory is nonactinic to photographic paper. Ultraviolet rays are actinic to many organic materials.

Activity of water. The activity of water of a material represents its ability to release water vapor. It is calculated by dividing the partial pressure of the water vapor above the material by the partial pressure above distilled water vapor.

Alkali. Compound that confers basic properties.

Alkaline reserve. Alkaline compound added to paper pulp, intended to neutralize the acidity acquired by the paper as it ages.

Analog. Used in contrast to digital. The signal is represented by continuously variable physical quantities.

Anion. Negatively charged ion.

ANSI. American National Standards Institute.

Anticurl layer. Layer of gelatin on the back of film substrates that limits curling caused by the emulsion.

Antihalation layer. Layer containing a dye for absorbing light rays during shooting, thereby preventing reflectance phenomena that cause halos on photographs.

APS. Advanced Photographic System. A photographic standard developed jointly by Canon, Kodak, Fuji, Minolta, and Nikon and first marketed in 1996. The photographic films are conventional emulsions on a flexible base, also comprising magnetic tracks to record operator or laboratory data.

ASA. American Standard Association. System for rating the speed of a photosensitive layer, calculated using ASA guidelines. It has been replaced by the equivalent ISO system.

Barium sulfate. White pigment with the chemical formula $BaSO_4$, used since 1885 in the industrial manufacturing of photographic paper bases.

Baryta paper, fiber-base paper. Photographic paper base with an intermediate layer of barium sulfate in suspension in gelatin (sometimes with optical brighteners). Used since the 1880s, the baryta layer, which is intended to improve the surface of paper bases, characterized traditional fiber-base photographic paper, in contrast to resin-coated paper.

Basic, or **alkaline.** Describes an aqueous solution whose pH is greater than 7.0.

Binder. Component that provides cohesion to a layer containing several compounds. Today, gelatin is used for photography and polyurethane is used for magnetic media.

Bit. Contraction of "binary digit." Elementary unit of a digital file, which takes the value 0 or 1.

Bleaching. In photography, a chemical process that consists of reducing the silver in a photograph to a colorless silver salt. The image can then be redeveloped, toned, or eliminated. Dyes can also be bleached.

Buffer solution. Solution containing compounds that keep the pH between certain limits, despite the addition of an acid or alkali.

Byte. Set of eight bits.

Calibration. In photography (conventional and digital), calibration refers to all factors that make it possible to exercise rigorous control over the restitution of values and colors of a photograph.

Candela (cd). SI unit of luminous intensity.

Cation. Positively charged ion.

CD-R. Compact Disk Recordable. Digital optical disk, 12 cm in diameter, that is recordable but not rewritable.

CD-ROM. Compact Disk Read Only Memory. Digital optical disk, 12 cm in diameter, that is not recordable or erasable and is used as a publishing medium.

Cellulose acetates. Polymers obtained from cellulose. Cellulose triacetate is used as a photographic and motion picture film base. It is less dimensionally stable and durable than polyester.

Cellulose nitrate. Cellulose nitrate was used, beginning in 1889, by Eastman-Kodak Company as a plastic substrate to replace the glass base of photographic negatives. Highly unstable and flammable, cellulose nitrate was prohibited in 1951. Cellulose nitrate–base film should be identified and stored under specific conditions. Celluloid, collodion, and pyroxylin are made up of cellulose nitrate.

Cibachrome. A color photographic process based on a technique of selective destruction of dyes on contact with a silver image (silver dye bleach). This process was developed by the Hungarian chemist Bella Gaspard (Gasparcolor process) in the 1930s. It was subsequently marketed under the name Cilchrome (1963), then Cibachrome, and finally Ilfochrome Classic (1991). Azoic dyes (yellow, magenta, and cyan) are added when the photosensitive layer is manufactured. These dyes are selectively destroyed (bleached) during development, using the catalytic properties of the silver image. Since such processes are not sensitive enough for use during shooting, their application is limited for printing and microfiches.

Colloidal silver. Very fine silver particles suspended in a medium, such as gelatin, that produce a colored appearance.

Color balance. Harmonious balance in the mixture of the three base colors, evaluated by an accurate rendering of the gray scale of the original in a color photograph.

Colorimeter. Instrument used to measure the trichromatic color coordinates of a light source or a colored object under standardized conditions.

Compact Disk (CD). Digital disk, 12 cm in diameter, developed in the 1970s and 1980s by Sony and Philips. Best known in its audio form, it is being widely developed for multimedia applications, as a publishing medium, and for computer data (CD-ROM, CD-R).

Compression. Method of processing computer data to reduce the size of the files. The current objective is to increase the compression factor while minimizing losses.

Conservation treatment. Interventions intended to stabilize and restore physical unity—or even a degree of legibility—to a deteriorated, vulnerable, or endangered artwork. The primary objective of conservation treatment is to ensure the survival of the original in its historical entirety.

Contact print. Print obtained by placing the negative in direct contact with the light-sensitive printing material. A contact print has the same size as the negative. In the nineteenth century most prints were made by contact, requiring large-format negatives.

Continuous-tone image. Image in which the transition from light to dark is achieved by a continuous increase in density (as opposed to a line image). See Halftone.

Contrast. Subjective evaluation of the difference in appearance between two portions of the visual field, viewed simultaneously or in succession. For prints, contrast means the difference between the extreme image density values. It is evaluated based on the contrast index or densitometric measurements.

Copy. Print made in the absence of the original negative, from an available print.

Copy negative (also **reproduction negative**). Negative element produced from an original, which may be a print or a negative (the term "copy" indicates that there is no absolute conformity with the size and polarity of the reproduced element).

DAT. Digital audiotape. Magnetic tape on which a digital signal is recorded.

Deacidify, deacidification. Chemical process for neutralizing the acidity acquired by certain papers and books over time. Not intended for photographs.

Degeneration. Loss of information through photographic copying, particularly over many generations.

Densitometer. Device for measuring optical density, either by reflection or transmission, of black-and-white or color photographs.

Density. In photography, this term refers to optical density. This is the measurement of the power of a colored or uncolored material to absorb light. It is defined by the logarithm of opacity (opacity is the relationship between incident light and transmitted light). Dark areas have high density values and light areas have low density values.

Developer. Bath used to develop photographs. This is a reducing solution that amplifies the silver mass of the latent image.

Development. Chemical process consisting of transforming a latent (invisible) image into a visible image. There are two types of development, physical development, in which the silver that forms the image partly results from the reduction of a soluble silver salt present in the developer solution, and chemical development, in which the silver formed derives solely from the photosensitive layer.

Dew point. Temperature at which the air moisture begins to condense. The dew point varies depending on the quantity of moisture in the air.

Dextrine. A modified starch, used as an adhesive. Its viscosity is lower than that of starch, and it dries more rapidly.

Diazo compound. Photosensitive chemical compound with a (-N = N-) bond. It is the basis for the diazo processes used for diazo microforms.

Dichroic fog. Iridescent deposit, composed of finely dispersed silver, that appears on the surface of photographs when the development is extended in the fixing bath or when the developer is polluted with traces of fixer. A stop bath is used to prevent this from forming.

Diffuse reflection. Reflection of light by a surface in all directions.

Digital optical disk (DOD). Disk containing information in binary code, read by an optical reader using a laser beam.

Digitization. Operation that consists of transforming a continuous (analog) signal into a discontinuous signal.

Dilatometer. Device used in research laboratories to monitor the swelling of the gelatin layer during processing.

Direct positive. Photograph (positive or negative) with the same density values as the subject, obtained by conventional processing, that is, development followed by fixing, without reversal processing. Direct positive (autopositive) emulsions were introduced to simplify duplication processes.

Disinfection. Technique or process that temporarily eliminates or kills microorganisms and/or inactivates undesirable viruses carried by contaminated inert media, depending on the specified objectives. The process is effective only on the microorganisms that are present at the time it is performed.

DOD. Digital optical disk.

dpi. Dots per inch. Unit used to define resolution. In Europe, the metric system is also used to characterize resolution in line pairs or dots per millimeter.

dpm. Dots per millimeter. See dpi and Resolution.

Dupe. Abbreviation for "duplicate."

Duplicate. Photographic reproduction on film.

Duplicate negative. Negative copy, on film, of an original negative.

Duplicate positive. Positive copy, on film, of an original positive.

Duplication. Reproduction of photographic images (negatives or positives) for purposes of preservation, restoration, or access. See Duplicate.

DVD. Digital Versatile Disk. Digital optical disk, 12 cm in diameter, with a storage capacity of several gigabytes.

Emulsion. In photography, this term means a silver halide suspension in gelatin, which, when applied to a substrate, constitutes the photosensitive layer. The invention of emulsion processes marked the start of industrial manufacturing of photosensitive surfaces. Previously, albuminized papers and wet collodion negatives were prepared in two steps. The substrate was covered with the binder and then photosensitive salts where precipitated in this layer. In emulsion processes, the substrate is coated with a mixture of a binder and photosensitive salts.

Encapsulate, encapsulation. (1) Terms describing the process of sealing a fragile image between two sheets of polyester, to protect and preserve it. (2) Term used in information technology to designate a set of digital information attached to a data file and indissociable from it. (3) Process of enclosing small quantities of an active chemical in a small capsule in order to control its release.

Encoding. Encoding converts data from one format to another so that these data can be moved across different computer systems.

Enlarger. Optical laboratory device used to produce prints in a format different from that of the negative.

Equilibrium moisture content (EMC). Also called specific humidity. This is the percentage of the mass of a material composed of water:

$$\% \text{ EMC} = \frac{\text{mass of water}}{\text{mass of dry material}} \times 100$$

Ethylene oxide (or **oxirane**). Highly toxic gas used to disinfect collections.

Facsimile. A print obtained by copying or by printing the original negative. The process is identical, as far as possible, to that used for the reference image.

Fading. A loss of density in a color or a black-and-white photograph. This is the consequence of the chemical deterioration caused by poor processing and/or by poor conservation conditions.

Ferrotyping. Process that gives photographs on fiber-base paper a very lustrous, "glossy" surface. Ferrotyping is achieved by hot or cold drying the print on a very smooth surface. This process is not used for RC papers. Ferrotyping may happen accidentally when photographs are stored in a humid environment against a smooth surface (e.g., glass, polyester).

Fixing. Chemical process intended to eliminate residual photosensitive salts. After the fixing bath, the image is stable and may be viewed in light without undergoing alteration. Fixing is achieved in two steps, formation and dissolution of silver-thiosulfate complexes. Several compounds are capable of playing this role, but following studies by Herschel in 1839, sodium thiosulfate was progressively adopted. Today, there is a trend toward replacing it with ammonium thiosulfate, which is faster acting.

Formol, formaldehyde. Colorless, toxic gas formerly used in an aqueous solution to harden gelatin or for its fungicidal properties.

Fungicide. A compound or treatment intended to kill fungi and their spores under specific conditions.

Fungistatic. A compound or treatment that temporarily inhibits growth of fungi.

GB. Gigabyte. Approximately one thousand million bytes, or one thousand megabytes.

Gelatin. Protein extracted from animal matter (bone, skin, etc.). It is the basic binder used in photographs to keep silver halides in suspension. Gelatin itself can be made photosensitive with alkali dichromate.

Gelatin silver bromide. Suspension of silver bromide in gelatin. The gelatin silver bromide process, invented by Maddox in 1871, is the basis for contemporary photographic processes.

Generation. Designates the chronological position of a photographic element in a reproduction process. In conventional photography, the original negative is called the first generation, the first interpositive is the second

generation, and the internegative is the third generation. If reversal or direct positive copy film is used, the first internegative may be the second generation.

H&D curve. Curve that represents the behavior of a photosensitive layer exposed to increasing luminous intensities. From this curve, it is possible to evaluate the contrast and speed of emulsions.

Halftone or continuous tone. Describes a photograph with a full range of values, from the lightest to the darkest, including intermediate tones (antonym: line).

Halogens. Class of elements that includes iodine, bromine, chlorine, and fluorine. Halogens combine with silver to form silver halides (silver iodide, silver bromide, silver chloride). See Silver.

Hardening. Treatment of gelatin emulsions with a hardening agent such as formol (formaldehyde) or chrome, potassium, or ammonia alum. Hardening improves the mechanical resistance of emulsions by limiting their swelling and softening in aqueous solutions.

Hydrolysis. Decomposition reaction of organic materials induced by water (in liquid or vapor form).

Hydrophilic. Describes a compound that has an affinity for water.

Hydrophobic. Describes a compound that does not have an affinity for water.

Hygroscopic. Describes a compound that has the property of absorbing or adsorbing moisture from the air.

Hypo, hyposulfite. Term used by photographers to designate the sodium or ammonium thiosulfate used in preparing a fixing bath. See Fixing.

Hypo eliminator. A hydrogen peroxide and ammonia aqueous solution that transforms thiosulfate into sulfate. This treatment was used to destroy residual fixer; it is no longer recommended.

Inerting gas. Gas or gaseous mixture containing little or no oxygen. Halon, nitrogen, and carbon dioxide are used as inertants during disinfection with ethylene oxide to prevent fire hazards.

Intensification. Chemical or physical treatment to increase the density and values of a photograph. Underexposed negatives are sometimes intensified with a chemical treatment. Similar methods have been recommended for restoring degraded photographs. However, such treatments are irreversible and the short- and long-term results are uncertain.

Internegative. A negative made as a step in copying.

Interpositive. A positive made as a step in copying. A negative (second original) is made from the interpositive, which can then substitute for the original for printing.

Ion. Electrically charged atom or group of small atoms.

ISO. International Standard Organization. International standards are developed by the experts of the TC-42 technical committee representing some ten countries, who adopt specifications by majority vote. These ISO standards

are often simply transcriptions of ANSI standards. The regular meetings of the American committee on physical properties and permanence of imaging materials (Committee IT9) have resulted in numerous proposals and revisions of standards, which were then adopted at the ISO level.

Latent image. Image invisible to the eye, formed on the atomic level after brief exposure of a photosensitive surface to light. The image is rendered visible by development.

Life expectancy. Estimation of the time (at 21°C and 50% RH) during which access to information is preserved. A former classification distinguished between medium-term preservation, which provided a minimum life expectancy of ten years for artifacts, and archival preservation for artifacts with "permanent value" (ISO Standard 5466: 1992). The concept of life expectancy currently tends to be used instead.

Light. Part of the electromagnetic spectrum perceived by the human eye (between 400 and 780 nanometers).

Line. Defines a photograph containing only the extreme values of the range of tones, that is, black and white.

Lux. Unit of illuminance. Characterizes the luminous flux received per unit of surface area.

Macroenvironment. Atmospheric conditions (temperature, humidity, air quality) prevailing in a large space where documents are preserved.

Master. Designates the first generation of photographic media that will be used to produce duplicates.

MB. Megabyte, 1,048,576 bytes, or approximately one million bytes.

Microclimate. Climatic conditions (temperature, humidity) prevailing in a small space, which are different from the ambient conditions.

Microenvironment. Atmospheric conditions (temperature, humidity, air quality) in a small enclosure where documents are preserved.

Microform. Any medium containing microimages.

Microimage. Small image that must be enlarged to be read.

Micron (μm). Unit of measure of length, representing one thousandth of a millimeter.

Microorganisms. Biological entities capable of multiplying when conditions are favorable. These are classified into two families, fungi and bacteria.

Migration. Process that consists of translating digital information into another code. The digital data are converted to be readable with another software or by other computers. The term "reformatting" is sometimes used.

Negative. Image whose tones are reversed with respect to the subject. The negative process, invented by Fox Talbot in 1841, makes it possible to produce a large number of positive images.

Neutral. Describes anything not acidic or alkaline, that is, with a pH of 7.0. (See pH.) The neutral nature of a material is neither a necessary nor a sufficient condition for its use in photographic preservation. Incorrectly used to mean inert.

Nitrocellulose. See Cellulose nitrate.

Opacity. Ratio between incident flux and the flux transmitted or reflected by a substrate.

Optical brightener. A fluorescent compound that absorbs uv light and reemits it as visible wavelengths. These compounds are used to increase the whiteness of photographic paper bases.

Orthochromatic. Characteristic of a photographic emulsion that is sensitive only to green and blue light.

Oxidation-reduction. When one substance reduces another, it oxidizes. This is an oxidation-reduction reaction, which is the basis for chemical development of photographs. As it oxidizes, the developer reduces to metallic silver the silver halides that have been exposed to light. Silver images degrade through other oxidation-reduction processes.

Panchromatic. Describes an emulsion sensitized to all light radiation.

Permanence. Capacity to remain chemically and physically stable for long periods (iso Standard 9760: 1994).

Permanent paper. Paper that, when stored for a long period in a protected environment, will undergo little or no change in the characteristics that have an impact on its use (iso Standard 9706: 1994).

pH. Potential of hydrogen. Corresponds to the cologarithm of hydronium ion activity in a solution. It defines the alkaline or acidic nature of the solution. A pH below 7.0 corresponds to an acidic solution, a pH greater than 7.0 corresponds to an alkaline solution, and a pH of 7.0 corresponds to a neutral solution. When the pH increases by one unit, the alkalinity of the solution is multiplied by 10. The pH scale ranges from 0 to 14.

Photographic paper. Generally designates sensitive paper intended for printing from negatives.

Photography. Permanent and visible recording of the action of radiant energy on a sensitive surface. There is a tendency for this definition to become more flexible with respect to the new computer printing technology.

Photolytic silver. Metallic silver produced from silver halides solely by the action of light. This is the case with both a latent image and the printed-out processes used in the nineteenth century.

Photomechanical process. Printing process using photographic negatives or positives exposed onto plates or cylinders covered with photosensitive coatings. The photomechanical image is obtained by the discharge of a dye or a pigment onto a paper base.

Pigment process. Designates photographic processes in which the image is formed by one or more pigments in a light-sensitized polymer. Pigment processes such as carbon process are very stable and allow great freedom of

interpretation. However, they require a good deal of skill. Very much in vogue in the late nineteenth century, they were used by the Pictorialist photographers.

Pixel. Picture element. Basic element of a digital image representing the smallest homogeneous component.

Plasticizer. Substance added to some polymer bases (cellulose acetate, cellulose nitrate) to make them more flexible.

Polaroid. Name of an instant photographic development process introduced by Edward Land in the late 1940s. The positive image is produced in a few dozen seconds after shooting. This image is formed using development by diffusion-transfer. Polaroids initially were black-and-white; color Polaroids were introduced in the 1960s.

Polyester. Polymer obtained by condensation between polyacids and unsaturated alcohols or glycols. In photography, poly(ethylene terephthalate) (PET) or poly(ethylene naphthalate) (PEN) is used as a film base. PET is very dimensionally stable over time. Invented in 1940 and used in photography beginning in 1955 as a substrate for photosensitive surfaces and more recently for document preservation, it is known under various brand names, Mylar (Du Pont), Estar (Eastman Kodak), Terphane (Rhône-Poulenc), and others. PEN was introduced more recently with the new APS format films. It has the property of flattening more easily after being wound.

Positive. Image whose tonal values correspond to those of the subject.

ppb. Parts per billion. One thousandth of a milliliter per cubic meter.

ppm. Parts per million. One milliliter per cubic meter.

Preservation. Direct or indirect action to minimize chemical and physical deterioration and damage and to prevent loss of informational content. The primary goal of preservation is to increase the life expectancy of a cultural asset that may be in good or poor condition to ensure continued access to its value.

Preventive conservation. Action(s) intended to ensure the survival of an asset without working directly on the object but by controlling its environment.

Print. Process consisting of producing a positive image from a negative. Also designates the photographic record image obtained thereby.

Projection positive. Transparent positive image whose sensitometric properties are suited to projection. The low density is very low (0.05 to 0.10), while the high density exceeds 3. Not to be confused with an interpositive, which is not intended for projection.

Reconstruction. Analog or digital process for re-creating or reconstituting an image from separated, deteriorated, or missing elements.

Reduction. Chemical process intended to lower the densities of an overexposed or overdeveloped photographic image.

Reflection factor. Ratio of reflected luminous flux to incident luminous flux.

Reformatting. Transformation of the native format of an information carrier artifact to an alternate format. In photography, duplication with modification of scale and microfilming are reformatting processes.

Refreshing. Process that consists of copying digital files onto a new medium before the old one becomes nonreadable due to deterioration or to the obsolescence of the reading system. This may consist of copying on an identical or different medium.

Relative humidity (RH). Ratio of the mass of water vapor contained in the air to the mass of water potentially contained in the same volume at saturation.

Resolution. Resolving power, or resolution, indicates the ability of a system (emulsion, sensor, printer, etc.) to distinguish the details of an image. It is expressed in line pairs per millimeter, dots per millimeter, or dots per inch (dpi). During shooting, the quality of the optics has an impact on the resolution.

> 200 dpi = 8 ppm = 4 line pairs per mm
>
> 300 dpi = 12 ppm = 6 line pairs per mm
>
> 400 dpi = 16 ppm = 8 line pairs per mm
>
> 1,000 dpi = 40 ppm = 20 line pairs per mm

Retouching. Digital or physical process that consists of improving the aesthetic aspect of a negative or positive image by masking its defects. The term "spotting" is also used for masking scratches or specks.

Reversal process. Process that produces a positive image, as opposed to the customary negative image. If exposure is made by printing from a negative, a negative image is produced directly. The process requires using two developers (a first developer, which produces a negative, and a second developer, which produces a positive).

Safety film. Defined in ISO Standard 543; designates transparent cellulose triacetate and polyester bases introduced since 1948 to replace unstable and flammable cellulose nitrate.

Sensitometry. Science of characterizing photographic layers during manufacture (emulsion preparation), use (shooting), and even storage (aging).

Silver. Metal used for preparing photosensitive layer (represented by the symbol Ag). Combined with a halogen (chlorine, bromine, or iodine), it forms a silver halide sensitive to certain types of electromagnetic radiation, such as light, UV rays, and X-rays. While it is possible to do without silver photographic processes for printing, it is still essential for shooting, where it provides high speed combined with a high image quality.

Silver bromide. The silver halide most commonly used in photography. Combined with gelatin, it is used to prepare photosensitive emulsions.

Silver dye bleach process. See Cibachrome.

Silver mirroring. Kind of reflective metallic haze over the dark areas of developed-out photographs (negative or positive). This bloom is composed of a superficial silver deposit originating from the image.

Sizing. Treatment applied to the fibers of paper in order to give it specific physical properties, for instance, to limit the spreading of ink.

Slide. Transparent positive photograph mounted for projection.

Specific humidity (SH). Mass of water vapor contained in a kilogram of air or in a kilogram of matter. See Equilibrium moisture content.

Specular reflection. Reflection of light by a smooth surface in a preferred direction (this is the case with a mirror). The angle of reflection is then equal to the angle of incidence.

Speed. The speed of a photographic emulsion means its ability to respond to a certain light exposure. It is expressed in ISO units.

Starch. Carbohydrate extracted from plants, formerly used in photography for sizing certain salted papers and preparing glues.

Stop bath. Acid solution used to stop the action of the developer by lowering the pH.

Storage capacity. Expresses in bytes (8 bits) the quantity of data that a computer medium can hold:

B = one byte

KB = one kilobyte, 1,024 bytes (approximately 10^3 bytes)

MB = one megabyte, 1,048,576 bytes (approximately 10^6 bytes)

GB = one gigabyte (approximately 10^9 bytes)

TB = one terabyte (approximately 10^{12} bytes)

PB = one petabyte (approximately 10^{15} bytes)

EB = one exabyte (approximately 10^{18} bytes)

Substratum. Intermediate layer intended to facilitate adherence of a sensitive layer to a base.

TB. Terabyte. Approximately one million million bytes, or one thousand gigabytes.

Titanium dioxide. White mineral pigment used in resin-coated paper bases.

Toning. Chemical treatment intended to change the visual aspect or improve the stability of a photograph. Silver is combined with another compound, such as gold, platinum, selenium, or sulfur.

Ultraviolet (UV). Portion of the electromagnetic spectrum invisible to the eye, located beyond the violet end of the spectrum. This radiation is very actinic to photographic emulsions and may deteriorate organic compounds such as dyes, and polymers.

Vesicular image. Image formed by microbubbles. Photographic process used with microforms.

Videodisc. Disc containing audio and video information written in analog mode.

Vintage. Print made by the artist or under the artist's direct supervision, immediately after the picture was shot (an interval of a few years is considered compatible with the qualifier "vintage").

Visual acuity. Ability of a person to distinguish among objects that are in very close proximity to one another.

VOC. Volatile organic compounds. Describes organic pollutants in the air.

Washing. Process that completes the processing of photographs, intended to eliminate residual salts from the fixing bath. Insufficient washing leaves behind chemical residues that break down and oxidize the silver image.

Washing aids. Saline aqueous solution (e.g., 10% sodium sulfite) intended to accelerate the washing step.

Water hardness. Result of the presence of mineral salts, such as calcium and magnesium, dissolved in water, which results in the formation of scale.

Water softening. Process that consists of replacing calcium and magnesium ions with sodium ions.

Wetting agent. Substance that lowers the surface tension of water and prevents the formation of droplets and spots on the surface of photographs after washing.

Window mat. Paper or cardboard mounting used to display graphic or photographic documents.

WORM. Write Once Read Many. Designates a writable digital optical disk.

Notes

Chapter 1. The Vulnerability of Photographs

1. J. Pouradier and A. M. Mailliet, "Conservation des documents photographiques sur papier: Influence du thiosulfate résiduel et des conditions de stockage," in *Photographic Science Symposium, Paris, 1965,* ed. J. Pouradier (London: Focal Press, 1967), 506–9.

2. Ctein, "Are Black-and-White Resin Coated Papers as Permanent as Fiber Papers?" *Photo Techniques,* March–April 1998, 44–47.

3. P. Krause, "Properties and Stability of Color Photographs," in *Proceedings of Conservation in Archives: International Symposium, International Council on Archives, Ottawa, May 10–12, 1988* (Paris: CIA, 1989), 129–35.

4. N. Nakamura, M. Umemoto, N. Sakai, and Y. Seoka, "Dark Stability of Photographic Color Prints from the Viewpoint of Stain Formation," in *The Stability and Preservation of Photographic Images,* 2d International Symposium, Ottawa, Ontario, Canada, August 25–28, 1985 (Springfield, Va.: Society of Photographic Scientists and Engineers [SPSE], 1985), 59.

5. D. G. Horvath, *The Acetate Negatives Survey* (Louisville, Ky.: University of Louisville, Ekstrom Library, 1987).

6. T. Ram et al., "Status Report on the Worldwide Molecular Sieve Trade Test Results," paper presented at the Joint Technical Symposium of FIAT/FIAF, National Film Theatre, South Bank, London, January 27–29, 1995.

7. W. Saffady, *Stability, Care and Handling of Microforms, Magnetic Media and Optical Disks,* Library Technology Reports (Chicago: American Library Association, 1991).

8. J. M. Reilly, *The IPI Storage Guide for Acetate Film* (Rochester, N.Y.: Image Permanence Institute [IPI], 1993).

9. Saffady, *Stability, Care and Handling of Microforms.*

10. L. E. Smith and B. J. Bauer, "Properties of PET Films," in *Proceedings of Conservation in Archives: International Symposium, International Council on Archives, Ottawa, May 10–12, 1988* (Paris: CIA, 1989), 103–15.

11. P. Z. Adelstein, "History and Properties of Film Supports," in *Proceedings of Conservation in Archives,* 89–101.

12. Y. Shinagawa, M. Murayama, Y. Sakaino, "Investigation of the Archival Stability of Cellulose Triacetate Film: The Effect of Additives to CTA Support," in *Polymer in Conservation,* ed. N. S. Allen, M. Edge, and C. V. Horie (Cambridge: Royal Society of Chemistry, 1992), 138–50.

13. M. Edge, N. S. Allen, T. S. Jewitt, and C. V. Horie, "Fundamental Aspects of the Degradation of Cellulose Triacetate Base Cinematograph Film," *Polymer Degradation and Stability* 25, nos. 2–4 (1989):345–62.

14. S. J. de Oliviera, "Acetate or Polyester?" *FIAF Bulletin* 46 (1993):39–48.

15. P. Glafkidès, *Chimie et physique photographiques* (Paris: Publications photo cinéma Paul Montel, 1976), 578.

16. G. G. Gray, "From Papyrus to RC Paper: History of Paper Supports," in *Pioneers of Photography: Their Achievements in Science and Technology,* ed. E. Ostroff (Springfield, Va.: Society for Imaging Science and Technology [SPSE], 1987), 37–46.

17. Ibid.

18. "Arles 1977. Colloquium on Photographic Paper," *Photo-revue,* September 1977, 480–81.

19. J. M. Reilly, "Archival Aspects of Resin Coated Papers," *Photo Educator International,* September 1991, 30–31.

20. Letter from Peter Krause to B. Lavédrine, May 15, 1993.

21. M. K. Lee, "Treatment of an Ansel Adams Mural Photograph," paper presented to a meeting of the Photographic Materials Group of the American Institute of Conservation, Austin, Texas, March 1993.

Chapter 2. Standards

1. P. Z. Adelstein, "International Standards on Permanence of Imaging Materials," in *Sauvegarde et conservation des photographies, dessins imprimés et manuscrits,* Actes des Journées internationales d'études de l'ARSAG, Paris, September 30–October 4, 1991 (Paris: Association pour la recherche scientifique sur les arts graphiques [ARSAG], 1991), 21–28.

2. Y. Seoka, S. Kubodera, T. Aono, and M. Hirano, "Some Problems in the Evaluation of Color Image Stability," *Journal of Applied Photographic Engineering* 8, no. 2 (1982):79–82; B. Lavédrine, "Prediction of Dark Stability of Color Chromogenic Films Using Arrhenius' Law and Comparison after Ten Years of Natural Aging," in *Research Techniques in Photographic Conservation,* Proceedings of the Conference in Copenhagen, May 14–19, 1995 (Copenhagen: Royal Danish Academy of Fine Arts, School of Conservation, 1996), 71–76.

3. D. W. Nishimura, "The Practical Presentation of Research Studies on Film Stability," in *Research Techniques in Photographic Conservation,* 85–92; J. M. Reilly, P. M. Adelstein, and D. W. Nishimura, *Final Report to the Office of Preservation, National Endowment for the Humanities: Preservation of Safety Film* (Rochester, N.Y.: Image Permanence Institute, 1991).

4. Seoka et al., "Some Problems in the Evaluation of Color Image Stability," 79–82; B. Lavédrine, F. Robert, and F. Flieder, "Evaluation of Dark Stability of Reversal Color Films Using Arrhenius' Law," *Journal of Photographic Science* 36, no. 3 (1988):68–71.

5. B. Cinnamon, *Gestion électronique de documents sur disques optiques* (Paris-La Défense: AFNOR, 1989), 40.

6. ANSI/NAPM IT9.21-1996: Life Expectancy of Compact Discs (CD-ROM), Method for Estimating, Based on Effects of Temperature and Relative Humidity; W. R. Nugent, "Issues in Optical Disc Longevity, from Trithemius to Arrhenius Testing," in *Archiving the Audio-Visual Heritage,* ed. G. Boston, Third Joint Technical Symposium, May 3–5, 1990 (Ottawa: Canadian Museum of Civilization, 1992), 89–102; W. P. Murray, "CD-ROM Archivability," *NML Bits, Newsletter of the National Media Lab,* May 1992; P. Z. Adelstein, "Standards Preservation of Electronic Imaging," in *International Conference on Conservation and Restoration of Archive and Library Materials, Erice, April 22–29, 1996, Preprints* (Rome: Istituto Centrale per la Patologia del Libro, 1996), vol. 2, 675–82.

7. Seoka et al., "Some Problems in the Evaluation of Color Image Stability," 79–82.

8. T. J. Collings and F. J. Young, "Improvements in Some Tests and Techniques in Photograph Conservation," *Studies in Conservation* 21, no. 2 (1976):79–84.

9. V. Daniels and S. Ward, "A Rapid Test for the Detection of Substances Which Will Tarnish Silver," *Studies in Conservation* 27, no. 2 (1982):58–60.

10. V. Daniels, "The Russell Effect: A Review of Its Possible Uses in Conservation and the Scientific Examination of Materials," *Studies in Conservation* 29, no. 2 (1984):57–62.

11. H. Burgess and C. G. Leckie, "Evaluation of Paper Products to Be Used in the Storage of Photographic Materials," in *Sauvegarde et conservation des photographies, dessins imprimés et manuscrits,* Actes des Journées internationales d'études de l'ARSAG, Paris, September 30–October 4, 1991 (Paris: Association pour la recherche scientifique sur les arts graphiques [ARSAG], 1991), 29–35.

12. V. Chatzigeorgiou, "Matériaux destinés à la conservation des photographies: Contrôle de leur innocuité" (DEA thesis in art history, Université de Paris I, Panthéon-Sorbonne, 1992).

13. D. Nishimura, J. Reilly, and P. Adelstein, "Improvements to the Photographic Activity Test in ANSI Standard IT9.2," *Journal of Imaging Technology* 17, no. 6 (December 1991):245–52.

14. Available from the IPI, Frank E. Gannett Memorial Bldg., Rochester, N.Y. 14623-0887, USA; or Agfa-Gevaert A.G., Sparte Bild-Foto, D-5090 Leverkussen, Germany.

Chapter 3. Enclosures

1. Expert Meeting on Conservation of Acid Paper Material and the Use of Permanent Paper, organized by the Dutch government and the Commission of the European Communities, December 17–19, 1991, the Hague, the Netherlands; full report published by CNC, National Preservation Office, the Hague, 1992. CNC-Publikaties, 3.

2. ISO Standard 9706: 1994, Information and Documentation—Paper for Documents—Requirements for Permanence.

3. G. S. Young and H. D. Burgess, "Lignin in a Paperboard Advertised as Lignin-Free," *Abbey Newsletter* 13, no. 6 (1989):101–2.

4. J.-L. Bigourdan, P. Z. Adelstein, and J. M. Reilly, "Acetic Acid and Paper Alkaline Reserve: Assessment of a Practical Situation in Film Preservation" in ICOM-CC, *11th Triennial Meeting, Edinburgh, September 1–6, 1996, Preprints* (London: James and James, 1996), vol. 2, 573–79.

5. H. Wilhelm and C. Brower, *The Permanence and Care of Color Photographs: Traditional and Digital Color Prints, Color Negatives, Slides, and Motion Pictures* (Grinnell, Iowa: Preservation Publishing Company, 1993), 497.

6. S. M. Bradley, "Hydrogen Sulphide Scavengers for the Prevention of Silver Tarnishing," in *Environmental Monitoring and Control,* Preprints of the SSCR Symposium, Dundee, March 15–16, 1989 (Edinburgh: Scottish Society for Conservation and Restoration [SSCR], 1989), 65–67.

7. H. Brandes, "Are There Alternatives to the Traditional Air-Conditioned Film Stores?" in *Archiving the Audio-Visual Heritage,* ed. G. Boston, Third Joint Technical Symposium, May 3–5, 1990 (Ottawa: Canadian Museum of Civilization, 1992), 23–27.

8. J.-L. Bigourdan and J. M. Reilly, "Preservation Strategy for Acetate Film Collections Based on Environmental Assessment and Condition Survey," ed. S. Clark, in *Care of Photographic Moving Image & Sound Collections,* papers from a conference, July 20–24, 1998, York, England (Leigh Lodge, Leigh, Worcestershire, U.K.: Institute of Paper Conservation, 1999), 28–37.

9. Personal communication, J.-L. Bigourdan, Paris, September 12, 1996.

10. A. T. Ram, D. F. Kopperl, R. C. Sehlin, S. Masaryk-Morris, J. L. Vincent, and P. Miller, "The Effects and Prevention of Vinegar Syndrome," *Journal of Imaging Science and Technology* 38, no. 3 (1994):249–61.

11. D. Grattan, "Degradation Rates for Some Historic Polymers and the Potential of Various Conservation Measures for Minimizing Oxidative Degradation" in *Symposium '91: Saving the Twentieth Century,* ed. D. Grattan, Proceedings of the Conference of the Canadian Conservation Institute (CCI), Ottawa, September 15–20, 1991 (Ottawa: Communications Canada, 1993), 351–60.

12. J. Burke, "Anoxic Microenvironments: A Simple Guide," *SPNHC Leaflets* 1, no. 1 (1996).

13. *Ageless Oxygen Absorber: A New Age in Food Preservation* (Tokyo: Mitsubishi Gas Chemical Company of Japan, n.d.).

14. D. Grattan and M. Gilberg, "Ageless Oxygen Absorber: Chemical and Physical Properties," *Studies in Conservation* 39, no. 3 (1994):210–14.

15. F. L. Lambert, D. Vinod, and F. D. Preusser, "The Rate of Absorption of Oxygen by Ageless: The Utility of an Oxygen Scavenger in Sealed Cases," *Studies in Conservation* 37, no. 4 (1992):267–74; M. Gilberg and D. Grattan, "Oxygen-Free Storage Using Ageless Oxygen Absorber," in *Preventive Conservation Practice, Theory and Research,* Preprints of the Contributions to the Ottawa Congress, IIC, Ottawa, September 12–16, 1994

(London: International Institute for Conservation of Historic and Artistic Works [IIC], 1994), 177–80.

16. W. K. Hollinger, "Micro Chamber Papers Used as a Preventive Conservation Material," in *Preventive Conservation Practice, Theory and Research*, 212–16.

17. ISO Standard 6051: 1992 (F).

18. ISO 5626, ISO 63283-2, ISO 1184, ISO/WD 16245.

19. M. Edge, "Factors Influencing the Breakdown of Photographic Film: Implications for Archival Storage," in *Environnement et conservation de l'écrit, de l'image et du son*, Actes des Journées internationales d'études de l'ARSAG, Paris, May 16–20, 1994 (Paris: Association pour la recherche scientifique sur les arts graphiques [ARSAG], 1994), 114–20.

20. M. Jacobsen, "Film Storage: State of the Art and Detection of the 'Vinegar Syndrome,'" paper presented at the Journées internationales d'études de l'ARSAG, Paris, May 16–20, 1994.

21. J. C. Harthan, M. Edge, N. S. Allen, and H. Schou, "The Development and Evaluation of a Sensory System to Detect Degradation in Cellulose Tri-acetate Photographic Film. Part I: The Detection of Acetic Acid Evolved from Degrading Cellulose Triacetate Photographic Film," *Imaging Science Journal* 45 (1997):77–79; J. C. Harthan, M. Edge, N. S. Allen, and M. Bodnert, "The Development and Evaluation of a Sensory System to Detect Degradation in Cellulose Triacetate Photographic Film. Part II: Selection of a Solid Support for the Indicator and Field Trials on Indicator Performance," *Imaging Science Journal* 45 (1997):81–83.

22. W. A. Oddy, "An Unsuspected Danger in Display," *Museums Journal* 73 (1973):7–28; W. A. Oddy, "The Corrosion of Metals on Display," in *Conservation in Archeology and the Applied Arts* (London: IIC, 1975), 235–37; L. R. Green and D. Thickett, "Testing Materials for Use in the Storage and Display of Antiquities, a Revised Methodology," *Studies in Conservation* 40, no. 3 (1995):145–52.

23. P. B. Hallebeek, "Comparison of Corrosive Properties of Seven Types of Plywood," in *Contribution of the Central Research Laboratory to the Field of Conservation and Restoration*, ed. H. Verschoor and J. Mosk (Amsterdam: Central Laboratory for Objects of Art and Science, 1994),

95–108; J. Tétreault and E. Stamatopoulou, "Determination of Concentrations of Acetic Acid Emitted from Wood Coatings in Enclosures," *Studies in Conservation* 42, no. 3 (1997):141–56.

24. C. Grzywacz and N. H. Tennent, "Pollution Monitoring in Storage and Display Cabinets: Carbonyl Pollutant Levels in Relation to Artifact Deterioration," in *Preventive Conservation Practice, Theory and Research*, 164–70.

25. C. M. Druzik, D. C. Stulik, and F. Preusser, "Carbonyl and Carboxylic Acid Pollutants in Museum Environments," American Chemical Society, Division of Environmental Chemistry, Preprints 198th National Meeting, Miami Beach, Fla., 1989.

26. A. J. Sparkes, "The Effect of Surface Coatings on Formaldehyde Emission," in *Environmental Monitoring and Control*, Preprints of the SSCR Symposium, Dundee, March 15–16, 1989 (Edinburgh: Scottish Society for Conservation and Restoration [SSCR], 1989), 87.

27. J. Tétreault, "Display Materials: The Good, the Bad and the Ugly," in *Exhibition and Conservation*, ed. E. Sage, Preprints of the SSCR Conference, Edinburgh, April 21–22, 1994 (Edinburgh: Scottish Society for Conservation and Restoration [SSCR], 1994), 79–87; K. Eremin and P. Wilthew, "The Effectiveness of Barrier Materials in Reducing Emissions of Organic Gases from Fibreboard: Results of Preliminary Tests," in *ICOM-CC, 11th Triennial Meeting, Edinburgh, September 1–6, 1996, Preprints* (London: James and James, 1996), vol. 1, 27–35.

28. Wilhelm and Brower, *The Permanence and Care of Color Photographs*, 457.

29. D. Grosjean and S. S. Parmar, "Removal of Air Pollutant Mixtures from Museum Display Cases," *Studies in Conservation* 36, no. 3 (1991):129–41.

30. P. Z. Adelstein, J.-L. Bigourdan, and J. M. Reilly, "Moisture Relationship of Photographic Film," *Journal of the American Institute for Conservation* 36 (1997):193–206.

31. Wilhelm and Brower, *The Permanence and Care of Color Photographs*, 655.

32. T. Padfield and J. S. Johnsen, "Preservation of Photographs in a Humidity-Controlled Freezer," in *Preventive Conservation Practice, Theory and Research*, Summaries of posters at the Ottawa Congress, IIC, Ottawa, September 12–16, 1994.

33. M. McCormick-Goodhart, "Methods for Creating Cold Storage Environments," in *Care of Photographic Moving Image & Sound Collections,* 19–23.

34. G. Thomson, "Stabilization of RH in Exhibition Cases: Hygrometric Half-Time," *Studies in Conservation* 22, no. 2 (1977):85–102.

35. M. Duchein, *Les bâtiments d'archives: Construction et équipements* (Paris: Documentation française, Archives nationales, 1985).

36. J. Tétreault, "Matériaux de construction, matériaux de destruction," in *La conservation préventive,* 3e colloque de l'ARAAFU sur la conservation-restauration des biens culturels, Paris, October 8–10, 1992 (Paris: Association des restaurateurs d'art et d'archéologie de formation universitaire [ARAAFU], 1992), 163–76.

37. L. H. Feldman, "Discoloration of Black-and-White Photographic Prints," *Journal of Applied Photographic Engineering* 7, no. 1 (1981):1–9.

38. B. Eshøj and T. Padfield, "The Use of Porous Building Material to Provide a Stable Relative Humidity," in ICOM-CC, *10th Triennial Meeting, Washington, D.C., USA, August 22–27, 1993, Preprints* (Paris: ICOM–Committee for Conservation [ICOM-CC], 1993), vol. 2, 605–9.

39. G. Scott, "Moisture, Ventilation and Mould Growth," in *Preventive Conservation Practice, Theory and Research,* 149–53.

40. N. Valentin et al., "Air Ventilation for Arresting Growth in Archives," in *Preservation in the Digital Age,* Proceedings of the 4th ARSAG International Symposium, Paris, May 27–30, 2002 (Paris: Association pour la recherche scientifique sur les arts graphiques {ARSAG], 2002), 139–50.

41. T. Oreszczyn, M. Cassar, and K. Fernandez, "Comparative Study of Air-Conditioned and Non-Air-Conditioned Museums," in *Preventive Conservation Practice, Theory and Research,* 144–48.

42. D. Camuffo, "Modern Technology: A New Opportunity or a New Challenge for the Indoor Conservation of the Cultural Heritage?" *European Cultural Heritage Newsletter on Research* 10 (1997):77–83.

43. S. King and C. Pearson, "Environmental Control for Cultural Institutions: Appropriate Design and Use of Alternative Technologies," in *La conservation préventive,* 63–73.

44. D. Erhart and M. F. Mecklenburg, "Relative Humidity Re-examined," in *Preventive Conservation Practice, Theory and Research,* 32–38.

45. Ministry of Housing, Spatial Planning and the Environment, *Advisory Guideline Air Quality Archives,* Delta Plan Culture Preservation, June 1994.

46. Ibid.

47. *Main Principles of Fire Protection in Libraries and Archives: A RAMP Study,* Document PGI-92/WS/14 (Paris: UNESCO–General Information Programme and UNISIST, 1992).

48. NPFA 40: Standard for the Storage and Handling of Cellulose Nitrate Motion Picture Film, 2001 ed.

49. NFPA 232: Standard for the Protection of Records; NFPA 232A: Guide for Fire Protection for Archives and Records Centers, 2001 ed.; NFPA 909: Code for the Protection of Cultural Resources.

50. C. R. Reimer and M. R. Shefter, "Clean-Agent Fire Suppression Alternatives," *SMPTE Journal* 103, no. 8 (August 1994):523–27.

51. A. Cote and P. Bugbee, *Principles of Fire Protection* (Batterymarch, Park Quincy, Mass.: National Fire Protection Association, 1988).

52. P. D. Leighton, "Un Américain à Paris," *Newsletter of the Association des bibliothécaires français,* no. 159 (1993):37–45.

53. P. Gros, J. De Madre, and M. Dobel, "Un accident mortel dans un centre informatique: Prévention des risques induits par la décharge accidentelle des agents extincteurs gazeux," *Sécurité et médecine du travail,* no. 76 (1987):40–42.

54. P. Baril, "Introduction to Fire Protection," *CCI Newsletter,* no. 15 (1995):4–6.

55. J. Lafon, "La protection des œuvres d'art contre l'incendie par agent extincteur Inergen," in *Environnement et conservation de l'écrit, de l'image et du son,* 239–42.

56. P. Baril, "Documents techniques—Protection des musées contre les incendies," Programme d'appui aux musées, March 1990.

57. T. Log and P. Cannon-Brookes, "Water Mist for Fire Protection of Historic Buildings and Museums," *Museum Management and Curatorship* 14, no. 3 (September 1995):283–98.

58. F. Flieder and M. Duchein, *Livres et documents d'archives: Sauvegarde et conservation,* Cahiers techniques: Musées et monuments 6 (Paris: UNESCO, 1983).

Chapter 4. Environment

1. J. R. Briggs, "Preservation Factors in the Design of New Libraries: A Building Services Engineer's Viewpoint," in *Conservation and Preservation in Small Libraries* (Cambridge: Parker Library Publications, 1994), 49–69.

2. "Architecture et climatisation," *Les rencontres de Barbizon, Architecture et confort thermique,* no. 2 (February 1995):7–15.

3. C. S. Tumosa, M. F. Mecklenburg, D. Erhard, and M. H. McCormick-Goodhart, "A Discussion of Research of Temperature and Relative Humidity in Museums," *WAAC Newsletter* 18, no. 3 (September 1996):19–20.

4. P. Chardot, *Le contrôle climatique dans les bibliothèques* (Saint-Rémy-lès-Chevreuse: Sedit éditeur, 1989), 1–11.

5. P. Z. Adelstein, C. L. Graham, and L. E. West, "Preservation of Motion-Picture Color Films Having Permanent Value," *SMPTE Journal* 79 (1970):1011–18.

6. T. Padfield, "Low Energy Climate Control in Museum Stores: A Postscript," in ICOM-Conservation Committee, *11th Triennial Meeting, Edinburgh, September 1–6, 1996, Preprints* (London: James and James, 1996), vol. 1, 68–71.

7. M. H. McCormick-Goodhart, "The Allowable Temperature and Relative Humidity Range for the Safe Use and Storage of Photographic Materials," *Journal of the Society of Archivists* 17, no. 1 (1996):7–21.

8. J. M. Reilly, *The IPI Storage Guide for Acetate Film* (Rochester, N.Y.: Image Permanence Institute [IPI], 1993).

9. M. F. Mecklenburg, M. McCormick-Goodhart, and C. S. Tumosa, "Investigation into the Deterioration of Paintings and Photographs Using Computerized Modeling of Stress Development," *Journal of the American Institute of Conservation* 55, no. 2 (1994):153–70.

10. P. Z. Adelstein and J. L. McCrea, "Stability of Processed Polyester Base Photographic Films," *Journal of Applied Photographic Engineering* 7, no. 6 (1981):160–67.

11. Adelstein, Graham, and West, "Preservation of Motion-Picture Color Films Having Permanent Value."

12. P. Z. Adelstein, J. M. Reilly, and D. W. Nishimura, "Recent Changes in Recommended Storage of Photographic Film," in *Environnement et conservation de l'écrit, de l'image et du son,* Actes des Journées internationales d'études de l'ARSAG, Paris, May 16–20, 1994 (Paris: Association pour la recherche scientifique sur les arts graphiques [ARSAG], 1994), 109–13.

13. S. Michalski, "Relative Humidity: A Discussion of Correct/Incorrect Values," in ICOM-CC, *10th Triennial Meeting, Washington, D.C., August 22–27, 1993, Preprints* (Paris: ICOM–Committee for Conservation, 1993), vol. 2, 624–29.

14. C. Shahani, F. H. Hengemihle, and N. Weberg, "The Effect of Fluctuations in Relative Humidity on Library and Archival Materials and Their Aging within Contained Environments," in *Proceedings of the Pan-African Conference on the Preservation and Conservation of Library and Archival Materials, Nairobi, Kenya, June 21–25, 1993,* IFLA Professional Report No. 43, International Federation of Library Associations and Institutions, the Hague, 1995, pp. 61–70.

15. "Smithsonian Institution News," *Abbey Newsletter* 18, nos. 4–5 (1994):45.

16. S. Michalski, "Relative Humidity and Temperature Guidelines: What's Happening?" *CCI Newsletter,* no. 14 (1994):4–6.

17. V. Wagener, "Déshumidification: Des précisions," *L'installateur,* no. 514 (1989):116–23.

18. L. F. Karr, *Proceedings of the Conference on the Cold Storage of Motion Picture Films,* American Film Institute and Library of Congress, Washington, D.C., April 21–23, 1980 (Washington, D.C.: American Film Institute, 1980).

19. Cargocaire, *Dehumidification Handbook* (Amesbury, Mass.: Cargocaire Engineering Corporation, 1982).

20. G. Thomson, *The Museum Environment* (London: Butterworth, 1978).

21. D. F. Kopperl and C. C. Bard, "Freeze/Thaw Cycling of Processed Motion-Picture Films," *SMPTE Journal* 94, no. 89 (August 1985):826–27.

22. M. McCormick-Goodhart, "Methods for Creating Cold Storage Environments," ed. S. Clark, in *Care of Photographic Moving Image & Sound Collections,* Papers from a Conference, July 20–24, 1998, York, England (Leigh Lodge, Leigh, Worcestershire: Institute of Paper Conservation, 1999), 19–23.

23. Adelstein, Graham, and West, "Preservation of Motion-Picture Color Films Having Permanent Value."

24. J. P. Brown, "Hygrometric Measurement in Museums: Calibration, Accuracy, and the Specification of Relative Humidity," in *Preventive Conservation Practice, Theory and Research,* Ottawa Congress, IIC, Ottawa, September 12–16, 1994, Preprints (London: International Institute for Conservation of Historic and Artistic Works [IIC], 1994), 39–43.

25. C. Renaudot, "Évolution et tendance de la qualité de l'air en Île-de-France," paper presented at the Journées internationales d'études de l'ARSAG: Environnement et conservation de l'écrit, de l'image et du son, Paris, May 16–20, 1994.

26. N. Gally, P. Ritter, and M. Sepetjan, "Pollution intérieure des locaux," *Pollution atmosphérique,* no. 129 (January–March 1991):6–10.

27. J. H. Hofenk de Graaff, "The Effects of Pollutants on Paper, a Research Programme in the Netherlands," lecture delivered at the IFLA/ICA Seminar on Research in Preservation and Conservation, Colombia University, New York, May 25–29, 1991.

28. T. Godish, *Indoor Air Pollution Control* (Chelsea, Mich.: Lewis Publishers, 1990), 38.

29. P. Hatchfield and J. Carpenter, *Formaldehyde: How Great Is the Danger to Museum Collections?* (Cambridge, Mass.: Harvard University Art Museums, Center for Conservation and Technical Studies, 1987).

30. P. Brimblecombe, D. Shooter, and A. Kaur, "Wool and Reduced Sulphur Gases in Museum Air," *Studies in Conservation* 37, no. 1 (1992):53–60.

31. Eastman Kodak Company, Technical Information Bulletin.

32. E. Zinn, J. M. Reilly, P. Z. Adelstein, and D. W. Nishimura, "Air Pollution Effects on Library Microforms," in *Preventive Conservation Practice, Theory and Research*, Ottawa Congress, IIC, Ottawa, September 12–16, 1994, Preprints (London: International Institute for Conservation of Historic and Artistic Works [IIC], 1994), 195–201.

33. G. de W. Rogers, "Particular Aspects of Silver Tarnishing," Proceedings of the 1975 Annual Meeting of IIC-CG, *Bulletin* 1, no. 1 (1976):5–6.

34. T. P. Nguyen, B. Lavédrine, and F. Flieder, "Effets de la pollution atmosphérique sur la dégradation de la gélatine photographique," in ICOM-CC, *12th Triennial Meeting, Lyon, 1999, Preprints* (London: James and James, 1999), vol. 2, 567–71.

35. C. Bard, "Conservation of Images," in *The Stability and Conservation of Photographic Images: Chemical, Electronic and Mechanical,* Proceedings of the International Symposium, Bangkok, Thailand, November 3–5, 1986 (Bangkok: SPSE and Chulalongkorn University, 1986), 1–13.

36. E. Zinn, J. M. Reilly, P. Z. Adelstein, and D. W. Nishimura, "Preservation of Color Photographs: The Danger of Atmospheric Oxidants in the Storage Environment," in *Environnement et conservation de l'écrit, de l'image et du son,* 25–30.

37. K. Kitamura et al., "Gas-Fastness of Photographic Prints of Epson PM 950," paper presented at the annual meeting of ICIS, Tokyo, May 13–17, 2002, Arcadia Ichigaya, Shigaku, Kaikan, Japan.

38. C. M. Grzywacz and D. C. Stulik, "Passive Monitors for the Detection of Pollutants in Museum Environments," paper presented to the Object Specialty Group at the annual meeting of the American Institute for Conservation, Albuquerque, New Mex., 1991.

39. J. Tétreault, *Airborne Pollutants in Museums, Galleries, and Archives: Risk Assessment and Control Strategies* (Ottawa: Canadian Conservation Institute, 2003).

40. L. M. Bellan, L. G. Salmon, G. R. Cass, "A Study on the Human Ability to Detect Soot Deposition on Works of Art," *Environmental Science and Technology* 34, no. 10 (2000):1946–52.

41. *Air Quality Criteria for Storage of Paper-Based Archival Records,* National Bureau of Standards, 1983, NBSIR 83-2795.

42. Wilhelm and Brower, *The Permanence and Care of Color Photographs,* 563; K. B. Hendriks, *Fundamentals of Photograph Conservation: A Study Guide* (Toronto: Lugus, 1991), 413.

43. Tétreault, *Airborne Pollutants in Museums, Galleries, and Archives.*

44. J. P. Brown, "Low Humidity Environmental Control," in *Environmental Monitoring and Control, Preprints of the SSCR, Dundee, March 15–16, 1989* (Edinburgh: Scottish Society for Conservation and Restoration [SSCR], 1989), 88–90.

45. ASHRAE Standard 52.

46. P. Chardot, *Le contrôle climatique dans les bibliothèques* (Saint-Rémy-lès-Chevreuse: Sedit éditeur, 1989), 10–16.

47. ISO Standard 6051, 1992, p. 4.

48. Thomson, *The Museum Environment,* 130.

49. ANSI/NISO Standard Z39.54-199X.

50. M. McParland, "Environmental Conditions in the National Gallery of Ireland," *The Conservator,* no. 16 (1992):55–64.

51. J.-Y. Rault, *La filtration de l'air* (Paris: Éditions parisiennes, 1987), 65.

52. B. Lavédrine, "An Assessment of Pollution and Its Effects on Photographic Collections," *European Cultural Heritage Newsletter on Research* 10 (1977):87–91.

53. E. Weyde, "A Simple Test to Identify Gases Which Destroy Silver Images," *Photographic Science and Engineering* 16, no. 4 (1972):283–86.

54. ISA Standard ISA-S71-04-1985: Environmental Conditions for Process Measurement and Control Systems: Airborne Contaminants.

55. D. R. Fuchs, H. Römich, and H. Schmidt, "Glass Sensors: Assessment of a Complex Corrosive Stress in Conservation Research," in *Material Issues in Art and Archeology II,* ed. P. B. Vandiver, J. Druzik, and G. S. Wheeler, *Materials Research Society Symposium Proceedings,* vol. 185 (1991):239–51.

56. D. Stulik and C. Grzywacz, "Carbonyl Pollutants in the Museum Environment: An Integrated Approach to the Problem," in *La conservation préventive,* 3e colloque de l'ARAAFU sur la conservation-restauration des biens culturels, Paris, October 8–10, 1992 (Paris: Association des restaurateurs d'art et d'archéologie de formation universitaire [ARAAFU], 1992), 199–205; L. Gibson et al., "Simple Flux-meters for Determining Carbonyl Pollutants Arising from Storage and Display Materials," in *Preventive Conservation Practice, Theory and Research,* Summaries of Posters, Ottawa Congress, IIC, Ottawa, September 12–16, 1994.

57. G. Martin and N. Blades, "Cultural Property Environmental Monitoring," in *Preventive Conservation Practice, Theory and Research,* 159–63.

58. K. Walker, "Taking Control of the Stores: A Conservator in Charge," in *La conservation préventive,* 53–58.

59. Letter from C. M. Grzywacz, Getty Conservation Institute, to B. Lavédrine, February 17, 1994.

Chapter 5. Monitoring Collections

1. M. Frost, "Preventive Conservation: A Major Invisible Design Influence upon Museum Architecture," in *La conservation préventive,* 3e colloque de l'ARAAFU sur la conservation-restauration des biens culturels, Paris, October 8–10, 1992 (Paris: Association des restaurateurs d'art et d'archéologie de formation universitaire [ARAAFU], 1992), 59–61.

2. S. Wolf , ed., *The Conservation Assessment: A Tool for Planning, Implementing, and Fund Raising* (Washington, D.C.: Getty Conservation Institute, National Institute for the Conservation of Cultural Property, 1990).

3. C. Costain, "Plan for the Preservation of Museum Collections," *CCI Newsletter,* no. 14 (1994):1–4.

4. S. Michalski, "A Systematic Approach to Preservation: Description and Integration with Other Museum Activities," in *Preventive Conservation Practice, Theory and Research,* Preprints of the Contributions to the Ottawa Congress, IIC, Ottawa, September 12–16, 1994 (London: International Institute for Conservation of Historic and Artistic Works [IIC], 1994), 8–11.

5. J. Forston, "Disaster Planning and Recovery, How-to-Do-It," in *Manual for Librarians and Archivists,* no. 21, ed. B. Katz (New York: Neal-Schuman Publishers, 1992).

6. B. de Tapol, "Conservation du mobilier des maisons coloniales—musée: ventilation, aération ou isolation?" in *La conservation préventive,* 75–83.

7. G. S. Learmonth, "Maintenance and Hygiene in Environmental Control," in SSCR, *Environmental Monitoring and Control,* Preprints of the SSCR Symposium, Dundee, March 15–16, 1989 (Edinburgh: Scottish Society for Conservation and Restoration [SSCR], 1989), 47–52.

8. D. K. Sebera, *Isoperms, an Environmental Management Tool* (Washington, D.C.: Commission on Preservation and Access [CPA], 1994).

9. J. M. Reilly, *IPI Storage Guide for Acetate Film* (Rochester, N.Y.: Image Permanence Institute [IPI], 1993).

10. C. H. Giles and R. Haslam, "The Keeping Properties of Some Colour Photographs," *Journal of Photographic Science* 22 (1974):93–96.

11. J. M. Reilly, "Preservation and the Economics of Information Access in Institutions, Libraries and Archives," in *La conservation: Une science en évolution. Bilan et perspectives,* Actes des troisièmes journées internationales d'études de l'ARSAG, Paris, April 21–25, 1997 (Paris: Association pour la recherche scientifique sur les arts graphiques [ARSAG], 1997), 70–76.

12. J. S. Johnsen, "Surveying Large Collections of Photographs for Archival Survival," in *Preventive Conservation Practice, Theory and Research,* Preprints of the Contributions to the Ottawa Congress, IIC, Ottawa, September 12–16, 1994 (London: International Institute for Conservation of Historic and Artistic Works [IIC], 1994), 202–6; J.-L. Bigourdan, "Collection de négatifs photographiques noir et blanc, Agence Roger-Viollet. Examen et plan de conservation. Comportement en atmosphère acétique de la réserve alcaline des papiers d'archivage," dissertation, IFROA, Paris, 1993.

13. B. L. Ford, "Monitoring Colour Change in Textiles on Display," *Studies in Conservation* 37, no. 1 (1992):1–11.

14. D. Saunders, "Color Change Measurement by Digital Image Processing," *National Gallery Bulletin* 12 (1988):66–77; D. Saunders and J. Cupitt, "Image Processing at the National Gallery: The Vasari Project," *National Gallery Bulletin* 14 (1993): 72–85.

15. W. Wilhelm and C. Brower, *The Permanence and Care of Color Photographs: Traditional and Digital Color Prints, Color Negatives, Slides, and Motion Pictures* (Grinnell, Iowa: Preservation Publishing Company, 1993).

16. T. J. Reedy and C. L. Reedy, *Principles of Experimental Design for Art Conservation Research,* GCI Scientific Program Report (Los Angeles, Calif.: Getty Conservation Institute, 1992), 44; NFX 06-022 (October 1991), "Sélection de plans d'échantillonnage pour le contrôle par comptage de la proportion d'individus non conformes ou du nombre moyen de non-conformité par unité."

17. C. M. Drott, "Random Sampling: A Tool for Library Research," *College and Research Libraries* 30 (May 1969):119–25; M. Goldstein and J. Sedransk, "Using a Sample Technique to Describe Characteristics of a Collection," *Colleges and Research Libraries* 38 (March 1977):195–202.

18. D. W. Nishimura, "Surveying a Microfilm Collection," IPI report, 1994, unpublished.

19. R. Erlandsen, "The National Plan for Conservation of Photographs in Norway," in *Research Techniques in Photographic Conservation,* ed. M. S. Koch, Proceedings of the Conference in Copenhagen, May 14–19, 1995 (Copenhagen: Royal Danish Academy of Fine Arts, School of Conservation, 1996); J. S. Johnsen, "Conservation Management and Archival Survival of Photographic Collections," in *Göteborg Studies in Conservation* 5 (Copenhagen: Acta Universitatis Gothoburgensis, 1997).

20. G. Genette, *L'œuvre de l'art: Immanence et transcendance* (Paris: Édition du Seuil [Collection Poétique], 1994).

21. C. Brandi, "Theory of Restoration I," in *Historical and Philosophical Issues in the Conservation of Cultural Heritage,* ed. N. S. Price, M. K. Talley Jr., A. M. Vaccaro (Los Angeles, Calif.: Getty Conservation Institute, 1996), 230–35.

22. G. Salles, *Le regard* (Paris: Plon, 1939; reprint, Paris: Réunion des musées nationaux, 1992), 21.

23. S. Bergeon, "La formation des restaurateurs: Niveaux, interdisciplinarité et recherches en conservation-restauration," lecture, Parrariano, September 30, 1994.

24. Canadian Association for Conservation, 2000, http://www.cac-accr.ca; M. Cl. Berducou, coord., *La conservation en archéologie* (Paris: Masson, 1990), 10–12; A. Cartier-Bresson, "Une nouvelle discipline: La conservation-restauration des photographies," *La recherche photographique,* no. 3 (1987):69–73.

25. J. Ashley-Smith, N. Umney, and D. Ford, "Let's Be Honest—Realistic Environmental Parameters for Loaned Objects," in *Preventive Conservation Practice, Theory and Research,* 28–31.

26. P. Marcon, "Shipping Study," CCI *Newsletter,* no. 14 (September 1994):7–14.

27. R. Rémillard, "Risques tous azimuts: Biens culturels en transit," in *La conservation préventive,* 223–29.

28. P. J. Marcon, "The Packing and Transport of Cultural Property," in *La conservation préventive,* 211–22.

29. *États d'urgence: Guide des mesures d'urgence pour les bibliothèques (inondation, incendie, infestation).* (Vendôme: Agence interprofessionnelle régionale pour le livre et les médias [AGIR], 1992).

30. D. Hess-Norris, "Air-Drying of Water-Soaked Photographic Materials: Observations and Recommendations," in ICOM-CC, *11th Triennial Meeting, Edinburgh, September 1–6, 1996, Preprints* (London: James and James, 1996), vol. 2, 601–8.

31. Eastman Kodak Company, *Storage and Care of Kodak Color Film,* Kodak Pamphlet No. E-30, 1980.

32. K. B. Hendriks, *Fundamentals of Photograph Conservation: A Study Guide* (Toronto: Lugus, 1991), 423–27.

33. E. F. Cuddihy, "Storage, Preservation, and Recovery of Magnetic Recording Tape," in *Environnement et conservation de l'écrit, de l'image et du son,* Actes des Journées internationales d'études de l'ARSAG, Paris, May 16–20, 1994 (Paris: Association pour la recherche scientifique sur les arts graphiques [ARSAG], 1994), 182–86.

34. S. Michalski, "Relative Humidity: A Discussion of Correct/Incorrect Values," in ICOM-CC, *10th Triennial Meeting, Washington, D.C., August 22–27, 1993, Preprints* (Paris: ICOM–Committee for Conservation [ICOM-CC], 1993), vol. 2, 624–29.

35. M.-F. Roquebert, "Admirables et redoutables moisissures," in *Patrimoine culturel et altérations biologiques,* Actes des journées d'études de la SFIIC, Poitiers, November 17–18, 1988 (Champs-sur-Marne: International Institute for Conservation, French Section [SFIIC], 1989), 15–25; M.-L. E. Florian, "Conidial Fungi (Mould) Activity on Artifact Materials: A New Look at Prevention, Control, and Eradication," in ICOM-CC, *10th Triennial Meeting, Washington, DC, August 22–27, 1993,* vol. 2, 868–74.

36. V. Opela, "Fungal and Bacterial Attack on Motion Picture Film," in *Archiving the Audio-Visual Heritage,* ed. G. Boston, Third Joint Technical Symposium, May 3–5, 1990 (Ottawa: Canadian Museum of Civilization, 1992), 139–44.

37. E. Czerwinska and R. Kowalik, "Microbiodeterioration of Audiovisuals Collections," *Restaurator* 3, nos. 1–2 (1979):63–80; C. Aranyanak, "Microscopical Study of Fungal Growth on Paper and Textiles," in *Biodeterioration of Cultural Property* 3, Actes de la 3e conférence internationale de l'ICBCP, July 4–7, 1995, Bangkok, Thailand (Bangkok: International Conference on Biodeterioration of Cultural Property [ICBCP], 1996), 83–95.

38. F. Gallo, C. Marconi, P. Valenti, P. Colaizzi, G. Pasqueriello, M. Scorrano, O. Maggi, and A. M. Persiani, "Recherches sur quelques facteurs clés dans la détérioration biologique des livres et des documents," in *Environnement et conservation de l'écrit, de l'image et du son,* 63–71.

39. P. Chevalier and P. Coffinier, "L'aérobiocontamination," *Food Hygienepraxis,* nos. 3–4 (1995):36–37.

40. T. Godish, *Indoor Air Pollution Control* (Chelsea, Mich.: Lewis Publishers, 1990), 346.

41. NF T 72-190 (1988): Désinfectants de contact utilisés à l'état liquide, miscibles à l'eau, méthode des porte-germes, détermination de l'activité bactéricide, fongicide et sporicide.

42. M. Rakotonirainy and F. Flieder, "La désinfection des aires de stockage," in *Environnement et conservation de l'écrit, de l'image et du son,* 251.

43. J. Pellecuer and J. Allegrini, "Huiles essentielles bactericides et fongicides," *Revue de l'Institut Pasteur de Lyon* 2, no. 9 (1976):135–59.

44. M. Malléa, M. Soler, F. Anfosso, and J. Charpin, "Activité antifongique d'essences aromatiques," *Pathologie biologie* 27, no. 10 (1979):597–602.

45. C. C. Bard and D. F. Kopperl, "Treating Insect and Microorganism Infestation of Photographic Collections," in *The Stability and Preservation of Photographic Images,* 2d International Symposium, Ottawa, Ontario, Canada, August 25–28, 1985 (Springfield, Va.: Society of Photographic Scientists and Engineers [SPSE], 1985), 53.

46. M. Trehorel, "Aspect reglementaires concernant l'utilisation de l'oxyde d'éthylène: Incidence sur la conception et la mise en œuvre des équipements de désinfection. Patrimoine culturel et altérations biologiques," in *Patrimoine culturel et altérations biologiques,* Actes des journées d'études de la SFIIC, Poitiers, November 17–18, 1988 (Champs-sur-Marne: International Institute for Conservation, French Section [SFIIC], 1989), 55–69.

47. F. H. Hengemihle, N. Weberg, and C. J. Shahani, "Desorption of Residual Ethylene Oxide from Fumigated Library Materials," paper presented at the Journées internationales d'études de l'ARSAG, Paris, May 16–20, 1994.

48. F. Gallo, *Il biodeterioramento di libri e documenti* (Rome: Centro di Studi per la Conservazione della Carta, ICCROM, 1992), 103–4.

49. K. Yamamoto et al., "On the ArP Fumigation System: Using Propylene Oxide for Cultural Property," in *Preservation in the Digital Age,* Proceedings of the 4th ARSAG International Symposium, Paris, May 27–30, 2002 (Paris: Association pour la recherche scientifique sur les arts graphiques [ARSAG], 2002), 255–63.

50. D. Pinniger, *Insect Pests in Museums* (Denbigh: Archetype Publications, 1990).

51. R. E. Child and D. B. Pinniger, "Insect Trapping in Museums and Historic Houses," in *Preventive Conservation Practice, Theory and Research,* 29–31.

52. H. Tonimura and S. Yamaguchi, "The Freezing Method for Eradication of Museum Pest Insects: The Safe Method for Both the Human Body and Artifacts. Experiments on Japanese Artifacts and the Present State of the Freezing Method in Western Countries," in *Biodeterioration of Cultural Property* 3, 555–66.

53. R. Flukinger and B. Brown, "Curatorship and Conservation at the Harry Ransom Humanities Research Center: The Evolution of a Process," *Topics in Photographic Preservation* (American Institute for Conservation, Photographic Materials Group), no. 5 (1993):73–83; M. C. Baughman, "Integrated Pest Management at the Harry Ransom Center: Three Elements at Work: Incoming Inspection, an Insect Monitoring Program and an Effective Avian Aversion System," Summaries, 12th Annual Congress, Montreal, IIC-GG, May 22–23, 1996.

54. V. Daniel, S. Maekawa, and F. D. Preusser, "Nitrogen Fumigation: A Viable Alternative," in ICOM-CC, *10th Triennial Meeting, Washington, D.C., August 22–27, 1993,* vol. 2, 863–67; V. Daniel and G. Hanlon, "Non-Toxic Methods for Pest Control in Museums," in *Biodeterioration of Cultural Property* 3, 298–307.

55. S. Maekawa and K. Elert, "Large-Scale Disinfestation of Museum Objects Using Nitrogen Anoxia," in ICOM-CC, *11th Triennial Meeting, Edinburgh, September 1–6, 1996,* vol. 1, 48–53.

56. F. Flieder and C. Capderou, *Sauvegarde des collections du patrimoine* (Paris: CNRS édition, 1999).

Chapter 6. Light

1. Association française de l'éclairage (AFE), *La photométrie en éclairage* (Paris: Société d'édition Lux, 1991).

2. C. A. Cuttle, "A Proposal to Reduce the Exposure to Light of Museum Objects without Reducing Illuminance or the Level of Visual Satisfaction of the Museum Visitor." *Journal of the American Institute for Conservation* 39 (2000):229–44.

3. *Vocabulaire international de l'éclairage,* Publication de la Commission internationale de l'éclairage (CIE) no. 17.4, term 845-01-22.

4. Association française de l'éclairage (AFE), *Guide pour l'éclairage des musées et des collections particulières et des galeries d'art* (Paris: Société d'édition Lux, 1991), 33.

5. R. H. Lafontaine and P. A. Wood, *Fluorescent Lamps,* Technical Bulletin No. 7 (Ottawa: Canadian Conservation Institute [CCI], 1982).

6. M. Sancho-Arroyo and J.-P. Rioux, "L'utilisation au musée des équipements à éclairs électroniques," *Techne,* no. 4 (1996):128–36.

7. J. G. Neevel, "Exposure of Objects of Art and Science to Light from Electronic Flash-Guns and Photocopiers," in *Contributions of the Central Research Laboratory to the Field of Conservation and Restoration* (Amsterdam: Central Research Laboratory for Objects of Art and Science, 1994), 77–87.

8. D. Saunders, "Photographic Flash: Threat or Nuisance?" *National Gallery Technical Bulletin* 16 (1995):66–72.

9. Neevel, "Exposure of Objects of Art and Science to Light from Electronic Flash-Guns and Photocopiers."

10. http://www.knaw.nl/ecpa/sepia/workinggroups/wp4/Scanlight.pdt.

Chapter 7. Mounting and Exhibition

1. NF Standard S20-007: 1969, Photographie, diapositives et épreuves photographiques en couleurs, conditions d'examens visuel et comparatif.

2. AFNOR Standard X35-103, Principes d'ergonomie visuelle applicables à l'éclairage des lieux de travail.

3. T. B. Brill, *Light: Its Interaction with Art and Antiquities* (New York: Plenum Press, 1980); ICOM, *La lumière et la protection des objets et des specimens exposés dans les musées et galeries d'art,*

272

2d ed. (Paris: Association française de l'éclairage, 1977); A. Cartier-Bresson, B. Lavédrine, and B. Marbot, "Les expositions de photographies," *International Preservation News,* no. 17 (May 1998):20–32.

4. D. G. Severson, "The Effects of Exhibition on Photographs," in *Topics in Photographic Preservation,* vol. 1 (Washington, D.C.: American Institute for Conservation, Photographic Materials Group, 1986), 38–42.

5. T. F. Parsons, G. G. Gray, and I. H. Crawford, "To RC or Not to RC," *Journal of Applied Photographic Engineering* 5, no. 2 (1979):110–17.

6. N. Reinhold, "The Exhibition of an Early Photogenic Drawing by William Henry Fox Talbot," in *Topics in Photographic Preservation,* vol. 5 (Washington, D.C.: American Institute for Conservation, Photographic Materials Group, 1993), 89–94.

7. AFNOR Standard X35-103, Principes d'ergonomie visuelle applicables à l'éclairage des lieux de travail, June 1980, p. 13; Association française de l'éclairage (AFE), *Guide pour l'éclairage des musées et des collections particulières et des galeries d'art* (Paris: Société d'édition Lux, 1991), 40.

8. A. Bergeron, *L'éclairage dans les institutions muséales* (Quebec: Musée de la Civilisation; Montreal: Société des musées quebécois, 1992), 147; Photographic Materials Conservation Catalog, *Exhibition Guidelines for Photographs* (draft), American Institute for Conservation, Photographic Materials Group, 1993; J. J. Ezrati, *Manuel d'éclairage muséographique* (Dijon: Office de coopération et d'information muséographiques [OCIM], 1995), 45.

9. J. C. McElhone, "Determining Responsible Display Conditions for Photographs," in *Topics in Photographic Preservation,* 5:60–72.

10. J. M. Ware, "Quantifying the Vulnerability of Photogenic Drawings," in *Research Techniques in Photographic Conservation,* ed. M. S. Koch, Proceedings of the Conference in Copenhagen, May 14–19, 1995, Copenhagen (Copenhagen: Royal Danish Academy of Fine Arts, School of Conservation, 1996), 23–30; C. Costain, S. Michalski, and N. Binnie, "Évaluation de la sensibilité à la lumière des matériaux colorés dans les collections de musées," in *21st Annual Congress of the IIC-GC, Calgary, 1995, Summaries* (Ottawa: International Institute for Conservation of Historic and Artistic Works, Canadian Group [IIC-GC], 1995), 16; P. Whitmore, C. Bailie, and X. Pan, "Photochemical Kinetics, Optics and Color Change: Studies on the Origin and Prevention of the Light Fading of Paint," in *Art et chimie: La couleur,* Summary, International Congress on the Contribution of Chemistry to Works of Art, Amphithéâtre Rohan, École du Louvre, Palais du Louvre, Paris, 1998, 149–50.

11. T. Kenjo, "Certain Deterioration Factors for Works of Art and Simple Devices to Monitor Them," *International Journal of Museum Management and Curatorship* 5 (1986):295–300; N. S. Allen, E. Pratt, and D. M. McCormick, "Development of a Visible Light Dosimeter Film Based on Crystal Violet Dye," *Conservation News,* no. 52 (1993):10–11.

12. British Standard 1006: 1971, Methods for the Determination of the Colour Fastness of Textiles to Light and Weathering, International Organization for Standardization, Recommendation R105; R. L. Feller and R. M. Johnston-Feller, "Use of the International Standards Organization's Blue-Wool Standards for Exposure to Light: Use as an Integrating Light Monitor for Illumination under Museum Conditions," in *Preprints, 6th Annual Meeting, Fort Worth, Texas, June 1–4, 1978* (Washington, D.C.: American Institute for Conservation of Historic and Artistic Works [AIC], 1978), 73–80.

13. N. H. Tennent, J. H. Townsend, and A. Davis, "Light Dosimeter for Museums, Galleries and Historic Houses," *Preprints of the Conference on Lighting in Museums, Galleries and Historic House* (Bristol: Museums Association, 1987), 31–35; S. Staniforth and L. Bullock, "Surveying Light Exposure in National Trust Houses," *Museum Practice* 2, no. 3 (1997):72–74.

14. French patent no. 9812825, dated October 13, 1998: Dosimeter for evaluating degree of lighting, particularly of objects whose light exposure should be limited.

15. N. H. Tennent, J. H. Townsend, and A. Davis, "A Simple Integrating Dosimeter for Ultraviolet Light," in *Science and Technology in the Service of Conservation, Preprints,* IIC, Washington Congress, September 3–9, 1982 (London: International Institute for Conservation of Historic and Artistic Works [IIC], 1982), 32–38.

16. K. J. Macleod, *Museum Lighting,* Technical Bulletin No. 2 (Ottawa: Canadian Conservation Institute [CCI], 1975), 11.

17. G. Radu, "Research Concerning the Preservation of Colour Film by the Application of Protective Substances," *BKSTS Journal* 5 (May 1981):266–72; M. B. Meyers and J. E. Riordan, "Light-Induced Fading of Colour Prints," *British Journal of Photography* 128 (1981):1170–71.

18. *How Post-processing Treatment Can Affect Image Stability of Prints on Kodak Ektacolor Paper,* Kodak Pamphlet No. E-30 (Rochester, N.Y.: Eastman Kodak, 1982).

19. M. A. Mac Donald, "Evaluation of UV Glazing Materials," *EDR Report,* No. 1912, Environment and Deterioration Research, Canadian Conservation Institute.

20. G. Monni, "Étude d'une solution de montage pour la présentation des photographies contemporaines," *Nouvelles de l'ARSAG,* no. 13 (1997):13–16.

Chapter 8. Analog Reformatting

1. M. Friend, "Film/Digital/Film," *Journal of Film Preservation* 50 (1995):36–49.

2. S. T. Puglia, *Duplication Options for Deteriorating Photo Collections,* ed. J. Porro, Photograph Preservation and the Research Library (Mountain View, Calif.: Research Libraries Group, 1991), 29–35.

3. G. Brunel, "Restitution: Les dangers d'une notion obscure," in *Environnement et conservation de l'écrit, de l'image et du son,* Actes des Journées internationales d'études de l'ARSAG, Paris, May 16–20, 1994 (Paris: Association pour la recherche scientifique sur les arts graphiques [ARSAG], 1994), 189–93.

4. M. Hager, "Negative Duplication," in *La fragilità minacciata, Aspetti e problemi della conservazione dei negativi fotografici* (Rome: Unione Internazionale degli Istituti di Archeologia, storia e storia dell'arte in Roma, 1991), 61–73.

5. H. Bradley, "Corrective Reproduction of Faded Color Motion Picture Prints," *SMPTE Journal* 90, no. 7 (1981):591–96.

6. L. Rosenthalter and R. Gschwind, "Restoration of Old Movie Films by Digital Image Processing," Proceedings of the European Workshop on Image Analysis and Coding for TV, HDTV and Multimedia Applications (HAMLET Race Workshop), Rennes, February 27–28, 1996; O. Buisson, L. Joyeux, B. Besserer, S. Boukir, and F. Helt, "Restauration de documents cinématographiques par des méthodes numériques," in *La conservation: Une science en évolution, Bilan et perspectives,* Actes des 3es Journées internationales d'études de l'ARSAG, Paris, April 21–25, 1997 (Paris: Association pour la recherche scientifique sur les arts graphiques [ARSAG], 1997), 175–84.

7. G. Romer, Lecture delivered in Huesca, Spain, May 1995.

8. R. Gschwind and F. Frey, "Electronic Imaging, a Tool for the Reconstruction of Faded Color Photographs," *Journal of Imaging Science and Technology* 38, no. 6 (1994):520; F. Frey and R. Gschwind, "Mathematical Bleaching Models for Photographic Three-Color Materials," *Journal of Imaging Science and Technology* 38, no. 6 (1994):513; Y. Ando, "Digital Reconstruction of Faded Color Image," lecture delivered at the Conference on Managing and Preserving Image Collection, Bangkok, Thailand, November 4, 1995.

9. NF Standard Z43-104: Micrographie—Vocabulaire—Supports et conditionnements; Standard Z43-101: Micrographie—Vocabulaire—Termes généraux.

Chapter 9. Digitization

1. J. Rothenberg, "Ensuring the Longevity of Digital Documents," *Scientific American* 272, no. 1 (1995):24–29.

2. J. C. Mallinson, "Archiving Human and Machine Readable Records for the Millennia," in *The Stability and Preservation of Photographic Images,* 2d International Symposium, Ottawa, Ontario, Canada, August 25–28, 1985 (Springfield, Va.: Society of Photographic Scientists and Engineers [SPSE], 1985), 60–63.

3. M. Friend, "Film/Digital/Film," *Journal of Film Preservation* 50 (1995):36–49; P. Conway, *Preservation in the Digital World* (Washington, D.C.: Commission on Preservation and Access [CPA], 1996).

4. www.paperdisk.com

5. Research Library Group (RLG), *Preserving Digital Information: Report of the Task Force on Archiving of Digital Information* (Washington, D.C.: Commission on Preservation and Access [CPA], 1996).

6. T. Hendley, *Comparison of Methods and Costs of Digital Preservation: A Consultancy Study,* British Library Research and Innovation Report 106 (London: British Library Research and Innovation Centre, 1995).

7. J. Rothenberg, *Avoiding Technological Quicksand: Finding a Viable Technical Foundation for Digital Preservation* (Washington, D.C.: Council on Library and Information Resources [CLIR], 1999).

8. N. Goodman, *Langages de l'art* (Nîmes: Éditions Jaqueline Chambon, 1990).

9. F. Choay, "Sept propositions sur le concept d'authenticité et son usage dans les pratiques du patrimoine artistique," paper presented at the Conference on Authenticity, Nara, December 1–6, 1994, Working papers compiled by ICOMOS.

10. R. Lemaire, "Authenticité et patrimoine monumental," paper presented at the Conference on Authenticity, Nara, December 1–6, 1994, Working papers compiled by ICOMOS.

11. J. Barda, "L'original numérique," *Le photographe,* no. 1526 (July–August 1995):38–39.

12. A. R. Kenney and S. Chapman, *Digital Resolution Requirements for Replacing Text-Based Material: Methods for Benchmarking Image Quality* (Washington, D.C.: Commission on Preservation and Access, 1995).

13. M. Ester, "Image Quality and Viewer Perception," *Leonardo: Digital Image–Digital Cinema,* supplemental issue (1990):51–63.

14. J. Stokes, "Image Management," paper presented at the winter meeting of the Photographic Materials Group, American Institute of Conservation, Austin, Texas, March 1993.

15. J. C. Mallinson, "Preservation of Video Recorded Images," in *Environnement et conservation de l'écrit, de l'image et du son,* Actes des Journées internationales d'études de l'ARSAG, Paris, May 16–20, 1994 (Paris: Association pour la recherche scientifique sur les arts graphiques [ARSAG], 1994), 177–81.

16. T. Nakamura, A. Hatai, and K. Okamoto, "Archival Stability of Metal Video Tape as Used for Beta-Cam SP," in *Archiving the Audio-Visual Heritage,* ed. G. Boston, Proceedings of the 3d Joint Technical Symposium, Ottawa, Canada, May 3–5, 1990 (Ottawa: Canadian Museum of Civilization, 1992), 61–68.

17. E. F. Cuddihy, "Aging of Magnetic Recording Tape," *IEEE Transactions on Magnetics* 16, no. 4 (1980):558–68.

18. H. N. Bertram and E. F. Cuddihy, "Kinetics of the Aging of Magnetic Recording Tape," *EEE Transactions on Magnetics* 18, no. 5 (1982):993–99.

19. E. F. Cuddihy, "Storage, Preservation, and Recovery of Magnetic Recording Tape," in *Environnement et conservation de l'écrit, de l'image et du son,* 182–86.

20. Y. Levrey, "L'induction électromagnétique d'origine nucléaire: Quels risques pour la conservation de l'écrit, de l'image et du son?" in *Environnement et conservation de l'écrit, de l'image et du son,* 169–71.

21. www.norsam.com

22. M.-F. Calas and J.-M. Fontaine, *La conservation des documents sonores* (Paris: CNRS édition, 1996).

23. B. Cinnamon, *Gestion électronique de documents sur disques optiques* (Paris: AFNOR, 1989), 40.

24. P. Z. Adelstein, "Standards Preservation of Electronic Imaging," in *International Conference on Conservation and Restoration of Archive and Library Materials, Erice, April 22–29, 1996,* Preprints (Rome: Istituto centrale per la patologia del libro, 1996), 2:675–82.

25. D. Stinson, F. Arnell, and N. Zaino, *Lifetime of Writable CD and Photo CD Media* (Rochester, N.Y.: Eastman Kodak Company, 1993).

26. A. Carou and T. Nguyen, "Estempillage des CD-R par gravure mecanique au laser, poster, in *Preservation in the Digital Age,* Proceedings of the 4th ARSAG International Symposium, Paris, May 27–30, 2002 (Paris: Association pour la recherche scientifique sur les arts graphiques [ARSAG], 2002), 279.

27. W. M. Holmes, "The ODISS Project: An Example of an Optical Digital Imaging Application," in *Proceedings of Conservation in Archives,* International Symposium, International Council on Archives, Ottawa, May 10–12, 1988 (Paris: Conseil international des archives, 1989), 233–41.

28. *La conservation entre microfilmage et numérisation,* Actes des journées patrimoniales organisées par la BNF et l'ARMELL, Sablé-sur-Sarthe, November 8–9, 1993 (Sablé-sur Sarthe: Bibliothèque nationale de France [BNF], Agence régionale des métiers du livre

et de la lecture des Pays de la Loire [ARMELL], 1993).

Chapter 10. Processing Photographs for Permanence

1. H. Gensac, "Le voile des émulsions photographiques," *Photo-revue*, January 1960, 1–3.

2. G. Haist, *Modern Photographic Processing*, vol. 2 (New York: John Wiley and Sons, 1979), 641.

3. ISO Standard 10602: 1993(F), p. 11.

4. G. T. Eaton and G. I. Crabtree, "Washing Photographic Films and Prints in Sea Water," *SMPTE Journal* 65 (1956):378.

5. ISO Standard 10602: 1993(F), p. 11.

6. B. Lavédrine, "Deterioration of Some Contemporary Prints," *Topics in Photographic Preservation* (American Institute for Conservation, Photographic Materials Group) 6 (1995):106–10.

7. ISO Standard 6051: 1992 (F), p. iii.

8. F. J. Drago and W. E. Lee, "Review of the Effects of Processing on the Image Stability of Black-and-White Silver Materials," *Journal of Imaging Technology* 12, no. 1 (1986):57–65.

9. D. Beveridge and D. H. Cole, "Stability of Black-and-White Photographic Images," lecture delivered at the International Symposium of SPSE, Ottawa, Ontario, Canada, August 30–September 1, 1982, p. 41.

10. Y. Minagawa and N. Torigoe, "Some Factors Influencing the Discoloration of Black-and-White Prints in Hydrogen Peroxide Atmosphere," lecture delivered at the International Symposium of SPSE, Ottawa, Ontario, Canada, August 30–September 1, 1982, Summary, pp. 42–44.

11. D. Owerbach, "A Colorimetric Determination of Residual Thiosulfate (Hypo) in Processed Paper," *Journal of Applied Photographic Engineering* 9, no. 2 (1986):66–70.

12. J. M. Reilly, D. W. Nishimura, K. M. Cupricks, and P. Z. Adelstein, "Polysulfide Treatment for Microfilm," *Journal of Imaging Technology* 17, no. 3 (1991):99–107.

13. W. E. Lee and C. C. Bard, "The Post Treatment of Microfilm with Selenium Toner to Enhance Stability in Storage under Adverse Conditions," *Journal of Photographic Science* 36, no. 3 (1988):73–74.

14. J. S. Johnsen and K. B. Pedersen, "Comparison of Selenium and Sulfur Treatment for Protecting Photographic Silver Images against Oxidation," paper presented at the NFK Congress, Copenhagen, September 1994.

15. J. S. Johnsen, U. B. Nielsen, and K. B. Pedersen, "New Approaches in Processing of Black-and-White Photographic Material for Maximum Stability," in ICOM-CC, *10th Triennial Meeting, Washington, D.C., USA, August 22–27, 1993, Preprints* (Paris: ICOM–Committee for Conservation [ICOM-CC], 1993), 2:903.

16. E. Bénard, "Sulfuration des papiers argentiques en noir et blanc par les polysulfures: Optimisation de la stabilité par une sulfuration minimale," graduate thesis, École nationale supérieure Louis-Lumière, 1998.

17. J. M. Reilly, "A Summary of Recent Research at the Image Permanence Institute (1992)," *Topics in Photographic Preservation* (American Institute of Conservation, Photographic Materials Group) 5 (1993):52–59.

18. N. E. Elkington, ed., *RLG Preservation Microfilming Handbook* (Mountain View, Calif.: Research Libraries Group, 1992), 193.

19. K. B. Hendriks and S. Dobrusskin, "The Conservation of Painted Photographs," in ICOM-CC, *9th Triennial Meeting, Dresden, Germany, August 26–31, 1990, Preprints* (Los Angeles, Calif.: ICOM–Committee for Conservation [ICOM-CC] 1990), 1:249–54.

20. T. Miyagawa, Y. Shirai, and Y. Kato, "Fading Reaction of p-Diethylaminophenyl Naphthoquinoneimine Dye with Thiosulphate," lecture delivered at the International Symposium of SPSE, Ottawa, Ontario, Canada, August 30–September 1, 1982, pp. 22–25.

21. T. Hisanaga, T. Oinque, E. Fujii, T. Miyagawa, and N. Yabe, "On the Test Methods for Image Stability of Color Photographic Paper (II): Effect of Residual Thiosulfate Ions and Stabilizing Baths on the Stability," *Journal of the Society of Photographic Sciences and Technology of Japan* 44, no. 5 (1981):418–20.

22. S. Koboshi and M. Kurematsu, "Influence of Residual Chemicals in Color Prints on Dye Stability," lecture delivered at the International Symposium of SPSE, Ottawa, Ontario, Canada, August 30–September 1, 1982, p. 27.

23. "Les avantages du système dit *washless*," *Minilab Magazine*, no. 4 (1987):12, 14, 16.

24. S. Koboshi and M. Kurematsu, "A New Stabilization Process for Color Films and Prints Using Konica Super Stabilizer," SPSE 2d International Symposium, Ottawa, Ontario, Canada, August 25–28, 1985, transcript summaries (Springfield, Va.: SPSE, 1985), 54–56.

25. T. Ishii, N. Takahashi, and Y. Matsuda, "Stability of Color Photographs–v," *Bulletin of the Japan Society for Arts and History of Photography* 6, no. 1 (1997):60–73; B. Lavédrine, M. Gillet, C. Garnier, and M. Leroy, "Étude de la stabilité photochimique d'impressions couleurs à jet d'encre," *Nouvelles de l'ARSAG*, no. 13 (1997):16–18.

Index

Note: Page numbers followed by the letters *f* and *t* indicate figures and tables, respectively.